BODY
GUARDS

THE CULTURAL POLITICS OF GENDER AMBIGUITY

EDITED BY
JULIA EPSTEIN AND
KRISTINA STRAUB

ROUTLEDGE
NEW YORK & LONDON

Published in 1991 by

Routledge
An imprint of Routledge, Chapman and Hall, Inc.
29 West 35 Street
New York, NY 10001

Published in Great Britain by

Routledge
11 New Fetter Lane
London EC4P 4EE

Library of Congress Cataloging in Publication Data

Body guards : the cultural politics of gender ambiguity / edited by
 Julia Epstein and Kristina Straub.
 p. cm.
 Includes index.
 ISBN 0-415-90388-2; ISBN 0-415-90389-0 (PB)
 1. Sexual deviation—History. 2. Sex role—History. I. Epstein,
Julia. II. Straub, Kristina, 1951– . III. Title: Gender
ambiguity.
HQ71.B57 1991
305.3—dc20 91-14070

British Library Cataloguing in Publication Data

Epstein, Julia
 Body guards : the politics of gender ambiguity.
 I. Title II. Straub, Kristina, 1951–
 305.3

 ISBN 0-415-90388-2
 ISBN 0-415-90389-0 pbk

Contents

Contents

Acknowledgments

The idea for this book developed, as most ideas do, from a combination of idiosyncracy and serendipity. We got to know each other when we were both engaged in feminist studies of the fiction of Fanny Burney. From Burney, Kris moved logically to gender configurations in eighteenth-century theater, and Julia, less logically, to work on medical case reports of hermaphroditism. As our interests continued to converge, we decided to collaborate on a book that could situate the ideologies of gender ambiguity.

The people who made it possible for us to realize this project are its heart and soul: the contributors. Their careful thinking through of the cultural and historical contexts of gender ambiguity literally make this book. *Body Guards* has been a collaboration in every sense, not just between its editors, but among its contributors, who have critiqued and deepened and cross-referenced each other's work. We wanted *Body Guards* to read as a coherent book, a collective statement on gender ambiguity, rather than simply a set of essays sharing a subject or an approach. The extent to which that collectivity has been achieved owes much to the contributors' willingness to take into account each other's insights and research, an activity that has been as intellectually challenging as it has been bureaucratically complex (not to mention a strain on photocopy machines and a boon to telephone companies, electronic mail systems, and the post office). Citation styles in this book are consistent within essays but vary from essay to essay because each contributor works with the forms particular to her or his own discipline.

Body Guards

The comments of Elizabeth Castelli, Danae Clark, Elaine Tuttle Hansen, Everett Rowson, M. Elizabeth Sandel, Judith Shapiro, Randolph Trumbach, and Michael Wilson helped us to shape the introductory essay's "guarded body." The anonymous readers for Routledge also gave us insightful suggestions and asked useful questions. Other advice, encouragement, debate, and general sustenance and cheering on came from Kim Benston, Lisa Frank, Seth Frohman, Cathy Griggers, Raphael Hoch, Randy Milden, Gail Shepherd, and Paul Smith.

Our editorial task has been facilitated by the smart, witty, and efficient secretarial assistance of Sharon Nangle and the office help of Liz Tillman at Haverford College. Haverford's English department defrayed some photocopying and mailing expenses. Cecelia Cancellaro, our editor at Routledge, has been friendly, calm, and encouraging throughout.

We want especially to thank our partners, Betsy Sandel and Danae Clark, for their tolerance and cheerfulness in the face of chaos. We could not do our work without their sustaining support. Five-year-old Anna Epstein managed to start school in the middle of the editorial process, and her mischievous play with gender expectations serves as an inspiration for understanding how we construct ourselves in relation to our bodies and to social conventions. Last, but important: our dogs, Kris' black Labrador Retriever Molly and Julia's Airedale Emily, succeeded in coexisting peacefully. Had that not been the case, *Body Guards* might not have had an introduction.

Collaborative writing is logistically complicated and professionally fraught with competition and tension. Its rewards have been many, and range from an enriched sense of commitment to cultural studies, feminist scholarship, and gay and lesbian politics to a growing respect for each other's work and a deepening friendship. Our names are listed alphabetically for the sake of convention. The contents of *Body Guards* belong to its contributors; the conception of this book and its introduction belong to both of us equally.

J.E.
Philadelphia

K.S.
Pittsburgh

I

Introduction:
The Guarded Body

Julia Epstein and Kristina Straub

A deliberately random list of ambiguously gendered bodies: in 1765, "Jean-Baptiste" Grandjean, born "Anne" in 1732, was indicted for profaning the sacrament of marriage, ordered to wear women's clothing, and forbidden to consort with members of the female sex. Every year since 1901 in Philadelphia, the city's official Mummers Parade on New Year's Day features hundreds of mostly working-class, presumably heterosexual, middle-aged men prancing down Broad Street in spangles and feather boas. Gay men and lesbians gathered near Spruce Street, looking mundane in comparison, exult in the spectacle of these annually cross-dressed American traditionalists. A man strolls down the street swinging his hips, wearing rings and bangles, synthetic eyelashes and lipstick, lace underclothing and a silk jumpsuit. His legs are shaved, his breasts are false. His companion is a powerfully-built woman in spandex and a muscle shirt, her spiked hair dyed platinum. Her breasts are real, her legs are hairy. It is not Halloween or Mardi Gras or Carnival. Maybe we're on Christopher Street in New York or on Hortaleza in Madrid or in the Castro in San Francisco or the Shinjuku district in Tokyo. But we could also be in Paris or Rio de Janeiro, Bombay or Cairo, Budapest or Sydney or Hong Kong. Here are the questions, not much changed from 1765 to 1991: why are we being stared at? why are we staring?

We agree with anthropologist Thomas Csordas that "the body is not an *object* to be studied in relation to culture, but is to be considered

as the *subject* of culture, or in other words as the existential ground of culture."[1] The thesis of this book is that distinctions between male and female bodies are mapped by cultural politics onto an only apparently clear biological foundation. As a consequence, sex/gender systems are always unstable sociocultural constructions. Their very instability explains the cultural importance of these systems: their purpose is to delimit and contain the threatening absence of boundaries between human bodies and among bodily acts that would otherwise explode the organizational and institutional structures of social ideologies.

This collection of essays investigates the unsettlingly fluid boundaries between biological sex, gender identity, and erotic practice. We take as our starting point the tensions between social and legal insistences on the absolute binariness of male and female on the one hand, and the biological, cultural, and psychological instabilities built into sex/gender systems on the other. In examining the cultural constructions of masculinity and femininity from within this tension, each essayist analyzes a deployment of gender shape-shifting within a particular historical moment and situates the ideological power of sex/gender systems in a cultural context. The essays are organized with a loose chronology, as befits our focus on the cultural inscriptions of historical shifts. They move from studies of the virtue of "manliness" among Christian holy women in late antiquity and of lists of sensual indulgences in medieval Arabic vice lists to analyses of Renaissance hermaphroditism, transvestite and gay and lesbian subcultures across the last three centuries, and modern and postmodern transsexualism, making use of medical, autobiographical, filmic, political, and legal texts. In each case, the essays interrogate and negotiate across the often blurred lines between normative conceptions of sex and so-called transgressive gender identities and practices. *Body Guards* ends with a judicial interpretation of *Padula* v. *Webster* and *Bowers* v. *Hardwick* that radically questions the relation between contemporary sodomy statutes in the United States, the production of homosexual identities, and the erasure of heterosexual sodomy.[2] As Judith Butler has asserted, "juridical power inevitably 'produces' what it claims merely to represent."[3] Halley's legal analysis concludes a collection that charts a terrain for cultural studies of the body and the ideologies of sex and gender that are invested in it.

Gender, sex, anatomy, and eroticism are not interchangeable as

Introduction

terms or as cultural conceptions, and we try throughout to be sensitive and responsible in our use of terminology. Even the supposedly empirical category of biological sex is disturbingly (or exhilaratingly) labile, as its chromosomal, gonadal, and secondary determinants may contest with each other.[4] It is crucial to keep the plasticity of these categories and their overlappings and intersections in the foreground in any attempt to analyze the way such classifications are culturally and ideologically produced. Biological sexual differentiation is not as clearcut as legal definitions would suggest, and on the ambiguous middle ground between male and female have settled notions of the abnormal and the anomalous. This privileging of coerced dualism has been created by social more than by physiological forces. At the same time as we want to flag the pliancy of anatomic and biological categories and the impossibility of empirical conscription, we also want to keep more apparently cultural notions separate: erotic desire shades into but cannot be equated with sexual practice, for example. Sexuality and gender identity also do not necessarily have clear points of cohesion. Indeed, if this collection as a whole makes any point with conviction, it is that designations of "normative" or "transgressive" are always historically and culturally relative, enormously unstable and labile, and highly indicative of threatened ideological positions. This is especially, even paradigmatically, the case with cultural constructions such as the charged categories of gender, race, and class.

We define gender as what we make of sex on a daily basis, how we deploy our embodiedness and our multivalent sexualities in order to construct ourselves in relation to the classifications of male and female. This deployment does not arise from any "natural" or scientifically representable idea of the body as a physical object, nor is it individually negotiable. The body functions, rather, as Nancy Armstrong puts it, "as an image or sign we use to understand social relationships, which include the relationship between ourselves as selves and the body within which, as modern selves, we find ourselves enclosed."[5] Sex/gender systems, as we understand them, are historically and culturally specific arrogations of the human body for ideological purposes. In sex/gender systems, physiology, anatomy, and body codes (clothing, cosmetics, behaviors, miens, affective and sexual object choices) are taken over by institutions that use bodily difference to define and to coerce gender identity.[6]

This introduction aims not to summarize the essays in *Body Guards*,

3

but to situate them within a cultural politics of the body. The first section of this introduction outlines some of the critical and theoretical moves that have led to our current fascination with bodies and embodied ideologies, or ideological incorporations. Ambiguities in gender identity and sexual practice occupy a crucial position in an important and heterogeneous project in critical theory, historical research, and sociopolitical concern. Since gender definitions offer one of the primary differentiating principles by which binary structures are socially initiated and maintained as hierarchical relations, ambiguous gender identities and erotic practices such as those manifested in transvestism, transsexualism, and intersexuality offer a point at which social pressure might be applied to effect a revaluation of binary thinking. The second section connects this trajectory in criticism and theory to recent right-wing governmental efforts to control and contain the body through political responses to the AIDS epidemic, reproductive technologies, the abortion debate, the new concern with "fetal rights" and the monitoring of maternal behavior during pregnancy. In social and political agendas that present themselves as moral missions to restore traditional family values, the transgressive body (gay or lesbian, cross-dressed, intoxicated or high, for sale, on display) both anchors and is acted upon by the discourses of a coercive dominant morality. In particular, the anti-sex rhetoric and gay-bashing produced in response to HIV infection have led to a struggle between pleasure and anxiety, and we try to understand, largely in the North American context we live in and can best interpret, how this tension operates. In the third section, we look at the early histories of our current interest in fashioning, defining, and harnessing embodiment as closure. We want to analyze what is at stake in guarding the physical and erotic body. In this section, we also discuss the purpose and contribution of our juxtaposition of these essays. We close with a statement of the kind of cultural and political interventions we want this volume to participate in making.

Bodies in Criticism

In the 1980s, ambiguities of sexuality and gender identity assumed a peculiarly interesting position in critical theory, theories of literature, and theories of popular culture. Phenomena such as passive men,

4

sexually aggressive women, gay men and lesbians, heterosexual men who cross-dress, transsexuals, fetishists of various sorts, and women body builders can be interpreted as escaping a binary system of sexuality and gender. Whether such manifestations are called ambiguity, excess, the Other, or positioned as a Lacanian construction of "femininity," they have become the focus of feminist, deconstructionist, and some psychoanalytic theories, as well as a concern for certain marxist theories of culture and ideology. Ambiguities of gender and sexuality are alternately and sometimes simultaneously celebrated as liberatory strategies for breaking with dominant ideologies and warned against as a recuperative, conservative cultural mechanism. In either case, such ambiguities are the objects of a political debate that itself calls for interrogation and examination: why are sexually ambiguous phenomena and ambiguous manifestations of gender characteristics such a site of interest and debate among theorists, critics, ethnographers, and historians?

In order to address this question about our present preoccupation with and research into ambiguities of sex and gender, this volume seeks first to place such ambiguities historically, in pre-industrial economies and capitalist cultures, in order to interrogate their function within or in relation to a range of dominant systems of sexuality and gender. This is not to say that we pretend to offer a comprehensive overview of such a huge and diverse topic. Rather, we hope that these essays will contribute to historical, theoretical, and critical inquiries into the ideological importance of the sexually ambiguous and ambiguously gendered in specific cultural contexts and within cultural politics. Stated as such, perhaps even this goal is too broad; a better formulation of what we seek to accomplish might be to say that we hope to investigate how we arrived at this present moment of fascination with such ambiguities. Can we trace a history of interest in this subject in earlier cultures in the West? Does such an interest come into play in pre-industrial and nonwestern cultures? What is the historically specific nature of this interest? When and why do ambiguities of sexuality and gender evoke pleasure? horror? indifference? criminal prosecution? Can we begin to draw some conclusions about the nature and function of gender ambiguity in relation to present concerns with the politics of gender and sexuality in academic inquiry and the advanced capitalist culture in which we live?

In the service of addressing these and related questions, this volume includes work on materials which roughly correspond to the emergence and development of capitalist economies and ideologies in the West. To avoid the trap of universalizing our present moment into an always/already, seemingly stable construction, we include essays on pre-industrial cultures and focus a significant proportion of the pre-nineteenth-century work on a period of emerging modernity, the eighteenth century. The work of many historians of sexuality and gender—from Foucauldian "archaeologists" to feminist re-writings of literary and cultural history, to lesbian and gay research into the history of "alternative" sexualities—positions the eighteenth century as one of the key periods of emergence for modern forms of sexuality, institutionalized sexual subcultures, and gender identity in the West.[7] Hence, this period calls for careful and detailed attention if we are to come up with historically responsible answers to the question of how and why ambiguities of sex and gender function in critical work in the humanities and social sciences and as important issues for the present moment in sexual and gender politics.

Two kinds of shifts have dominated recent academic criticism. On the one hand, poststructuralist inquiry into the slipperiness and instability of linguistic forms has moved to an analysis of the postmodern condition, manifested in the giddy meaninglessness of cultural icons, and in urban and technological fragmentation. While much of this work has been done in Britain and America, it emanated originally from French philosophical thought, and its chief spokespersons have been Jacques Derrida, Jean-François Lyotard, and Pierre Bourdieu. On the other hand, feminist (especially materialist feminist) theory and then new historicism have shifted to the practice of a cultural studies that emphasizes cross-disciplinary methodologies in uniting the techniques of ethnography, literary criticism, and social history and that aims to understand sociocultural discourses as the ideological representations of meaning production.[8]

The stakes of this inquiry are especially high from three different, although often overlapping, disciplinary points of view that inform the shaping of this volume, if not the writing of all the essays: cultural studies, feminist theory, and gay and lesbian history and liberation theory. All three are concerned with the politics of how sexuality and gender function within the social systems which are their objects of

Introduction

study. All three are inclined to ask questions about power and subjuga-
tion, about how some forms of identity or behavior are constructed as
"natural" while others are marginalized and repressed. And all three
focus, to one degree or another, on ambiguous forms of sexuality and
gender as sites in which these power relations can be read.

British cultural studies, beginning with Stuart Hall's ground-break-
ing seminars at Birmingham, have made the politics of ambiguity in
general important to the analysis of popular culture.[9] By making the
artifacts and tropes of mainstream culture available to subcultural
reinterpretation and subversion, Dick Hebdige, for instance, makes it
possible to read consumer culture as incorporating resistance within
itself.[10] Prior to the inception of British cultural studies, the Frankfurt
School of marxist theory had afforded glimpses of a reading practice
that theorized ambiguity at the heart of capitalist culture; Theodor
Adorno, in particular, posed a "dialectic of luxury" which "opens
up consumer culture to be read as its opposite."[11] Recent feminist
approaches to cultural studies, exemplified in Jane Gaines and Char-
lotte Herzog's recent anthology, *Fabrications*, focus specifically on the
sexual ambiguities articulated in media as opportunities, in the forms
of masquerade and subversive uses of fashion, for feminine resistance
to dominant sexual ideologies.[12] Lesbian theorists such as Sue-Ellen
Case have recently found subversive energies in the gender ambiguities
of role-playing and camp, while Judith Mayne reads the films of the
lesbian director, Dorothy Arsner, as ambiguously posed critiques of
Hollywood gender ideology.[13] The political left of critical theory could
be said to be in the midst of a long love affair with the subversive
potential of gender ambiguity, but this affair has not been an untrou-
bled one.

The trouble often emerges when leftist critics subject readings which
valorize ambiguity to the test of political efficacy. Feminists, lesbian
and gay theorists, and marxist proponents of cultural studies often find
themselves caught between a politics of "identity," of naming and
valorizing particular constructions of groups and individuals, and a
politics that seeks to exploit the ambiguous in terms of class, race, and
gender. For feminists, this conflict takes the form of a contradictory
need both to claim and to question the identity "woman," or, even
more radically, the more open-ended and historically responsible cate-
gory "women."[14] Recent debates over the perceived problems of "es-

7

sentialism" and the equally pressing needs to assert feminist political identities and agency and to underline the force of positionality fore-ground the problematic nature of gender ambiguity as a means of political resistance to dominant and oppressive systems of sexuality and gender.[15] Similarly, marxist theorists such as Chantal Mouffe and Ernesto LaClau seek to find ways to resist the reification of the working class—a reification that may be holding marxist theory back from coming to terms with the complexities of postmodern, advanced capitalist culture.[16] What gives many of us pause, however, is the loss of such points of political purchase as can be and have been afforded by constructions of identity such as "the working class." Theories of racial difference struggle to balance the liberatory potential of "hybridiza-tion," of race as a constructed signifier, against what Stuart Hall sees as the need to recast and deploy the notion of identity as a means to political action.[17]

The tension between identity politics and a politics of ambiguity is perhaps most vividly illustrated in the burgeoning field of lesbian and gay history. Like much work in African-American history, gay and lesbian history grew out of a modern move to claim identity and community as sources of psychological and political strength. The search for "roots," for ancestors and origins, became more complex for both African-Americanists and lesbian and gay historians, however, than a simple trip "home." The nature of identity based on race could change in different times and contexts, of course, but the very notion of an identity based on sexual object choice proved to be contingent in and of itself. From different perspectives and with different materials, for example, both Everett Rowson and Janet Halley make similar distinctions between acts and identities using medieval Arabic vice lists and 1980s American legal articulations of sodomy. Social construction theories of sexual and gender identity emphasize the instability and fluidity of all such identities—to many an exhilarating liberation from rigid or confining categories. But the ambiguous nature of sex and gender revealed in gay and lesbian historiography is sometimes difficult to reconcile to present needs, in an age of AIDS hysteria and renewed homophobia, for politically strong gay and lesbian communities and identities. What is crucial to this debate over essentialism versus the fluidity of gender constructions, is, then, as Diana Fuss has pointed

out, politics—the politics of gender ambiguity versus identity.[18] Is the latter a trap from which the former can liberate us, or is gender ambiguity a seductive but dangerous illusion in political struggles with a right wing which is all too comfortable with its beliefs in "essentials" such as compulsory heterosexuality, white and first-world supremacy, and male dominance?

In sum, gender ambiguity has become the focus of some of the most serious political debates in recent critical theory. It is not coincidental that popular cultural depictions of gender play on and with ambiguity, from David Bowie, Michael Jackson, Boy George, and k.d. lang to "Victor, Victoria," "Tootsie," and *M. Butterfly*, and the fashion photography of magazines such as *Vogue* and *Mirabella*. Academic critical theory too has come to focus on the gendered body as a site of ambiguity and/or identity. This focus on the body would seem to promise resolution both as physical evidence of gender identity and the site of claims from the corporal body to the body politic. Bodies prove, however, to be recalcitrant to critical theory in both respects. Anatomical sex may resist empirical classifications, and gender, the alleged cultural correlative of sex, cannot be tethered even to this tenuous "truth."[19] Furthermore, the ambiguous body itself eludes political certainties. The grotesque body of Mikhail Bakhtin's work on the carnivalesque exemplifies the slipperiness of the ambiguously gendered body in relation to political theory. Bakhtin positions this body as both recuperative, a sort of safety valve in the service of dominant ideology, and as subversive, that which exceeds and refuses that ideology.[20]

This political ambivalence has been seen as a leverage point for social change by both marxists and feminists, but it also demonstrates the recuperability of gender-ambiguous bodies into oppressive political and social systems.[21] Nonetheless, it is instructive to observe the uses to which Bakhtin's sometimes nostalgic, often politically conservative construction of a grotesque, uncategorizable body has been put by feminist critics in recent years. Mary Russo's important essay on "Female Grotesques" outlines an agenda for feminist appropriations of Bakhtin's grotesque, ambiguously gendered bodies that marks the increased political clarity and seriousness of critical and theoretical work on the body.[22] Work such as Russo's and that of Terry Castle and Dale Bauer approaches gender ambiguity with caution, cognizant of the

lesson learned from history and the careful study of modern cultures: that gender ambiguity, in and of itself, answers to many different political masters.[23]

The fact, however, that the gender-ambiguous body is, for all its political hazards, a focus for recent, highly politicized forms of theory and criticism leads us to the question of why ambiguities of gender and sexuality continue to be compelling points of congregation for those who seek to question or displace oppressive (even if always labile) sex/gender systems. One partial answer may rest with the recuperative, appropriative modes of capitalism. As marketplace phenomena such as gay window advertising suggest, capitalism allows marginalized or stigmatized forms of sexual behavior and identity to filter into consumer culture packaged in disguised forms which take away the edge of political threat posed by those sexualities.[24] However ultimately recuperative and conservative the "marketing" of gender ambiguity may be, it may also allow a pleasurable "point of purchase," to use John Fiske's term, that allows those who are politically marginalized opportunities to "decode" ambiguity in more politicized interpretations.[25] Hence, the anarchistic tendencies of the industrial marketplace afford some opportunities for challenging its dominant ideologies that politically subversive forms of theory and criticism are quick to take up. More compelling, perhaps, are some of the cultural and political contexts of present theory: the current containment and control of bodies by technologies and right-wing political discourses.

Bodies in Culture

The material presented in *Body Guards'* essays is compelling: we are drawn into the lives and representations of Perpetua and the Chevalier d'Eon, of Salomé and Omani *xanith*, of Charlotte Charke and the eponymous heroine of "Black Widow." What appeals to us, and to what do these narratives appeal? This is not a stupid or an innocent question. Do we gape at drag shows or at photographs of women wearing dildos in the same way that we gape at a fire or a car wreck? Radio traffic reports label this latter phenomenon, in fact, a "gaper block": so many slack-jawed human lemmings blocking the roads for a glimpse of forbidden Otherness. Or is that unfair? Is it just that there

is a logical progression in intellectual and conceptual development from feminist concerns to unearth and revalue "lost foremothers" and to revalidate "feminine" attributes; to renegotiating political and social theory through feminist insights; to a broadening out into "gender studies"; to a rethinking of and resistance toward the whole notion of sex/gender systems and their construction? Sandy Stone's posttranssexual manifesto addresses this final move most directly, by tying gender identities to personhood and "self"—the whole range of human subjectivities. Judith Shapiro points out the importance of detaching gender from sex in order to maintain the ideological operations of a fictively stable sex/gender system. It is clear from this collection that gender blurrings have a long pre-twentieth-century history and a wide cultural distribution, and have attracted a variety of different explanations, or explanatory narratives. Surgical possibilities for "gender reassignment"[26] have only opened in a late modern period (and what is more *postmodern* than transsexualism?), but there is indeed nothing remotely new about transvestism or "gender dysphoria" except the official professionalizing and medicalization of the terms.[27] Why all the attention now from scholars? What are the academic politics of the kind of cultural studies work *Body Guards* showcases?

Academic critical theories are often rightly accused of insularity from any sense of lived experience or practical application. But there are uncanny ways in which shifts in academic critical thinking mirror other kinds of social change. The last decade has been a time of contested struggles for social understanding and of great intellectual contradictions. The 1989 dismantling of the Berlin Wall apparently broke down political difference between the Soviet Union, eastern Europe and the Baltic and Balkan states, and the United States and its western European allies. But this breakdown masks a fundamental concentration of economic and social difference in the West (North America and western Europe are, in practice, the geographical locations designated by this political category) in increased homelessness, unemployment, substance abuse and despair, and decreased availability of resources for education, drug treatment, job training, birth control, child care, and housing. The subsequent military build-up and war in the Persian Gulf almost too conveniently has thwarted attention from the social failures of capitalist democracies, which can no longer gesture toward a moral rhetoric of competing political ideologies now

Body Guards

that "democracy" has, for the moment, won the day.²⁸ As this concentration occurs, the hegemonic right-wing political agenda for "traditional family values" argues that these politically wrought ills are actually the products of a breakdown in morality rather than a breakdown in community welfare or education or health care systems or state funding for the disadvantaged.

At the same time, and not coincidentally a catalyst for political and economic tensions, the most marginalized and disenfranchised groups in Western and African societies have been battling an epidemic infection with scant help from state agencies. Surrounding the AIDS epidemic has sprung a distantiating and self-denying discourse of self and other. As the right has mobilized around its sacred narrow definitions of family, there has been a concurrent increase in non-normative family structures and in tolerance for alternative sexual arrangements. Jeffrey Weeks has pointed out that this tension results in part from "a complex crisis in sex relations, in race relations, and in class relations which most of the Western world has been undergoing over the past twenty or thirty years," and argues that "the response to the AIDS crisis has been shaped by its association with a threatening sexuality, and with the gay movement that emerged around that threatening sexuality, and with other despised and marginalized groups in our culture."²⁹ AIDS has crystallized and given urgency to a number of cultural discourses that had already asserted themselves before 1980: the deployment of Otherness as a literalized contamination; a new focus on censorship, from the Meese Commission³⁰ to the Helms amendment to the funding review practices of the National Endowment of the Arts, and even to rock and rap lyrics and Bart Simpson t-shirts; and an answering repoliticization of art in the AIDS images produced by ACT UP and the Gran Fury collective, and in attacks on the work of artists such as Keith Haring, Barbara Kruger, Robert Mapplethorpe, Cindy Sherman, Holly Hughes, David Wojnarowicz, Jock Sturges, and Karen Finley.

Academic critical theory has focused on paradigms of the body and embodiedness, then, just at the moment that the AIDS epidemic and HIV infection have focused social concerns on the human body as a carrier of culture, values, and morality. Such a focus has occurred despite, or, perhaps tellingly, *because* of the body's literal incorporation of contagion. This is not a coincidence. AIDS discourses have in many

12

ways catalyzed the operations of cultural analysis, and Simon Watney's work provides one of the best discussions so far of this. As Watney points out in the Preface to his *Policing Desire: Pornography, AIDS & the Media*, "whether we like it or not we live with the complex inheritance of two bodies of theory, one emphasizing the diversity and mobility of sexual behaviour and identities *between* different social groups, the other emphasizing the diversity and mobility of sexual desire and behaviour *within* individuals."[31] So AIDS has been quarantined to particular "risk groups" rather than "risk behaviors" in the social imagination.[32] These groups must by definition be identified as "not us." This process of ideological resistance to contamination requires a corresponding segregation of behaviors by group and classification of groups by alleged sexual practices, as Janet Halley's essay demonstrates, such that stigma can be affixed and contained and the marginalization and continued disenfranchisement of these groups ("not us") justified. Hence the denial that married, white, middle-class heterosexuals ever engage in anal sex or are promiscuous or visit prostitutes or inject drugs, against all clear knowledge to the contrary. In consequence, Watney continues, we must "contest and refute the heavily overdetermined picture of 'normal' sexuality and 'abnormal' sexual acts that so massively informs AIDS ideology"[33] and "insist that in all its vibrant forms, human sexuality is much of a muchness."[34]

Watney's analysis of AIDS representations and the discursive efforts to contain the HIV virus by "policing desire" points to the variety and mutability of sexual desire and to the cultural production of identity and subjectivity through the terms of sexuality. A deep sexual anxiety in Western cultures has surfaced through our social and organizational responses to AIDS as a disease of gay men, of IV drug-users (largely in indigent African-American and Latino communities) and of black Haitians and black Africans. Some analysts of the cultural politics of AIDS have connected the social constructions that enclose people with AIDS and those who are seropositive with Julia Kristeva's notion of "the abject"—the unnameable terror, a kind of psychologization of threat and deviance.[35] The politics of gender, class, and race are everywhere visible in the social production of Otherness orchestrated by the fear of HIV infection. Because it has been constructed as an "ideological disease" (though in fact, of course, AIDS is a syndrome rather than a disease and HIV infection must be kept distinct from AIDS), according

to Watney, "the real complex tragedy of AIDS has been grotesquely exploited in order to bolster an ideologically powerful, cruelly narrow and punitive fantasy of family life."[36]

Anxieties surrounding variant sexualities and right-wing prescriptions for the traditional family return us to the centrality of the body in cultural discourses, and to multivalent notions of "decency," "morality," "dignity," and "degradation" that have been aligned with the body's subjectivities. Michel Foucault's studies of power relations present this clearly:

> The body is directly involved in a political field; power relations have an immediate hold upon it: they invest it, train it, torture it, force it to carry out tasks, to perform ceremonies and to emit signs. The political investment of the body is bound up, in accordance with complex, reciprocal relations, with its economic use; it is largely as a force of production that the body is invested with power and domination; but, on the other hand, its constitution as a labour power is possible only if it is caught up in a system of subjection . . . the body becomes a useful force only if it is both a productive body and a subjugated body.[37]

It is no surprise, then, that categories of sex and gender have become so vexed, that the radical feminist and sometimes right-wing essentialist notions of "true" femaleness and maleness are challenged by increasing awareness of the elastic nature of sexuality and the variety of sexual practices.[38] An even greater anxiety emerges from the play of difference *within* the notion of gender, from biological gender disorders of chromosomal or hormonal development to the radical disjunction of biological sex from gender identity represented by transsexualism and transvestism as official *DSM-III* categories.[39] As Sandy Stone reminds us, the paradoxes inherent in the inclusion of the "diagnosis" of transsexualism in the *DSM* represent something of a Pyrrhic victory.

The strict binary delineations of the sex/gender system of masculine and feminine provide an ordered classification schema against which the only alternative seems to be uncontainable elasticity and a chaotic and terrifying lack of boundaries within or between human bodies. Political theorist Joan Cocks puts it this way:

> Masculine/feminine is disciplinary first in the fairly benign sense that, like any classificatory order, it is particular and so is less than infinitely

Introduction

permissive. Through supplementing sheer chaos, fluidity, and bound-
lessness with relatively fixed identities and thus relatively stable possibili-
ties for desire, will, and action, it curtails the utter creativity of thought
and action, at the same time as it enables them to occur. The order is
disciplinary in a second, malignant sense that it speaks in the particular
language of overweening social power. It delineates as the two star
characters in its cast, a masculine subject to whom it assigns the preroga-
tives of the seer, the thinker, the doer, the law-giver; and a feminine
object constituted by the subject's gaze, his conception, his acts, his
rule.[40]

As AIDS discourses in the mainstream press emphasize an anti-sex
rhetoric of sexual repression that reinstates penetrative sex as both the
norm and the threat, the challenge of AIDS, especially for feminists, is
to go back to an earlier sexual agenda of inventive creativity in sensual
expression, a creativity that challenges the hegemonic power of pene-
tration and phallic performance.[41] A related challenge comes from the
contestations of the relentlessly binary sex/gender system in the form
of gender ambiguities and their attendant revised vision of social units.

AIDS has in common with gender ambiguity its threat to fixed
oppositional categories and its reinforcement of the notion that bodies
are neither sacrosanct nor inviolable, that they cannot be fully guarded
against mutability or encroachment. In both cases, self-appointed
moral crusaders, public health regulators, and often the media have
lined up to justify social and political infringements on individual rights
and to point the finger at elusively, tantalizingly vague "lifestyles" and
individual "choices" as the harbingers of moral disruption. Individual
differences and mutabilities cannot be tolerated because of the danger
of seepage, leakage, spread to the ill-defined "general population,"
those who perhaps, like Melville's Bartleby, "prefer not to" or "just
say no" and hence style themselves as "innocent victims." Bodily
deviance in the form of illness or infection, anatomic anomalousness,
or participation in nonmainstream (or silenced) erotic practices is un-
derstood to lead to what Allan Brandt calls "the fateful link between
social deviance and the morally correct."[42]

Thus AIDS has appeared at a particular and culturally potent histori-
cal moment, and is perhaps the first disease to be historically self-
conscious.[43] People living with AIDS know they are menacing the
boundaries of the socially acceptable, and literally embodying the

metaphorical enactment of the physical body as social body. Hence the emphasis on disciplining and regulating the physical body, in arenas from the gym to the courts. As the first human retrovirus, HIV infection is "perhaps the first post-modern disease," according to Roberta McGrath.[44] The conditioned, muscular, flat-bellied, classically contoured body now in vogue is the body under surveillance, punished, regimented, in and under control, contained and intact. Such a body produces no secretions, transmits no viruses, takes in no bodily fluids, and engages in safe, dry, regulated sex if it engages in sex at all.[45]

Several AIDS analysts have proposed that the epidemic of HIV infection we are currently living with has been exploited to bolster right-wing, heterosexist and racist ideological positions through the media's play with language. Paula Treichler calls the AIDS crisis "an epidemic of signification" as well as a transmissible virus. Treichler discusses the struggles in the biomedical community over naming the virus, and argues that "the very nature of AIDS is constructed through language."[46] Powerful and entrenched cultural narratives intersect to produce the plethora of meanings AIDS has generated, according to Treichler, and we need to uproot these narratives in order to intervene in the negating language they promote. Jan Zita Grover also contends that AIDS has been discursively as well as infectiously manipulated and writes that "AIDS is not simply a physical malady; it is also an artifact of social and sexual transgression, violated taboo, fractured identity—political and personal projections."[47] In the Introduction to the collection of essays he edited, *AIDS: Cultural Analysis/Cultural Activism*, Douglas Crimp makes a compelling argument about AIDS that articulates one of the assertions we want this book to make about gender:

> AIDS does not exist apart from the practices that conceptualize it, represent it, and respond to it. We know AIDS only in and through those practices. This assertion does not contest the existence of viruses, antibodies, infections, or transmission routes. Least of all does it contest the reality of illness, suffering, and death. What it *does* contest is the notion that there is an underlying reality of AIDS, upon which are constructed the representations, or the culture, or the politics of AIDS. If we recognize that AIDS exists only in and through these constructions, then hopefully we can also recognize the imperative to know them, analyze them, and wrest control of them.[48]

Introduction

We would make a similar argument: the "normative" and the "transgressive" in our sense of our bodies, our sexual practices, our erotic desires, and our gender identities exist in and through the cultural discourses that construct and enforce them. To investigate and locate the operations, meanings, and ideological work of these discourses is to intervene in their deployment and to reassert and celebrate the plural and elastic potential of an *unguarded* human embodiment.

The organization of bodies into oppositional, we-they categories of the "low-risk" versus the contaminated or contagion-prone in AIDS discourses should also be seen in the context of a growing repertoire of right-wing strategies to control and contain female bodies, bodies of people of color, gay and lesbian bodies, and bodies of third-world peoples of all racial descriptions, sexualities, and genders. As Lucia Folena argues in her comparison of Reagan's characterizations of the Sandinistas as "Stalinistas" with James I's use of demonology against witches in seventeenth-century England, the construction of a moral Other is a common staple of political and literary discourses as they function to consolidate the power of particular groups or institutions.[49] Yet the historical pervasiveness of this general function of divisive and exclusionary rhetoric—the extreme of which is, perhaps, the rhetoric of genocide—should not obscure the specific nature of the threat posed by current right-wing discourses which seek to discipline bodies to fit "family" structures that are punishingly rigid for all but a privileged minority. Discourses that seek to position the poor, black, Latino, or gay HIV-infected person as abject (while denying the existence of the virus in white, middle- and upper-class heterosexuals) are integrally related to discourses that privilege fetal rights over the rights of women and children; both are parts of the cultural work of constructing a sex/gender system that upholds binary power relations between rich and poor, black and white, male and female, straight and gay.

AIDS is, therefore, as much a concern for feminists as reproductive rights. Both have provided discursive sites on which a right-wing, elitist hegemony perpetuates itself at the expense of a range of laboriously constructed Others. The slogan "Just Say No"—whether applied to drugs or sex in abstinence-oriented media campaigns—ultimately says "Yes" to the subjugation of women's control over their bodies to a white, middle-class construction of what "motherhood" should be— a construction that favors the dominance of particular forms of family

relations actually available only to a privileged few. As Katha Pollitt points out, medical rhetoric, media bias, "the new temperance," and a language of "fetal rights" combine to erode the freedoms of pregnant women who are excluded from most drug rehabilitation programs and yet may be jailed for "failing to deliver support to a child" or delivering drugs to a minor or criminal child abuse.[50] Carol E. Tracy, executive director of the Philadelphia Mayor's Commission for Women, notes that only 11 percent of the pregnant women who need substance-abuse treatment get it, and asserts that "we live in a society that romanticizes motherhood but provides virtually no structural supports for mothers."[51] Instead, Tracy remarks, we offer useless and punitive bureaucratic responses rather than appropriate intervention. "Choice" itself becomes a means by which women allegedly commit themselves to state surveillance over their pregnancies; once she decides to bear a child (if she has the luxury of a decision), a woman may be subjected to legal constraints over how she treats her own body—which becomes defined solely as a container for the fetus.[52] Pollitt points out that such "decisions" might not be clear-cut choices on the parts of poor and/or drug-addicted women, but the nature of "fetal rights" discourses, like the nature of AIDS discourses, is to deny the pressures of ambiguity, to insist on clear-cut moral choices as the basis for distributing blame for the very real sufferings inflicted by disease and birth malformations.

Perhaps leftist critical theory's attraction to various forms of ambiguity might be seen as responsive to right-wing refusals to admit grey areas into language. The political potential of the ambiguous is to erode the logic of rightist arguments that seek to contain and control human bodies. Of course, as work as various as Paul Smith's on Clint Eastwood or Christopher Newfield's on Nathaniel Hawthorne forcefully argues, sexual and/or gender ambiguity does not, in and of itself, guarantee resistance to hegemonic constructions of masculinity or femininity.[53] In fact, as theorists such as Peter Stallybrass and Judith Shapiro point out, the "carnivalesque" body may be both a site of ambiguities that disturb naturalized binarisms such as male/female, rich/poor, and a necessary Other by which dominant positions may be defined. But it is equally undeniable that a new academic left, composed of marxists, feminists, African-American theorists, and gay and lesbian historians and critics, rearticulates what the right contains as Other *as ambiguity*, as, therefore, glitches in the system by which the self/other

dichotomies of race, class, gender, and sexual object choice are composed. The gender-ambiguous subject is recuperated from Otherness to be positioned as that which gives the lie to supposedly natural and inflexible sex/gender systems.

Bodies in History

The political stakes of current struggles to define and control the gendered body in law, medicine, and media-disseminated popular debates over reproduction, "pornography," and AIDS, are, then, very high for leftist academicians as well as for their opponents on the right. At this particular moment, the formulation and deployment of historical information about the functions of ambiguity in relation to sex/gender systems might well be one of our most powerful means of exposing right-wing mystifications of gender and sexuality, mystifications that often take the form of "clarifications"—a rigid and oppressive categorizing (and conflation) of roles and behaviors. Historical research into the discursive functions of gender ambiguity reveals the periodic failure (as well as the laboriously maintained force) of rigidly oppositional categories such as male/female or hetero/homosexual.

From the earliest systematic medical texts in the West, the fifth century B.C.E. Corpus Hippocraticum, there have been empirical efforts to explain sex differences. In the Hippocratic On Regimen (Peri Daitês), there is a complex discussion of the provenance and meaning of male and female that employs sex distinctions while also celebrating ambiguity as a kind of potential transcendence: "Male and female have the power to fuse into one solid, both because both are nourished in both and also because soul is the same thing in all living creatures, although the body of each is different." The text goes on to say that while soul is always alike, "the body of no creature is the same, either by nature or by force, for it both dissolves into all things and also combines with all things." The description of male and female development that follows is at once highly differentiated in terms of strength and weakness, greatness and smallness, mastery and diminution. Yet the mechanism is highly fluid: "For the small goes to the greater and the greater to the less, and united they master the available matter." In addition, there are not two but three sexual possibilities within each

sex, because "if male be secreted from the woman but the female from the man, and the male get the mastery, it grows just as in the former case, while the female diminishes. These turn out hermaphrodites ('men-women') and are correctly so-called." So finally there are three kinds of men, and what differs is "the degree of manliness." Each parent can secrete either male or female matter, and in the production of women, the permutations lead to more or less boldness or modesty. So there are "womenly" men, "mannish" women, and "men-women" in addition to less mixed male and female beings.[54] The notion of a "natural" continuum along which sexual differentiation subtly occurs derives, then, from the earliest biomedical explanations in Western discourse.

This subtlety, with its naturalized and thus sanctioned spaces for ambiguity, continues at least into the Middle Ages. The medieval *Anatomia Magistri Nicolai Physici* or "Anatomy of Nicholas," among other texts, outlines the theory of the seven-celled womb. According to this theory, the seven cells of the uterus determine the sex of an embryo; males are begotten in the three right-hand cells, females on the left, and hermaphrodites in the middle.[55] This theory proved to be incorrect but it seems lucid, if hedged round a bit by that uneven middle cell. The interesting thing is that seven-celled womb theories made room for ambiguity. The pseudo-Galenic *De Spermate*, for example, contains this explanation of the sex-differentiation process:

> If the seed falls into the right-hand part of the womb, the child is male. . . . However, if a weak virile seed there combines with a stronger female seed, the child, although male, will be fragile in body and mind. It may even happen that from the combination of a weak male seed and a strong female seed there is both a child having both sexes. If the seed falls into the left-hand part of the womb, what is formed is female. . .and if the male seed prevails, the girl child created will be virile and strong, sometimes hairy. It may also happen in this case that as a result of the weakness of the female seed there is born a child provided with both sexes.[56]

So a virtual combat between the seeds determines the sex of an embryo, and hermaphrodites result from "an indecisive conflict."[57] Ambiguity can exist, then, but only if the forces of sovereign binary opposition let down their guard. Consequent recombinations always align them-

selves in relation to the gender-coded dichotomies of strength and weakness. So the very space for ambiguity in early Western medical accounts derives from its relation to rigid categories of manliness and effeminacy.

Has that changed? Transsexuals can now locate physicians and surgeons willing to participate in their decision to obtain sex reassignment; most major cities have organizations for transvestites, transsexuals, and others who identify themselves as "gender people"; gay men, lesbians, and bisexuals have become more visible, and are even occasionally protected under civil rights legislation against certain kinds of discrimination. But appearances to the contrary, we are now less rather than more tolerant of gender ambiguity in the West. Crossdressing still occurs primarily in protected clubs and private residences, going public only to "pass." The majority of non-heterosexuals maintain a second-nature vigilance in most situations. Festivals—Halloween or Mardi Gras; lesbian music weekends or drag shows—still do the work of defusing gender ambiguity by incorporating it into institutionally available and culturally demarcated spaces. We no longer put to death hermaphrodites, but we render them invisible in the pharmacy and the operating room. We do not imprison homosexuals, but we criminalize their erotic practices, bar them from foster or adoptive parenting, and institute employment discrimination in the military services and in government agencies requiring security clearances. We continue to insist not just on sexual difference, but on social and cultural differences as well.

How do we explain the tyranny of binary sex oppositions? These essays look at historical, theological, cultural, literary, and legal visions of the gender-ambiguous body, the body that threatens rigidly oppositional categories by its defiance of ideologically produced gender boundaries.[58] Bodies remain signs. But their significations have been purified as Poe purifies the signification of his "purloined letter" by leaving it blank, to be inscribed only by its interpreter and rewriter and bearing no originary intent. The body is just such a blank page, ready to be written on or rewritten by the text-production apparatus of culturally fluid sex/gender systems.

Body Guards traces early manifestations of body symbolism and manipulation through gender ambiguity in Christian late antiquity (Castelli), medieval Islam (Rowson), and Renaissance Europe (Jones

and Stallybrass). Ann Jones and Peter Stallybrass analyze the production of gender and the relationality of sexual identity through the figure of the hermaphrodite, and conclude that gender is "a fetish that misrecognizes itself," that it has no fixity, and that attempts to fix the category of gender are "prosthetic." Randolph Trumbach examines shifting taxonomies of sexual practice in the eighteenth century, as same-sex activities came to be defined in new ways. He describes a key conceptual shift in ideas about the relation between erotic practices, sexual object choice, and gender role classifications. Kristina Straub and Gary Kates explore the cultural and theoretical implications of, respectively, an instance of ambiguous sexuality in the eighteenth century and an instance of gender ambiguity. Michael Wilson's essay argues that one form of resistance to dominant, middle-class culture in the modern period may well be articulated in terms of compliance to that culture's categories of gendered spheres of human behavior and identity, as well as in support of a heterosexuality that is deliberately constructed in opposition to the lesbian or homosexual Other. Marjorie Garber and Judith Shapiro make similar arguments about the normalizing and projective functions of Othering, Garber through a study of the appropriation of the Middle Eastern "exotic," and Shapiro in a cross-cultural analysis of Euro-American transsexualism in relation to other institutionalized gender anomalies. The questions asked by our essayists shift back and forth between how bodies are guarded and how they elude or resist the institutions that guard them. Even the most partial and tentative answers yielded by historical research reveal pervasive and intense struggles to control, define and negotiate the sexual and gendered body.

"History" is not, of course, somehow distinct from a "Present" whose struggles shape the cultural contexts of this volume. Sandy Stone's work on transsexual identities gives us a postmodern example of how gender identity is still being worked out in relation to an increasingly medicalized and technologically constructed body. Valerie Traub analyzes an example of the psychological and cinematic unfolding and disciplining of fluid erotic potential in her study of the film *Black Widow*. Bonnie Spanier demonstrates the pervasive influence of heterosexist models of sexuality and gender on the study of cellular and molecular biology. Her essay points to the integral connection between our most "scientific" and "objective" institutions of knowl-

edge production and the cultural discipline and construction of oppressively guarded bodies. Janet Halley analyzes the disjunction between the discursive formulation and cultural deployment of sodomy laws in their occlusion of heterosexual sodomy. Our contributors approach their topics from different positions within and perspectives on the complex and diverse terrain of gender and sexuality. Their conclusions do not always agree, and they differ markedly in their stances with regard to boundary maintenance; the politics of individual essays do not necessarily "match" those of the others in this book or of the editors. That, we believe, is as it should be, as is the provocative nature of many of these essays. This volume is as much a document of the present moment in the cultural and academic politics of sexuality and gender as it is a documentation of historical instances of ambiguities in sexuality and gender. Its publication testifies to the current political stakes implicit in attempts to articulate, valorize, resolve or recuperate such ambiguities. From these stakes comes our desire to examine past and present contexts for the construction of gender and sexuality.

We hope that our part in the discussion of these contexts can avoid a blind and destructive complicity in both that history and the struggles of the present moment. We have tried to keep track of a temptation that probably accompanies the politically strategic (and, we feel, necessary) dichotomy between a reductive and oppressive right-wing construction of gender identities and sexual categories, and a liberatory endeavor to unsettle these categories. The temptation is to reify ambiguity and to celebrate the disruption of binary oppositions without asking concrete questions about how power is distributed through that disruption or ambiguity. Who is empowered by our intervention into discussions of gender and sexual ambiguity? And whose powers are resisted or displaced? As Michael Wilson suggests, an ambiguous, "feminized" masculinity may play out its resistance to dominant class structures in terms that duplicate and reinforce an already powerful male dominance. Hence, we have tried to consult the evidence of historically concrete bodies, guarded or unguarded, in sorting through the politics of sexual and gender ambiguity. We understand the guarded body in both its meanings, as a reserved and secretive edifice, and as an embattled public fortress protected (and constrained) from without. The point is not so much to explode the binary oppositions that tend to organize and mystify gender and sexual identity as it is to mount

resistance against mystifications of either gender categories *or* gender ambiguities that conduce to the oppression of the already marginalized.

Notes

1. Thomas J. Csordas, "Embodiment as a Paradigm for Anthropology," *Ethos* 18 (1990): 5.
2. Ed Cohen examines some of these issues in "Legislating the Norm: From Sodomy to Gross Indecency," *South Atlantic Quarterly* 88 (Winter 1989): 181–218.
3. *Gender Trouble: Feminism and the Subversion of Identity* (New York: Routledge, 1990): 2.
4. Bonnie Spanier's essay directly investigates biological definitions of sex and the insistence on "naturalizing" sex as a category. This insistence is reflected not just in the *E. coli* bacteria Spanier studies but in unlikely jargons such as that of computer technology, in which, for example, there is a kind of connector cable known as a "gender changer."
5. Armstrong also notes that "gender determines the social disposition of the body and thus possesses a kind of materiality in its own right." "The Gender Bind: Women and the Disciplines," *Genders* 3 (1988): 3; 2.
6. Gayle Rubin uses the term "sex/gender system" in "The Traffic in Women: Notes on the 'Political Economy' of Sex," in *Toward an Anthropology of Women*, ed. Rayna R. Reiter (New York, 1975), 157–210. See also Sherry B. Ortner and Harriet Whitehead, ed., *Sexual Meanings: The Cultural Construction of Gender and Sexuality* (Cambridge: Cambridge University Press, 1981). Much of the recent work on gender ideologies and their deployments is indebted, as we are, to Suzanne J. Kessler and Wendy McKenna's *Gender: An Ethnomethodological Approach* (Chicago: University of Chicago Press, 1985; orig. pub. New York: John Wiley & Sons, Inc. 1978). Judith Butler's *Gender Trouble* also outlines in provocative ways how the categorical constitutions of gender and sex appear illusorily to hold a mimetic relation to one another.
7. See especially *Unauthorized Sexual Behavior during the Enlightenment*, ed. Robert P. Maccubbin, special issue of *Eighteenth-Century Life* 9 (1985) and *Sexual Underworlds of the Enlightenment*, ed. G.S. Rousseau and Roy Porter (Chapel Hill: University of North Carolina Press, 1988). Randolph Trumbach makes a case for the importance of early eighteenth-century shifts in sexual ideologies, in this volume and elsewhere. See also Nancy Armstrong, *Desire and Domestic Fiction: A Political History of the Novel* (Oxford: Oxford University Press, 1987); Thomas Laqueur's *Making Sex: Body and Gender from the Greeks to Freud* (Cambridge, Mass.: Harvard University Press, 1990); and Robert Padgug, "Sexual Matters: On Conceptualizing Sexuality in History," in *Passion and Power: Sexuality in History*, ed. Kathy Peiss and Christina Simmons (Philadelphia: Temple University Press, 1989), 14–31.
8. Among the key thinkers for this agenda have been Natalie Davis, Michael Foucault, and Clifford Geertz. For a discussion of these discourses, see Judith Lowder Newton, "History as Usual? Feminism and the 'New Historicism'," in *The New Historicism*, ed. H. Aram Veeser (New York: Routledge, 1989), 152–167.
9. For a representative selection of the work of the Birmingham group, see *Culture, Media, Language: Working Papers in Cultural Studies, 1972–79*, ed. Stuart Hall, Doro-

Introduction

thy Hobson, Andrew Lowe and Paul Willis (London: Hutchinson, 1980). See also Hall's "Culture, the Media and the 'Ideological Effect'," in *Mass Communication and Society*, ed. James Curran, Michael Gurevitch, and Janet Woollacott (London: Sage Publications, 1979), 315–48 and "The Rediscovery of 'Ideology': Return of the Repressed in Media Studies," in *Culture, Society, and the Media*, ed. Michael Gurevitch, Tony Bennett, James Curran, and Janet Woollacott (London: Methuen, 1982), 56–90.

10. Dick Hebdige, *Subculture: The Meaning of Style* (London: Methuen, 1979).

11. See Gaines' "Introduction: Fabricating the Female Body," in *Fabrications: Costume and the Female Body*, ed. Jane Gaines and Charlotte Herzog (New York: Routledge, 1990), 12–13.

12. *Fabrications: Costume and the Female Body* (London: Routledge, 1990).

13. Sue-Ellen Case, "Towards a Butch-Femme Aesthetic," *Discourse* 11.1 (1988–89), 56; Judith Mayne, *The Woman at the Keyhole: Feminism and Women's Cinema* (Bloomington, Indiana: Indiana University Press, 1990), 89–123.

14. See Denise Riley, *"Am I That Name?": Feminism and the Category of "Women" in History* (Minneapolis: University of Minnesota Press, 1988).

15. See Elizabeth V. Spelman, *Inessential Woman: Problems of Exclusion in Feminist Thought* (Boston: Beacon Press, 1988) and *Differences 1:2: The Essential Difference: Another Look at Essentialism* (Summer 1989).

16. Ernesto LaClau and Chantal Mouffe, *Hegemony and Socialist Strategy: Towards a Radical Democratic Politics* (London: Verso, 1985).

17. Henry Louis Gates, Jr., "Introduction: Writing 'Race' and the Difference It Makes," *Race, Writing, and Difference*, ed. Henry Louis Gates, Jr. (Chicago: University of Chicago Press, 1986), 1–20; Hall, public lecture, Cultural Studies Program, University of Pittsburgh, Pittsburgh, PA, October, 10, 1989.

18. Diana Fuss, *Essentially Speaking* (New York: Routledge, 1989), 97–112.

19. For a discussion of how anatomic sex eludes empirical taxonomies, see Julia Epstein, "Either/Or—Neither/Both: Sexual Ambiguity and the Ideology of Gender," *Genders* 7 (1990): 99–142.

20. Mikhail Bakhtin's most extensive discussion of the "carnivalesque body" can be found in *Rabelais and His World*, trans. Helene Iswolsky (Bloomington: Indiana University Press, 1984). Other important accounts of ambiguous bodies and their simultaneous function as safety valves and as occupiers of subversive space, including Natalie Zemon Davis' "Women on Top: Symbolic Sexual Inversion and Political Disorder in Early Modern Europe," are collected in *The Reversible World: Symbolic Inversion in Art and Society*, ed. Barbara A. Babcock (Ithaca: Cornell University Press, 1978).

21. See Peter Stallybrass and Allon White, *The Politics and Poetics of Transgression* (Ithaca, NY: Cornell University Press, 1986); Terry Castle, *Masquerade and Civilization: The Carnivalesque in Eighteenth-Century Culture and Fiction* (Stanford: Stanford University Press, 1986); Mary Russo, "Female Grotesques: Carnival and Theory," in *Feminist Studies/Critical Studies*, ed. Teresa de Lauretis (Bloomington: Indiana University Press, 1986), 213–229.

22. Mary Russo, "Female Grotesques: Carnival and Theory," in *Feminist Studies/Critical Studies*, ed. Teresa de Lauretis (Bloomington: Indiana University Press, 1986), 213–229.

23. Terry Castle, *Masquerade and Civilization: The Carnivalesque in Eighteenth-Century English Culture and Fiction* (Stanford: Stanford University Press, 1986); Dale Bauer, *Feminist Dialogics: A Theory of Failed Community* (Albany: State University of New York Press, 1988), 1–16.

25

24. Karen Stabiner, "Tapping the Homosexual Market," *The New York Times Magazine*, May 2, 1982, p. 80.

25. John Fiske, "Critical Response: Meaningful Moments," *Critical Studies in Mass Communications* 5 (September 1988): 249; Danae Clark, "Commodity Lesbianism," *Camera Obscura* forthcoming.

26. The lay term "sex change operation" on the one hand and the official medical language of "gender reassignment surgery" on the other raise intriguing questions about naming. Biomedical discourses view sex as inalterable but gender as constructable. What does it mean that gender can be *assigned*? And, most important, who is authorized to do the assigning?

27. For an excellent account of this process, see Janice M. Irvine, *Disorders of Desire: Sex and Gender in Modern American Sexology* (Philadelphia: Temple University Press, 1990).

28. Despite the Bush administration's declarations of decisive victory in the Gulf, the war's effects on the Gulf region and on future international "policing" actions are unclear as we go to press in April 1991.

29. "AIDS, Altruism and the New Right," in *Taking Liberties: AIDS and Cultural Politics*, ed. Simon Watney and Erica Carter (London: Serpent's Tail, 1989), 127.

30. Susan Stewart offers a provocative analysis of the Attorney General's Commission on Pornography (the Meese Commission) in "The Marquis de Meese," *Critical Inquiry* 15 (1988): 162–192.

31. (Minneapolis: University of Minnesota Press, 1989): xi.

32. It has been one of the primary goals of AIDS workers to make this crucial conceptual shift. Our effort not to conflate erotic practices, gender identities, biological sex, sexual object choices, etc. but rather to allow each to float freely of the others and to maintain plurality is conceptually similar to this effort by AIDS activists.

33. Watney, xiii.

34. Ibid, xi.

35. See Erica Carter, "AIDS and Critical Practice," 60–61 and Judith Williamson, "Every Virus Tells a Story: The Meanings of HIV and AIDS," 78–79 in *Taking Liberties*.

36. "Introduction" to *Taking Liberties*, 26.

37. *Discipline and Punish* (London: Peregrine, 1979), 25–26. Cited by Watney, 16.

38. See Joan Cocks, *The Oppositional Imagination: Feminism, Critique and Political Theory* (Routledge, 1989): 9–10 and passim.

39. American Psychiatric Association, *Diagnostic and Statistical Manual of Mental Disorders*, 3rd edition (Washington, D.C.: American Psychiatric Association, 1980).

40. Cocks, *The Oppositional Imagination*, 185–86.

41. See Lynne Segal, "Lessons from the Past: Feminism, Sexual Politics and the Challenge of AIDS," in *Taking Liberties*, 133–145.

42. Allan M. Brandt, "AIDS: From Social History to Social Policy," in *AIDS: The Burdens of History*, ed. Elizabeth Fee and Daniel M. Fox (Berkeley: University of California Press, 1988), 155. This useful collection contains essays that draw parallels between AIDS and other epidemics: plague, yellow fever, cholera, and syphilis. Historians of medicine and epidemiology have been able to shed light on the ideological functions of public health enforcement.

43. Jeffrey Weeks makes an especially compelling argument concerning the political timing of AIDS in "Post-Modern AIDS?" In *Ecstatic Antibodies: Resisting the AIDS Mythology*, ed. Tessa Boffin and Sunil Gupta (London: Rivers Oram Press, 1990), 133–141.

44. McGrath, "Dangerous Liaisons: Health, Disease and Representation," in *Ecstatic Antibodies*, 142–155.

45. For an interesting analysis of cultural bodily ideals and the strategic management of desire, see Susan Bordo, "Reading the Slender Body," in *Body/Politics: Women and the Discourses of Science*, ed. Mary Jacobus, Evelyn Fox Keller, and Sally Shuttleworth (New York: Routledge, 1990), 83–112.

46. Paula A. Treichler, "AIDS, Homophobia, and Biomedical Discourse: An Epidemic of Signification," *Cultural Studies* 1 (1987): 263–305.

47. Jan Zita Grover, "AIDS: Keywords," in *AIDS: Cultural Analysis/Cultural Activism*, ed. Douglas Crimp (Cambridge, MA: MIT Press, 1988), 17–30. One has only to look at the brouhahas concerning AIDS imagery to see that these assertions are not farfetched. For example, in 1990, the French protested an official Swedish government AIDS poster intended to warn international travellers to be careful. The offending poster featured an image of the Eiffel Tower made of blue, white, and red condom packages.

48. Crimp, 3. See also Simon Watney and Sunil Gupta, "The Rhetoric of AIDS," and Simon Watney, "Representing AIDS," in *Ecstatic Antibodies*, 7–18 and 165–192.

49. Lucia Folena, "Figures of Violence: Philologists, Witches, and Stalinists," in *The Violence of Representation: Literature and the History of Violence*, ed. Nancy Armstrong and Leonard Tennenhouse (London: Routledge, 1989), 219–238.

50. Katha Pollitt, " 'Fetal Rights': The New Assault on Feminism," *The Nation*, March 25, 1990, p. 409. See also Jan Hoffman, "Pregnant, Addicted—and Guilty?" *New York Times Magazine*, August 19, 1990.

51. "Help the Women Drug Users," Philadelphia *Inquirer*, September 14, 1990, p. 21-A.

52. Surrogacy also raises this question, as the Baby M case showed and as is demonstrated by the current case before the California courts, *Johnson v. Calvert*, concerning a woman carrying a child genetically unrelated to her. The Johnson Controls case, involving strictures on hiring women of childbearing age unless they prove sterility for jobs deemed to be dangerous to fetal development, has also produced new case law in this area. On March 20, 1991, the Supreme Court ruled against Johnson Controls' refusal to hire nonsterile women for certain jobs. This apparent victory for the rights of women to fair employment practices, was, however, hedged around by the Justices' privileging of "the family" as the appropriate body for making such decisions. Yet again, it is not women's rights that motivated this decision, but the policing of human relations in accordance with a narrowly-defined construct, "the family." The short-term news of this judicial decision is good, but perhaps we should be wary of its long-term implications.

53. Paul Smith, "Action Movie Hysteria, or Eastwood Bound," *Differences* 1.3 (Fall 1989): 88–107; Christopher Newfield, "The Politics of Male Suffering: Masochism and Hegemony in the American Renaissance," *Differences* 1.3 (Fall 1989): 55–87.

54. *On Regimen (Peri Daitês)*, I. xxviii, in *Hippocrates*, trans. W.H.S. Jones, Vol. IV: *Heraclitus on the Universe* (Cambridge: Harvard University Press, 1979): 267–271. We would like to thank Elizabeth Castelli for bringing this text to our attention.

55. An English translation of this work can be found in G.W. Corner, *Anatomical Texts of the Middle Ages*, Carnegie Institution of Washington Publication No. 364 (Washington, D.C.: National Publishing Co., 1927), 67–87.

56. MS Paris, Bibliothéque Nationale, Latin 15456, fol. 188r; cited by Danielle Jacquart and Claude Thomasset, *Sexuality and Medicine in the Middle Ages*, trans. Matthew Adamson (Princeton: Princeton University Press, 1988), 141. See also F.

Kudlien, "The Seven Calls of the Uterus: The Doctrine and Its Roots," *Bulletin of the History of Medicine* 39 (1965): 415–423.

57. Jacquart and Thomasset, 141.

58. Susan Bordo has analyzed body management and "the imprint of culture" on bodies in a study of slenderness. Referring to Mary Douglas' work on the strict delineation of "inside" and "outside" and rituals concerning excreta in *Purity and Danger*, Bordo hypothesizes that instabilities in the way desire can be regulated in social systems (or the social body) produce cultural preoccupations with the management of bodies and desires. See Bordo, 96.

2

"I Will Make Mary Male": Pieties of the Body and Gender Transformation of Christian Women in Late Antiquity

Elizabeth Castelli

From the very earliest Christian texts and practices, the human body functioned as both a site of religious activities and a source of religious meanings. The body as a physical fact, along with the complex and sometimes contradictory cultural meanings emerging from it and superimposed upon it, provided a rich foundation for the development of ideologies and pieties grounded in the body. Physical sexual differences and the gendered meanings that emerged from them were a frequent source of imagery for Christian writers and practitioners. This essay will seek to explore one of the more intriguing dimensions of this deployment of gendered meanings, texts in which particularly holy women are "made male" or "become men."[1] Beginning with the earliest Christian text in which such piety is given voice, the late first- or early second-century *Gospel of Thomas*, the essay considers the broader ideological framework of the notion of the female becoming male in Greco-Roman thought. The discussion then moves on to examine the intersection of the topos of women-becoming-men with the two most spectacular and highly praised forms of bodily piety in early Christianity, martyrdom and asceticism, as it is elaborated more fully in some exemplary texts from the third and fourth centuries. The essay concludes with some reflections on the cultural meanings of this religiously grounded gender ambiguity.

As early as the mid-50s of the first century C.E., when Paul wrote his letters that would become so influential in the formation of Christian

churches, the idea that being "in Christ" somehow undid or made more complex the commonplace opposition between male and female began to circulate in Christian discourse. Paul's repetition of the ancient baptismal formula, "there is neither Jew nor Greek, slave nor free, male nor female," in Galatians 3:28 suggested that becoming a Christian somehow elided one's other social markers; this is not to say, however, that this elision was part of a social change movement to undo social inequalities or prejudices between groups understood in antiquity to relate to each other hierarchically. Further, Paul's notion that Christian identity destabilizes the markers of cultural, social, or gender identity is an embryonic and undeveloped notion whose elaboration becomes crucial for later Christian writers. Whereas Paul's notion is that gender distinctions will no longer be important "in Christ," later thinkers inscribed some implicit notion of gender distinction even as they embraced the possibility for all humans, male and female, to "become male." In all these situations, gender distinction is seen as a characteristic of the fallen status of human beings, one undone by redemption.

The use of gender imagery, and more specifically, imagery which blurs the relationship between biological sex and cultural gender identity, makes its first clear appearance in a noncanonical collection of sayings of Jesus, the apocryphal *Gospel of Thomas*.[2] The final saying of the gospel (114) involves a controversy between Jesus and the disciple Simon Peter over the appropriateness of Mary's association with the group:

> Simon Peter said to them [the other disciples], "Let Mary leave us, because women are not worthy of life." Jesus said, "Behold, I myself shall lead her so as to make her male, that she too may become a living spirit like you males. For every woman who makes herself male will enter the kingdom of heaven.

The notion that maleness is linked to salvation (and the underside of that notion, that femaleness has a special relationship to sin) is not an innovation on the part of the tradition; what is new is the idea that women can gain access to holiness and salvation by "becoming male." Before looking at the ways in which this trope becomes one of the central signifiers for female piety, its ideological context requires some examination.[3]

Masculine and feminine, male and female, man and woman are not always self-evident and parallel categories in ancient discourses. That is, the categories are certainly generally fixed, and further are arranged in a hierarchical dualism whereby masculine/male/man are in ascendancy over their "opposites." There exist occasions, however, when qualities of masculinity may inhere in the persons of biological females ("women") or characteristics of femininity in the persons of "men." This is not to say that "gender bending" was necessarily looked upon favorably in antiquity, but rather that it was seen as a real possibility, if also an aberration.[4]

At the same time as sexual difference was perceived as a real and foundational characteristic of human nature, even when individuals may have stretched the limits of convention, one needs to emphasize that there is also a thoroughgoing suspicion of difference to be found in many of the discourses of ancient Mediterranean philosophies, particularly those influenced by Plato. Sexual difference itself comes to be seen as a decadent state following the more originary moment of human sameness. The fanciful image evoked by Aristophanes in Plato's *Symposium* of the original human beings as androgynous wholes, now separated and forever seeking reunification with their other halves, is but one articulation of the notion that human perfection is only accessible apart from sexual difference.[5] Related to this idea is the privileged status accorded to "oneness" as opposed to multiplicity. Multiplicity is perceived as problematic, a result of decadence and diffusion. At the same time, it is important to keep in mind that the Platonic understanding was not the only one at work in antiquity; Aristotle, by remarkable contrast, used sexual differentiation to classify the species as more or less perfect; the greater the differentiation between the sexes, the more highly developed the species.[6]

The *Gospel of Thomas*, however, reflects the Platonic understanding of difference; salvation is perceived to have occurred when the problem of sexual difference has been resolved through the return to a singular state, a return to unity. In saying 22, Jesus is reported to have said:

'When you make the two into one, and when you make the inner like the outer and the outer like the inner, and the upper like the lower, and when you make male and female into a single one, so that the male will not be male and female will not be female, when you make eyes replacing

an eye, a hand replacing a hand, a foot replacing a foot, and an image replacing an image, then you will enter the kingdom.'

It is important to stress that there is a clear differentiation in gnostic texts between a notion of "oneness," where sexual or gender identity is erased, and a notion of an "androgyne," where genders are blended. In these texts, androgyny is seen as monstrous and problematic, not as a state to be embraced.

One has, in the case of the *Gospel of Thomas*, to account further for the apparent contradiction between saying 22 and saying 114: in the first, it appears as though male and female are to be completely undercut, while in saying 114, maleness is embraced as a higher and desirable quality. Here, the work of the first-century Egyptian Jewish philosopher, Philo Judaeus, whose attempts to reconcile Platonism and Judaism are remarkable studies in ingenuity, can perhaps lend some assistance. For Philo, the categories of male and female are not balanced, but rather represent superior and inferior states; the movement from femaleness to maleness is understood to be a progressive movement to a higher state of virtue, and is paralleled by a movement toward oneness.[7]

> For progress is indeed nothing else than the giving up of the female gender by changing into the male, since the female gender is material, passive, corporeal, and sense-perceptible, while the male is active, rational, incorporeal, and more akin to mind and thought.[8]

Further, the movement between genders is not a reciprocal gesture in Philo's system; the point is for the female to become male, not for gender to be elided more generally:

> ... it is fitting and proper for it [the soul] to bring together those (elements) which have been divided and separated, not that the masculine thoughts may be made womanish, and relaxed by softness, but that the female element, the senses, may be made manly by following masculine thoughts and by receiving from them seed for procreation, that it may perceive (things) with wisdom, prudence, justice, and courage, in sum, with virtue.[9]

Just so, in the Christian tradition, there is virtually no evidence for the movement across conventional gender boundaries by the "male" toward the "female," except when it is negatively construed, as in polemics against homosexuality.[10] The female can and should strive to become male—to overcome gender distinction, since the male embodies the generic "human" and therefore the potential for human existence to transcend differences and return to the same. Of course, it is precisely in the assumption that "male" can stand for both the masculine and the human that a tension emerges in the discourses under discussion. "Becoming male" marks for these thinkers the transcendence of gendered differences, but it does so only by reinscribing the traditional gender hierarchies of male over female, masculine over feminine; the possibility that women can "become male," paradoxically however, also reveals the tenuousness and malleability of the naturalized categories of male and female. That feminine gender identity can be set aside in the process of spiritual advancement both reiterates the dominant understandings of gender differences (in the insistence that movement from female to male is a sign of development and progress, a movement from the lesser to the greater) and undercuts the dominant understandings of gender differences (in the recognition that they are not fixed). I would argue that these discourses do not simply rearticulate the hegemonic gendered order, nor do they simply deconstruct it; rather, they stretch its boundaries and, if only for a moment, call it into question—even if, ultimately, things return to "normal."[11]

The double insistence attributed to Jesus in the *Gospel of Thomas* saying—that Mary should remain among the disciples at the same time as she must be made male—points to the paradoxical ideological conditions that helped to shape the lives of early Christian women. At once they are to have access to holiness, while they also can do so only through the manipulation of conventional gender categories. As other texts produced during the early Christian centuries demonstrate, such manipulation of gender categories remained as controversial as it was central to many forms of female piety.

Just such a manipulation of the constraints of gender and the social conventions linked to them can be found in the intriguing *Martyrdom of Perpetua and Felicitas*, included in a well-circulated collection, *The Acts of the Christian Martyrs*.[12] A third-century text combining a

narrative with Perpetua's own diary of her last days in prison, it represents the earliest Christian text undisputedly attributed to a woman. The story recounts the arrest, imprisonment, and eventual execution of a group of Christians in Carthage (North Africa)—including Vibia Perpetua, a young (apparently wellborn) woman who has recently given birth to a child, and a slave woman, Felicitas, whose pregnancy threatens to keep her from being executed with the rest of the group. In the course of the imprisonment, Perpetua experiences and records a number of visions which assure her that her fate is to die in the arena but which promise that her reward will be access to heaven. Her death itself is narrated as a profound act of will, as she is reported to have guided the gladiator's sword to her throat; the narrator speculates that "it was as though so great a woman, feared as she was by the unclean spirit, could not be dispatched unless she herself were willing" (21.10). Most striking is the highly elaborated weaving together of Perpetua's female body with its social functionings, and how her series of visions lead her ultimately to cast off the female body ("I became a man") and the social roles and ties it has enacted in her life.

The Martyrdom of Perpetua and Felicitas is an unusual text because it includes two genres of writing, a fairly standard martyrological narrative written in the third person, and a first-person memoir generally accepted as the diary Perpetua wrote while in prison. The introduction to the narrative indicates that the writer understands this text to stand in a tradition of texts which prove God's favor and provide for the spiritual strengthening of human beings; these fairly recent events are being written down because the examples they articulate will one day be ancient and therefore take on an authority that at the moment only ancient examples hold. The closing paragraph of the martyrdom reiterates this assertion of the power of the narrative to transform and to possess significance "no less than the tales of old." The narrative comes to its unified and singular conclusion; the story is written to testify to the glory of God.

Within this teleological narrative is embedded Perpetua's own, complicating narrative which strains against so simple a reading. Part of the strain has to do with the contradiction of the genre of autobiography itself; by its nature, no autobiography can come to closure, no writing about oneself within the conventions of narrative autobiography can ever finish the story. As much as Perpetua's narrative attempts

to bring closure to the conflicts in her own existence, ultimately she must give over the power of narrative to some other writer. Her diary closes after the fourth vision with the statement, "About what happened at the contest itself, let him write of it who will" (10.15). While by the end of the fourth vision, Perpetua is persuaded that she will "be victorious," (i.e., be killed), and so in that sense she has brought her story to a close, it remains that at the textual/generic level, the narrative remains unfinished, open-ended, resistant to closure. Just as her narrative remains open-ended and therefore ambiguous, it also narrates an ambiguity toward gendered imagery and gendered identity on the part of its main character; whereas Perpetua's own story calls narrative closure and fixed gender identity into question, the framing narrative finishes the story and puts Perpetua back into the conventions of gender, as a "woman [femina]."

Perpetua's account of her imprisonment and her dreams and visions is an extended narrative of conflicts and their resolutions, all pointing forward to the final conflict, the final battle, Perpetua in the arena with her executioner. These conflicts have to do with fundamental issues of social relation, with her understanding of her status as a woman in her social network, with the very category of femininity. Each event and vision narrated is part of a movement of resistance against the dominant cultural narratives of relationship, paternal authority, and femininity. As Perpetua moves closer to the arena, she strips off the cultural attributions of the female body—first figuratively in leaving behind her child and in the drying up of her breast milk, and then finally and "literally" in her last vision, in the transformation of her body into that of a man; here she has stripped off all the physical marks of femaleness. Perpetua's spiritual progress is marked by the social movement away from conventional female roles and by the physical movement from a female to a male body; these processes of transformation signify her increasingly holy status.

Perpetua's narrative begins with a description of her conflict with her father who wants her to recant her confession of Christian faith in order that she might be released from prison. She makes a kind of Socratic argument, pointing to a vase and asking whether it might be known by any other name than what it is; when he responds, "no," she argues, " 'Well, so too I cannot be called anything other than what I am, a Christian' " (3.2). The argument produces such anger in her

father that he moves toward Perpetua "as though he would pluck my eyes out" (3.3). He departs, taking his diabolical arguments with him, and Perpetua spends several days comforted by her father's absence.

Part of the emerging pathos of Perpetua's story has to do with the ongoing renegotiation of conventional family relations. As the father disappears temporarily from the narrative, Perpetua's mother, brother, and baby appear on the scene. For the moment, Perpetua takes her child into her care in the prison. During this period, she experiences the first of her four visions, a vision she has requested from God to determine whether she will be condemned or freed.

This vision resonates with biblical allusions and other complex imagery, and begins Perpetua's journey toward the resolution of certain social conflicts. In the vision, she sees "a ladder of tremendous height made of bronze, reaching all the way to the heavens, but it was so narrow that only one person could climb up at a time" (4.3). The ladder is studded with swords, spears, hooks, daggers, and spikes, promising to mangle the flesh of the unwary climber. At the foot of the ladder a dragon of enormous size is positioned, ready to attack those who wish to climb the ladder. "Slowly," Perpetua recounts, "as though he were afraid of me, the dragon stuck his head out from underneath the ladder. Then, using it as my first step, I trod on his head and went up" (4.7). Arriving at the top of ladder, Perpetua sees a pastoral scene of heaven, and is offered milk by an elderly shepherd who has been milking sheep. As she comes out of the vision, Perpetua still has the sweet taste of the milk in her mouth. The vision communicates to her that she "would no longer have any hope in this life" (4.10).

These images have some roots, certainly, in the biblical tradition; the ladder may well refer back to Jacob's ladder, the dragon a recurring demonic image, the woman's foot on the serpent's head, an echo of Genesis 3:15, "I will put enmity between you and the woman and between your seed and her seed; he shall bruise your head, and you shall bruise his heel." Perhaps, however, there are other resonances to be heard from these powerful images. In reading this text against another fascinating ancient text, the second-century handbook for the interpretation of dreams, Artemidorus' *Oneirocritica*,[13] one discovers some remarkable and suggestive clues for interpretation. Artemidorus documents the symbolism of a whole catalogue of objects and images,

both everyday and fantastic; he is particularly interested in the imagery of the human body and its varied meanings, but he addresses other issues at length as well. The ladder, for example, is a well-known symbol for travel and its rungs signify both progress and danger (2.42). More interesting for our purposes is Artemidorus' analysis of the meanings of body imagery and of serpents. The *Oneirocritica* includes a lengthy and elaborate interpretation of different varieties of snakes, which signify a variety of ethical positions. "Venomous animals," writes Artemidorus, "that are formidable, mighty, and powerful as, for example, the dragon, the basilisk, and the hollow oak viper signify powerful men" (4.55). He argues elsewhere that the head signifies parents, in that both the head and parents are the cause of life (1.35); putting these two readings together, Perpetua's trampling on the head of the dragon may be read as one of her first gestures against paternal authority, the dragon signifying his power, the head signifying his personage.

This reading would be more capricious were it not for the repetition of imagery emphasizing the connection between power and Perpetua's feet later in the narrative. In a last desperate gesture of supplication to Perpetua, narrated just after the account of this vision, her father throws himself down at her feet, addressing her no longer as a daughter but as a woman. "Have pity on my grey head," he says (5.2). He also calls up the familial relationships Perpetua will be abandoning—those with him, her brothers, her mother, her child. She rejects his entreaties, and the father disappears once again, temporarily, from the narrative. In her last vision, Perpetua is victorious over against her Egyptian opponent, a victory signified by her placing her foot on his head. By this advanced point, her female body has been replaced by a male body, and her rejection of paternal authority and the concomitant abandonment of her subjectivity in the feminine are complete. But even the first vision of her foot on the head of the dragon begins Perpetua's movement beyond the confines of gendered conventions as they are articulated in family relationships, especially those with her father. This vision which combines imagery of paternal authority with the demonic imagery of the dragon reinforces here the suggestion that Perpetua's father's actions are in some fashion "diabolical," a suggestion first made explicit in their first set of interactions.

The scene that follows this first vision, in which her father begs her

to pity his grey head, suggests a complexity of gendered meanings. Perpetua writes, "This was the way my father spoke out of love for me, kissing my hands and throwing himself down at my feet. With tears in his eyes, he no longer addressed me as his daughter but as a woman" (5.5). This scene is confounding of gendered meanings in at least two ways: first, the actions of the father in his desperation can be read as feminizing actions—crying and kissing the hands of his daughter, throwing himself down before her feet. At the same time, there is an additional ambiguity in the statement that he addresses her not as a daughter but as a woman. In a psychoanalytic reading of this story, classicist Mary Lefkowitz has cited the interpretation of Jungian analyst Marie-Louise von Franz who has read the scene as an articulation of "unconscious incest," the desperate attempt on the part of the father to keep the disintegrating family together.[14] Perpetua's husband—the father of her baby—is completely absent from the narrative, and Perpetua's mother appears on the scene only briefly and passively when Perpetua speaks to her out of anxiety for her own baby. One might be hesitant to read back into this ancient document modern categories of analysis in this way; this particular reading seems overly reductive, because it appropriates psychoanalytic categories ahistorically and unproblematically and because it ignores the complexity of the textuality of the story, reading the account provided in Perpetua's diary as though it were a simple rendering of the "truth" of Perpetua's actual, real-life experience rather than as, at some level, a fiction. Nevertheless, the scene at the very least suggests another layer of complexity in the family constellation, and may function to decenter certain conventional family relations in Perpetua's journey beyond these networks.

The next scene continues the conflict between paternal authority, family relationships, and Perpetua's own competing self-understanding apart from these relations. Having been brought, together with the other prisoners, to a hearing, Perpetua stands on the prisoner's dock. Her father appears in the crowd, carrying Perpetua's baby, and drags her from the step; the governor himself at this point begs Perpetua to "have pity on your father's grey head; have pity on your infant son" (6.3). Perpetua continues to confess her Christian identity, and when her father persists in trying to dissuade her, the governor Hilarianus orders him to be thrown to the ground and beaten with a rod. The

continuing feminizing of the father matches the movement of Perpetua away from her identity within the family.

At her condemnation to death in this scene, Perpetua's ambivalent relationship to her child is both highlighted and then resolved by divine intervention. The baby had been accustomed to breast feeding, and so Perpetua sends to have the baby retrieved from her father. Her father refuses to turn over the infant—reinscribing his increasingly feminized role, now as mother. At the same time, Perpetua reports that "as God willed, the baby had no further desire for the breast, nor did I suffer any inflammation; and so I was relieved of any anxiety for my child and of any discomfort in my breasts" (6.8). Perpetua moves further away from the conventional positions she has occupied in the society— no longer dutiful daughter, she is also separated from her role as a mother, in a miracle of immediate and divinely inspired weaning of her child. The detail of this description is poignant, for Perpetua is still very much embodied in the specificity of female flesh—the emphasis on the absence of the physical pain she would have experienced under ordinary circumstances underscores her continuing life in a female body. At the same time, she complicates her identification with the social roles that accrue to that female body—she gives her baby up, refusing thereby the maternal function.

Having detached herself from these two foundational relationships, with her father and with her son, Perpetua now experiences two visions concerning a third relationship with another important male relative, her brother Dinocrates who died of a facial cancer when he was seven years old. In the first dream/vision, Perpetua sees Dinocrates emerging from a dark hole, still bearing the wound on his cheek. In the dream the child cannot reach to the rim of a pool of water, and though parched, cannot get a drink. In the second vision of Dinocrates several days later, Perpetua sees that her brother has been refreshed, and no longer has an open wound, but a scar. The rim of the pool of water had been lowered, and he could drink easily from the golden bowl. These visions are interpreted by Perpetua to mean that Dinocrates was suffering, but has now been redeemed through her prayers offered in the days intervening between the two visions. Again, for Perpetua, the visions function to resolve conflict.

One might well read these visions at a somewhat different level,

through the matrix of relationships in which Perpetua is both impli-
cated and in the process of extricating herself, and through the symbol-
ism again of the body in dreams. Mutilated cheeks, according to Artem-
idorus, signify mourning (1.28); wounds on any part of the body
should be interpreted as having the same meaning as that part of the
body when it is uninjured, while a scar indicates an end to all one's
anxieties (3.40). If this story can be read as Perpetua's movement from
more self-evident to more fluid understandings of gender, then the
wound and the scar may be interpreted as standing for both the loss
of this male family member, but also for the resolution of that loss.
Further, given the pattern of disengagement that is being traced out
here—disengagement from familial relations, from male relations, and
by implication from conventional gender understandings—the resolu-
tion of Dinocrates' suffering in the vision may be read as a resolution
of the relationship itself. The resolution is further reinscribed by the
image of Dinocrates drinking from a gold drinking vessel which, Ar-
temidorus argues, is "auspicious for everyone" and "symbolize[s] great
safety" (1.66).

In one psychoanalytic reading of this text, the relationship of the
details of the story to Perpetua's own journey across and beyond gender
has been read in this way: First of all, Perpetua and Dinocrates are
linked in both of them having come out of a dark hole—he, in her
vision; she is being released from the dark hole of the prison. Dino-
crates' wound is read as a symbolic marker of his pre-gendered posi-
tion, as a possibility of femininity. In this interpretation, the sex and
the smallness of the brother both contribute to Perpetua's journey,
marking the path along a continuum away from femininity.[15]

This vision is followed by the final encounter with Perpetua's father,
an encounter which is beyond dialogue. The old man is desperate, and
appears for the final time in the narrative, tearing out his beard and
throwing himself on the ground. The loss of the beard, even self-
inflicted, marks the further feminization of the father.

The final vision by Perpetua marks her radical transformation in
terms of gender. The vision is lengthy, but significant, and worth
quoting at length:

> Pomponius the deacon came to the prison gates and began to knock
> violently. I went out and opened the gate for him. He was dressed in an

unbelted white tunic, wearing elaborate sandals. And he said to me: 'Perpetua, come; we are waiting for you.'

Then he took my hand and we began to walk through rough and broken country. At last we came to the amphitheatre out of breath, and he led me into the centre of the arena.

Then he told me: 'Do not be afraid. I am here, struggling with you.' Then he left.

I looked at the enormous crowd who watched in astonishment. I was surprised that no beasts were let loose on me; for I knew that I was condemned to die by the beasts. Then out came an Egyptian against me, of vicious appearance, together with his seconds, to fight with me. There also came up to me some handsome young men to be my seconds and assistants.

My clothes were stripped off, and suddenly I was a man. My seconds began to rub me down with oil (as they are wont to do before a contest). Then I saw the Egyptian on the other side rolling in the dust. Next there came forth a man of marvelous stature, such that he rose about the top of the amphitheatre. He was clad in a beltless purple tunic with two stripes (one on either side) running down the middle of his chest. He wore sandals that were wondrously made of gold and silver, and he carried a wand like an athletic trainer and a green branch on which there were golden apples.

And he asked for silence and said: 'If this Egyptian defeats her he will slay her with the sword. But if she defeats him, she will receive this branch.' Then he withdrew.

We drew close to one another and began to let our fists fly. My opponent tried to get hold of my feet, but I kept striking him in the face with the heels of my feet. Then I was raised up into the air and I began to pummel him without as it were touching the ground. Then when I noticed there was a lull, I put my two hands together linking the fingers of one hand with those of the other and thus I got hold of his head. He fell flat on his face and I stepped on his head.

The crowd began to shout and my assistants started to sing psalms. Then I walked up to the trainer and took the branch. He kissed me and said to me: 'Peace be with you, my daughter!' I began to walk in triumph towards the Gate of Life. Then I awoke. (10)

This fourth vision brings to its narrative height the journey of Perpetua through the conventions of gender. As she is brought into the arena where she will play out the role of an athlete—a common enough trope in early Christian literature for spiritual struggle—Perpetua is stripped of her clothing and of her feminine identity, located in the physical body. She becomes a man. As in the case of the *Gospel of Thomas* texts, this scene produces a paradox: Perpetua has stretched

the conventional bounds of gender identity, at the same time as her spiritual ascendancy is figured in gendered terms, or more precisely, in terms of maleness.

Commentators have frequently argued that this transformation occurs in the interests of feminine modesty, but I believe that something else is at stake here. The pinnacle of Perpetua's struggle is described in this scene, and she is victorious in the battle—*and* victory is described *as* and *by* the stripping off of feminine gender. It is not simply that Perpetua's victory is assured through becoming a man—rather it is marked by the emblem of her new male body, it is signified by the transformation itself. Now clearly, Perpetua is not the only early Christian woman to be narrated in this way; as the tradition develops, particularly in narratives about the lives of ascetic holy women (discussed below), the mark of true holiness is that the women become men. The trope, by the time it is repeated in the ascetic materials, has become domesticated, even a cliché. The transformation itself is never narrated, as it is here in Perpetua's diary; it is *fait accompli*. Perpetua's account then becomes a kind of double narrative, I would argue— about victory in spiritual struggle, and about shifting gender identity as the major signifier for a woman's journey toward that victory. The battle is between Perpetua and the forces of evil *and* between competing understandings of gender.

The scene itself is worth reading briefly. It is remarkable for its sensual imagery and for its continuation of the already established themes of victory over the father/devil. The Egyptian stands for both father and devil, and the battle itself is ambiguously sexual. Once again, Perpetua's feet serve her well, and her ascendancy over her opponent is narrated through the image of her foot on his head. The irony and double meaning of martyrdom itself are called up in this scene, when the trainer announces that if the Egyptian is successful, he will slay Perpetua; if she is successful, she will receive the branch of victory. If her opponent succeeds, Perpetua will die—and just so, Perpetua knows that if her father "saves" her, she is doomed. If she succeeds, she gains life—but in the ideology of martyrdom, she can only do so by losing her life. Perpetua's victory, signified by her walk toward the Gate of Life, is a spiritual victory and a final victory over the father and over gender conventions.

As the account of Perpetua's company's martyrdom unfolds, the

descriptions are explicit and bloody—bodies torn and tortured, terrible pains inflicted for the purposes of spectacle and discipline. Once again, gender specificity is important in the telling, for it is female bodies which are displayed in both a sadistic and sexualized fashion. When Perpetua and Felicitas are brought out into the arena, they are displayed naked before the crowd. Margaret Miles, in her recent book, *Carnal Knowing*, has traced out the history of female nakedness in the Christian West, and she argues here that the particular attention to the female body as an object of display in the martyrological tradition betrays male confusion over how to interpret the lives of heroic women. While naked female martyrs are an ever-present feature, the naked female bodies are at once a sign of their own resistance to social power and a sign that females remain, at some level at least, inscribed as sexualized beings for male viewers/spectators/readers. The imagery of nakedness is strong enough to contain these disparate meanings.[16]

When Perpetua dies, her death is portrayed as an act of will. "It was as though so great a woman [*femina*], feared as she was by the unclean spirit, could not be dispatched unless she herself were willing" (21.10). The narrator betrays none of the ambiguity surrounding Perpetua's gender identity which is present in the first-person narrative. The narrative itself has brought all such ambiguities and tensions to a forced kind of resolution. Perpetua is reinserted into the gendered order through displays of modesty to the end, and the narrator has no difficulty asserting closure and a moral for the story.

Perpetua was not alone among Christian women in her rejection of the gendered meanings of her culture and time. In a remarkable collection of narratives composed in the second and third centuries, the *Apocryphal Acts of the Apostles*, are chronicled the conversions of a number of upper-class women to Christian life which, in the context of these texts, is constituted primarily as the practice of sexual renunciation.[17] While there is considerable scholarly controversy over the question of whether these fictionalized texts recount historical women's lives, the question is less relevant in this context, because clearly these texts represent idealized—and extremely popular—forms of piety, whether the specific women whose lives are narrated actually lived or not. The theme predominates in these texts of women demonstrating this renunciation by means of cutting their hair and wearing men's clothing; gender ambiguity becomes a sign of special holiness.

Perhaps the most famous of the women of the Apocryphal Acts is Thecla, a well-born young woman whose conversion and subsequent activities are recorded in *The Acts of Paul and Thecla*. Thecla would remain a model for generations of women who dedicated their lives to virginity, and she first cuts her hair as a sign of her renunciation of the world (§25) and later puts on men's clothing in order to travel in the world as a teacher (§40). Mygdonia in the *Acts of Thomas* 114 cuts her hair, and Charitine wears men's clothing in the *Acts of Philip* 44. It is striking that in all of these narratives, the women who perform these outward gestures of stretching dominant cultural expectations related to gender are also embracing a form of piety (sexual renunciation and virginity) which resists dominant cultural expectations vis-à-vis social roles. This connection may be seen in the description of the renunciation performed by a fourth-century Egyptian holy woman, Syncletica, who publicly demonstrated her casting aside of the things of the world (*kosmos*) by the rejection of self-beautification (*kosmetikês*) through the act of cutting her hair.[18] The cutting of hair continues to this day as the bodily signifier for women taking religious orders, marking their difference from their sisters in the world.

Transvestism among holy women remained a highly controversial sign of female piety well into the ninth century, and there are numerous accounts of holy women who "passed" their entire lives as monks, their sex being revealed only as their bodies were being prepared for burial.[19] Though these women are often praised in the stories told about them, there was also considerable criticism of women who carried their asceticism "too far." In his famous letter to the teenager Eustochium on the virtues of virginity, Jerome warns her against women who dress as men;[20] a church council held during the middle of the fourth century condemned ascetic women who "in the name of asceticism" put on men's clothing and cut their hair.[21] Interestingly, in the case of the cursing of women who cut their hair, the council held that this gesture was problematic precisely because women's hair stands for their subjugation (canon 17), a position articulated variously and over time ever since Paul's insistence on the veiling of women in 1 Corinthians 11. The casting off of conventional gender distinctions here was perceived as a resistance to the proper order of nature/society.

The paradigmatic lives of holy women produced during the third and fourth centuries provide yet another example of texts in which

gender ambiguity becomes a sign of the women's special status. Fourth-century bishop of Antioch John Chrysostom was reported to have said of his friend, the neighboring abbess Olympias, "Don't say 'woman' but 'what a man!' because this is a man, despite her physical appearance."[22] Olympias, Melania, Macrina, and others are described constantly as having gained access to holiness through the renunciation of nature itself, figured conventionally during this period as being aligned in a particularly intimate way with "female nature."[23] Other writers of prescriptive literature for virgins urged women to give up "feminine mentality" in order that they might be advanced by God to male ranks,[24] while at least one holy woman says of herself, "I am a woman by nature but not in reason."[25]

At the same time as such encomia to women becoming male were being written in late antiquity, there is also a widely-perceived threat of such blurring of gender distinctions. John Chrysostom, who felt at ease referring to Olympias as 'what a man!' also wrote two searing condemnations of a widely practiced form of ascetic piety in late antiquity, that of a virgin woman and a continent man cohabiting; interestingly, the argument is not made that these people are breaking their vows of chastity, but rather their practice is problematic because they are blurring the distinctions between the sexes, and the men in particular are at risk of the feminizing effects of such close proximity to women.[26] "Christ wants us," he writes,

> to be stalwart soldiers and athletes. He has not furnished us with spiritual weapons so that we take upon ourselves the service of girls worth only three obols, that we turn our attention to matters which concern wool and weaving and other such tasks, that we sit alongside women as they spin and weave, that we spend all day having our souls stamped with women's habits and speech. We have rather been so armed in order that we might cast down the invisible powers which assault us, wound their leader, the devil, drive out the fierce phalanx of demons, raze their fortifications to the ground, bind in chains the powers of the world ruler of darkness, rout the evil spirits, breathe fire, and prepare and equip ourselves to brave daily.[27]

Clearly, the military work of the average male Christian can be only diverted and obscured by the company of women.[28]

Roman historian Mary Beard has suggested that the bodily ambigu-

ity implied by the category of "virginity" in the case of the Vestal Virgins at Rome contributes fundamentally to these women's status as sacred. Standing on the brink of sexual categories, occupying more than one category at a time, always in the process of (but never completing) passage from one social role to another (virgin to bride, girl to matron), isolated from social conventions, the Vestal Virgins attain their sacred status from the ambiguities inherent in the ideological construction of their sexual status.[29] I would argue that a similar function is at work among early Christian women who, through rigorous bodily pieties, constructed their special relationships to holiness, relationships that came to be described as the transformation of gender. These women's refusal to participate in the conventional sexual roles ascribed to them by late antique culture (not as an attempt to undercut the patriarchal social order, but in order to achieve spiritual perfection) was perceived ambivalently. On the one hand, their holiness was marked by the abandonment of socially sanctioned gender roles; on the other hand, that same abandonment was seen as dangerous to the natural and hierarchical order of social relations. It would not be the first time in the history of religions that holiness and danger were seen as two sides of the same coin.

When Mary was greeted with the opportunity of being made male and thereby gaining access to salvation, when Perpetua became a man in the height of spiritual battle, when those holy women who were so successful in their pieties no longer deserved the derogatory name "woman," something remarkable was happening to the ideology of gender differences in late antiquity. All of these examples demonstrate the complex interaction between contemporary gender conventions and the Christian ideology that insisted upon the necessity and possibility for personal and corporate transformation; these ideological constructions interacted in turn with the embodied experiences of Christian women (experiences mediated through commonplace notions of female nature). It is both too simple and too anachronistic an explanation to argue that these pieties offered women "liberation" from social conventions in any sense approximating modern notions of women's liberation; neither is it adequate to argue the opposite, that women who became men were victims of an ideology that ultimately robbed them of something essential and authentic, their "femaleness." Rather it seems to me that this asymmetrical process of transformation,

whereby the "female" could, under certain rather extraordinary spiritual conditions, become "male," marks an important early, but by no means unique, example of a remarkable cultural phenomenon, the destabilization of gender identity in the history of a tradition usually seen to cast gender in fairly fixed and dualistic terms. This is not to argue that early Christian discourses escaped the confines of patriarchy as they played themselves out in late antiquity in the Mediterranean basin, but to point out moments of slippage, spaces where the self-evidency of gender conventions and the relationships for which they were foundational might have been thought otherwise.

Notes

1. This notion is not unique to Christian discourse, but may be found in relation to holy women of other traditions. See the in-depth article by Nancy Schuster, "Changing the Female Body: Wise Women and the Bodhisattva Career in Some *Mahāratnakūta-sūtras,*" *Journal of the International Association of Buddhist Studies* 4 (1981): 24–69.

2. Greek fragments of this gospel were first discovered in the enormous cache of papyrus documents found in the latter part of the nineteenth century at the Egyptian site of Oxyrhynchus. At the time, they were labelled "Fragments from an Apocryphal Gospel"; these fragments (POxy 1, 654, 655) may be found in the multivolume work, G. P. Grenfell and A. S. Hunt, eds., *Oxyrhynchus Papyri* (London, 1898), and are discussed in the context of early Christian literature in Edgar Hennecke and Wilhhelm Schneemelcher, eds., *New Testament Apocrypha*, vol. 1 (Philadelphia: Westminster, 1964), 93–113. Some fifty years later, with the discovery of the Coptic gnostic library at Nag Hammadi, also in Egypt, an entire manuscript of the Gospel of Thomas, a Coptic translation of the presumed Greek original, was uncovered. This text exists in numerous editions, the standard English translation by Helmut Koester and Thomas O. Lambdin to be found in James M. Robinson, ed., *The Nag Hammadi Library*, rev. ed. (San Francisco: Harper and Row, 1988), 124–138.

3. A useful study that situates this staying in the broader thematic concerns of the gospel is Marvin W. Meyer, "Making Mary Male: The Categories of 'Male' and 'Female' in the Gospel of Thomas," *New Testament Studies* 31 (1985): 554–570. See also the work which cautions scholars against simple generalizations about "gnosticism": Michael A. Williams, "Variety in Gnostic Perspectives on Gender," in *Images of the Feminine in Gnosticism*, ed. Karen King, (Philadelphia: Fortress, 1988), 2–22; and idem, "Uses of Gender Imagery in Ancient Gnostic Texts," in *Gender and Religion: On the Complexity of Symbols*, ed. Carolyn Walker Bynum, Stevan Harrell, and Paula Richman, (Boston: Beacon Press, 1986), 196–227.

4. See, among other studies, Bernadette J. Brooten, "Paul's Views on the Nature of Women and Female Homoeroticism," in *Immaculate and Powerful: The Female in Sacred Image and Social Reality*, ed. Clarissa Atkinson, Constance Buchanan, and Margaret R. Miles, (Boston: Beacon Press, 1985), 61–87; and more recently, John J.

Winkler, *The Constraints of Desire: The Anthropology of Sex and Gender in Ancient Greece* (New York: Routledge, 1990).

5. Plato, *Symposium*, 189D–190. See also Wayne A. Meeks, "The Image of the Androgyne: Some Uses of a Symbol in Earliest Christianity," *History of Religions* 13 (1974): 165–208.

6. See G.E.R. Lloyd, *Science, Folklore and Ideology: Studies in the Life Sciences In Ancient Greece* (Cambridge: Cambridge University Press, 1983), 94–105, esp. 98–99.

7. For a general overview of Philo's understanding of these categories, see Richard A. Baer, Jr., *Philo's Use of the Categories of Male and Female* (Arbeiten zur Literatur und Geschichte des hellenistischen Judentums 3; Leiden: Brill, 1970), esp. 45–49.

8. Philo, *Quaestiones et Solutiones in Exodum* I:8; cited in Baer, 46.

9. Philo, *Quaestiones et Solutiones in Genesin*, II:49; cited in Baer, 48.

10. But see the suggestive interpretation by Peter Brown, *The Body and Society: Men, Women, and Sexual Renunciation in Early Christianity* (New York: Columbia University, 1988), 169, of the controversial self-castration of the third-century church father Origen:

> What Origen may have sought, at that time, was something more deeply unsettling. The eunuch was notorious (and repulsive to many) because he had dared to shift the massive boundary between the sexes. He had opted out of being male. . . . Deprived of the standard professional credential of a philosopher in late antique circles—a flowing beard—Origen would have appeared in public with a smooth face, like a women [sic] or like a boy frozen into a state of prepubertal innocence. He was a walking lesson in the basic indeterminacy of the body.

This is a fascinating, if highly speculative reading of Origen's actions, without other ancient parallels.

11. Thanks are due here to Kristina Straub, whose comments on the first draft of this essay helped to clarify this point.

12. Herbert Musurillo, ed. and trans., *The Acts of the Christian Martyrs* (Oxford: Clarendon Press, 1972) 106–131. References to *The Martyrdom of Perpetua and Felicitas* will be included parenthetically in the text.

13. Artemidorus, *Oneirocritica/The Interpretation of Dreams* (trans. by Robert J. White; Noyes Classical Studies; Park Ridge, NJ: Noyes Press, 1975). All references to this edition (Artemidorus' book and chapter numbers) will be included in the text.

14. Mary R. Lefkowitz, "The Motivations for St. Perpetua's Martyrdom," *Journal of the American Academy of Religion* 44 (1976): 417–421.

15. Mieke Bal, "Perpetual Contest," unpublished manuscript; forthcoming in *On Storytelling* (Sonoma, CA: Polebridge Press).

16. Margaret R. Miles, *Carnal Knowing: Female Nakedness and Religious Meaning in the Christian West* (Boston: Beacon Press, 1989), esp. chapter 2.

17. *Acta Apostolorum Apocrypha*, ed. R. A. Lipsius and M. Bonnet, 2 vols (Hildesheim: Georg Olms, 1959); English translation in Edgar Hennecke and Wilhelm Schneemelcher, eds., *New Testament Apocrypha* (Philadelphia: Westminster Press, 1965), vol. 2, 167–531. The most important secondary literature on the significance of the apocryphal acts for understanding early Christian women's piety is: Ross Kraemer, "The Conversion of Women to Ascetic Forms of Christianity," *Signs* 6 (1980/81) 298–307; Stevan L. Davies, *The Revolt of the Widows: The Social World of the Apocryphal Acts* (Carbondale: Southern Illinois University, 1980); Dennis R. MacDonald, *The Legend and the Apostle: The Battle for Paul in Story and Canon* (Philadelphia: Westmin-

ster Press, 1983); Virginia Burrus, *Chastity as Autonomy: Women in the Stories of the Apocryphal Acts* (Studies in Women and Religion 23; Lewiston: Edwin Mellen Press, 1987).

18. Pseudo-Athanasius, *Vita Syncleticae*, 11. My English translation of this *Vita, The Life and Activity of the Holy and Blessed Teacher Syncletica* is found in *Ascetic Behavior in Graeco-Roman Antiquity: A Sourcebook* (ed. Vincent L. Wimbush; Minneapolis: Fortress, 1990), 265–311.

19. Evelyne Patlagean, "L'histoire de la femme deguisée en moine et l'évolution de la saintéte féminine à Byzance," *Studi Medievali*, 3d ser., 17 (1976): 597–623; J. Anson, "The Female Transvestite in Early Monasticism: Origin and Development of a Motif," *Viator: Medieval and Renaissance Studies* 5 (1974): 1–32. See as one example the poignant narrative of Pelagia, the prostitute-turned-"monk" in Sebastian P. Brock and Susan Ashbrook Harvey, *Holy Women of the Syrian Orient* (Berkeley: University of California, 1987), 40–62.

20. Jerome, *Epistle* 22:27.

21. Council of Gangra, canons 13 and 17.

22. Palladius, *Dialogus de vita S. Ioannis Chrysostomi* (J.-P. Migne, *Patrologiae Cursus Completus, series graeco-latina* [Paris, 1854–1866; hereafter cited as PG] 47, 56).

23. *Vita Olympiadis* 3, in John Chrysostom, *Epistolae ad Olympiadem/Lettres à Olympias*, 2d ed. aug. with *Vita Olympiadis/La Vie Anonyme d'Olympias* (trans. Anne-Marie Malingrey; Sources Chrétiennes 13bis; Paris: Cerf, 1968); Palladius, *Historia Lausiaca* (ed. Cuthbert Butler; Cambridge: Cambridge University, 1904), 9; Gregory of Nyssa, *Vita Macrinae/Vie de Sainte Macrine* (trans. Pierre Maraval; Sources Chrétiennes 178; Paris: Cerf, 1971), 1.

24. Athanasius, *De Virginitate*, 10–12; PG 28, 261C–266B.

25. Amma Sara in the *Apophthegmata Patrum/Sayings of the Fathers*, PG 65, 420D.

26. John Chrysostom, *Adversus eos qui apud se habent subintroductas virgines* ("Instruction and Refutation Directed Against Those Men Cohabiting with Virgins") and *Quod regulares feminae viris cohabitare non debeant* ("On the Necessity of Guarding Virginity"), introduced and translated by Elizabeth A. Clark in *Jerome, Chrysostom, and Friends: Essays and Translations* (Studies in Women and Religion 1; New York: Edwin Mellen Press, 1979), 158–248. See also Elizabeth A. Clark, "John Chrysostom and the *Subintroductae*," *Church History* 46 (1977): 171–185.

27. John Chrysostom, *Introduction and Refutation*, 10; Clark translation,195–196.

28. See also *On the Necessity of Guarding Virginity* 4–5 (Clark translation, 221–222) on men and women being constitutionally suited to particular kinds of work; later, §7 (Clark translation, 230–231) where women dominating men is presented as going against the divinely inspired hierarchy of sexual difference.

29. Mary Beard, "The Sexual Status of Vestal Virgins," *Journal of Roman Studies* 70 (1980) 12–27, esp. 19–22.

3

The Categorization of Gender
and Sexual Irregularity
in Medieval Arabic Vice Lists

Everett K. Rowson

In the long history of Western discourse on Middle Eastern societies, for which Edward Said has given us the label "Orientalism," exotic images of sex and gender have played a major, not to say inordinate, role. Certainly the most significant factor in creating these images has been the sheer obviousness of difference in certain gender-based institutions in "the East" (and particularly in the Ottoman Empire). These include, notably, the harem and the veil, as well as an apparent inversion of conventions in attire for the sexes, as discussed by Marjorie Garber in this volume. But another important component of this complex of images, and one that is very much still with us, is the characterization of these societies, or of their dominant religion, Islam, as sanctioning and even promoting self-indulgence, licentiousness, and sexual deviance. With differing emphases, this characterization can be traced from medieval polemics to contemporary scholarship. In the fourteenth century, for example, a French bishop and missionary wrote that in Islam "any sexual act at all is not only not forbidden, but allowed and praised";[1] in the nineteenth, Sir Richard Burton propounded his notorious theory of a "Sotadic Zone" extending from the Mediterranean to Japan in which "the Vice [pederasty] is popular and endemic, held at the worst to be a mere peccadillo";[2] and in 1976 Vern Bullough gave to one chapter in his *Sexual Variance in Society and History* the title "Islam: A Sex-Positive Religion."

Most of these assertions tell us considerably more about Western

attitudes than they do about the societies they purport to describe, but they also raise important questions about the reality that has given rise to such caricatures. Unfortunately, very little serious scholarship has as yet been directed at conceptions of gender and sexual attitudes and behavior in premodern Middle Eastern societies.[3] Not that there is any lack of evidence to be explored; over the past millennium, the Islamic world has produced an enormous literature, mostly in Arabic, Persian, and Turkish, which is of extraordinary variety and anything but reticent about topics relevant to these questions. Legal tracts, medical treatises, parenetic discourses, historical annals, and, above all, a massive belletristic literature include regular and sometimes exhaustive discussions of sex and gender. But relatively little of this material has been translated into Western languages, and the philologists who deal with the original texts have shied away from such questions, mostly for reasons having to do with not only Western but also contemporary Middle Eastern societal attitudes.[4]

While in one sense it is treatises of religious law which have first claim on scholars' attention, as establishing the official norms of societies dominated by Islam, the belletristic literature offers the advantage of giving us greater insight into attitudes actually held—at least by literate (urban, elite, and mostly male) writers and readers. In Arabic (as in Persian and Turkish, which will not be dealt with here), *belles lettres* means, to a large extent, collections of poetry and anecdote. From the ninth century to the nineteenth, we have a vast outpouring of both, presented together or separately, and organized by what seems to be virtually any set of parameters one could think of—by author, by genre, by period, by geographical region, and so forth. There are collections of faux pas, of put-downs, of proverbs, and of love stories, as well as multivolume encyclopedias that subsume a whole range of topics. Some of these works, for a number of different reasons, include sexual behavior, proclivity, or identity as one of their organizing principles. An analysis of the structure as much as the content of such works offers one way of drawing a preliminary map of traditional attitudes towards gender, sex, and, particularly, sexual irregularity in the societies that produced them.

To use the phrase "traditional attitudes" is to suggest an invariability over time which, while historically indefensible, is assumed by the sources themselves. The Orientalist tendency to see the East as an

eternal unchanging monolith has been in fact partly the result of the nature of the indigenous tradition, in which important variations over space as well as time are largely masked by adherence to canonical forms established, in their essentials, by the tenth century at the latest. In the case of anecdotal literature, such traditionalism must be understood quite literally: an anecdote which first appears in a ninth-century collection will reappear, unchanged, in subsequent collections for a millennium. The gradual accumulation of new material (as well as some degree of formal innovation) does provide the social historian with important evidence for historical change; but it is the continuity which predominates in the sources and which must be dealt with first.

Besides the inevitable questions of audience and literary traditionalism, a further limitation on the use of belletristic sources for social history involves the specific motivation for including poetry and anecdotes on sex and gender in these collections. Most of the material to be dealt with here falls under the rubric "*mujūn*," a term which means approximately "profligacy" and was applied both to behavior, and particularly sexual behavior, which flouted societal and religious norms, and to the literary expression of such behavior. As in the modern West, but to a far greater extent, society was more indulgent toward the literary treatment of sexual irregularity than toward its practice. Persons who lived irregular lives might be tolerated, in varying degrees; but even the most respectable, or indeed sanctimonious, individual with literary ambitions could be expected to compose or reproduce poems and stories describing the most outrageous behavior, and even attributing it to himself. It was neither surprising nor unseemly for religious judges to retail dirty stories (and they were perceived as "dirty"), this being a recognized and fully sanctioned genre of literary activity. From a given author's *mujūn* production one can assume nothing *prima facie* about his behavior, his insincerity being as much in question as his sincerity.

Despite this distance between literature and reality, however, such material does offer insight into the real attitudes which underlie its effectiveness. The essential point of *mujūn* was humor, and without certain basic assumptions, a joke will be neither coherent nor funny. Quite apart from their truth value, moral assumptions, or humorous intentions, anecdotes about sexual practices and practitioners reveal how a society categorizes the latter and offer evidence for the relative

weight sexual behavior, sexual object choice, and gender stereotyping play in these categorizations. In addition, the point of a sexual joke will depend crucially on implicitly accepted attitudes toward the kind of person or behavior to which it refers. *Mujūn* by definition deals with the officially proscribed, but for it to be humorous there must be some factor that mitigates this negativity. Such a factor may be simply the gap between speech and action: *double entendres* refer unexpectedly, and humorously, to sex in an inappropriate context, without necessarily articulating any moral position. A false claim about one's own sexual profligacy, on the other hand, while substituting speech for action, also depends on a perceived gap between the acceptability of certain actions and that of certain desires. For example, one may claim (humorously and falsely) to be an adulterer, since adulterous *desires* are assumed to be normal and inevitable; but one is unlikely to claim to be a catamite, since in this society, as we shall see, even the desire for such an activity is thought to be both pathological and shameful. Jokes at the expense of another, in contrast, are far more likely to depend for their effectiveness on implicit, or indeed explicit, hostility, and may reveal just where societal attitudes are most uncompromising.[5]

A good initial overview of the varieties of sexual behavior dealt with in Arabic belletristic literature can be obtained from a look at the contents of an eleventh-century philological work, *The Book of Metonymic Expressions of the Littérateurs and Allusive Phrases of the Eloquent* by the Iraqi religious judge al-Jurjānī.[6] Not itself a work of *mujūn*, but rather a handbook for the instruction and entertainment of the littérateur, this book nevertheless draws extensively on the *mujūn* tradition for its content. In his introduction, the author explains five reasons for using indirect expressions: as euphemisms for indecent topics, as euphemisms for ill-omened words or topics (e.g., death), as backhanded compliments, as a form of argot among the littérateurs, and as a way of displaying one's erudition and mastery of the Arabic lexicon. He adds, however, that of these five it is the first which is the most basic, "indecency" referring to topics involving elimination and sex. Correspondingly, after an opening chapter on metonymy in the Qur'ān, he devotes ten of his twenty-four chapters to these two topics. Chapter 11 is on elimination; the others bear the following headings:[7]

2. Fornication (*zinā*)
3. Sexual intercourse (*jimāʿ*), the penis, impotence and potency
4. Virginity and non-virginity
5. Heterosexual anal intercourse
6. Male homosexual prostitution (*ijāra*) and active homosexual intercourse (*liwāṭ*)
7. Intercrural intercourse, male masturbation, and tribadism (*saḥq*)
8. Passive male homosexuality (*ubna, bighāʾ*)
9. Lack of marital jealousy
10. Pandering

To a modern Western eye, this list must at first glance appear peculiarly incoherent, and might seem to reinforce the crude notion that "in Islam" anything goes. Socially illicit activities (fornication, pandering), behavioral irregularities (heterosexual anal intercourse, male and female homosexuality), physical attributes (virginity, impotence), and subjective attitudes (jealousy) are apparently set down indiscriminately. Male homosexuality is dealt with in several different chapters, and female homosexuality is grouped with male masturbation and with an activity that can be either homosexual or heterosexual but must include a male.

This impression of incoherence, however, depends on a whole series of cultural assumptions—a particular view of the relation between the illicit and the irregular, a perceived symmetry between male and female, and a prioritization of sexual object choice over sexual activity—which do not fit al-Jurjānī's world. Our author is working from a quite different set of assumptions, which can be recovered to some extent from his (in fact rather well-organized) list of chapters itself. Two factors determine the structure he has adopted. First, his basic topic is what is sexually illicit (as we might expect from a book of euphemisms), whether this illicitness be due to choice of partner, activity, or social context. It is true that some chapters (3, 4, 9) do not deal explicitly with the illicit, but their inclusion can be explained on the basis of the second factor, namely, his adoption of the viewpoint of a conventional adult male, who is sexually identified first and foremost as someone who penetrates. Thus, the first topic to be treated is the most important, or common, illicit sexual activity of such a person, the sexual transgression par excellence—penetration of a woman to whom he has no sexual right. This is followed by three related topics: inability to penetrate

(and sexual intercourse in general), penetration of a virgin, and anal penetration of a woman. Slightly more irregular is the next topic, penetration of a boy. Options for penetration thus exhausted,[8] the author turns in chapter 7 to nonpenetrative sexual activities, including here, almost parenthetically, the one form of sexual activity for which he has relevant material that does not involve an adult male, tribadism. The following chapter deals with the yet more irregular topic of role reversal in which an adult male is himself penetrated. Finally, al-Jurjānī concludes his survey of sexual expressions with consideration of two purely socially determined sexual situations, jealousy and pandering, each involving a third party, one potentially and the other materially.

If recognition of the importance of the idea of the illicit and of the perspective of the adult male as penetrator affords the arrangement of al-Jurjānī's book some rationality, a brief consideration of its contents and sharper delineation of the categories he deals with will show more fully how these two factors shaped attitudes toward sexual conduct in his society. Since the "illicit" is conceived essentially as a legal category, defined in specific detail by Islamic jurisprudence, we must note particularly the formal stance of the latter toward each of the activities described. Apart from the law, the effect on perceptions of a view of "regular" sexual behavior as penetration by the male must also be traced, and will be of particular significance in looking at conceptions of homosexual behavior. After surveying the individual categories, we will be in a better position to understand why the articulation of the varieties of sexual behavior took the form it did in the society al-Jurjānī addresses and represents.

Chapter 2. Fornication. "*Zinā*" is an extremely precise term in Islamic law, referring to vaginal intercourse between a man and a woman who is neither his lawful wife nor his concubine. The gravity of the offense is highlighted by its inclusion among the few offenses for which the Qur'ān specifies a penalty.[9] Men and women are subject to the same penalties; a married offender is punished more severely than an unmarried one, but the offense is *zinā* in either case.[10] Other sexual acts (particularly heterosexual or homosexual anal intercourse) may be analogized to *zinā* for purposes of determination of legal punishment (this varies in different law schools), but are usually not included under the term itself. Al-Jurjānī's concern in this chapter is to cite and illustrate (mostly in poetry) the use of various indirect

55

expressions for *zinā* ("letting down the curtain," "riding between the wrist-bracelet and the ankle-bracelet"), as well as its opposite, chastity ("turning back the toucher's hand"); he quotes verses referring to both men and women, although mostly to the latter. Since one of the primary dangers of *zinā* is its effect on legitimacy and bloodlines, it is not surprising that al-Jurjānī also deals with indirect expressions concerning bastards, foundlings, and false ancestral claims (a common topos in Arab society).

Chapter 3. Sexual intercourse. Unlike *zinā, jimāᶜ* is a purely physical term, referring to the act of penetration, and can be applied, although only by extension, to anal intercourse with a male or a female, as well as to vaginal intercourse. The related verb, and its common synonyms (of all registers), are transitive in Arabic. Correspondingly, al-Jurjānī's expressions in this chapter all describe the act as a male activity, whether the female partner is mentioned or not. Examples: "he puts the spade in the ditch," "he speaks to his wife," "he shakes her bed," "he polishes his mirror," or, most commonly, "he builds on his family" ("family" being such a common euphemism for "wife" that al-Jurjānī does not even remark on it). A few examples refer to homosexual relations ("you took my boy away . . . and deprived my monk of his monastery"[11]). Al-Jurjānī's focus on the male experience and on penetration also leads him to add to this chapter expressions for the male, but not the female, genitals, and to cite several poems on impotence, some of which "quote" the female partner's complaints, although none of them are actually composed by women. (Some examples of the latter do exist in Arabic literature.)

Chapter 4. Virginity and non-virginity. This chapter is equally focused on the male as penetrator and his concerns, opening with anecdotes and poems about defloration (on the wedding night as well as in illicit relations), and especially about cases of failure to achieve it.[12] According to one anecdote, a poet who was offered a non-virgin slave girl for purchase complained:

> What a difference between a bored pearl
> On a string and an unbored pearl!
> I am not pleased by a mount that has been broken in;
> My preferred mounts are those that have never been ridden.

To which the "lively and cultured" slave girl retorted:

It is not pleasant to ride a mount
 Until it has been broken to the bridle and already ridden;
And a pearl is of no use to its owner
 Until it has been joined to the string and bored.

Impressed, the poet bought her.

This is followed by verses on the tightness and looseness of both women's vaginas and boys' anuses, and, in a series of odd but interesting transitions, by verses expressing the sentiment that a boy's pretty face may imply a loose (previously penetrated) anus, then several verses applying the phrase "you can't tell a book by its cover" to boys with beautiful faces but ugly bodies, and then the following lines:

When the down appears on the cheeks of a beardless boy,
 A waist-wrapper of hair (already) covers his thighs;
Have you not noticed that a book comes
 With one line for a title and many lines inside?[13]

This poem represents a variation on the extremely common theme of the growth of a boy's beard, which will be discussed further below; its relevance to a chapter on virgins and non-virgins is indirect, but clear.

Chapter 5. Heterosexual anal intercourse. This short chapter offers a few expressions for this practice, which was condemned by most of the major schools of Islamic law;[14] some of the examples present it as a recourse during a woman's menses, during which Islamic law uniformly forbids conventional intercourse.

Chapter 6. Male homosexual prostitution *(ijāra)* and active homosexual intercourse *(liwāṭ)*. Ijāra refers specifically to the practice of a boy (normally under the age of twenty) submitting to anal penetration for pay. There is little hint anywhere in the literature that such a boy took any pleasure in this activity. One of the expressions mentioned by al-Jurjānī is "he takes from the basin and spends on the pitcher," meaning "the boy collects money from renting himself out [as passive partner for men] and spends it on fornication [with women]." Men who seek the passive role in homosexual intercourse for pleasure constitute another category entirely (chapter 8). The fact that al-Jurjānī here pairs the active partner (the *lūṭī*[15]) with the boy prostitute, rather than with the male *desiring* the passive role, presumably reflects the prevalence of the former arrangement in actual homosexual activity. While it

might be convenient (and cheaper) for the *lūṭī* to find a partner who sought pleasure from the passive role, sentiments to this effect are quite rarely expressed in the literature, and the crucial concern to the *lūṭī* was not his partner's enthusiasm, but his youth—and beauty.

The parallelism between (male active) homosexual desire and (male) heterosexual desire is in fact exceedingly close. The canons for beauty of boys are virtually the same as those for women, a fact underlined by the extraordinary prominence of the question of the beard in homoerotic poetry and anecdote. The wearing of beards was a universal custom in these societies, and the beard was the single most potent symbol of manhood. Numerous anecdotes testify to the power of shaving off someone's beard as a form of humiliation.[16] Like women, boys lacked both beards and power, and that they should be assimilated to them as objects of sexual desire as well is hardly surprising.[17] In fact, the substantivized adjective "beardless" (*amrad*) is probably the most frequently encountered term for "boy" in erotic poetry. On the other hand, the fact that boys were *not* women was obviously crucial to the existence of homoerotic desire in the first place; and whatever the psychological basis for this (about which the sources give us few clues), its most common manifestation in the texts, indicating interest in a physical attribute not shared by women, is the expressed delight in the first down on a boy's cheeks. That this down was also the harbinger of the coming full beard which would spell the end of the boy's desirability introduced a tension which took a variety of literary (and presumably psychological) forms. Most common is the lament over the inevitable brevity of one's passion for a boy, compared to that for a woman; but we also find, from the earliest Arabic homoerotic poetry (late eighth century) on, expressions of protest against the cessation of desire with the appearance of the full beard. By the eleventh century, predictably, these protests were brought into the literary canon with the appearance of collections of poetry for and against continued passion for the now-bearded youth.[18]

Further testimony to a parallelism between the desire for boys and that for women is provided by a series of texts explicitly devoted to just the opposite point, that is, to disputes over the comparative merits of the two as sex partners. Like the beard collections, these texts represent a subgenre of the exceedingly common literary form of the debate. Two early and influential exemplars, both from the pen of

the famous ninth-century littérateur al-Jāḥiẓ, are now available in English;[19] a later version included in the *Arabian Nights* dates probably from the twelfth;[20] but there are many more.[21] The arguments advanced in these texts for the advantages of one sex over the other tend to concentrate on what may be termed practicalities (boys do not get pregnant; anal intercourse can be messy), while the rarer appeals to aesthetic considerations suggest rather the similarities between the two sexes as objects of sexual desire. Thus, the advocates of girls argue that the fleshiness and smooth skin of women can be enjoyed in boys for only a limited period of time, and that boys lack altogether such female attractions as full breasts; the advocates of boys make no corresponding counterarguments on the basis of physical attributes.[22]

Another factor that would seem to favor the cause of women is that of legal status; for while heterosexual desire can be indulged licitly, in marriage and concubinage, *liwāṭ* is always illicit according to Islamic law. We do not as yet have any detailed scholarly treatment of the discussions of *liwāṭ* which appear regularly in the vast literature of Islamic jurisprudence, despite this topic's obvious importance, and the general situation can only be summarized briefly here. Much of the legal material consists of complex arguments over the legitimacy of analogizing *liwāṭ* to *zinā*, but these were in fact usually overridden by appeals to explicit precedent from the Prophetic tradition which prescribed the death penalty for both male partners caught in the act of anal intercourse.[23] It is important to note that the law is concerned exclusively with definable acts, and says nothing about "propensities" or "identities."[24] Outside the realm of law, it is true, attacks on homosexual *desire*, while exceptional, are not unknown; al-Jāḥiẓ, notably, argues[25] that "this desire is reprehensible and abhorrent in itself" on the basis of the contrast in the Qur'ān between the description of wine in Paradise, which is said to produce neither drunkenness nor hangover and which al-Jāḥiẓ considers a reward for those who have observed its proscription in this world, and the description of the servant boys in Paradise, for whom no such compensatory (sexual) role is described. The debate texts, on the other hand, make no such argument; and while the advocates of women do appeal to the Qur'ānic condemnation of *liwāṭ* itself, their arguments are countered by references to the more explicit and more emphatic condemnation of *zinā*, the licit alternatives for heterosexual intercourse being generally left out of account.[26] It

would be unwarranted to argue that this omission implies that hetero-sexual desire was seen as more appropriate or likely in an illicit context than in a licit one; the inappropriateness of referring to the latter *in public discourse*, on the other hand, conforms fully to contemporary social imperatives which discouraged *any* direct public references to the women of one's household. But overriding these considerations is the fact that such literary debates fall under the rubric *mujūn*, and thus literary convention itself dictated that the subject matter be limited to the illicit.

Bearing in mind that al-Jurjānī was a religious judge who also composed works of jurisprudence, we may cite some of his own exam-ples of expressions for *liwāṭ* and the *lūṭī* to illustrate just how far this literary convention of *mujūn* permitted one to go, not only in flouting religious norms, but even in using religious language to do so. It is one thing for a Muslim to call a *lūṭī* a "monk," as in "more devoted to *liwāṭ* than a (Christian) monk, who claims that women are forbidden to him."[27] More shocking to Muslim society would be an expression referring to Islamic religious obligations such as "he collects the alms-tax from (male) gazelles," which depends on the following lines:

"O you whose glances are swords
 Which reduce hearts to shards,
The beauties of your cheeks are perfection, so pay the alms-tax on them!"
 But he answered, "Gazelles are not subject to alms-tax."[28]

Similarly, to refer to one who prefers boys to women, one says, "he visits the house from the back," avoidance of the front door during certain times being a superstitious practice explicitly forbidden in the Qur'ān (2:189); both this and another sexual application of Qur'ānic phraseology are again illustrated by al-Jurjānī with verses, here attrib-uted to "a caliph":

I am a man who loves *liwāṭ* and its people,
 But I keep my garments pure of those who practice *zinā*;
I come to houses from the back, and do not subscribe
 To entering a house from the (front) door;
I do not enter the prayer-niche at the time of the obligatory prayer,
 But believe in praying outside the niche.

But yet another religiously-colored expression included by al-Jurjānī in his section on *liwāṭ* calls into question how adequate "literary convention" may be as an explanation for the indulgence in literary *mujūn* by religiously committed personages, and casts doubt on the assumption that such men wrote about things that they would never do. This is the description of a *lūṭī* as someone who "subscribes to the religion of Yaḥyā ibn Aktham." Like al-Jurjānī himself, but two centuries earlier, Yaḥyā ibn Aktham was a judge in Iraq. His advocacy of, and, by all accounts, indulgence in, *liwāṭ* made him a byword for the practice, which he remains even today. How such a situation would be regarded can be seen from two sets of verses quoted sequentially by al-Jurjānī to illustrate the phrase:

> I am a profligate, a *lūṭī*, with just one religion,
> And I love to collect sins.
> I subscribe to the religion of the shaykh Yaḥyā ibn Aktham,
> And avoid those who love *zinā*.

> We used to hope that justice would become apparent,
> But our hopes have been overtaken by despair.
> Are this world and its people well,
> When the Chief Judge of the Muslims practices *liwāṭ*?[29]

In Yaḥyā ibn Aktham's day, the conventions that were to rule Arabic poetry and *belles lettres* for the following centuries were just in the process of being established, and a historically sensitive investigation of this process is well beyond the scope of this essay.[30] But these two poems can be taken as representative of what were to become conventional attitudes. Both stress that *liwāṭ* was a sin, one of them taking an antinomian stance, the other a reproving one. The standard opposition between *liwāṭ* and *zinā* expressed in the first poem further implies an underlying equivalence between the two offenses: not only are they equally serious sins (in terms of societal disapproval as well as formal law)—and presumably equally difficult to prosecute[31]—but they are also both the result of failure to suppress equally natural impulses. From the time of Yaḥyā ibn Aktham the entire Arabic literary tradition assumes that the "lust in the heart" to which all men are susceptible is as likely to be stimulated by boys as by women. Poets who composed love lyrics exclusively about boys were probably rarer

than those who wrote only about women, but both were exceptional compared to those who concerned themselves with both. In terms of practice, because of the cult of female virginity and the dependence of a man's honor on the chastity of his female relations, heterosexual philanderers were in fact playing a more dangerous game than *lūṭīs*, and an argument could be made for a shift over time in the weight of societal disapproval toward the former and away from the latter.

One particular manifestation of such a shift, which begins to assume some importance about the time of al-Jurjānī, deserves a brief mention. Among the various meditative practices developed by circles of Islamic mystics, the Sūfīs, was that of *naẓar*, the contemplation of a beautiful pubescent boy, who was considered a "witness" (*shāhid*) to the beauty of God and the glory of His creation. As chastity (but not celibacy) was an unquestioned imperative for the Sūfī, as for any good Muslim, this practice occasioned considerable controversy among the Sūfīs themselves, being frequently attacked as a dangerous temptation; the Sūfīs' enemies also exploited it to disparage the entire mystical movement as decadent and immoral. But whatever its status, Sūfī contemplation was always of a boy, never of a woman, the latter being completely precluded by seclusion and the veil.[32]

Chapter 7. Intercrural intercourse, male masturbation, and tribadism (*saḥq*). If *zinā* and *liwāṭ* are the two basic forms of penetrative, transgressive sex, *liwāṭ* being generally practiced with a male prostitute,[33] what the topics in this chapter have in common is their being nonpenetrative forms of sexual activity. The term for intercrural intercourse (*tafkhīdh*) is applied to both male-female and male-male activity, although more commonly to the latter. In both cases, the formal legal penalties are considerably milder than those for penetrative sex, and al-Jurjānī's anecdotes indicate this consideration as a primary motive for the practice. Given the crucial importance of female virginity at marriage in Islamic society, one might expect illicit sex with a virgin to be the usual occasion for the heterosexual practice, but the sources do not support this; perhaps the opportunities were in fact too rare.[34] Rather, a non-virgin woman would insist on the practice simply to avoid committing the greater sin. Boys would be more likely motivated by the desire to avoid the intense humiliation of taking the passive role in (anal) intercourse itself (see on chapter 8 below). Most of al-Jurjānī's sample expressions (e.g., "drinking water when you want wine") stress

the frustration resulting from *tafkhīdh*. His expressions for male masturbation are mostly jocular: "marrying Hand daughter of Arm," etc., as well as what was in fact the usual term, "flogging ʿUmayra."[35]

More interesting is al-Jurjānī's treatment of tribadism, in Arabic "*saḥq*." This term, a verbal noun literally meaning "pounding, rubbing, shaving," is the usual one for female-female sexual activity, and al-Jurjānī is typical in treating such activity only under this rubric.[36] The verses he quotes are notably male-centered (being all by male poets), and striking for the aggressive implications of the military expressions employed:

> May God curse the "head-shavers,"
> For they are a scandal to respectable women:
> They manifest a war in which there is no spear-thrusting,
> But only fending off a shield with a shield.

Similarly:

> Woe to you women, you ignore true delight,
> And hitting of the target with arrows;
> What pleasure can you find in a seashell
> Whose edges close over another seashell?

There is a hint of an actual lesbian relationship in two of al-Jurjānī's anecdotes and an appended comment, which, however, express much the same attitude, although attributed to women:

A woman wrote to her friend when the latter was led in her wedding procession to her husband: "Just because one sees a staff and finds it handsome does not mean one should lean on it; so do not be taken in by the love he shows you, for it can dissolve more easily than dry potash." But her friend wrote back: "I used to enjoy the striking of tambourines, until I heard the sound of flutes; but when I heard the latter, something fused in my soul which will not dissolve until I die."

And one woman wrote to another: "How fine is the cucumber!"— meaning the penis—to which she replied: "Were it not for the fact that it swells the belly!"—meaning pregnancy.

63

One also says [to allude to a tribade], "So-and-so eats figs" and "So-and-so is an acquaintance of So-and-so."

Al-Jurjānī's rather perfunctory treatment of this topic is typical of the literary tradition, although some sources (one of which will be considered below) do have somewhat more to say about lesbian relationships.

Chapter 8. Passive male homosexuality (*ubna or bighā'*).[37] If a man's choice of partner to penetrate (or desire to penetrate) is essentially a matter of taste, and non-penetrative sex is (at least for men) assumed to be *faute de mieux*, a man's desire to be penetrated is uniformly considered sick, perverted, and shameful. Al-Jurjānī refers in the first line of this chapter to this condition as an illness, and continues to do so throughout. Unlike *liwāṭ*, or indeed any other sexual practice, *ubna* was dealt with in the medical literature, where questions of genetic cause, physical gender confusion (correlated with such other topics as facial hair on women and hermaphrodites[38]), and incurability or possible treatment were all discussed.[39] Al-Jurjānī has none of this; but his poetic examples, all quite negative (although some are jocular), show the same unresolved tension between views of the condition as involuntary physical disorder and as freely-chosen moral depravity that we know so well from recent Western views of "homosexuality." (At one point he refers to a man "accused of the illness.") His citations of figurative expressions ("he hides the staff," "carries the banner," "loves the flute") are mostly jejune, but a few of his examples hint at a relationship between *ubna* and *liwāṭ* closer than simple complementarity of behavior. He admires a rhetorical trick in the following lines:

> Abū Bakr is a *lūṭī* in truth,
>> But there is perhaps a whiff of suspicion about him:
> I see that he likes his boys black and devilish,
>> Which makes me think that he may be—[40]

Another line states:

> He is more devoted to *bighā'* than a needle,[41]
> But he pretends to people that he is a *lūṭī*.

64

And according to one anecdote, a man known for *liwāṭ* "got the disease" when he became older, and explained, "We used to play with spears, but when they broke, we started playing with shields" (yet again the military metaphor). Such statements seem to be the closest one comes in the tradition to any suggestion that choice of a male partner on the basis of his sex might transcend considerations of behavior role, although even this is probably an overreading.

Chapter 9. Lack of marital jealousy. This brief chapter is concerned exclusively with lack of *male* jealousy, and most of the quoted verses play with the image of the horns of the cuckold; all are derisive. The last poem given is a lament by a poet who has had the misfortune to fall in love with a promiscuous boy.

Chapter 10. Pandering. Al-Jurjānī quotes a famous anecdote in which a grammarian defines for the caliph Hārūn al-Rashīd three kinds of panderer (*qawwād*): one is a poor man who permits a rich friend to use his home for assignations, a second lodges two or three girls with a friend and visits them there, while a third, the basest, brings partners together for pay. Hārūn replies that he has been one of the second type for forty years without knowing it. To make sense of this story, we must here gloss "*qawwād*" (for which "panderer" is usually quite an accurate translation) as "someone who breaks the societal rules for secluding women from men to whom they are unrelated—with or without illicit sexual activity," and assume that Hārūn is referring implicitly to the eunuchs who guarded his harem. Aside from this anecdote, al-Jurjānī's expressions mostly indicate the third type, and are on the order of "rivet of scissors" and "blacksmith (who sharpens another's weapon)"; most of the quoted verses refer to men, but a few are about women. One man is derided for being both cuckold and panderer, apparently of his own wife, who practices *saḥq* to boot.

Al-Jurjānī clearly lived in a man's world. Free adult men virtually defined the public world, sharing it with subordinate adolescent boys, male slaves, and, to a degree, female slaves. In the private world, they dominated their secluded wives and female relations. The public badge of a dominant male was his beard. In sexual terms, he dominated as penetrator. Beardless non-men—women and boys—were his natural sexual partners. Official morality restricted a man's penetrative options to his wives and female slaves, but if he chose to become a "profligate," he could expand these options and seek penetrative satisfaction with

other women or boys. Such a course made him a sinner, but did not imperil the status and honor due him as a man. We may safely assume that the sexual pleasure of penetration was psychologically linked with the emotional gratification of starkly physical domination. Women's sexual pleasure was assumed (by men) to be linked correspondingly with their sense of subordination.[42] For a man to seek sexual subordination, on the other hand, was inexplicable, and could only be attributed to pathology. Boys, being not yet men, could be penetrated without losing their potential manliness, so long as they did not register pleasure in the act, which would suggest a pathology liable to continue into adulthood; the quasi-femininity of their appearance, a condition for their desirability as penetratees, was a natural but temporary condition whose end marked their entry into the world of the dominant adult male.

The somewhat ambiguous position of boys can be illustrated further from two other topoi common in the *mujūn* literature. Neither happens to turn up in al-Jurjānī's book, but both are touched on in another work that includes a survey of *mujūn* topics, *The Colloquies of the Littérateurs* by al-Rāghib, a religious scholar of the previous generation.[43] In this large-scale anthology, which attempts to cover every conceivable subject, from "intelligence" (the first chapter) to "insects" (the penultimate one), al-Rāghib brings all his *mujūn* material together in a single chapter, which he divides into four sections: sexual irregularities involving males (beginning with *liwāṭ* and concluding with *zinā*), genitalia and sexual intercourse (including defloration and impotence), tribadism, and farting.[44] The first of these sections, besides citing poems and anecdotes about male prostitutes and passive homosexuals, also mentions two other alternatives available to the *lūṭī*. One possibility is to engage in *mubādala*,[45] or taking turns as active and passive partners in anal intercourse. As one poet puts it,

> If you're empty-handed and out of cash,
> It seems to me the best course is to buy a fuck with a fuck.

In such an exchange (which we hear about more often between two boys than, as implied here, between a man and a boy), the shame of being penetrated is more or less cancelled out by also penetrating, although public recitation of verses such as these would constitute a

fairly extreme example of *mujūn*;[46] in practice, one might expect that the parties would have an equal interest in keeping the matter strictly private.

If *mubādala* represents an accommodation between a dominant-subordinate relationship seen as natural to sex and an equality in social status between two boys (or between a needful man and a boy who is already a man insofar as he is a free agent), the other alternative, *dabīb*, rather emphasizes the disparity in power between the active and passive partners. This term, which literally means "creeping," refers to the practice of initiating anal intercourse with a sleeping boy. Stories and verses about *dabīb*, which are quite common in the literature, often imply an unacknowledged willingness on the part of the boy to engage in the act; and while the startled sleeper may successfully resist the attack, true violence is rarely described. Only very occasionally do we hear of *dabīb* directed at women, and in such cases the victim is inevitably a slave girl of, it is implied, easy virtue.[47] In any case, no parallel to heterosexual rape (*ightiṣāb*) is ever drawn; the latter was of course a much more serious matter, and probably extremely rare in practice, except in the context of war and pillage. *Ightiṣāb* belongs to the realm of violent crime, not *mujūn*, and was never a subject for literary humor. Ultimately, the difference lies in the stakes: a boy who is penetrated, whether voluntarily for gain or involuntarily, suffers no permanent injury to his manliness, and the dishonor thus incurred by his father and other male relations is mitigated by the temporary and partial nature of his subordination to them; in contrast, rape of a respectable woman represents an almost unthinkable assault on the honor of her husband and family, and would result in the severest reprisals from both them and the state. The situation of the slave girl, liable to be passed from hand to hand through purchase, lies somewhere in between.

Al-Rāghib also offers a bit more information than al-Jurjānī on tribadism, to which he devotes the third section of his *mujūn* chapter. Like al-Jurjānī, he understands this activity as essentially non-penetrative, as is clear from the fact that, although he discusses dildoes, he does so not here, but in his second section, on sexual intercourse. (There he offers two anecdotes, one giving a religious scholar's condemnation of them—"any recourse to satisfy your sexual desires other than your husband is forbidden"—and the other describing a woman's use

of one to sodomize an effeminate man, as a kind of ultimate sexual irregularity.[48]) Unlike al-Jurjānī, al-Rāghib cites one anecdote expressing a woman's preference for tribadism with another woman (saḥq) over heterosexual intercourse (jimā'); but this is outweighed by five poems and anecdotes asserting the opposite. References to saḥq as sexual relations between women and saḥq as female masturbation are thoroughly mixed throughout this section; a description of tribades' aversion to phallic objects and other things that remind them of men suggests that, from a man's perspective, the essence of the phenomenon is a rejection of males in general, and thus of penetration. Nevertheless, al-Rāghib does allow for the possibility of affective relations between women, tracing the "origin" of saḥq back to an enduring love affair between an Arab noblewoman and the wife of an Christian Arab prince of pre-Islamic Iraq; after the death of the former, we are told, the princess founded a convent at the site of her tomb, to which she retired.[49]

If male sexuality was understood as domination expressed by penetration, it is perhaps not surprising that what references we do have to sexual relations between women carry no implications of "masculinization." Neither in al-Jurjānī nor al-Rāghib, nor elsewhere in the literature I have investigated, is there any suggestion that women involved in same-sex relations take on any of the nonsexual gender attributes of men; nor do we find any references to active-passive role differentiation in lesbian relationships. There are, to be sure, occasional descriptions of women adopting masculine modes of behavior—donning male attire and swords, riding horseback, and so forth—particularly in the earlier (seventh and eighth) Islamic centuries, when conventions of seclusion were apparently less rigorous. Such women were sometimes admired, sometimes criticized for venturing into the public world of men; but they were never associated with any particular form of sexual irregularity. Even the ghulāmīyāt, singing slave girls who were dressed up as boys (on occasion complete with painted mustaches) and became the rage at the caliphal court in ninth-century Baghdad, were not known for having sexual interest in or relations with other women; on the contrary, whether the initiative for this fashion came from the slave girls themselves or, more likely, from the caliph and his male courtiers, they were competing with boys for the attention of men.

The question of correlation between homosexual behavior and non-

sexual gender irregularity in men is, predictably, somewhat more com-
plicated, but not quite in the way one might expect. Certainly there is
no reason to expect any connection to be made between effeminacy
and active *liwāṭ*: if to be male (and adult) is to penetrate, men who
penetrated boys were just as masculine as those who penetrated
women—and one could argue that the many who penetrated both
were even hypermasculine (although the texts do not explicitly portray
them as such). One might predict that the male penetratee, on the other
hand, or at least the adult male passive homosexual, afflicted with
ubna, would be regularly portrayed as effeminate. Remarkably, this is
not the case. Such a man was certainly the object of contempt, and
suffered from loss of manliness as well as honor; yet nowhere in the
works of al-Jurjānī and al-Rāghib, or elsewhere, is he in any way
assimilated to women. It would seem, then, that despite the asymmetry
between the sexes symbolized by penetration, neither male nor female
homosexual interest or behavior carries any implications for general
conceptions of gender.

But this impression requires modification when we consider the
fourth term in this complex, the man who adopts nonsexual feminine
attributes of appearance or behavior. Such men, known as *mukhan-
naths*, are well-known from medieval Arabic texts, although al-Jurjānī
ignores them and al-Rāghib deals with them only cursorily in the first
section of his *mujūn* chapter. For clarification of the nature of their
image, their societal role, and especially the sexual component of their
identity, we must turn to a third literary collection, again from the
eleventh century, The *Scattering of Pearls* by the government minister
al-Ābī (d. 1030).[50] This massive anthology is comparable to al-Rāghib's
work in its comprehensiveness with regard to subject matter, but distin-
guished from it by the author's decision to exclude poetry and restrict
himself to prose selections. Information on *mujūn*, while abundant, is
distributed among a number of different chapters scattered throughout
the book. Most of this material is comparable to what we have seen
in our other two collections, but what is of particular interest here is
a sequence of three chapters which al-Ābī devotes to anecdotes about,
respectively, effeminates (sg. *mukhannath*), active male homosexuals
(sg. *lūṭī*), and passive male homosexuals (sg. *baghghā'*).[51]

Al-Ābī's chapters on active and passive homosexuals, although put
under a rubric referring to those who indulge in a given behavior,

rather than the behavior itself, offer little that we have not seen in al-Jurjānī and al-Rāghib. The *lūṭī*'s partner is a "boy" or more specifically a "male prostitute" (whose prices are mentioned in a few anecdotes); the taste for the unbearded is contrasted with that for the bearded; *liwāṭ* is frequently contrasted with *zinā*. The passive homosexual is portrayed as obsessed with the phallus and with phallic imagery; one series of anecdotes concerns the clever justifications offered by men caught in the humiliating circumstance of being penetrated, while another offers smart answers by the incorrigible and defiant passive; nowhere is there any allusion to femininity or effeminacy. On the contrary, it is precisely this latter point that distinguishes the passive homosexual from the "effeminate" of the first of these subsections.

This "effeminate" is defined by nonsexual feminine gender characteristics, not by sexual role. The Arabic term *mukhannath* is derived from a root signifying "bending, flexibility, languor," and the application to this category of persons seems to depend on an image rather close to the Western "limp wrist." While al-Ābī's anecdotes offer little in the way of a physical description of the *mukhannath*, it is clear that his status as such was instantly recognizable. Several anecdotes depend on the fact that the *mukhannath* plucked his beard, and from other sources it is clear that he adopted feminine garb, at least to some extent, as well as wearing his hair longer than was conventional for men. No attempt was made, however, to "pass" as a woman, and the general impression was probably one of a mixture of the conventional appearance of the two sexes.[52] *Mukhannaths* also imitated women in their speech. In some anecdotes in other sources *mukhannaths* address each other in the feminine gender. Al-Ābī cites exchanges such as the following:

"You are the Father of whom?"[53] "I'm the Mother of Aḥmad!"[54]

"How old are you?" "Ninety-five." "Why have you not married?" "There aren't any decent men around these days!"

This unmarried state may well have been usual for *mukhannaths* (although we can never be sure, as we so seldom hear about the wives of even indubitably married men). But whatever their marital status, it is important to note that, from the ninth century on, *mukhannaths*

were always assumed to be sexually passive with other men. They thus shared an important characteristic with passive homosexuals—those suffering from *ubna* or *bighā'*—while remaining distinct from them, as indicated by the fact that al-Ābī devotes separate chapters to the two. Rarely is the term *ubna* applied to a *mukhannath*, and it would appear that the gender inversion of the latter rationalized a sexual behavior pattern that in conventionally gendered males (who were, we may be sure, usually married) was considered pathological.[55] Furthermore, much (although by no means all) of the quick wit of the *mukhannaths*, for which they were particularly known, concerned their passive sexual behavior. To a constipated man who complained he could not take the smallest enema, for example, one quipped, "That is because you wasted your youth!" Asked if he submitted to anal penetration, another replied, "Do I have any other place?"[56] It is noteworthy that *all* of al-Ābī's anecdotes in this section involve humor produced *by* the *mukhannaths*, in contrast to those in the section on passive homosexuals, many of which are told rather at the latters' expense.

This sense of humor was more than a characteristic—it could be a source of livelihood. The *mukhannaths* often served at court as buffoons; the most famous of them, ʿAbbāda, was court jester to the ninth-century caliph al-Mutawakkil, and is the subject of a third of the anecdotes cited by al-Ābī in his chapter on them.[57] (That a few ʿAbbāda anecdotes also appear in his chapter on passive homosexuals indicates that the two categories were not completely disjunct.) The *mukhannaths* were entertainers in another way, too, being frequently employed as musicians. Besides singing, they specialized as performers on a particular kind of lute, and were even more particularly associated with drums, of which one variety was apparently played only by them. This occupation with music suggests a kind of parallel to the role of the singing slave girls (although we do not hear of *mukhannaths* as slaves), and the *mukhannaths* seem in fact to have enjoyed a kind of camaraderie with women—at least publicly accessible ones—not shared by other men.[58] They may also have been actors—or at least mimes—although the evidence is difficult to assess; they certainly were known for performing devastating, and side-splitting, impersonations of people as a form of attack.[59] All these entertainment functions are summarized in a famous boast of theirs, quoted by al-Ābī and many others, in which they claimed that "We are the best of companions:

71

when we speak, you laugh; when we sing, you are delighted; and when we lie down, you mount." Their role as entertainers also suggests how the *mukhannaths'* social position is to be envisioned. Publicly recognizable, with a distinct identity (certainly corporate as well as individual), they were "public persons," belonging, like other entertainers, artists, and slave girls, to a kind of demimonde, where public appreciation, and even fame, were accessible, but respectability was emphatically not.[60]

The sharp distinction between public and private realms in this society goes far toward explaining how the relations between gender and sexual roles were understood. Sexual behavior is, essentially, a private matter; gender role is a public one. In a society where public power was a monopoly of those marked for gender as (adult) men, those not so marked were, as such, no threat, nor was their gender identity a focus of great concern. Men who voluntarily removed themselves from the dominant category, by behaving as women, lost their respectability, but could be tolerated and even valued for their entertainment value. Their assimilation to women was assumed to extend to the private sphere of sexual behavior. More problematical was the case of men who maintained a public image as men, yet in their private sexual behavior assumed a submissive role. They were not assimilated to women, because they behaved publicly as men. (Women were in any case not the only sexually submissive persons—there were boys as well.) But such men were eminently attackable, because of the contradiction between their public image as dominant persons and their private, sexual role as submissive—unlike the *mukhannaths*, who renounced any claims to dominance altogether. Women were excluded by anatomy from being sexually dominant, and thus their sexual behavior was irrelevant to questions of gender. Their conformity to an expected gender role, on the other hand, was not guaranteed; if they attempted to adopt masculine attributes—which in itself implied entry into the public world, at least potentially—men would react ambivalently: they could empathize with an entirely rational aspiration toward dominance, but would be unlikely to welcome a challenge from a realm where their own dominance could normally be taken as given, and which was in addition such an intense focus for their own honor.

Although illustrated here by a narrow range of texts from the eleventh century, these concepts can be taken as broadly representative

of Middle Eastern societies from the ninth century to the present. Considerable research will be needed to identify important changes over time and variations in space in these attitudes. Perhaps the most important historical question is that of continuity with earlier societies. Certainly much of what has been described here is similar to what we know of Mediterranean societies in antiquity. The general importance of male dominance, the centrality of penetration to conceptions of sex, the radical disjunction of active and passive roles in male homosexuality—all have been stressed in recent scholarship on the classical world.[61] But the parallels are even more specific. To cite just two examples, the Arabic debates on the comparative merits of women and boys as sex partners reproduce (with some significant differences) the Greek debates on the same subject;[62] and the motif of the emerging beard, already important in Plato, is exploited in essentially the same way in both Greek and Arabic poetry.[63] To be sure, there are important differences as well, notably, the lack of identification of passive male homosexuals as effeminate, which seems to have been automatic in the Greek and Roman traditions. Nevertheless, the case for a basic continuity would appear to be a strong one.

Yet there are problems. First, the parallels seem to be closer to the situation in earlier periods than to the world of late antiquity that the Muslims inherited. The changes wrought by Christian ideology, in particular, seem to be simply missing. Furthermore, with regard to the specific similarities we find in literature, direct influence is impossible to document; many Greek medical and philosophical works were eventually translated into Arabic, but the Greek literary tradition remained essentially unknown. Finally, some aspects of the picture of Islamic societies I have drawn here are not applicable to the period before the ninth century. Early Arab society seems to have paid little attention to male homosexuality, and certain did not celebrate it in its poetry; we do hear about *mukhannaths*, but, surprisingly, they were not particularly associated with passive homosexuality. How the rather abrupt changes in mores at the end of the eighth century suggested by our sources can be reconciled with the evidence for some kind of continuity with Mediterranean cultures constitutes a major puzzle.[64]

For tracing developments in more recent centuries we have abundant materials, but very little research has been done. There are some indications that homosexual behavior (passive male, and female) came to be

more closely correlated with gender stereotypes in the later medieval period.[65] The degree of societal and state tolerance of sexual and gender irregularity in general naturally varied; the rigorous pronouncements of Islamic law represented an ideal that could always be appealed to, and periodically was, for campaigns against vice. On the whole, however, the general acceptance of a public role for the male effeminate, and the saturation of literature with homoerotic sentiment, implying a fairly broad tolerance of male homosexual behavior of the sort outlined here, as well as an apparent indifference toward female homosexuality, all contributed to the image of unrestrained licentiousness which the West constructed for Islamic societies. The reality was far more complex, and the evidence adduced here from the belletristic tradition is intended as a preliminary step toward disentangling it.

Notes

1. William Adam, quoted in Norman Daniel, *Islam and the West: The Making of an Image* (Edinburgh, 1960), 144.

2. "Terminal Essay," in *The Book of the Thousand Nights and a Night* (New York, 1886), vol. 10, 205–53.

3. Not surprisingly, questions about women and gender in the contemporary Middle East have become an important focus of attention over the past decade; for a critical review of this work, see L. Abu-Lughod, "Zones of Theory in the Anthropology of the Arab World," *Annual Review of Anthropology* 18 (1989), 287–94.

4. Sporadic attempts to suppress such works as the *Arabian Nights* , for example in Egypt as recently as the 1970s, indicate major changes in attitude in the twentieth-century Middle East, at least as regards public discourse. To my knowledge, investigation of this shift, and the role of Western influence in it, remains to be undertaken. A good idea of the state of Western scholarship on the premodern Middle East can be obtained from the collection of essays entitled *Society and the Sexes in Medieval Islam*, ed. A. Lutfi al-Sayyid-Marsot (Malibu, 1979), particularly the essay by F. Rosenthal, the honoree of the conference at which these papers were presented, entitled "Fiction and Reality: Sources for the Role of Sex in Medieval Muslim Society."

5. What sexual humor will *not* tell us is how common a given behavior was in fact, or how it was dealt with in the real world. To draw an obvious comparison, one can learn a great deal about sexual attitudes in ancient Greece from the plays of Aristophanes, but they hardly represent a realistic depiction of Greek society.

6. Al-Qāḍī Abu l-ʿAbbās Aḥmad ibn Muḥammad al-Jurjānī (d. 1089), *al-Muntakhab min kināyāt al-udabā' wa-ishārāt al-bulaghā'* (published together with al-Thaʿālibī, *Kitāb al-kināyāt*), Hyderabad, 1983. This is actually an anonymous abridgement of the original work, which has apparently not survived.

7. These succinct but necessarily paraphrastic translations of the Arabic terms will

be further refined in the discussion which follows. My titles represent a compromise between the author's table of contents and the chapter headings themselves, which are worded slightly differently. The remaining chapters (12–25) deal with such topics as euphemisms for ill-omened topics and base occupations (stereotypically, weaving), back-handed compliments, and inside jokes among the littérateurs.

8. Arabic literature is almost completely silent on oral-genital activity; bestiality is mentioned, but not commonly.

9. These are the so-called *ḥadd* offenses, which also include false accusation of *zinā*, wine-drinking, theft, and highway robbery; they are crimes against religion, as opposed to, e.g., homicide, which is a crime between persons. On *zinā* and its penalties, see J. Schacht, *An Introduction to Islamic Law* (Oxford, 1964), 178f.

10. Simplifying slightly, the punishment for a married offender is death by stoning, and for an unmarried offender one hundred lashes. But the evidence required for conviction is either confession by the offender or eyewitnessing of the act of penetration by four male adults of established probity. There is general consensus on the law regarding fornication among all four major Sunnī law schools (which in general differ more on questions of theory than on provisions of positive law, and all of which recognize each other's validity) as well as Shīʿite law.

11. The reference is to Christian monasticism, but the expression as such could be used equally by Muslims.

12. It should be noted that the Arabic words for "virgin" (*bikr*) and "non-virgin" (*thayyib*) are semantically feminine but morphologically masculine (as are also terms such as "pregnant," "barren," and "menstruating"). The concept "male virgin" is usually expressed paraphrastically.

13. These verses are attributed to Qābūs ibn Vushmgīr (d. 1013), a celebrated ruler and littérateur in eastern Iran.

14. The Mālikī school, adhered to by most Muslims in North Africa, was notorious for permitting it.

15. This word is derived from Lot, and refers to the sin of his people, the "people of Lot"(*ahl Lūṭ*), i.e., the Sodomites; "*liwāṭ*" is an abstract form derived in turn from "*lūṭī*," via the (transitive!) verb "*lāwaṭa*." Pace J. Boswell, *Christianity, Social Tolerance, and Homosexuality* (Chicago, 1980), 194. n. 95, there can be no doubt about this etymology, which carries no implications about Lot himself, who is considered a prophet in Islam.

16. A famous example (from the late tenth century) is the *maqāma* ("séance") of Saymara in *The Maqāmāt of Badīʿ al-Zamān al-Hamadhānī* (English trans. by W. J. Prendergast, London, 1915, reprinted 1973, 156–164), in which the narrator gets back at his fair-weather friends who had deserted him in his hour of need by inviting them to a drinking party, getting them drunk, and shaving off their beards while they sleep.

17. Girls, of course, do not constitute a separate category, as women were marriageable as soon as they reached puberty (indeed earlier, but consummation was not permitted until puberty).

18. Notably by al-Jurjānī's literary predecessor al-Thaʿālibī (d. 1038), in his own collection of indirect expressions (see note 6 above), which is organized somewhat differently from al-Jurjānī's. Al-Thaʿālibī has separate chapters on "women and wives" and "boys and men." Subsections of the "women and wives" chapter are devoted to women, wives, female genitals, male genitals (!), heterosexual intercourse, defloration, menstruation, pregnancy, and miscellaneous anecdotes; the "boys and men" chapter is

divided into sections on puberty and circumcision, boys, anal intercourse with boys, *liwāṭ*, and praise and blame of emergence of the beard. Another work by al-Thaʿālibī, *Making the Bad Seem Good and the Good Seem Bad (Taḥsīn al-qabīḥ wa-taqbīḥ al-ḥasan*, ed. Sh. al-ʿAshūr, Baghdad, 1981), includes a chapter on the emergence of the beard in the first of the two parts reflected in its title. The earliest independent work devoted entirely to the question of boys' beards of which I am aware dates only from the fifteenth century; neither it nor any of its successors has been published.

19. Al-Jāḥiẓ, *Maids and Youths* and *Superiority of the Belly [to the Back]*, in W. M. Hutchins, trans., *Nine Essays of Al-Jāḥiẓ*, New York, 1989. The translation is problematical; see the review by A. F. L. Beeston in *Journal of Arabic Literature* 20 (1989), 200–209. Al-Jāḥiẓ stacks the argument in favor of women more heavily than most later authors, and in fact also wrote *An Attack on Liwāṭ* (apparently part of another work attacking school-masters, although the situation is not entirely clear).

20. In the Burton translation (see note 2), vol. 5, 154–63. Arno Schmitt has found the same text in the unpublished *Rawḍat al-qulūb wa-nuzhat al-maḥbūb* (The Garden of Hearts and Park of the Beloved) by the physician al-Shayzarī (d. 1193), which probably represents the original source; see Schmitt's *Kleine Schriften zu zwischen-männlicher Sexualität und Erotik in der muslimischen Gesellschaft* Berlin, 1985 50.

21. A further development of this tradition is the production of parallel anthologies of poetry on the beauty of boys and of girls. The earliest exemplars of this genre I know of are al-ʿAdilī's (c. 1250) *A Thousand and One Boys* and *A Thousand and One Girls*. None of these anthologies have been published.

22. Besides the beauty of face and hair, the bodily qualities most often praised in Arabic love poetry about both women and boys are a narrow waist and ample hips. (The cliché comparing the beloved to a ben-tree on a sand dune, for instance, is constantly applied to both.)

23. An apparent exception among some scholars of the Mālikī school, who are said to have permitted *liwāṭ* with one's own male slaves, has been noted occasionally in the secondary literature, but not yet systematically investigated. Such legal arguments would presumably rest on analogy to female concubinage—there being no comparable analogy to heterosexual marriage.

24. There is thus no evidence for, or indeed possibility of, any drift in Islamic law toward legal pronouncements on "homosexual persons" comparable to that documented for contemporary American law by Janet E. Halley in this volume.

25. In his *Attack on Liwāṭ (Rasāʾil al-Jāḥiẓ*, ed. A. M. Hārūn, vol. III, Cairo, 1979, 43f.).

26. That such was the case with the lost work entitled *Arbitration between the Fornicators and the Active Homosexuals* of Ibn Hindū (d. 1029) is clear from its title alone; but even al-Jāḥiẓ's *Maids and Youths*, which ostensibly poses the problem in more general terms, with an "advocate of boys" debating an "advocate of girls," is similarly described by the author at one point as a dispute between active homosexuals and fornicators. More "anatomically" oriented debates, such as that of al-Jāḥiẓ between the belly and the back, or that of Ibn al-Ḥajjāj (d. 1001) between the vagina and the anus, also clearly oppose two *illicit* activities.

27. Christian monasteries were not only notorious for *liwāṭ* among their residents; they were also celebrated by Muslim poets and *bon vivants* for providing opportunities for the illicit pleasures of both wine and boys—the former willingly provided, the latter apparently often surreptitiously available.

28. As something from which the lover derives benefit, the beloved's cheeks should

Medieval Arabic Vice Lists

be subject to the alms-tax (one of the most important obligations in Islam); but in Islamic law all animals except camels, cattle, sheep, and goats are in fact considered exempt from the tax.

29. It should be noted that the poet to whom al-Jurjānī attributes these latter verses, Aḥmad ibn Abī Salama, is also credited with several love-verses to boys. According to another source, these lines belong rather to Rashīd b. Isḥāq, a secretary who wrote erotic verses on a boy beloved by his employer.

30. Yaḥyā ibn Aktham was a contemporary of Abū Nuwās, a *mujūn* poet and unquestionably the most famous *lūṭī* in all of Arabic literature. The influence of both men was probably crucial in establishing the enduring fashion for homoerotic poetry and anecdote in Arabic, largely unknown before their generation. For the related question of continuity in attitudes with earlier Greek Mediterranean culture, see further below.

31. See note 10 above. With regard to *zinā*, besides the difficulty of obtaining the required evidence, one may confidently surmise that in fact summary justice, although contrary to the law, was more often dealt out by concerned third parties, that is, husbands or blood relatives.

32. For a discussion of *naẓar*, see A. Schimmel, "Eros—Heavenly and Not So Heavenly—in Sūfī Literature and Life," in *Society and the Sexes in Medieval Islam*, 119–41. Al-Jurjānī does not mention the *shāhid*, but his predecessor al-Thaʿālibī includes the term among those for a boy as object of sexual desire in his *Kitāb al-kināyāt*, 26.

33. It is striking that female prostitution does not appear as a category in al-Jurjānī's book or other works of this type; it seems to be included in the category of female fornication. Arabic does not lack terms for "female prostitute," and they do turn up in many poems and anecdotes elsewhere in the literature.

34. The prohibition against permitting a female virgin to be alone with a man other than a close relative was extremely strong.

35. A feminine proper name.

36. To underscore this point, I have translated "*saḥq*" and "*saḥḥāqa*" as "tribadism" and "tribade," rather than "lesbianism" and "lesbian," because the former terms (from Greek *tribō*, "to rub"), albeit somewhat archaic in English, refer, like the Arabic, to an activity rather than to choice of sexual partner. Both "*saḥq*" and "tribadism" can refer to female masturbation as well as genital rubbing between women; I know of no instances, however, where "*saḥq*" is applied to (penetrative) use of a dildo, another sexual act occasionally referred to in the sources in both solitary and lesbian contexts.

37. Al-Jurjānī uses both these terms, which are apparently synonyms. The former is known from the earliest Arabic poetry (sixth century), while the latter seems to have been coined in the tenth century. If there is any difference in meaning between them, it remains to be determined. A third synonymous term, rare after the ninth century, is *ḥulāq*.

38. In this respect the medical literature contrasts with the literary tradition, as will be noted below.

39. For all this, see F. Rosenthal, "Al-Rāzī on the Hidden Illness," *Bulletin of the History of Medicine*, vol. 52, no. 1 (spring, 1978), 45–60. This article includes a translation of al-Rāzī's (tenth-century) essay, as well as comments on connections with the Greek tradition, including the well-known passage on the subject in the Aristotelian *Problemata* (IV.26). In conformity with the common view that this disorder is incurable, al-Thaʿālibī in his earlier book on *kināyāt* does not deal with it in either of his two chapters on sex, but rather relegates expressions for "the disease which cannot be treated

77

except by disobeying God" to the chapter on physical defects and other unpleasant things, where the subject is squeezed in between sections on bores and on lepers.

40. This is the end of the poem (which rhymes). The stereotypical assumption that black men have large genitals is known if not common in Arabic literature.

41. I.e., which is threaded.

42. Such, for example, would appear to be the implication of the anti-lesbian poem quoted above, with its military metaphors.

43. Abu l-Qāsim Husayn ibn Muḥammad al-Rāghib al-Iṣfahānī, *Muḥāḍarāt al-udabā' wa-muḥāwarāt al-shuʿarā' wal-bulaghā'*, 4 vols. in 2, Beirut, n. d.

44. Marriage, divorce, chastity, and cuckoldry are treated in a separate chapter, although elsewhere cuckoldry does appear as a *mujūn* topic.

45. The more common term elsewhere in the literature is *bidāl*.

46. Their author, al-Jammāz, was a companion of Abū Nuwās, and in fact notorious for his (behavioral as well as literary) *mujūn*.

47. Al-Rāghib offers one example of such a case, in which a man's attempt to "creep" on his host's slave girl is thwarted when he is stung by a scorpion; according to the host's subsequent verses on the incident, the scorpion thus effectively enforced the *ḥadd* sanction (against *zinā*). According to another anecdote, a man was reproached for spending a large sum to obtain the favors of another man's slave girl when he could have bought her outright for less, but replied, "You fool! Where then would be the sweet lust of *dabīb* and the pleasure of theft and of clandestine expectation? How can one compare the chilly tepidity of the permitted with the heat of the forbidden?" *Dabīb* here seems to lack its usual technical sense and mean something rather like "sneaking around;" but the sentiments expressed are an excellent illustration of the essential spirit of *mujūn* and its defiant exploitation of the gap between official morality and societal conceptions of manliness.

48. But not *too* ultimate, as neither participant is a normal adult male; the status of the "effeminate" (*mukhannath*) is discussed below.

49. References to love in general are rare in *mujūn* literature, but it should be understood that this is due simply to the nature of the genre. Although the Arabic literature on love, in both prose and poetry, cannot be dealt with here, it is extensive— far more extensive than the literature on *mujūn*.

50. Abū Saʿd Manṣūr ibn al-Husayn al-Ābī, *Nathr al-durr*, vol. I- vol. VI, pt. 1, various editors, Cairo, 1980–1989; vol. VII, ed. U. Būghānimī, Tunis, 1983. The author was wazir to the Buwayhid prince of Rayy (modern Tehran), and also wrote an important history, unfortunately lost.

51. Formed from the abstract noun *bighā'*; see note 36 above.

52. I have seen no references to *mukhannath*s wearing veils.

53. In Arabic, *Abū man?* Abū ("father of") followed by the name of one's first-born son was the standard form of address in polite society, so the questioner is merely asking the *mukhannath* his name.

54. *Umm* ("mother of"), also followed by the name of the first-born son, was the polite form of address to women.

55. Al-Ābī cites one *mukhannath* as claiming that there is a reason for everything a man possesses, except his beard and his testicles.

56. Cf. note 8 above.

57. ʿAbbāda is a feminine name, as are the names of virtually all the *mukhannath*s we hear of from the ninth century on.

58. One of al-Ābī's anecdotes has a *mukhannath* functioning as a marriage broker.

Before the ninth century, when the *mukhannath*'s societal role was quite different in Arab society, this seems to have been one of their primary functions. Such a role depended on being allowed access to respectable women, unlike other men, and the *mukhannaths* in later periods may have continued to enjoy this privilege. For the early period, see my article "The Effeminates of Early Medina," forthcoming in the *Journal of the American Oriental Society*.

59. On this, see the preliminary investigation by S. Moreh, "Live Theatre in Medieval Islam," in *Studies in Islamic History and Civilization in Honour of Professor D. Ayalon*, ed. M. Sharon (Leiden, 1986), 565–611.

60. According to one poignant anecdote, the caliph Hārūn al-Rashīd was inconsolable after losing a son, until he was approached by a *mukhannath*, who said, "O Commander of the Faithful, I am a man who imitates women, as you see; what would you do, then, if your son were alive and looked like me?" Hearing this, Hārūn finally dismissed the attendant wailing women (Abū Hayyān al-Tawḥīdī, *al-Imtāʿ wal-muʾānasa*, ed. A. Amīn and A. al-Zayn [Beirut, n.d.], II, 130).

The institution of the *mukhannath* still survives in Oman (and probably elsewhere); see Unni Wikan, "Man Becomes Woman: Transsexualism in Oman As a Key to Gender Roles," *Man* 12 (1977), 304–19, and the subsequent discussions in *Man* 13 (1978), 133f., 322f., 473–75, 663–71. With full allowance for historical change, the depiction of the *mukhannath* in the medieval sources nevertheless calls into question some of Wikan's formulations and interpretations concerning the contemporary Omani *khanīth* (in her transliteration, *xanith*), particularly her assertion (p. 310) that "the essence of Omani *xanīth* behaviour [is] homosexual relations." For further discussion of Wikan's work, see the essays by Judith Shapiro and Marjorie Garber in this volume.

61. See, for example, the second and third volumes of M. Foucault's *History of Sexuality, The Use of Pleasure* (New York, 1985) and *The Care of the Self* (New York, 1986); David M. Halperin, *One Hundred Years of Homosexuality* (New York and London, 1990).

62. See Foucault, *The Care of the Self*, 187–232; Halperin, 134ff.

63. Plato, *Protagoras* 309a, *Symposium* 181d. For Greek poems on beards, see *The Greek Anthology*, book XII, *passim*.

64. One important, and largely missing, piece of this puzzle is the society of pre-Islamic Iran, for which our sources are frustratingly meager.

65. See, for example, the references to "masculine" lesbians in chapter 1 of Shaykh Nafzawi, *The Glory of the Perfumed Garden* (London, 1978), which dates from the fifteenth century at the earliest. Arabic "sex books" like this one are a potentially valuable resource. Unfortunately, the few English translations of such works available to date cannot be relied on for serious scholarship, due to both imprecise translation and insufficient control of the Arabic text tradition.

4

Fetishizing Gender: Constructing the Hermaphrodite in Renaissance Europe

Ann Rosalind Jones and Peter Stallybrass

The hermaphrodite has been central to much recent historical and theoretical debate in Renaissance studies and there is now substantial scholarship on the figure in a number of fields.[1] There have been two dominant trends in the analysis of this figure. In the first, the hermaphrodite is read as the problem which a binary logic attempts to erase. In this reading, androgyny is the necessary irritant in the production and stabilization of a systematic division of gender. In the second, the hermaphrodite is understood as the vanishing point of all binary logics, a figure which embodies the dissolution of male and female as absolute categories. But in both kinds of analysis, there is frequently a slide into the assumption that gender is a *known* quantity which is then, at a second stage, destabilized. We want to show, on the contrary, the varied and contradictory work in the *production* of gender in Renaissance Europe.[2]

In Genesis, the whole world is considered as gendered ("male and female created he them"), and yet in the Renaissance there was no privileged discourse (as biology was to become in the nineteenth century) that could even *claim* to establish a definitive method by which one distinguished male from female. Take, for example, the anonymous *Physiologus,* one of the most popular books of the early Renaissance. Most editions have a passage on the "Pirobili rocks" which are, we are told, "of masculine and feminine gender." "As long as they are

separate from one another, they do not burn, but, if the male ap-
proaches the female, fire breaks forth and consumes all." On the other
hand, the hyena is said to be "an *arenotelicon,* that is, an alternating
male-female. At one time it becomes a male, at another a female." In
Physiologus, there is both a compulsion to differentiate by gender and
a sense of the collapse of any such differentiation. But perhaps what is
most striking of all is the extent to which gender is never *grounded:*
there is no master discourse which is called upon to fix the essence of
gender.

This is not to suggest that the Renaissance was without medical and
biological theories but that those theories were themselves composite,
contradictory and unstable. Take, for instance, the Galenic tradition,
which rivaled the Aristotelian throughout Europe until the seventeenth
century. With our modern categories of sexual difference (with what-
ever skepticism and hostility we treat them), it is difficult to compre-
hend the Galenic view, in which the only genital distinction between
men and women is one of *heat*—the heat which causes the female
vagina to 'pop out' into the morphologically identical male penis (see
Laqueur, 1986). We even have to reconsider menstruation in a world
where it was believed that men as well as women should have their
periods—hence, the medical significance of purgation or letting blood
through incision, cupping, or leeching. In Galenic, if not Aristotelian
theory, there was no stable *biological* divide between male and female.
At the same time, every child's birth might be considered hermaphro-
ditic, since the pseudo-Galenic *De Spermate,* which was a formative
text from the twelfth until at least the sixteenth century, argued that
men and women alike produced seed and that the child was the product
of a conflict between the seeds. The *Anatomia Magistri Nicolai Physici*
follows *De Spermate* in arguing that " 'the womb is divided into seven
cells, three on the right, three on the left, and the seventh in the middle.'
The author notes the opinion according to which males are begotten
in the right-hand cells and females in the left-hand, while the central
cell is reserved for hermaphrodites (Jacquart and Thomasset, 34). The
seven-celled uterus came under increasing challenge in the sixteenth
century, and was explicitly rejected in the 1545 *Birth of Mankind,* yet
Nicholas Culpeper and Jane Sharp in the mid-seventeenth century
claimed that many midwives still believed in it (Eccles, 27). The prob-

lem posed by the hermaphrodite could never anyway be limited to the central cell or one cell in seven, because, as *De Spermate* shows, every meeting of male and female seed is precarious:

> If the seed fall into the right-hand part of the womb, the child is a male. . . . However, if a weak virile seed there combines with a stronger female seed, the child, although male, will be fragile in body and mind. It may even happen that from the combination of a weak male seed and a strong female seed there is born a child having both sexes. If the seed falls into the left-hand part of the womb, what is formed is female . . . and if the male seed prevails, the girl child created will be virile and strong, sometimes hairy. It may also happen in this case that as a result of the weakness of the female seed there is born a child provided with both sexes. (Jacquart and Thomasset, 141)

Hermaphroditism, then, is not only a problem of the central cell, but of the act of conception itself.

The contradictory ways in which the hermaphrodite was discursively situated is revealingly demonstrated in Paré's *Workes*. Treating hermaphrodites and those who change sex at greatest length in his book *Of Monsters and Prodigies,* he would seem to be expelling them from the human domain. But even here, hermaphrodites and those who change sex are accounted for by perfectly "natural" processes. Indeed, he describes hermaphrodites not in terms of deficiency but in terms of plenitude: they

> draw the cause of their generation and conformation from the plenty and abundance of seed, and are called so because they are of both sexes, the woman yeelding as much seed as the man. For hereupon it commeth to passe that the forming faculty (which alwaies endeavours to produce something like it selfe) doth labour the matters almost with equall force, and is the cause that one body is of both sexes. (Paré, 973)

What is strange to a modern reader is the way in which Paré intertwines medical and magical genealogies of "monsters" of all sorts. On the one hand, monsters are caused by "defect of seed" (chapter 6), by "the straitnesse of the womb" (chapter 8), by various natural or hereditary causes (chapters 9 to 11), even by "the Cozenages and crafty Trickes of Beggars" (chapter 18); on the other hand, they are caused by the "imagination of their parents" (chapter 7), by "the craft and subtlety

of the Devill" (chapter 13), by "Sucubi and Incubi" (chapter 16), by "Magicke and supernaturall diseases" (chapter 17). This juxtaposition of explanatory systems is most striking in the conclusion to Paré's fourth chapter, "Of Hermaphrodites or Scrats," which is immediately followed by an illustration inserted by the publisher of "the effigie of an Hermaphrodite" (974). While the text insists upon medical explanations, the caption to the "effigie" reads the hermaphrodite as a supernatural emblem of a political treaty: "the same day the Venetians and Genoeses entered into league, there was a monster born in Italy having foure armes and feet, and but one head" (974).

The hermaphrodite, though, does not only appear in Paré's "supplementary" (if immensely popular) book on monsters (the twenty-fifth book of the English version of the *Workes*), but also in *An Introduction or Compendious Way to Chyrurgerie,* placed as the first book, the gateway to his corpus. Here, the hermaphrodite is considered in a chapter "Of the Adjuncts of things Naturall" which begins with the following extraordinary statement:

> Sexe is no other thing than the distinction of Male and Female, in which this is most observable, that for the parts of the body, and the site of these parts, there is little difference betweene them (27)

What is "observable" about the distinction of male from female is thus that there is little to observe. Hermaphrodites and eunuchs are considered, then, as troubling a distinction which can scarcely be established medically in the first place:

> The Nature of Eunuches is to be referred to that of weomen, as who may seeme to have degenerated into a womanish nature, by deficiency of heate; their smooth body and soft and shirle [sic] voyce doe very much assimulate weomen. Notwithstanding you must consider that ther be some Manly weomen, which their manly voyce and chinne covered with a little hairinesse doe argue; and on the contrary, there are some womanizing, or womanish men, which therefore we terme dainty and effeminate. (27)

Thus, for Paré, as for Galen, the supplementary figure of the hermaphrodite comes to stand for the lability of the whole gendering process. If he/she "in the middle of both sexes seemes to participate of both

Male and Female" (28), "male" and "female" themselves seem to partake of each other, and so to be hermaphrodite categories.

If the hermaphrodite could not secure by antithesis stable gender norms, the ability of women to transform themselves into men threatened to erase any principle of differentiation. If only heat, and not physical structure, differentiated men from women, the difference might at any moment be abolished. Paré writes:

> Certainely women have so many and like parts lying in their wombe, as men have hanging forth; onely a strong and lively heat seemes to be wanting, which may drive forth that which lyes hid within. (975)

Consequently, women are constantly threatening to become men, "especially if that to that strength of the growing heat some vehement concussion or jactation of the body be joined" (975). But followers of Galen and Aristotle alike denied that men could become women, appealing not to medical observation but to the laws of nature:

> it is not fabulous that some women have been changed into men: but you shall finde in no history men that have degenerated into women; for nature alwaies intends and goes from the imperfect to the more perfect, but not basely from the more perfect to the imperfect. (Paré, 975)

Women can become men; men cannot become women. It is curious, then, that Paré talks about women *degenerating* into men, since such a transformation is, according to his logic, a move towards greater perfection.

This contradiction is emended by George Sandys in an extended gloss to his 1632 translation of Ovid's *Metamorphoses*. Sandys is commenting on the ninth book in which, Iphis, a girl brought up as a boy, is espoused to another girl, Ianthe. The night before her wedding, Iphis goes with her mother to the shrine of Isis, "from whence *Iphis* by the favour of the Goddesse returns a boy, and marries his beloved *Ianthe*." Sandys notes that there is no difficulty in believing this account "if we give any credit to Authors either ancient or moderne" (449). After giving classical examples from Pliny and Licinius Mutianus, he continues:

Pontanus, who lived in the last Century, makes mention of a Fishermans wife of *Caieta* who sodenly became a man, after she had been fourteen yeares married. . . . *Montaigne* reports that he saw by *Vitry* in *France* a man, whom the Bishop of *Soysons* had then in Confirmation, called *German* (knowne from her childhood to have bin a woman, until the age of two and twenty, by all the inhabitants there about, and then named *Mary*) well strucken in yeares, and having a long beard who said that on a time by straining to overleap an other, he sodenly felt those parts to descend. And how at this day the Maidens of that Towne and Country have a merry song, wherein they admonish one an other not to leap too much for feare of the fortune of *Mary German.* But it is with out example that a man at any time became a woman. From whence we may derive this morall, that as it is preposterous in Nature, which ever aimes at perfection, when men degenerate into effeminacy; so contrarily commendable, when women aspire to manly wisdome and fortitude. (450)

The story of Mary German is also told in Paré's chapter "Of the Changing of Sexe" in *Of Monsters and Prodigies,* but Sandys follows through Paré's thinking to its logical conclusion: women, far from degenerating into men, should *want* to become men and should "aspire to manly wisdome and fortitude."

We should perhaps note the extent to which such a potential collapse of everyone into a single male sex had already been partially authorized both by classical myth and by the Church. The myth of Hermaphroditus is itself an example of the absorption of the Other into the Same. For if Hermaphroditus's name suggests the intertwining of male and female, the name is that of a boy who, even as he intertwines with Salmacis, erases her name: henceforth, the name is transformed from the conjunction of two genders to the absorption of the woman's name into the man's, paradoxically at the very moment of the submission of the man to the woman. Similarly, various Christian traditions allowed for the activity of women to the extent that women could be reclassified as making the passage to "manly wisdome and fortitude." In *The Gospel of Thomas,* Jesus says that he will make Mary Magdalene male "so that she also may become a living spirit like you males. For every woman who has become male will enter into the kingdom of heaven" (Anson, 8). Similarly, Clement of Alexandria, commenting on the beliefs of the Valentinians, noted that "the woman is said to be changed into a man" (Anson, 9). If such views were often expressed by heretical

sects, they were also endorsed by St. Jerome who wrote: "As long as woman is for birth and children, she is different from man as body is from soul. But if she wishes to serve Christ more than the world, then she will cease to be a woman and will be called a man" (Clover, 47). The effect, though, of Jerome's reclassification of the daughter of God is to question the very category of masculinity. On the one hand, woman differs from man as body from soul; on the other, the souls of godly females become male, and in the process deny that the body is the site of any given gender differentiation.

At the same time, the male state, supposedly secured by the laws of Nature's hierarchy, was constantly revealed as teetering performance. As Peter Brown writes:

> lack of heat from childhood on could cause the male body to collapse back into a state of primary undifferentiation. No normal man might actually become a woman; but each man trembled forever on the brink of becoming "womanish." His flickering heat was an uncertain force. If it was to remain effective, its momentum had to be consciously maintained. It was never enough to be male: a man had to strive to remain "virile." He had to learn to exclude from his character and from the poise and temper of his body all telltale traces of "softness" that might betray, in him, the half-formed state of a woman. (Brown, 11)

For all the assertions of Paré and Sandys that nature tended towards perfection and that thus the male could never "degenerate" into the female, they both told stories which seemed to contradict such a view. Paré, as we noted above, wrote that eunuchs "may seeme to have degenerated into a womanish nature, by deficiency of heate" (27).

And in the mythological realm of Ovid's *Metamorphoses*, Sandys was confronted by the tale of Tiresias:

> For, two ingendring Serpents once he found,
> And with a stroke their slimy twists unbound;
> Who straight a Woman of a Man became.
> <div align="right">(Sandys, 88)</div>

What is striking is the extent to which Sandys felt impelled to ward off the implications of Tiresias' tale. In his commentary upon it, he writes:

86

Women, if we give credit to histories either ancient or moderne, (whereof wee shall treat in the transformation of *Iphis*) have often been changed into men; but never man into woman. We therefore must fly into allegory. (Sandys, 103)

That "flight" seems both an attempt at transcendence and an evasive fleeing, but the allegory strangely foregrounds the problem of gender hierarchy which it is supposed to erase. The story of Tiresias, Sandys argues, alludes to "the alternate seasons of the yeare":

the spring [is] called Masculine, because the growth of things are then inclosed in the solid bud; . . . he is turned into a Woman; that is, into the flourishing Summer, defigured by his name: which season is said to be Feminine, for that then the trees doe display their leaves, and produce their conceptions. . . . Winter, which deprives the Earth of her beauty, shuts up her wombe, and in that barren in it selfe is said to be Masculine. (Sandys, 103)

Such a gendering of the seasons in this context has a surprisingly subversive effect. Sandys flies to allegory to restore the hierarchy of male over female. But the allegory itself suggests the reverse: of the "male" seasons, spring is enclosed in the bud and winter is an enclosed and sterile womb ("barren in it selfe") while the "flourishing Summer" is female and unenclosed, a season of display and the production of "conceptions." Not only does this suggest an inversion in the political hierarchy of space, the female denoting public display while the male is *couvert(e)*, but also the female here represents summer, the season of a heat which, for Galen and Paré, is the very mark which distinguishes male from female.

It was, no doubt, the very precariousness of gender hierarchy which suggested to some physicians the need to maintain differentiation by force. To this end, John Pechey recommends "all means," all of them violent, so that women who are "robust and of a manly Constitution" will be "reduced to a womanly state": "that they may become fit for generation, they must forbear strong Meats and Labour, and the Courses must be forced, and by Bleeding and Purging and the like, the habit of the Body must be rendered cold and moist" (Eccles, 27). Even the terms—man, woman, virile, womanish—give the impression of universal categories, mediating between now and then. We need to

undo any such impression, to remember that to be womanly was to be cold and yet more subject to the "heated" passions of anger and lust. Conversely, as Paré noted, the position of the male genitals was designed to keep men relatively chaster than women. It was men with *undescended* testicles who were "most excessive prone to lechery"; men with testicles *inside* their body were like male birds—notoriously lustful (Eccles, 26).

Medical discourses in medieval and Renaissance Europe chart a landscape which is radically other than ours. Where medical discourse from the eighteenth century increasingly emphasized a supposedly *manifest* difference between male and female, Galenic medicine might be said to have asserted hermaphroditism as the norm. Not only was conception a mingling of male and female seed, but also the maintenance of gender differentiation required the most minute and vigilant attention so as to preserve the heat of the male and the coldness of the female. Gender was manifestly a *production*. But we need to beware of giving too much attention to biological discourse in the production of Renaissance genders. By beginning with such discourse, we have ourselves repeated the priorities of post-Enlightenment thinking, in which it is "obvious" that to determine gender is to appeal to biology. In the Renaissance, though, we would argue, medical discourses were muted and secondary. For all the prestige of Aristotle and Galen, biology and medicine could claim no theoretical priority or consistency in defining and producing gender. And as we move away from Aristotle and Galen, whose influence was dominant throughout Europe, we can begin to see how differential and local was the production of gender from state to state, class to class, ethnic group to ethnic group.

One of the machines which determined gender differentially was the legal apparatus. Stephen Greenblatt's important essay, "Fiction and Friction," begins with what Greenblatt calls "an odd experience": in 1601, Marie, a woman who had been sharing her bed with a 32-year-old widow, Jeane, publicly announced that she was in fact a man, changed her name to Marin, and declared his intention to marry Jeane. Marin was arrested, sentenced to be burned alive, a punishment which was reduced to death by strangling, and only after a doctor, Jacques Duval, had disagreed with the examinations earlier performed by his colleagues by arguing that Marin had a small penis concealed within him/her was she released on the condition that she wore women's

clothes until the age of 25 (Greenblatt, 30–32). (For a much fuller account of the case and of the medical arguments between Duval and Jean Riolan, see Daston and Park [1985]). Marin/Marie was defined as a *tribade* and her offence was said to be sodomy (it was for that that 'she' was sentenced to death). The term "sodomy" was thus applicable to women as well as men within French law. 'She' was also accused of cross-dressing, a further legal offence in France. Thus French law had, on the one hand, an extended definition of sodomy which was applicable across genders and, on the other, sumptuary laws which rigidly differentiated male from female.

Neither of these legal definitions applied in England. Whatever moralists said about transvestism, in England only class transvestism was an offence; there were no laws against men dressing as women or women dressing as men. This may help to explain the fact that, as Stephen Orgel has argued, the English theater was the *only* European theater to practice systematic transvestism, and thus to disregard the prohibition of Deuteronomy (Orgel, 1988 and 1989). At the same time, sodomy was not a charge levelled against women in the law courts. The nearest analogy to the case of Marin and Jeane that we have found in England is from over a century later, by which time, of course, definitions of gender and of sexuality had undergone profound transmutations. Nevertheless, the comparison is illuminating in suggesting that the distinction of cultural formations is as important as the distinction of temporalities. In 1746, Mary Hamilton, under the name of "Dr. Charles Hamilton," married Mary Price. After three months of marriage, apparently including sexual relations as in the French case, Price declared that Hamilton was a woman. What is striking is that, although Mary Hamilton was arrested and prosecuted, she could not be easily defined within any English legal categories. Although Henry Fielding wrote a pamphlet denouncing Hamilton as *The Female Husband,* and the courts declared that she was an "uncommon notorious cheat," it was hard to find any legal offence that she had committed. When she was convicted, it was under the vagrancy act, and she was sentenced "to public whippings in four Somerset towns and six months in Bridewell" (Castle, 604). Whatever the brutality of the whippings, the punishment does not begin to compare with the original sentence of Marin. And perhaps what is most striking about Mary Hamilton's case is that, unlike Marin, she was not accused of

tribadism or of sodomy or of cross-dressing. While Hamilton was brought to court for a sexual offence, the court's sentence suggested nothing about her gender or her sexuality. She was simply and literally out of place, a vagrant. The contrast of these two cases suggests both the uncertainty and the specificity of legal definitions about the relation between male and female. In the categorization of female sexuality, the radical discontinuities between different legal traditions produced radically different interpretations of what gender was and meant.

In France, there was certainly an increasing tendency to absorb the hermaphrodite into the figure of the deviant woman, a conflation which was made more plausible by the medical rediscovery of the clitoris in the mid-sixteenth century. Henceforth, in France, at least, the hermaphrodite could be categorized as a woman with an enlarged clitoris, and was thus prosecutable for committing sodomy with other women (Park, 1990). Nevertheless, at least some of the summaries of legal cases in France during the seventeenth century suggest that the status of the hermaphrodite as a public figure was not entirely erased by new, more rigid distinctions between male and female. Pierre Brillon, for example, in his *Dictionnaire des Arrets,* an abstract of decisions made in French courts and parliaments throughout the first half of the seventeenth century, wrote that the civil status of hermaphrodites had been defined rather liberally. They were allowed to serve as witnesses, unlike persons of dubious reputation; and they were allowed to marry, in the role to which the predominant features of their physiology assigned them ("suivant le sexe qui domine en leur personne," 3: 604). The decision about sexual identity was usually left up to the hermaphrodite; the only punishable offence was departing from that chosen status. Brillon mentions a case, in Paris in 1603, in which a young hermaphrodite was hanged and burned because he had officially assumed the role of a man but then allowed his body "to be used as a woman's"; the man/woman's sexual mobility was the issue, not his initial right to decide on his sex or the legality of his reasons for doing so. Hermaphrodites were also assigned the right to leave bequests and to inherit them: they were assumed to have a stable place in the property rules governed by marriage.

Eunuchs, however, were a different case—the negative or privative other against which hermaphrodites were seen as fully procreative. Eunuchs may overlap with hermaphrodites because their incapacity to

"engender" can arise from a congenital bodily deformation as well as an imposed one—castration (Brillon, 3: 194). No biological-psychic essence is implied in this acknowledgement that eunuchs can be made as well as born. But because they cannot reproduce themselves, they are forbidden to marry. This law affirmed marriage as an institution for procreation, but even so, it was aimed at a category in which biological and socially imposed sterility were understood as parallel in their effects. As Brillon's discussion of eunuchs continues, it becomes clear that church laws relating to them were not absolutely fixed; although they were now excluded from holding any benefices, this had not always been the case. Brillon offers a long and poignant version of the Heloise and Abelard story to show that Abelard was called before church courts not because of his castration but because of beliefs his interrogators suspected of being heretical. Certainly Brillon's history of Roman and medieval ecclesiastical practices relativizes contemporary laws according to which church and civil marriage exiled eunuchs from social communities.

Hermaphrodites, however, were unvaryingly excluded from church benefices, because they were assumed to be sexually fully potent. Brillon cites a case in which a priest had accused a canon of being a hermaphrodite: when two surgeons and two doctors declared the canon unambiguously a man, the priest was fined three hundred livres and forced to sue for pardon in public, at the entry to the church as the entire chapter of monks looked on, and kneeling on the floor of the church in front of the canon (3: 604). The concern of the church, evidently, was that sexual instability in convent or monastery could damage the reputation of the entire enclosed community, and this threat to group identity rather than sexual disorder between two lovers seems to have been the main justification for excluding problematic bodies. The double penalty assigned to the priest, a one-to-one and then a group retraction, suggests that the social effect of his accusation—the defaming of the whole brotherhood at Toulouse—was what motivated the ecclesiastical decision.

Ideas about the relation between the natural and social orders interact in interestingly parallel ways in another Renaissance discourse: fantastic-satiric travellers' tales. Two quite different texts in the tradition of Lucian's *True History* explore what a society based on sexual doubleness would mean, and in both cases, the satirist's official disap-

Body Guards

proval of the culture he represents is dissipated by the possibilities of
invention and proliferation that a hermaphroditic culture presents to
his imagination. Thomas Artus wrote his *Description de l'Isle des
Hermaphrodites* during the 1560s as an attack on the French court of
Henri III, and Joseph Hall wrote his *Mundus alter et idem,* translated
into English as *The Discovery of a New World* by John Healey in
1609, to attack what he saw as the social follies of contemporary
England. Both texts denaturalize sexual doubleness by framing it as
the result of a specific cultural structure. Artus's book ferociously
satirizes what he and other Protestants saw as the depravity of Henri's
court, in which male favorites, the famous "mignons du roi," led a
life of extravagance, depravity and political corruption. But Artus's
voyager-narrator never sees the private parts of any hermaphrodite;
rather, he observes their social rituals in faux-naif astonishment. In
practice, these courtiers are bisexuals, permitted by local custom to
make love to men and women both, in churches or any other convenient
place; they are driven by mutual rivalry rather than any bodily precon-
dition to dress in the splendid fabrics and fast-changing styles that
Artus characterizes as "female fashion" (59). The mock-serious list of
the hermaphrodites' laws and decrees, reversing all the responsibilities
of good government, positions them as social rather than natural
creatures. In Artus's dystopian conceptual scheme, sexual renegades
are produced by a corrupt culture, not by a nature given by physiology.
Whatever the intended effect of the satire, moreover, the double sexual-
ity of the isle's inhabitants guarantees them diverse pleasures. As the
frontispiece engraving suggests, with its motto claiming that "double
delight" is more valuable than any clarity about the sex of the figure
coiffed as a woman, wearing an ambiguous doublet, and dressed in
men's breeches and shoes (fig. 1), Artus's polemical reversal of laws
of sexual difference in fact produces a sense of proliferating possibilities
as much or more than horror at such transgression of orderly heterosex-
uality.

Hall's satire, too, slips away from the straightforward criticism of
willful women with which it begins. His "Double-sex Ile, otherwise
called Skrat or Hermaphrodite Iland," is set offshore from "Shee-
land," a country where women dominate men sexually and politically.
But the absurdity Hall attributes to reversed male/female power hierar-
chies on the mainland is represented as a kind of witty corporeal

92

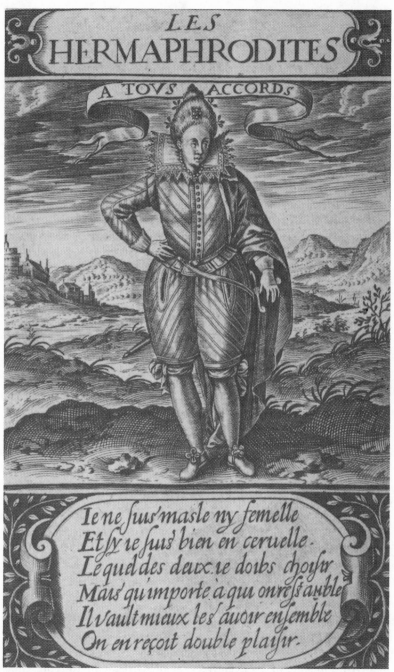

Fig. 1: Picture of a frontispiece engraving, Thomas Artus. Reprinted with permission from The Folger Shakespeare Library.

ingenuity among the Hermaphrodites. They argue that they are born with a double capacity: nature makes them perfect by giving them two sexes, just as she gives people two eyes, two noses, two legs; they are not grotesque but more perfectly symmetrical than other human beings (72). And here, as in Brillon's civil law, the hermaphrodite is held preferable to the eunuch. Hall's speakers point out that they are formed through nature's perfect design rather than through human intervention, that is, the vile practices of castration used among the Greeks and Romans. Hall dismisses this invocation of nature's beneficence on both counts as an example of the "man's wit and woman's craft" combined in each hermaphrodite. But the comical logic of their position has a momentum of its own, by which acts later termed "unnatural" are celebrated as feats of nature at her most evolved. These satirists, whatever official goal they have of affirming pious and properly masculine social orders by mocking their opposites, become intrigued by the multiple possibilities their imagined counter-orders generate. To posit and elaborate a society in which everyone is bisexual turns out not to mean condemning innate monstrosity but exploring the potentials of a fascinatingly *hyper*natural cultural system.

Medical and legal perspectives are juxtaposed with anecdotes from ancient history and recent law cases in a typically unstable mix in George Sandys' commentary on Ovid. The poet narrates that Salmacis pursued the resisting Hermaphroditus into her pool; the gods answer her prayer by combining the two bodies into one, leaving the combined figure to make a last request: that any man swimming in the pool will likewise lose his masculine identity, will leave it "a half man" (4, 289 ff.).

Sandys' commentary is less a synthesis than a grab-bag of allegorical interpretation and hermaphroditic lore. He opens with a moralizing comment on the tale: "Sensuall love is the deformed issue of sloth and delicacy; and seldome survives his inglorious parents" (206). Then, by way of sources for the tale, he refers to Plato's androgyne, which he reads as "an obscure notion . . . of *Eva's* being taken out of the side of Adam." This linking is an interesting feat of syncretic reading, but what follows eludes coherence entirely. Sandys summarizes past and present judgments of hermaphrodites, classical, legal and contemporary-ethnographic, in a blur of detail that produces an effect of cultural relativism, in spite of his negative view of what the myth represents:

94

Aristotle writes that they have the right brest of a man; and the left of a woman, wherewith they nourish their children. They were to choose what sex they would use, and punished with death if they changed at any time. One not long since burnt for the same at Burges: who elected the female, and secretly exercised the male; under the disguise committing many villanies. *Caliphanes* reports, how among the *Nasamones* there were a whole nation of these; who used both with like liberty. There are many at this day in Aegypt, but most frequent in *Florida;* who are so hated by the rest of the *Indians,* that they use them as beasts to carry their burthens; to suck their wounds and attend to the diseased. But at *Rome,* they threw them as soone as borne into the river; the Virgins singing in procession, and offering sacrifice unto Juno. (Sandys, 209)

He complicates his data further by quoting the historian Strabo, who declares that the fountain of Ovid's myth really exists but that bisexuality was understood by natives of the region as a moral rather than a physical status:

"In *Caria* is the fountaine of *Salmacis,* I knowe not how infamous for making the drinker effeminate: since luxury neither proceeds from the quality of the ayre nor water, but rather from riches and intemperance." The Carians therefore addicted to sloath and filthy delights were called *Hermaphrodites;* not in that [they were] of both sexes but for defiling themselves with either. (Sandys, 209)

Hermaphroditism, by this account, is not a bodily surplus ascertainable from within but a surplus of lecherous *behavior* evident to the public eye.

Sandys concludes with another instance in which context rather than inner essence determines sexual status. He suggests that Mercury, the father of Hermaphroditus, is himself an ambiguous or intermediate figure, according to the linked discourses of medicine and astrology:

Hermaphroditus is feigned to be the sonne of *Mercury;* because wheras the other are called either masculine or foeminine, or their more or lesse vigour, heat, drouth, or humidity; the Planet of *Mercury* participat[e]s of both natures; hot and dry, by reason by his vicinity to the Sunne, never above 20 Degrees; cold and moist, by the neighborhood of the Moone and the Earth; conforming himself also to the auspicious or

95

malevolent aspects of those Planets with whom he joyneth his influence.
(210)

Sandy's encyclopedic commentary on Ovid is a particularly revealing
example of the way in which interpretations of the hermaphrodite
proliferated, changed, slipped from one discourse to another and slid
away from any fixed view. One reason for this diversity of meanings
and judgments, in spite of moralists' attempts to take a firm line on
the "half man," is that the myth itself foregrounds the instability of
Renaissance gender theories and practices. The very name Her-
mAphroditus insists on the activity of the mother as physical genetrix
of the boy, even as it effaces the mother's gender (Aphroditus, not
Aphrodite). Rather than confirming Aristotle's notion of man as the
source of generation and woman as mere receptacle, the predominance
of Aphrodite in the boy's name corresponds to the Galenic notion
whereby female seed meets male seed in the womb.

At the same time, because Hermaphroditus is young, fifteen at the
most, he stands in between boy and man, and is turned by the nymph
into the object of desire, while she herself becomes the desiring subject.
Indeed, the boy's beauty suggests that his mother's legacy overwhelms
what he has inherited from Hermes as god of eloquence. Because he is
silent and blushing, Salmacis must play the wooer's role: it is she who
is "hot" and verbally seductive. His silence also drives her to contradict
conventionally gendered rules of lyric: it is she who praises, he who is
the silent recipient of praise. Francis Beaumont in his epyllion of 1602,
Salmacis and Hermaphroditus, expanded and further elaborated the
instabilities of object-choice and of subject-position implicit in Ovid.
Beaumont imagines Phoebus as the lover of Hermaphroditus and Sal-
macis alike and he inverts the hierarchy of the gods by transforming
Jove into a humble suitor to Astraea. Hermaphroditus is also the object
of Beaumont's (as of Ovid's) elaborate physical description; he writes
a male-authored blason (part by part physical description, usually
portraying a beloved woman) of a *male* figure, inverting conventions
of rhetoric and gaze. As beautiful boy, Hermaphroditus destabilizes
the behavior and the language of both sexes.

Yet a curious feature of the end of the myth disrupts what we might
call the symmetry of its confusion. The female nymph disappears in
the course of the metamorphosis; Salmacis is incorporated into the

effeminized boy, who remains alone, lamenting his deformation. His prayer to the gods to make other swimmers leave the pond "less than men" obliterates the nymph as active ingredient in the metamorphosis. She is present not as the female half of a hermaphrodite but as the drainer away of Hermaphroditus' masculinity; she defines him through negation. Thus Hermaphroditus' change is represented as a problem of male identity.

Ovid's closing focus on the hermaphrodite as problematic male is sustained in medieval and certain Renaissance readings of the myth and in their concepts of the effeminate man. In the fourteenth-century *Ovide moralisé*, for example, Hermaphroditus is read as the figure of a monk lured from his monastery by the glitter of worldly pleasures; on this reading, Salmacis is the temptress, a figure for female vanity and seductiveness, even, finally, the whore of the Apocalypse (IV, 2252–2298). The spiritual crisis "revealed" in the pagan tale is thus a masculine one. It is no doubt because Ovid's version of Hermaphroditus so elaborately plays with the androgynous and the promiscuous, both at the thematic and linguistic levels, that Christian commentators felt impelled to append moralizing glosses. Thomas Peend, who published *The pleasant fable of Hermaphroditus and Salmacis* in 1565, concluded:

> By *Caria*, signifye the worlde
> where all temptations be.
> Whereas the good and il[l], always
> together we may see.
> By *Salmacis*, intende eche vyce
> that moved one to ill. (Bv)

Unsurprisingly, Hermphroditus's death is glossed by: "[h]e drownes hym selfe in fylthy sinne" (Bv). Peend reinscribes the common Renaissance view that effeminacy depends not upon an absence of sexual 'virility' but the very obverse. It is 'heterosexuality' itself which is effeminating for men.

Arthur Golding, developing an analysis that Protestants in particular were to emphasize, traces the roots of sexual desire to idleness. In the preface to his 1567 translation of Ovid's *Metamorphoses*, he writes:

Hermaphrodite and Salmacis declare that idleness
Is cheefest nurce and cherisher of all voluptuousnesse,
And that voluptuous lyfe breedes sin: which linking all
 toogither
Make men too bee effeminate, unweeldy, weeke and lither.
 (Golding, a iii)

Sandys, similarly, assumes that the tale points to sloth as the source of masculine lust, and he quotes Ovid's *Remedia amoris* on the value of rational activity as a remasculinizing cure.

More favorable interpretations of the hermaphrodite, on the other hand, held onto some concept of the feminine as constitutive agent: the androgyne, a perfect balance of opposing principles, was read as an emblem of the union of husband and wife in an ideal marriage, as in "Matrimonii typus," an emblem in Barthélemy Aneau's collection *Picta Poesis* (Lyons, 1564, fig. 2. A certain ambiguity exists in this image, however, since a leering satyr on the right apparently echoes the horned Moses on the left). John Donne read the hermaphrodite as a figure for the minister, mediating between the male perfections of heaven and the female imperfections of earth ("To Mister Tilman after he had taken orders," *Divine Poems*, 331–2). And Lauren Silberman notes that the hermaphrodite could become a figure of Christ: in the fourteenth century, Bersuire moralized Ovid's tale as signifying the incarnation ("the nymph, that is, human nature, joined itself to him, and thus he clung to himself by the blessed incarnation, since from two substances one person emerged" (Silberman b, 648). Such "elevated" interpretations of the hermaphrodite made it possible for Renaissance monarchs to appropriate the figure to themselves. Thus, François I, who was frequently represented as Hercules, was also painted as an androgyne, the bearded monarch assuming women's clothes. The hermaphrodite monarch is allegorized as "a mystical cipher of divine perfection":

O France heureuse, honore donc la face
De ton grand roi qui surpasse Nature:
Car l'honorant tu sers en même place
Minerve, Mars, Diane, Amour, Mercure.
 (quoted in Wind, 213–14)

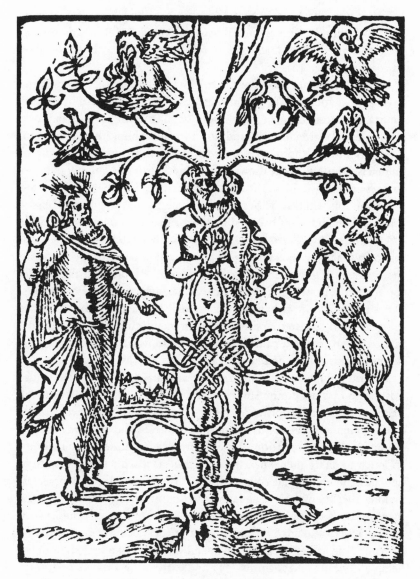

Fig. 2: Matrimonii Typus. Barthekemy Aneau, Picta Poesis. Reprinted with permission from The Folger Shakespeare Library.

Jonathan Goldberg notes that James I, in calling himself a "loving nourish-father," presents himself as simultaneously father and mother of his realm: "the king is *sui generis,* self-contained as a hermaphrodite, an ideal form" (142).

If Ovid's hermaphrodite was incorporated into Christian myth and royal propaganda, he/she was also theorized and elaborated by neoplatonists who posited the hermaphrodite as the meeting of human senses with celestial perfection. In addition to transvaluing the hermaphrodite, this interpretation of the myth required a different reading of Salmacis. Maurice Scève drew on Sperone Speroni's *Dialoghi d'amore* to present himself in the role of a hermaphrodite, evolving toward perfect union with his beloved in the highest stage of spiritual bliss— a bliss to which he has been led by the idealized woman (*Délie,* Lyons 1554, dizain 435). Lodovico Dolce specifically alerted his female readers to Salmacis as an exemplar of pure, natural beauty, in contrast to the cosmetic refinements of modern women. By praising the nymph for adorning herself only with clear water and a garland of flowers, Dolce rejects the view that women are to be blamed for "the lascivious thought" and "twisted desire" that turn men into beasts (*Le Trasformationi,* Venice 1553, canto 9, stanza 13). In its parts and as a whole, the myth was articulated in radically different ways.

But this Salmacian version of the hermaphrodite had few analogues outside literary neoplatonism. However labile the myth could be in the hands of poet-philosophers, in most social contexts the "hermaphrodite" woman was seen as a monster. Identified by the wearing of men's clothes and the usurpation of men's privileges, she was assumed not so much to share men's heat as to elicit it as a seductress, in spite of her masculine sartorial coding. In *Hic Mulier,* a 1620 pamphlet attacking the "he-women" at large in London, the writer accuses the mannish woman of wearing men's attire—a short-waisted doublet with open plackets—so as to be more available for quick illicit sex initiated by men ("the loose, lascivious civill embracement of a French doublet, being all unbutton'd to entice, . . . and extreme short waisted to give a most easie way to every luxurious action," A4v). What was seen as most abhorrent in such deformity was women's appropriation of men's public roles: Hic Mulier is accused of gadding about outdoors, visiting barber shops and tobacconists, displaying herself at the theater and throughout the city. Legendary mannish women such as Long Meg

of Westminster and Moll Frith (alias Moll Cutpurse, the heroine of Middleton and Dekker's *The Roaring Girl*) were also famous for public performances; fighting as soldiers and as swordsmen, they could expose male pretensions and interrogate the gendering of tools (Waage).

But both women are also said to be prostitutes and procuresses. The coexistence of mannish independence and sexual depravity in these legends may seem puzzling to a modern reader: given the self-sufficiency such women demonstrate, why should they need to make sexual commodities of themselves? The cultural fixation upon such cases results from the perception that these women are *out of place,* parading in the market and on the stage rather than contained within the walls of the private house. Their transgression of the rule of feminine domesticity is taken as a sign that they also transgress rules of chastity. Whatever the female hermaphrodite's sexual organs may be, her behavior takes her entire body outside the household, making it scandalously visible in the public sphere.

For women poets, the scandal was equally extreme: by entering a manuscript and print culture dominated by men, they were transgressing a gendered grammar of eloquence. Louise Labé wrote as Hermes when she praised her own reputation for abundant speech in her second elegy (*Euvres,* Lyons 1555), and such behavior elicited an accusation of double hermaphroditism. Linking Labé to an enemy Catholic churchman in Lyons, Jean Calvin wrote to Gabriel Saconay to denounce him for "bringing about metamorphoses," that is, for disporting himself at orgies with the "common whore" Louise Labé, who came to his house crossdressed as a man (Boy, 2: 101). Calvin's letter implicates poet and prelate alike in a series of sexual reversals: the man proves his effeminacy not only by indulging in such rites but because the woman comes from outside into his domestic space: she travels like a man as well as dressing like one. Anxiety about gender certainly underlies Calvin's image of the invasive female transvestite, but it also provides him with a useful strategy: to defame Saconay as rival theologian by emasculating him as a lover. Calvin's attack on Labé can also be read as a reaction to the popularity of her poems— texts in which she plays with the gender of love itself, sometimes invoked as the masculine Cupid, sometimes as the feminine "amour lesbienne" (Rigolot, DeJean). In his contest with Saconay, Labé is an unstable weapon—infamous, in Calvin's terms, for her desire for

publicity but worth invoking in the first place because she was, in fact, famous for her eloquence.

"Hermaphrodite" was used to insult another woman writer, again for boundary transgressions rather than anatomical doubleness, in England, in Edward Denny's attack on the Jacobean poet Mary Wroth. Denny believed that Wroth had satirized his violent treatment of his daughter in the figure of Seralius, a brutal father in Wroth's romance *Urania:* the woman writer had made the nobleman's domestic secrets public. Denny responded to this infringement of masculine and feminine spheres with a furious poem accusing Wroth of being "Hermaphrodite in show, in deed a monster." He translates Wroth's actions as a satirist into the traits of a hideous body, positioning the poet as a physical grotesque. Her "wrathful spirit," man-like, he writes, has fathered a book as ugly as its mother; her attentiveness to court life makes her into a "common oyster," that is, a taker-in of all kinds of news, in analogy to the promiscuous receptivity of a "common woman," or a whore; her exposure of his private life, her "slanderous flying fames," arise from drunkenness, particularly unbecoming in a woman; and by being an author of books, she parts company with "wise and worthyer [women] who have written none" (32). By representing the woman writer as a mannish offender of sexual norms, Denny attempts to displace attention from the actions for which she criticizes him. "Hermaphrodite" as epithet turns the public gaze away from his specific guilt onto a figure generally accepted as sexually monstrous. But this rhetorical subterfuge is exposed by Wroth in her response, composed as a close imitation of Denny's verse letter. In what might be called a hermaphroditic take-over of Denny's lines, she follows the man's form but rearranges each couplet internally, to rewrite his claim to privilege on account of his "noble blood" as proof of his lack of real nobility, and his "foolishness" rather than his sex as the reason he should keep his writing private. In her "Railing Rimes Returned," Wroth challenges hermaphroditism as a reinforcement of the silence of the proper woman by noisily cross-dressing the man's words, incorporating them into a counter-attack that strips Denny of his authority:

> Thus you have made yourself a lying wonder
> Fooles and their pastimes should not part asunder

Take this then now[:] lett railing rimes alone
For wise and worthier men have written none.
(Robertson, 35)

In another English exchange, a man similarly under attack attributes a
different kind of sexual abnormality to his female enemy: Ben Jonson's
"Epigram on the Court Pucell" links hermaphroditism to lesbianism
in order to discredit a female critic. In an earlier poem in praise of
Lucy, Countess of Bedford, Jonson frames a compliment in terms of
positive androgyny by writing that she possesses both "softest vertue"
and "a learned and manly soule" (*Epigrammes,* 76). But in his attack
on Cecelia Bulstrode, a member of the Countess' literary circle, he
manipulates the convention whereby the muse is imagined as female
to explain Bulstrode's criticism of him as the result of her masculine
sexuality, which he represents as driving her into a woman/woman
rape:

Do's the Court-Pucell then so censure me,
　And Thinkes I dare not her? let the world see . . .
What though with Tribade lust she force a Muse,
　And in an Epicoene fury can write newes
Equall with that, which for the best newes goes. . . .
(Jonson, 76)

Here, too, the man takes revenge for the woman's exposure of him by
rewriting her public text as private, improper sex act. But Jonson goes
further than Denny by presenting the woman's entry into public speech
as an unnatural and monstrous penetration into a space reserved for
men. By presenting the Muse as the victim of lesbian rape, he implies
that literature itself is a sexed terrain, a damsel in distress whose
innocence condemns any actual woman's claim to be heard, and he
suggests that any sex between women must involve violence. He also
renders the woman's writing ridiculous by insisting on her embodi-
ment: "pucell" means hymen as well as virgin, "tribade" (from a Greek
root meaning "to rub," a term for lesbian used only by Jonson in
this period, according to the *OED*) linked to "lust" suggests clumsy
intensity, and "Epicoene fury" suggests a muddle of motives rather
than the movement upwards of the traditional *furor poeticus.* In re-
venge for the way the woman's criticism has disturbed his public self-

representation, the man presents her as a grotesque trespasser on the masculine terrain of satiric writing.

Whatever the variability of the hermaphrodite as interpretable emblem, then, a consistent pattern emerges when a Renaissance man uses it to attack women as writers: his attack on female manliness (and in Calvin's case, on manly effeminacy as well) is intended to shore up his identity as a proper man. But such strategies often accomplish different goals from those intended. In *Haec Vir,* for example, the companion pamphlet to *Hic Mulier,* the mannish woman says that if men would stop being womanish, women would return immediately to their proper role. But rather than affirming sexual order, as most critics have argued, this conclusion still suggests that sexual identity is *relational,* not a fixed bodily condition but a response to contexts—which are always changing. Likewise, Calvin's attack on Saconay had meaning only because Labé had succeeded in becoming a public figure; his invocation of the "insignis" (infamous) Louise Labé takes its topical bite from an international consensus that this particular woman had risen above the limits laid on her sex. Wroth accurately pointed out that Denny's attack on her proved his guilt rather than hers; by signing himself "the father-in-law of Seralius," after the villain of her romance, he gave the parallel she intended further currency. Jonson sustained his attack on learned women in his play *Epicoene,* in which a gaggle of "hermaphroditicall Collegiates" are revealed as women eager not for education but for extravagant entertainment and multiple adultery. But the aggression in this comedy, as in his attack on the Court Pucell, his exposure of her to the same onlookers who have heard her attack on him, demonstrates that women were claiming the male prerogative of using language in public and that they were finding a hearing. Try as such writers would to ground "hermaphrodite" in a symbolic system that intermeshed women's bodies and their "natural" roles, their texts in fact demonstrate that the word was not enough to silence one sex to glorify the other.

But if gender could not itself be grounded, it was paradoxically itself one of the main grounds for the distribution of political and legal power: rights of inheritance (for instance, the Salic laws in France), forms of judicial punishment (petty treason if a wife killed her husband), the claim to a political voice—all followed upon the differentiation of male from female. But it would never have occurred to Sir

Edward Coke, the most famous lawyer of early modern England, to turn to medicine (unprestigious as it was and torn between contradictory Aristotelian and Galenic theories) for an answer to the legal problem posed by the hermaphrodite. He wrote: "an Hermaphrodite may purchase according to that sexe which prevaileth." But *which* sex 'prevailed' could only be determined by the persons themselves or by the judge and doctors who decided the case. For Coke, it was a legal imperative to distinguish by gender, but there were no given rules to follow in making such a distinction, since there was no privileged discourse through which to establish gender. As French cases show, debates were possible even within medicine, to which judges had recourse in cases of contested identity; time after time, appeals led to a redefinition of medical sex (Daston and Park 1989; Park 1990). Gender was thus central (and had, of course, a variety of real effects in, for example, the punishment of scolds and witches and of hermaphrodites who abandoned the unisexual status they had chosen) at the very same time as it was indeterminable.

The hermaphrodite recurs, then, as the site of fixation where there is an imperative to categorize without one single normative system by which such categorization can be made. This may help us to understand the extraordinary ambivalence shown toward the hermaphrodite in the Renaissance, since the figure conjured up either the threatened abolition of the categorical imperative or the playful promiscuity of categorization. The former sense led to a denunciation of the very principle of hybridization; the latter led to the assumption of hermaphroditism as norm.

The problem with most existing attempts to understand this ambivalence is that they assume *either* the fixity of a binary logic *or* its dissolution. Against both these views, we argue that the hermaphrodite in Renaissance discourses enables us to interrogate the eighteenth-century establishment of gender as a fetish which misrecognizes itself, masquerading as the "real." For if the Renaissance hermaphrodite suggests that categorical fixity is inevitably unstable (the tyrant turns into a woman, the serpent changes sexes, the actor is both boy and woman), he/she equally embodies the fact that there was no absolute categorical fixity to begin with. All attempts to fix gender are thus revealed as *prosthetic:* that is, they suggest the attempt to supply an imagined deficiency by the exchange of male clothes for female clothes

or of female clothes for male clothes; by displacement from male to female space or from female to male space; by the replacement of male with female tasks or of female with male tasks. But each elaboration of the prosthesis which will supply the "deficiency" can secure no gender essence. On the contrary, the Renaissance hermaphrodite exposes what, during the eighteenth and nineteenth century, will be covered over by the grounding claims of medicine and biology; he/she articulates gender as itself a fetish. But in the Renaissance it is a fetish which plays with its own fetishistic nature, producing sexual identity through changeable fixations upon specific "parts" (the mouth as much as the genitals, clothes as much as the body). The imagined "truth" of gender which a post-Renaissance culture would later construct depended upon the disavowal of the fetishism of gender, the disavowal of gender as fetish. In its place, it would put a phantasized biology of the "real."

Notes

1. We could not have done the work for this without the help of Gaby Spiegel, Jonathan Dollimore, Julia Epstein, Phyllis Rackin, Michael Cadden, Diane Fuss, Marjorie Garber, Greg Bredbeck, the Renaissance Discussion Group at the University of Pennsylvania, the Gender and Sexuality Seminar at Princeton University, and the English Department at the University of Utah. We are above all grateful to the work (and help) of Thomas Laqueur and Katharine Park.

2. We are particularly indebted to the work of Laqueur (1986 and 1990), Daston and Park (1985), Park and Daston (1989), and Park (1990). The work of Daston and Park and of Park raises a number of problems for the work of Laqueur and, by implication, for the work we are pursuing here. *Some* of these problems are attributable to the fact that Laqueur's work, like our own, is focused upon England, whereas Daston and Park are focusing upon France. In France, sexuality between women, if it involved penetration, was punishable as sodomy. Consequently, lives hung upon the decision of whether "hermaphrodites" who were prosecuted might be said to be "really" male or female. And, as Daston and Park show, hermaphroditism was increasingly seen in France as a boundary problem relating to women alone. In England, this was not the case: female sodomy was not recognized by the law, and consequently there was less emphasis in England upon establishing legal and medical definitions of the hermaphrodite. Further differences between the arguments of Daston and Park and our own analysis follow from the fact that their fine analysis works out from medical treatises, many in Latin, whereas ours depends upon vernacular writing which is neither strictly medical nor legal, although it may intersect with the conflicting discourses of both those institutional practices. But there are also deeper disagreements about both the meaning and the status of the "natural" in the Renaissance. We would want to argue that gender was *not*

primarily defined within medical discourse in the Renaissance and to emphasize the radical discontinuity between, for instance, Aristotle's analysis of gender in the *Generation of Animals* and in the *Politics*. In the latter, Aristotle distinguishes between "man," "woman," and "slave," and it is thus clear that he is thinking there of gender as a *political*, rather than a medical, category. On this latter point, see Spelman, 37–56. Unfortunately, the work of Park and Daston came to our attention too late for us fully to consider its implications, and we can only encourage the reader to read it.

Bibliography

Adelman, Janet " 'Born of Woman': Fantasies of Maternal Power in *Macbeth*," in ed. Marjorie Garber, *Cannibals, Witches, and Divorce: Estranging the Renaissance,* Baltimore: The Johns Hopkins University Press, 1987.

Ahl, Frederick "Ars Est Caelare Artem (Art in Puns and Anagrams Engraved)," in ed. Jonathan Culler, *On Puns: The Foundation of Letters,* Oxford: Blackwell, 1988, 17–43.

Anon *The Birth of Mankind* (London, 1545).

Anson, John "The Female Transvestite in Early Monasticism: The Origin and Development of a Motif," *Viator* 5 (1974), 1–32.

Artus, Thomas *Description de l'Isle des Hermaphrodites novellement découverte,* Paris: 1605, rpt. Cologne [Brussels]: H. Demen, 1724.

Augustine, *The Citie of God with the Learned Comments of Vives,* trans. J. H. (London, 1610).

Beaumont, Francis *Salmacis and Hermaphroditus* (1602), in ed. Nigel Alexander, *Elizabethan Narrative Verse,* Stratford-upon-Avon Library 3, London: Arnold, 1967, 168–191.

Berggren, Paula " 'A Prodigious Thing': The Jacobean Heroine in Male Disguise," *Philological Quarterly* 62, 3 (1983), 383–402.

Berry, Philippa *Chastity and Power: Elizabethan Literature and the Unmarried Queen,* London and New York: Routledge, 1989.

Bloch, R. Howard *Etymologies and Genealogies: A Literary Anthropology of the French Middle Ages,* Chicago: University of Chicago Press, 1983.

Bloch, R. Howard (1986). *The Scandal of the Fabliaux* (Chicago: University of Chicago Press, 1986).

Boswell, John *Christianity, Social Tolerance, and Homosexuality,* Chicago and London: University of Chicago Press, 1980.

Boy, Charles, ed. *Les Oeuvres de Louise Labé,* Paris: Lemerre, 1887, vol. 2

Bradbury, Gail "Irregular Sexuality in the Spanish 'Comedia,' " *Modern Languages Review* 76, 3 (1981), 566–80.

Bray (1982), Alan *Homosexuality in Renaissance England,* London: Gay Men's Press, 1982.

Bray (1990), Alan "Homosexuality and the Signs of Male Friendship in Elizabethan England," *History Workshop Journal* 29 (1990), 1–19.

Brillon, Pierre Jacques *Dictionnaire des arrets, ou Jurisprudence Universelle des Parlemens de France, et autres tribunaux,* Paris: Cavalier et al., 1727, vol. 2 ("Eunuque"), vol. 3 ("Hermaphrodite").

Brown, Peter *The Body and Society: Men, Women, and Sexual Renunciation in Early Christianity*, New York: Columbia University Press, 1988.

Brundage, James *Law, Sex and Christian Society,* Chicago: University of Chicago Press, 1987.

Bullough, Vern L. "Transvestites in the Middle Ages," *American Journal of Sociology* 79, 6 (1974), 1381–94.

Bush, Douglas *Mythology and the Renaissance Tradition in English Poetry*, revised ed., New York: Norton, 1963.

Bynum, Caroline Walker *Jesus as Mother: Studies in the Spirituality of the High Middle Ages,* Berkeley: University of California Press, 1982.

Calvin, Jean *Gratulatio ad venerabilem presbyterum dominum Gabrielum de Saconay,* cited in *Louise Labé: Oeuvres complètes,* ed. François Rigolot, Paris: Flammarion, 1986.

Castle, Terry "Matters Not Fit to be Mentioned: Fielding's *The Female Husband,*" *ELH* 49, 3 (1982), 602–622.

Cheney, Donald "Spenser's Hermaphrodite and the 1590 *Faerie Queene,*" *PMLA* 87, 2 (1972), 192–200.

Cheney (a), Patrick "Moll Cutpurse as Hermaphrodite in Dekker and Middleton's *The Roaring Girl,*" *Renaissance and Reformation,* n.s. 7, 2 (1983), 120–34.

Cheney (b), Patrick "Jonson's *The New Inn* and Plato's Myth of the Hermaphrodite," *Renaissance Drama* n.s. 14 (1983), 173–94.

Cirillo, A. R. "The Fair Hermaphrodite: Love-Union in the Poetry of Donne and Spenser," *SEL* 9 (1969), 81–95.

Clark, Sandra "*Hic Mulier, Haec Vir,* and the Controversy over Masculine Women," *Studies in Philology* 82, 2 (1985), 157–183.

Cleveland, John *Poems,* ed. Brian Morris and Eleanor Withington, Oxford: Clarendon Press, 1967.

Clover, Carol J. "Maiden Warriors and Other Sons," *Journal of English and Germanic Philology* 80, 1 (1986), 35–49.

Curley, Michael J. (ed. and trans.) *Physiologus,* Austin: University of Texas Press, 1979.

Damico, Helen "*Thrymskvida* and Beowulf's Second Fight: The Dressing of the Hero in Parody," *Scandinavian Studies* 58 (1986), 407–28.

Daston, Lorraine and Katharine Park "Hermaphrodites in Renaissance France," *Critical Matrix* 1, 5 (1985), Princeton Working Papers in Women's Studies.

DeJean, Joan *Fictions of Sappho 1546–1937,* chap. 1: "Preliminaries," Chicago: University of Chicago Press, 1989.

Dekker, Rudolf M., and Lotte C. van de Pol *The Tradition of Female Transvestism in Early Modern Europe,* New York: St. Martin's Press, 1989.

Denny, Edward, Baron of Waltham "To Pamphilia from the father-in-law of Seralius," in *The Poems of Lady Mary Wroth,* ed. Josephine Roberts, Baton Rouge: Louisiana State University Press, 1983.

Dolce, Lodovico *Le Trasformazioni,* Venice, 1568, ed. Stephen Orgel, New York: Garland, 1979.

Dollimore (a), Jonathan "Subjectivity, Sexuality, and Transgression: The Jacobean Connection," *Renaissance Drama* n.s. 17 (1987), 53–81.

Dollimore (b), Jonathan "The Cultural Politics of Perversion: Augustine, Shakespeare, Freud, Foucault," *Genders* 8 (1990), 1–16.

Donne, John *The Divine Poems,* ed. Helen Gardner, Oxford: Clarendon Press, 1952.

Fetishizing Gender

Dugaw, Dianne "Balladry's Female Warriors: Women, Warfare, and Disguise in the Eighteenth Century," *Eighteenth Century Life* n.s. 9, 2 (1985), 2–20.

Durling, Nancy Vine "Rewriting Gender: *Yde et Olive* and Ovidian Myth," *Romance Languages Annual* 1 (1990), 256–62.

Eccles, Audrey *Obstetrics and Gynaecology in Tudor and Stuart England*, London: Croom Helm, 1982.

Epstein, Julia "Either/Or—Neither/Both: Sexual Ambiguity and the Ideology of Gender," *Genders* 7 (1990), 99–142.

Foucault, Michel *The History of Sexuality*, vol. 1, trans. Robert Hurley, New York: Pantheon, 1978.

Freccero, Carla "The Other and the Same: The Image of the Hermaphrodite in Rabelais," in ed. Margaret Ferguson, Maureen Quilligan, and Nancy Vickers, *Rewriting the Renaissance: The Discourses of Sexual Difference in Early Modern Europe*, Chicago: University of Chicago Press, 1986.

Garber, Marjorie "Fetish Envy," paper delivered at the MLA, Washington D.C., 1989.

Goldberg, Jonathan *James I and the Politics of Literature: Jonson, Shakespeare, Donne, and their Contemporaries*, Stanford: Stanford University Press, 1983.

Golding, Arthur *The xv Bookes of P. Ovidius Naso, entytuled Metamorphosis*, London, 1567.

Gossett, Suzanne " 'Man-maid, begonne!': Women in Masques," *English Literary Renaissance* 18 (1988), 96–113.

de Grazia, Margreta "The Motive for Interiority: Shakespeare's *Sonnets* and *Hamlet*," *Style* 23, 3 (1989), 430–44.

Greenblatt, Stephen "Fiction and Friction," in ed. Thomas C. Heller et al., *Reconstructing Individualism: Autonomy, Individuality, and the Self in Western Thought*, Stanford: Stanford University Press, 1986.

Hall, Joseph *The Discovery of a New World, Englished by John Healey*, London, 1610, ed. Huntington Brown, Cambridge: Harvard University Press, 1937.

Hermann, Anne "Travesty and Transgression: Transvestism in Shakespeare, Brecht, and Churchill," *Theatre Journal* 41, 2 (1989), 133–54.

Howard, Jean E. "Crossdressing, the Theatre, and Gender Struggle in Early Modern England," *Shakespeare Quarterly* 39, 4 (1988), 418–40.

Jacquart, Danielle and Claude Thomasset *Sexuality and Medicine in the Middle Ages*, trans. Matthew Adamson, Princeton: Princeton University Press, 1988.

Jardine, Lisa *Still Harping on Daughters: Women and Drama in the Age of Shakespeare*, Brighton, Sussex: Harvester Press, 1983.

Jonson, Ben (1610) *Epicoene, or The Silent Woman*, in *Ben Jonson*, ed. C. H. Herford and Percy Simpson, vol. V, Oxford: Clarendon Press, 1937.

Jonson (1616), Ben *Epigrammes*, in *Ben Jonson*, ed. C. H. Herford and Percy Simpson, vol. VIII, Oxford: Clarendon Press, 1947.

Kilgour, Maggie. *From Communion to Cannibalism: An Anatomy of Metaphors of Incorporation*, Princeton: Princeton University Press.

Labé, Louise "Elégie 2," in *Oeuvres complètes*, ed. François Rigolot, Paris: Flammarion, 1986.

Laqueur, Thomas "Orgasm, Generation, and the Politics of Reproductive Biology," *Representations* 14 (1986), 1–41.

Lucas, R. Valerie "*Hic Mulier:* The Female Transvestite in Early Modern England," *Renaissance and Reformation* n.s. 12, 1 (1988), 65–84.

Body Guards

Lyly, John *Gallathea,* in *The Complete Works of John Lyly,* ed. R. Warwick Bond, vol. II, Oxford: Clarendon Press, 1902.

Maclean, Ian *The Renaissance Notion of Woman: A Study in the Fortunes of Scholasticism and Medical Science in European Intellectual Life,* Cambridge: Cambridge University Press, 1980.

McGerr, Rosemarie Potz "Donne's 'Blest Hermaphrodite' and the *Poetria Nova,*" *Notes and Queries* 33, 3 (1986), 319.

Orgel (1988), Stephen "The Boys in the Back Room: Shakespeare's Apprentices and the Economics of Theater," unpublished ms.

Orgel (1989), Stephen "Nobody's Perfect: or why did the English stage take boys for women?," *South Atlantic Quarterly* 88 (1989), 7–29.

Ovid *Metamorphoses,* Cambridge: Harvard University Press, 1916, rpt. 1971, vol. 1.

Ovide moralisé ed. C. De Boer, Amsterdam: Muller, 1915, vol. 2.

Payer, Pierre *Sex and the Penitentials: The Development of a Sexual Code 550-1150,* Toronto: University of Toronto Press, 1984.

Perret, Michèle "Travesties et Transexuelles: Yde, Silence, Grisandole, Blanchandine," *Romance Notes* 25, 3 (1985), 328–40.

Paré, Ambroise *The Workes of Ambrose Parey,* trans. Thomas Johnson, London, 1634.

Park, Katharine and Lorraine J. Daston (1981) "Unnatural Conceptions: The Study of Monsters in Sixteenth- and Seventeenth-Century France and England," *Past and Present* 91 (1981), 20–54.

Park, Katharine and Lorraine J. Daston (1989) "The Hermaphrodite and the Order of Nature: Sexual Ambiguity in Renaissance Europe," unpublished ms.

Park, Katharine (1990) "Hermaphrodites and Lesbians: Sexual Anxiety and French Medicine, 1570–1620," paper delivered at the History of Science Society, Seattle, 1990.

Rackin, Phyllis "Androgyny, Mimesis, and the Marriage of the Boy Heroine on the English Renaissance Stage," *PMLA* 102, 1 (1987), 29–41.

Rigolot, François "Gender vs. Sex Difference in Louise Labé's Grammar of Love," in *Rewriting the Renaissance: The Discourses of Sexual Difference in Early Modern Europe,* ed. Margaret Ferguson, Maureen Quilligan and Nancy Vickers, Chicago: The University of Chicago Press, 1986.

Roach, Joseph R. "Power's Body: The Inscription of Morality as Style," in *Interpreting the Theatrical Past,* ed. Thomas Postlewait and Bruce McConachie, Iowa City: University of Iowa Press, 1989.

Rose, Mary Beth *The Expense of Spirit: Love and Sexuality in English Renaissance Drama,* Ithaca and London: Cornell University Press, 1988.

Sandys, George *Ovid's Metamorphosis Englished, Mythologized, and Represented in Figures,* London, 1626, ed. Karl Hulley and Stanley Vandersall, Lincoln: University of Nebraska, 1970.

Scève, Maurice *Délie,* ed. I. D. McFarlane, Cambridge: Cambridge University Press, 1966.

Schleiner, Louise (1989) "Ladies and Gentlemen in Two Genres of Elizabethan Fiction," *SEL* 29 (1989), 1–20.

Schleiner, Winfried (1988) "Male Cross-Dressing and Transvestism in Renaissance Romances," *Sixteenth Century Journal* XIX, no. 4 (1988), 605–19.

Shapiro (a), Susan C. "A Seventeenth-Century Hermaphrodite," *Seventeenth-Century News* 45, 1–2 (1987), 12–13.

Fetishizing Gender

Shapiro (b), Susan C. "Sex, Gender, and Fashion in Early Modern Britain," *Journal of Popular Culture* 20, 4 (1987), 113–28.

Silberman (a), Lauren "The Hermaphrodite and the Metamorphosis of Spenserian Allegory," *English Literary Renaissance* 17, 2 (1987), 207–23.

Silberman (b), Lauren "Mythographic Transformations of Ovid's Hermaphrodite," *The Sixteenth Century Journal* 19, 1 (1988), 643–52.

Slights, William W. E. " 'Maid and Man' in *Twelfth Night*," *Journal of English and Germanic Philology* 80, 3 (1981), 327–48.

Spelman, Elizabeth V. *Inessential Woman: Problems of Exclusion in Feminist Thought*, Boston: Beacon, 1988.

Waage, Frederick O. "Meg and Moll: Two Renaissance London Heroines," *Journal of Popular Culture* 20, 1 (1986), 105–17.

Wagner, Joseph B. "*Hudibras* and the Hermaphrodite," *College Language Association Journal* 25, 3 (1982), 359–81.

Whittier, Gayle. "The Sublime Androgyne Motif in Three Shakespearean Works," *Journal of Medieval and Renaissance Studies* 19, 2 (1989), 185–210.

Wind, Edgar *Pagan Mysteries of the Renaissance,* New York: Norton, 1968.

Wroth, Mary Sidney "Railing Rimes Returned upon the Author by Mistress Mary Wrothe," in *The Poems of Lady Mary Wroth*, ed. Josephine Roberts, Baton Rouge: Louisiana State University Press, 1983.

Wolfson, Susan J. " 'Their She Condition': Cross-Dressing and the Politics of Gender in *Don Juan*," *ELH* 54, 3 (1987), 585–617.

Woodbridge, Linda *Women and the English Renaissance: Literature and the Nature of Womankind, 1540–1620,* Urbana: University of Illinois Press, 1986.

Ziolkowski Jan *Alain of Lille's Grammar of Sex: The Meaning of Grammar to a 12th Century Intellectual,* Medieval Academy of America: Cambridge, Mass., 1985.

5

London's Sapphists: From Three Sexes to Four Genders in the Making of Modern Culture

Randolph Trumbach

In almost all discussions of the relationship of biological sex to gender, and of the female gender to the male, the presumption is made that there are two biological sexes, man and woman, and two genders, female and male. But this is not so in all cultures, and it has not always been so in western culture. The paradigm that there are two genders founded on two biological sexes began to predominate in western culture only in the early eighteenth century. It can be tied to the beginnings of modern equality between the two legimated genders. It appeared probably throughout the modernizing societies of northwestern Europe; in France and the Netherlands, and in England for certain—as this essay shows. But the new paradigm of the early eighteenth century was not really one of two genders. There was a third illegitimate gender, namely, the adult passive transvestite effeminate male or molly who was supposed to desire men exclusively. This third gender marked the limits of desire in the majority of men who were in the new paradigm not supposed to know what it was like to desire males, though in practice they sometimes did. The desire of one male for another when it did occur was taken to be the result of the corruption of an individual's mind that had occurred in his early experience. It was not held to arise from the biological structure of his body. By the end of the eighteenth century there is some evidence that there was beginning to appear a role for women which was parallel to that of the molly for men. At least one source called such women *tommies;*

but the more usual term was sapphist—with sapphist and tommy being the high and low terms for women, as sodomite and molly were for men. But it is likely that in the public mind, women were not fully incorporated into the new gender paradigm until the late nineteenth and the early twentieth centuries, since women continued to be given legitimate feminine status more because of their sexual relations with men than because of their avoidance of sex with women. At the point that the lesbian role became crucial for women, western societies would have come to have a gender system divided into the four roles of man, woman, homosexual man, and lesbian woman. These four roles were supposed to rest on the existence of simply two biological sexes, since all attempts either to find either a biological basis for homosexual behavior or to characterize some homosexual persons as transsexuals, have never been accorded in either popular or elite culture the standing that experience in childhood and adolescence have been given as the supposed cause of homosexual behavior.

For the most part, especially in the early eighteenth century, women lived under an older paradigm as to the nature of the relationship of biology to gender and sexual behavior. In the seventeenth century, this paradigm had been applied to both women and men. In this paradigm there were two genders—male and female—but three biological sexes—man, woman and hermaphrodite. All three biological sexes were supposed to be capable of having sexual relations with both males and females. But they were presumed, of course, to have sex ordinarily with the opposite gender only, and then in marriage, so as to uphold the Christian teaching that sexual relations were supposed to be primarily procreative. Men and women had no difficulty in ascertaining their opposite genders. Hermaphrodites, on the other hand, were obliged to permanently choose one gender or the other for themselves and then to take sexual partners only from the remaining opposite gender. If hermaphrodites moved back and forth in their gender, their sexual relations could then be stigmatized as the crime of sodomy. Men who had sex with males, and women with females, were also guilty of sodomy; but they were not (unlike the molly in the eighteenth century) assigned to a third illegitimate gender because of these sexual relations. In the seventeenth century these relations between members of the same gender did not violate the gender code for apparently two reasons. First, all persons were conceived of as capable of desiring both genders.

Furthermore, the minority who illegally acted upon this universal human desire ordinarily had sexual relations with both genders and usually enacted their sodomitical desires within the rules of patriarchal domination. That is, adult men had sex with adolescent boys whom they penetrated and whose bodies tended to be smooth and small like women's. Women had sex with females, but without penetration. Sodomitical acts contravened the gender system only when they violated the patriarchal code, that is when adult men allowed themselves to be penetrated and when women penetrated women. Because there was no third gender to which to assign individuals who inverted the patriarchal order in their sexual acts by penetrating or being penetrated in violation of their gender status, such persons were likely to be classified as hermaphrodites, that is as biologically deviant. In men, this classification was sometimes understood to be symbolic, but in the case of women, they were likely to be examined by doctors for signs of actual clitoral enlargement.

In the early eighteenth century there were two systematic transitions for males. The first transition was from a system of two genders and three bodies, to one of three genders and two bodies. The second involved a change from a system in which active adult males had sexual relations with passive adolescent boys without either party losing their masculine status, to a system in which the minority of adult males who desired other males (whether adult or adolescent) were likely to try to transform themselves into women by moving, speaking and dressing as women. These two transitions in England, France and the Netherlands have been adequately described elsewhere by myself and others.[1] What I wish to do in this present essay is to consider the extent to which women in the eighteenth century—and specifically in London—were affected by the new paradigm regarding the relationships of bodies and genders to sexual acts between persons of sexually similar bodies. I will look at three things: first, the standing of women as hermaphrodites especially in the early eighteenth century; second, cross-dressing by women; and finally, what male contemporaries would have considered to be actual sexual relations between women.

It will appear that for women, the development of the sapphist role began slowly after mid-century, and could be seen enacted very clearly by some individuals in the last quarter of the century. In the first half of the eighteenth century, on the other hand, women who had sex with

women also had sexual relations with men and were likely to use their hands for stimulation and to avoid penetration. Men speculated that women who did penetrate other women must do so either because their clitorises were enlarged or by using an artificial penis. It is likely that some women did in fact use dildoes, and that some of these women dressed as men and married women. But it is likely that most women who dressed and passed as men for any length of time, did not seek to have sexual relations with women, and this was probably true even of those who married women. Some women (like the actresses who took male roles on stage) cross-dressed in order to be sexually appealing to men not women. But the appeal of such women lay in the beholder's knowledge that they were women. The women who passed in life as men, on the other hand, did their best to conceal their body's sex. Only at the end of the century did there appear women who sought to be sexually desireable by dressing in part as men, but who wished the eye of the knowing beholder to be a woman's and not a man's. These women dressed partly as men and partly as women, and their appeal lay in this ambiguity. They therefore differed considerably from the occasional passing woman who lived entirely as a man and may have married women and perhaps used an artificial penis. These new ambiguously gendered women were London's first sapphists of the modern kind, and their sexual taste was conceived to be the perversion of a minority and not a wicked sin to which any woman might be brought by the effects of great debauchery.[2]

Hermaphrodites and Women

Men who had sexual relations with other men were sometimes still classified as hermaphrodites in the early eighteenth century even after the new role of the molly had appeared. In the late seventeenth century the term seems to have been used for men who were both active and passive in the sexual act. "There are likewise hermaphrodites," the *Wandering Whore* (1660) had said, "effeminate men, men given to much luxury, idleness, and wanton pleasures, and to that abominable sin of sodomy, wherein they are both active and passive in it, whose vicious actions are only to be whispered amongst us." But the same work had earlier described in a more matter of fact way those men

who desired sodomy either with female prostitutes or with beardless, apprentice boys. When, however, Joseph Addison in 1716 referred to an ambiguous wizard as "one of your hermaphrodites, as they call them," he was probably not yet using the term to refer to the new species of the molly, who was characterized as a kind of male whore. The usage is clearer in Jonathan Wild's exchange in 1714 with William Hitchen, the corrupt Under Marshal of the City of London. Hitchen said he wanted to introduce Wild (the leader of the underground of thieves) "to a company of he-whores." But Wild "not apprehending rightly his meaning, asked if they were hermaphrodites: No ye fool, said the M[arsha]l, they are sodomites, such as deal with their own sex instead of females." By 1731, William Pulteney's employment of the term against Lord Hervey shows that hermaphrodite, when used of a man, had come quite clearly to mean an effeminate man who desired sex with other men, and had no reference to the biological condition of his body. Pulteney called Hervey "such a delicate hermaphrodite" who "you know that he is a lady himself; or at least such a nice composition of the two sexes, that it is difficult to distinguish which is more predominant." Pulteney also made no distinction as to the roles taken in the act: "It is well known that there must be two parties in this crime; the pathick and the agent; both equally guilty." Both the active and the passive role in sodomy now made a man into a hermaphrodite of this kind. About the same time Alexander Pope wrote his character of Hervey as being "one vile antithesis. Amphibious thing! that acting either part . . . now trips a lady and now struts a lord." This sort of hermaphrodite was characterized not only by the sexual acts performed but by the public combination of behaviors taken from both of the two legitimate genders, and it was this combination of behaviors, not the structure of his body, which made him hermaphroditical. Pope later in 1739 used the term hermaphrodite of Addison and Richard Steele themselves when he told Joseph Spence that both men were "a couple of H————s. I am sorry to say so, and there are not twelve people in the world that I would say it to at all." But it was *molly* not hermaphrodite that was the term most commonly used to describe the effeminate sodomite. And molly had originated not as a description of a type of body, but as a term for a female whore. Male sodomites were, as William Hitchen had said, he-whores.[3]

The term hermaphrodite was also sometimes used of women in a

metaphorical way in the early eighteenth century, but its purpose was usually to stigmatize female clothing that seemed to impinge on the male domain. Women's riding-habits especially brought out these comments. In 1713 John Gay in *The Guardian* spoke of riding-habits "which some have not injudiciously stiled the hermaphroditical, by reason of its masculine and feminine composition." In the previous year Addison similarly had complained of these "hermaphrodites" and their "amphibious dress" and had said that it was "absolutely necessary to keep up the partition between the two sexes." But Addison did not imply that these clothes (which were usually masculine only from the waist up since they were worn with skirts) signalled any desire for sex between women. There may, however, have been some anxiety on his part in this regard. Certainly in the previous year when he had written to commend Sappho's great lyric of desire for a young woman she observed speaking to a man, Addison had taken care to say that "whatever might have been the occasion of this ode, the English reader will enter into the beauties of it, if he supposes it to have been written in the person of a [male] lover sitting by his mistress." But by and large, many eighteenth-century readers were able to ignore the lesbian dimension of Sappho's work, and by a similar procedure, *hermaphrodite* could be used to stigmatize gender infractions in women without implying (as it did when used of men) any accompanying form of sexual desire between women.[4]

The woman who desired women, however, and accompanied this by overt masculine characteristics, was in the eighteenth century often supposed to be an actual physical hermaphrodite. Her clitoris was likely to be examined by physicians for signs of an enlargement that might be the first state in its transformation into a penis. There was even a tendency to think of all hermaphrodites as female. *The Treatise of Hermaphrodites* that Edmund Curll published in 1718 is an example of this. The anonymous author of this work acknowledged that there were male hermaphrodites as well as female and even presumed there would be more males. Nonetheless almost all of his discussion was about female hermaphrodites—demonstrating the tendency to think of all hermaphrodites as female. This author also thought of female hermaphrodites as women with enlarged clitorises. He did not insist that they all desired women, but he did claim that "the intrigues of my hermaphrodites are indeed very amazing and monstrous as their

natures; but that many lascivious females divert themselves one with another at this time in this city, is not to be disputed." Women were more likely than men to desire to be hermaphrodites because of their lascivious irrationality. Pregnant women, as a result of their longings, were more likely to seek out a female hermaphrodite—an opinion shared by the author of *The History of the Human Heart* (1749). Women in hot places like Italy and France were more likely than those in cool England to seek such pleasures. But despite this libertine author's similarities to a more scientific writer like James Parsons who wrote in 1741, it is apparent that he did not yet share Parson's view that there were only two anatomies on which there were founded two genders. He still presumed that in women there were three anatomical sexes, and that the desire of one woman to dominate another woman in a masculine fashion was likely to be the result of an anatomical, hermaphroditic condition.[5]

Young girls who engaged in mutual masturbation were warned that their actions would result in the enlargement of the clitoris and that this might eventually cause them to be classified as hermaphrodites. In 1725 a girl of eighteen supposedly wrote to the author of the *Onania* (the most famous of anti-masturbatory tracts) that for seven years she had practiced mutual masturbation with an older girl who shared her bed and served as her mother's chambermaid. The first girl said that she now found that "for above half a year past, I have had a swelling that thrusts out from my body, as big and almost as hard, and as long or longer than my thumb, which inclines me to excessive lustful desires, and from it there issues a moisture or slipperiness to that degree that I am almost continually wet, and sometimes have such a forcing, as if something of a large substance was coming from me." Her periods had stopped, and she wondered whether it was all tied to her masturbation, or came "from anything in nature more in my make than is customary to the sex."[6]

In reply the author of *Onania* cited the case of two nuns in Rome that Dr. Carr had discussed in his *Medical Epistles*. These two women had changed their anatomical sex as a result of masturbation; they were expelled from their convent and took up male dress and occupations. Carr had said that this transformation did not have to be explained as magical. He argued that the genitalia of women were exactly like those of men, except that "by a defect in that respect they are only

to be perceived inwardly." For women's bodies were conceived as being exactly like men's, only defective. The clitoris, uterus and ovaries in women were equivalent to the penis, scrotum and testes in men. What had occurred in the two nuns was that what was ordinarily hidden inwardly in a woman's body, had by manipulation been brought outside of the body, thereby transforming them into men.[7]

The author of the *Onania* also cited the work on anatomy of Dr. Drake which reflected a later point of view. Drake did not believe in the possibility of anatomical transformation whether by magic or physical manipulation. Hermaphrodites were for him simply girls who had large clitorises and were consequently assigned to the wrong gender at birth. He had seen a three-year-old mistaken for a boy and christened as such by her parents: the neighbors had called her an hermaphrodite. James Parsons in 1741 took the same view, claiming that he was promoting scientific enlightenment against traditional superstition and cruelty. He cited the case of a London girl that he had been told of by the surgeon John Douglas. The girl had been mistaken for a boy by her parents because of an enlarged clitoris. They dressed her as a boy and put her to serve as drawer or waiter at the King's Arms tavern in Fleet street. There she shared a bed with a fellow servant who made her pregnant. She was turned away in shame and obliged to put on woman's clothes. "The rumor," Parsons wrote, "of the drawer's being changed into a woman made a great noise all over the neighbourhood, and very likely would have been recorded for truth, if it had happened in any age a little earlier."[8]

Reports of hermaphrodites continued to be made. Dr. William Cadogan was said to have "seen many cases of confirmed hermaphrodites" in the course of his London practice. In some cases they apparently changed gender, to the confused disgust of some contemporaries who wished them to be one gender or the other. In 1771 it was asserted that there was then "living in the East part of the town an hermaphrodite, who appeared about twelve years since in men's clothes, and was married to a woman with whom it lived till her death. After her decease, it dressed in women's apparel, and about four or five years since was married to a man, with whom it now lives."[9]

Parsons would have insisted that such an individual must be either a male or female who had moved from one gender to another. Human beings, he explained, could not like earthworms go back and forth

between sexes. But in the early seventeenth century, physiological and legal theory had presumed otherwise. Sir Edward Coke in his great commentary on the common law had said that "every heir is either a male, or female, or an hermaphrodite, that is both male and female." But Coke had also said that hermaphrodites could not live as both males and females. They were obliged to pick one gender and adhere to it forever. This was customary European law. If individuals went back and forth, they were guilty of sodomy. Some individuals actually did go back and forth in Coke's day. Thomasine Hall was christened as a girl. At twenty-two, however, she dressed as a man and joined the army. He went to America, where once again she became a woman. But when searched, he proved to have fully developed male genitalia. He was probably a male pseudo-hermaphrodite whose male genitalia had descended in late adolescence, but who had been assigned to the female gender at birth. The American court in 1629 could not encompass such complications and sentenced Hall to dress as a man and partly as a woman.[10]

Parsons in 1741 did mention briefly that some hermaphrodites could be males who had been wrongly assigned at birth. But in most of his discussion he presumed that most hermaphrodites were female. Nicholas Venette (in the 1710 translation of his work) had been able to distinguish five types of hermaphrodites. Parsons really had only one. He was interested in the women he called *Macroclitorideae*— the women with large clitorises. He intended to defend them against prejudice and cruelty by denying that they were different in nature from the rest of us; they were not a separate race; they were not capable of "exercising the functions of either sex with regard to generation." To tell such women that they were obliged under penalty to choose one sex and to stick with it, was not to the point. Such "poor women" could not "exercise the part of any other sex but their own." And their sexual desire must presumably have been for men not women. It was the beginning of the argument that biologically there are only two sexes, that on these anatomical differences are founded two gender roles, but that both genders sexually desire only the opposite gender. No individual was able to perform the role of a gender which was not a reflection of the individual's sexual anatomy.[11]

It is apparent, then, that for Parsons hermaphrodites were not a third biological category (as tradition had held) but bodily defective

males or females, who were given, like all human beings, a male or female gender identity founded on the biology of their bodies, and which they were not psychologically able to change. But there were still others who held the traditional view that hermaphrodites were a third biological category. These authorities now tended to fill this category with women, since the passive sodomites who went back and forth between being male and female, were supposed to behave as they did not because of a physical condition of their bodies but as a result of the corruption of their minds. Parsons himself must have felt the influence of this molly's role, since he limited his discussion to those hermaphroditic bodies which were to him fundamentally female. Both the new and old-fashioned views of hermaphrodites probably had been encouraged to see hermaphrodites as female by the long-standing view that the female body was an imperfect version of the perfect male body; hermaphroditic bodies being imperfect were therefore likely to be female. In the early eighteenth century the woman with the large clitoris did provide a biological category into which those women who were sexually active with other women could be placed by a society that had not yet conceived for such women a social role that paralleled that of the molly among men. It was likely, however, that Parson's view was becoming the dominant one in the middle of the century. This was no doubt in part a result of scientific observation, but it is also likely to have been linked to the beginning of the construction of a social role for women who had sex with women. By the end of the century there would be no need of a separate biological category in which to place such women. It would become possible to stigmatize them as tommies or sapphists, that is as individuals whose minds had been corrupted from the normal desires of their female bodies.

Women and Cross-Dressing

John Cleland in his discussion of the case of Catherine Vizzani suggested that women who dressed and passed as men were likely to be involved in sexual relations with other women. But this was not so with most of the cross-dressing women who appeared in eighteenth-century London. For most of the century, sexual relations between women were not yet tied to cross-dressing, as sexual relations between

men had come to be. Mollies, everyone knew, dressed as women. Most cross-dressing women did not dress as they did as a means of attracting other women. Some sapphists began to do that only at the end of the eighteenth century.[12]

There were women who married or courted other women in eighteenth-century London, and who may have tried to use a dildo in the way that we will see Mary Hamilton and Catherine Vizzani doing; but the use of a dildo cannot be proven. These marriages were prosecuted as frauds. Some of them were clearly intended to defraud women of their money. Sarah Ketson posed as a man called John in 1720 and tried to defraud Ann Hutchinson by courting her in marriage. Constantine Boone in the previous year had also been convicted of a fraudulent marriage; in her case there may have been an anatomical basis for her behavior, since she was also exhibited as an hermaphrodite at Southwark Fair. One young woman married an older one in 1773 for her £100, and another woman was convicted in 1777 of marrying three different women. But some of these marriages, no matter how they may originally have begun, eventually became acceptable to both women. Sarah Paul (who used the name of Samuel Bundy) was debauched at 13 by a man. To avoid the girl's mother, the man dressed her as a boy and adopted her as his son. Paul left him and went to sea for a year. When she returned, she bound herself to a painter (her seducer's trade). She was there attracted to a young woman, Mary Parlour, and married her. Her wife soon discovered her husband's true identity but at first decided not to expose the affair. Eventually, however, she had her arrested for fraud. But the bond had become too strong. The wife kept the arrested husband company in prison and failed to appear at the trial. The magistrate burnt Paul's male clothes and ordered her never to appear again as a man.[13]

Some marriages lasted most of a lifetime. John Chivy always dressed as a man and was married to a woman for nearly twenty years; he separated from her a few years before his death. His identity as a woman was discovered only at his death. The most complicated, best reported, and hardest to interpret of these long marriages is that of Mary East. At the death of her wife in 1766, it came out that for thirty-six years she had passed as the husband of the couple; she had successfully run a public house at Poplar and had creditably held many of the parish offices. The question that is most difficult to resolve is the

nature of their sexual relation, and whether there had been one at all. Had they posed as man and woman for economic convenience? A girl who was discovered to have dressed as a boy when she was hired at a public house in Duke's place in London, explained that she had done so because "boys could shift better for themselves than girls." It is possible though that Mary East and her wife had had some sort of sexual relationship. She was very frightened by the men who tried to blackmail her after her friend's death when they threatened to take her to the magistrate for passing as a man. It sounds very similar to the men who paid a blackmailer who threatened them with charges of sodomy. This latter kind of blackmail was a widespread practice, and must have been known to a woman like East who had moved so successfully in the world of men. Her blackmailers may themselves have made a parallel between East's behavior and that of sodomites. But her blackmail case is the only one that possibly involved the question of sexual relations between two women.[14]

The magistrate sometimes did arrest women for cross-dressing. Elizabeth Morris was arrested, whipped and put to hard labor in 1704 because she had dressed as man and enlisted as a soldier in Lt. General Steward's regiment. At the end of the century Mary Jones, who was probably a prostitute, was arrested for dressing as a man and making a disturbance in Turmmill Street. Five years later, Ann Lewis was arrested for dressing as a sailor.[15] But it is impossible to say why these women were arrested when other women who dressed and passed as soldiers and sailors were treated indulgently and sometimes even made into popular heroines. Christian Davies, Hannah Snell, Mary Knowles and Mary Talbot were the best known eighteenth-century heroines of this kind, but many other cases appeared in the newspapers. These women usually joined the army or the navy either to be with their male lovers or husbands, or to go in search of them. The writers of their stories occasionally displayed a certain prurient interest as to how these women had hidden their anatomy or proved their sexual interest in women to their male companions. Hannah Snell had had to show that she was as interested as her fellow sailors in women, since they had begun to call her Miss Molly, implying that she was an effeminate sodomite; and she had had to explain away the appearance of her breasts when she was stripped and whipped. Christian Davis had had to have a silver tube made so that she could stand up in public and

urinate. This was one of the tests of manhood, as Dryden knew when he mocked the Amazonian whore who could otherwise pass for a man; Dryden told his male audience that they should

> . . . laugh to see her tyr'd with many a bout,
> Call for the Pot, and like a Man Piss Out.

But no one ever arrested any of these women for passing as men.[16]

Other women dressed as men because it facilitated their libertine life with men. Sally Salisbury dressed as a beautiful youth and went out into the streets with her young aristocratic male friends to attack passers-by. Three men drank together in a public house in Gateshead. When they tried to leave without paying, there was a scuffle and one of the men was discovered to be a woman. Lady Ann Harvey's coachman of 16 years' service was brought to bed of a child. She had been married to another servant in the family in the days when masters did not care for their servants to be married and had dressed and worked as a man to hide the marriage. Catherine Meadwell frequently went in men's clothes and used the name of Captain Clark. It probably helped her to get past suspicious landladies with the lover for whom she was divorced. Charlotte Clarke also probably started to dress in public "en cavalier," because it facilitated her secret, second marriage to John Sacheverell in 1746.[17]

Charlotte Charke's *Narrative* can serve as a final demonstration of the complications that arise in the interpretation of a cross-dressing woman's life. On the one hand, Charke seemed to put on men's clothes for convenience and under special circumstances: it hid her secret marriage; and it was perhaps safer for her and her actress friend to stroll the provinces as a male actor and his wife (her Mr. and Mrs. Brown) than as two women. On the other hand, on a number of occasions she courted women who were marriageable and withdrew from the situation only at the last moment. She enjoyed her popularity among the Covent Garden whores with whom she passed as Sir Charles. She stressed that she was not adept at female occupations like the needle, and preferred those that were male. She remembered dressing in her father's clothes when she was four. All of this seems to suggest what John Cleland would have called a secret bias. But she also liked men to some degree and bore a daughter. It has been sug-

gested that because she drew a hostile portrait of an effeminate male sodomite in her novel, that she could not have had sexual relations with any of the women with whom she flirted. But this does not necessarily follow. It is likely that one could disapprove of the new role of the exclusive sodomite, and yet practice a traditional bisexual libertinism—especially if one were a woman. This (as we shall see) was certainly the position of John Cleland in *Fanny Hill,* where the two women were approved of but the two male sodomites were very harshly condemned. Such libertinism did not, however, make a woman respectable. Charke's family were always uneasy over the possibilities that her life seemed to imply, and they broke with her over the question of her cross-dressing. It was one thing for Charke to take male roles on the stage where the audience knew the actress was a woman—it was another to try to pass as a man in the street. Still Charke did not hesitate to publish her memoirs. But it is in the end impossible to say whether she ever experienced what would have seemed to her to be sexual intercourse with another woman. The majority of women who cross-dressed, did so either because it made it easier for them to make a living, or because it allowed them to move safely to a hostile environment. But a minority of women seem to have done so because it allowed them to enact a dominating sexual attraction with other women. A woman like Charlotte Charke, could cross-dress for both reasons. But throughout most of the century, the majority of women who had sexual relations with women—and they must have been a very small libertine minority of all women—did not cross-dress, and did not even take on masculine airs.[18]

Sexual Relations Between Women

Sexual relations between women were not illegal in England. Sir Edward Coke in the seventeenth century had defined sodomy to mean either sexual intercourse between a woman and a beast, or anal intercourse by a man with either a male or a female.[19] But sexual relations between two women did not come under the sodomy statute. As a consequence there are no detailed descriptions of sex between women in the legal sources that parallel those for sodomy between men. There

are, however, some imaginary descriptions—one by a woman: Delari-
viere Manley; and the rest by men.

Married women and prostitutes figure most prominently in these
imaginary descriptions, but there are also descriptions of sex between
young unmarried girls. In the case of the married women and the
prostitutes, it is apparent that the women usually also have sex with
men, even if in some cases their preference may be for women. Mrs.
Manley in 1709 in her *Secret Memoirs . . . from the New Atalantis*
(vol. 2) described a "new cabal" or "sect" (43) of aristocratic women
who "have all of happiness in themselves." They kiss and embrace and
are suspected by others of taking these things a little too far. The older
women lament to the young "the custom of the world that has made
it convenient (nay, almost indispensable) for all ladies once to marry,"
but their intention was "to reserve their heart, their tender amity for
their fair friend" (47). Occasionally one of the two women in a couple
was described as having "something so robust in her air and mein, that
the other sex would have certainly claimed her for one of theirs," but
for the fact that she dressed as a woman (48). The Marchioness of
Sandomire (who was identified as the actual Lady Popham, for what
that is worth), dressed as a man and wandered through the prostitutes'
quarter with her female favorite. Together they had sex with the prosti-
tutes (49). Another woman in the novel called Zara (or Catherine
Portmore) grew discouraged with her male lovers and took a female
lover, Daphne, who herself had affairs with men. Both women were
part of the theatrical world. But financial necessity obliged Daphne to
look for a husband, though she continued to live only for her female
friend (50–56).[20]

The two prostitutes who have sex with each other in John Cleland's
Memoirs of a Woman of Pleasure (1748) do not of course have hus-
bands. But they do have sex with many men, and clearly prefer that
mode. In addition, neither of them seems to display any of the mascu-
line characteristics that aristocratic women in fiction and in life some-
times displayed as part of their taste for women. Phoebe Ayres prepared
Fanny Hill to have sex with men by enjoying the girl herself. Cleland
described it as "one of those arbitrary tastes for which there is no
accounting." It was "not that she hated men, or did not even prefer
them to her own sex; but when she met with such occasions as this
was, a satiety of enjoyments in the common road, perhaps too a secret

bias, inclined her to make the most of pleasure, wherever she could find it, without distinction of sexes" (12). Cleland, however, made it clear that his heroine Fanny has no real interest in this direction. She eventually says that she "pin'd for more solid food, and promis'd tacitly to myself that I would not be put off much longer with this foolery from woman to woman" (34). In the actual world of prostitution, libertine men sometimes did take two women together with them to bed—it was called "lying in state" (or like a king)—but it is impossible to say to what degree the two women in such situations became involved with each other. It was, in any case, not a widespread practice. Of six hundred men arrested for being with whores in London in the 1720s, only twenty-seven men (4.5%) were found with two women at once. Phoebe Ayres's taste for women may have been one that developed in prostitutes: it was claimed that there was unnatural wickedness in the Magdalen Hospital for repentant prostitutes when one girl put her hand into the bosom of another.[21]

The fashionable London world was able to talk of actual examples of these relations throughout the century—the women with shock, the men with delight. The Duchess of Marlborough told Queene Anne that Mrs. Manley's novel had in it (among other scandal) "stuff not fit to be mentioned of passions between women." Horace Walpole reported that Lady Pomfret went traveling not with her husband but with Miss Shelly "whom Winnington used to call *filial piety,* for imitating her father, in bearing affection to her own sex." He observed that Mrs. Cavendish was "*in-cun-sole-able*" on the death of Lady Dysart. This married woman had also displayed her taste to the eyes of others: "Gilly" Williams said that she seemed "by the heat of the waters, and the natural richness of her constitution" to be "more wickedly inclined than any young fellow here, and if Lady Betty Spencer is not sent away, I believe she will by force go in unto her and know her."[22]

Such stories, and the material from the novels, are distinctly parallel to the late seventeenth and early eighteenth century attitude toward sodomy between males that could be found among male rakes prior to the development of the role of the adult passive, effeminate sodomite, or molly. Such a rake was prepared to have sexual relations with both women and boys, because he took the dominant role in both kinds of act. Others might view his behavior as very wicked, but they did not think of him as effeminate. Sexual relations with a younger male did

not lessen the masculine status of a rake; if anything, it reinforced the image of his power. The rake certainly did not go in for any degree of cross-dressing as part of his dominant sodomitical behavior. There were, however, a few adult males who took the passive role in sodomy. They were likely to be classified as hermaphrodites, since they had changed, in effect, from being men to being women.

The women so far described were also likely to have sex with both women and men. It is true that in some cases marriage and sex with men were forced on them by economic necessity. But in most cases they are described as genuinely desiring both men and women, though sometimes as preferring one or the other. They were of course wicked because they were not chaste. But they are for the most part not described as losing feminine status because of their bisexual behavior. The one woman who cross-dresses in Mrs. Manley's novel does so probably as a means of passing unmolested in the prostitutes' quarter. In a few more cases, one of the two women in a relationship is described as having masculine airs but not as cross-dressing. It is these women alone who were deviant. It is they who were likely to be described as hermaphrodites. In this, these unusually active women were directly parallel to the late seventeenth-century adult males who because they were unusually passive in sodomy were also characterized as hermaphrodites.

The author of the 1718 *Treatise of Hermaphrodites* had mentioned that some women used dildoes. This was an alternative explanation of aggressive female sexuality that was likely to appeal to male writers like Henry Fielding and John Cleland who belonged to the minority who in the middle of the century wished to say that one woman's desire for another was founded on a corruption of the mind and was therefore similar to the adult, effeminate, male sodomite's desire for another male. Fielding in his heavily fictionalized account of Mary Hamilton (who married several women) stressed again and again the problem that Hamilton had faced because she did not have a penis. She was brought to trial when her last wife's relatives found in her trunk "something of too vile, wicked, and scandalous a nature." That this was in fact a dildo is confirmed in the periphrastic language of the legal depositions and the newspaper reports. Fielding concluded that "unnatural affections are equally vicious and equally detestable in both sexes." He also tried to show that Hamilton had acted as she did after

being corrupted by an older woman and not because of the structure of her body.[23]

John Cleland translated and commented on the case of Catherine Vizzani that Giovanni Bianchi had reported from Italy. Vizzani had seduced several young women, including nuns. At her death Bianchi investigated her body to see whether it was anatomically different. He reported that her clitoris was not "of any extraordinary size," as it was supposed to be with women "who followed the practices of Sappho." It was indeed smaller than middle size. Vizzani, instead, had used as her penis a leather cylinder stuffed with rags and fastened below her abdomen. Cleland commented that her behavior must have proceeded "from some error in nature, or from some disorder or perversion in the imagination." The autopsy had proven that her body was like those of other women. It must therefore have been that her imagination had been "corrupted early in her youth" by lascivious tales. In the course of time, her vicious practices might have caused "a preternatural change in the animal spirits and a kind of venereal fury." All this was written in a very different tone from the way in which Cleland three years before had described in his novel the sexual encounters between Phoebe Ayres and Fanny Hill. It may be that having been once prosecuted, Cleland was simply being careful. But there is possibly something more. Vizzani had died a virgin with her hymen intact. She had never submitted to a man. She had used a penis, and dressed as a man. In all these ways she differed from Cleland's fictional heroines. Vizzani had become a sort of hermaphrodite, undergoing a "preternatural" change—she had deviated from the acceptable libertine norm of the bisexual woman and had become a monster. Because she had been exclusively interested in women, she had lost in Cleland's mind her status as a woman. Cleland added that women should be more severely punished when they appeared in public places in men's clothes. This should not be done for the sake of a silly diversion. For him cross-dressing was likely to become a part of a more serious sexual deviation.[24]

Men like Cleland and Fielding sometimes tried to fit the woman who actively sought women into a category parallel to that of the passive male sodomite: they consequently denied that such women had enlarged clitorises and said that they were motivated by the corruption of their minds—and by the end of the century could call them tommies, as men were called mollies. But such men were never consistent in their

view about women who desired women. They used both the old and the new models to describe them. It is likely that they did so for two reasons. First, women, unlike men, had not in the eighteenth century yet come to be consistently classified into what by the late nineteenth century would be called a heterosexual majority and a homosexual minority. And secondly, women, again unlike men, did not yet define their gender identities in terms of their relationship to other women, as men defined theirs in relation to other men. Women were still given conventional female status because of the way they behaved with men.

The best evidence for both the emergence of the tommy's role and its relative unimportance for women's gender status can be found in a single source after 1770—the diary of Mrs. Hester Thrale Piozzi. Mrs. Piozzi made many comments about male sodomy in the thirty years after she began keeping her diary in 1776. It might even be described as one of her great interests. She noticed the difference between Italian tolerance and English ostracism, and she usually approved of the latter, except when she found the poor man personally sympathetic. She wondered about the dynamics of personality that were involved. She was frequently convinced that she could detect sodomitical inclinations in men who had otherwise sought to hide them. And she felt that sodomy was on the increase, along with adultery and most other sexual vices.

Sexual relations between women, especially in Bath and in London, also caught Mrs. Piozzi's attention, if not to the same extent that male sodomy did. She was less comprehending of it, and more likely (in her mind) to be taken in by the vicious content of seemingly innocent female friendship. At Bath she found Dr. Dobson's wife "so odd" and "odious," and wrote that "this nasty Bath is a cage of unclean birds"— a phrase she fondly repeated ten years later. In 1789 she noted the charges that Marie Antoinette had been at the head of a set of monsters called by each other "Sapphists." In 1792 she praised Miss Trefusis's poems in honor of her female friends, Miss Weston and Miss Powell. But a year later she discovered that Miss Rathbone's house where these women had lived was "supposed to have been a cage of unclean birds, living in a sinful celibàt." She wondered why Miss Weston had been so averse to marriage, and why she had made "such ado" about Sally Siddons, the actress's daughter; but she explained to herself that "Miss Weston did use to like *every girl* so." Mrs. Siddons had told her that

Siddons' "sister was in personal danger once from a female fiend of this kind." Mrs. Piozzi went so far as to say in 1795 that "whenever two ladies live too much together," they were suspected of "what has a Greek name now and is called Sapphism." But to Mrs. Piozzi, what these women did with each other were "impossibilities"—"such I think 'em." Or in other words, it was not clear to her phallocratic mind, what two women could do sexually with each other. For Mrs. Piozzi, the point of sexual honor among men was the avoidance of sodomy: "no sin but one seems punished by the world's disapprobation—that crime is still discountenanced, no gentleman will speak to Doctor William Wynne" who was suspected of sodomy. But for women, honor flowed from their correct behavior with men; and to show this Mrs. Piozzi immediately followed her comments on Wynne by writing that there was "*some* idea—a *faint* one—about the point of honor amongst women too; Helena Williams's friends are all shamed of *her*" for running away with a married man.[25]

Among the sapphists Mrs. Piozzi knew of, one stood out. This was Mrs. Damer whose tastes became the subject of widespread gossip. She was a sculptress and the daughter of General Seymour Conway. She was also a great favorite of Horace Walpole who left her his house when he died and who had been in love with her father, who was Walpole's cousin. Damer had married at eighteen, but nine years later her libertine husband had blown out his brains after dismissing the blind fiddler and the four whores he had taken to a tavern. Within six years of her husband's death, her taste for women was well enough known to become the subject of *A Sapphic Epistle from Jack Cavendish to Mrs. D***** (1782). By 1795 when she was a woman of forty-seven, she had become so notorious that Mrs. Piozzi wrote that it was "a joke in London now to say such a one visits Mrs. Damer." Lord Derby insisted that Mrs. Farren, a comic actress who was his mistress, should stay away from Damer who was fond of her. Five years before the affection between the two women had produced a quatrain which ran:

> Her little stock of private fame
> Will fall a wreck to public clamour,
> If Farren leagues with one whose name
> Comes near—Aye very near—to Damn her.

By the end of the decade, according to Joseph Farrington, Mrs. Damer had adopted some articles of men's clothes: "she wears a man's hat, and shoes—and a jacket also like a man's—thus she walks about the fields with a hooking stick." But she evidently still wore a woman's skirt. She was not a passing woman who dressed entirely as a man, but instead she combined female and male characteristics in order to attract women. She was courting Mary Berry. (Berry was thirty-five and Damer fifty.) Farrington thought their ecstacies "on meeting and tender leave on separating . . . is whimsical;" their servants described one such separation when Miss Berry went to Cheltenham, "as if it had been parting before death." All that was lacking to make Mrs. Damer the female equivalent of a molly was a name. This the *Sapphic Epistle* of 1782 had given her when it wrote that Sappho was said to have been "the first Tommy the world has upon record." "Tommy" was probably the popular libertine term for a sapphic woman. But whereas "molly" has an extensive history from the early eighteenth century, this late eighteenth-century poem seems to make the first recorded use of "tommy."[26]

The partial social ostracism that Mrs. Damer suffered was, however, quite different from society's reaction to Eleanor Butler and Sarah Ponsonby, and it is important to ask why this was so. These two friends first met when Butler was twenty-nine and Ponsonby thirteen. Eight years later in 1778 (after a first unsuccessful attempt) they eloped together and two years later they leased a house in the beautiful Welsh vale of Llangollen. There they spent the remainder of their lives in dedicated friendship. The world eventually came to visit them, including Mrs. Piozzi who found them charming, corresponded with them, and never made any negative judgment of them. Butler was handsome and looked rather like her own nephew; Ponsonby was pretty. They seemed always both to have dressed in riding habits, and from the nineties onward they cropped their hair. As they aged in the early nineteenth century, it became impossible for strangers to tell them from old men, at least when they were seated, since they continued to wear skirts. Elizabeth Mavor in her biography of them suggested that it would be incorrect to categorize them as sapphists since their affection for each other was part of a pattern of romantic friendships between women. Mrs. Piozzi, for instance, had such a friendship with Mrs. Siddons. Mavor also said that the clothes and hair of Butler and

Ponsonby might be explained by the custom among Irish gentlewomen (which they were) of wearing riding-habits indoors and by their conservatism in keeping a hairstyle which had been popular among many women in the 1790's. It is certainly true that Mrs. Piozzi, who was very attuned to the issue of sapphism, does not seem to have suspected them in the teeth of the apparent evidence. It is clear that they did not project their relationship as an erotic one; and it is probable that if there had been erotic feelings between them, they themselves would have been unable to think of their feelings in such a way.[27]

Nevertheless, it is also true that some of their contemporaries did classify them as sapphists. In the summer of 1790 a column describing them appeared in a number of the London newspapers. It was sympathetic, but it left no doubt as to its meaning. Butler was described as "tall and masculine—always wears a riding habit;" Ponsonby was said to be "polite and effeminate, fair and beautiful." Ponsonby, in typical female fashion, oversaw the house, and Butler superintended the grounds in masculine fashion. It is likely that whoever wrote the column had only heard of the ladies and not seen them: Butler, at any rate, was short and fat. But the writer had a category in which to place them, and the ladies and their friends understood the meaning and were outraged. They wrote, significantly enough, to Edmund Burke to ask advice about legal action. Burke in 1780 and 1784 had sued two different papers for suggesting that he was at least sympathetic towards sodomy because he had protested in the House of Commons against the treatment that was meted out to sodomites in the pillory. He won both cases. In the year after the appearance of the column against the ladies, Burke also defended the honor of the Queen of France against the revolutionaries, aware, no doubt (as was Mrs. Piozzi) that she had been charged with being a sapphist. But his own experience with the libel cases had been unsatisfactory. He advised the two ladies not to act; he told them that he trusted "that the piety, good sense, and fortitude that hitherto have distinguished you and make you the mark of envy in your retreat" would allow them to despise the scandal; and he reassured them that it made no impression on those who valued them.[28]

The romantic friendship of Butler and Ponsonby does seem to have approached sapphism in some regards. They never married men, they lived together, and they dressed, both of them, in a hermaphroditical

manner. The relationship between them also seems to have had ele-
ments of traditional male-female differentiation, because of the sixteen
years difference in age, as well as the difference to be seen in the
handsomeness of one and the prettiness of the other. But they appar-
ently did not experience their relationship as sexual. They did not
project it as sexual. And consequently those who knew them did not
perceive it as sexual. Mrs. Damer, on the other hand, not only dressed
in a hermaphroditic fashion, as well as liking younger pretty women;
she clearly projected her affection for women as sexual. It was certainly
perceived that way, and she was stigmatized consequently as a tommy
and a sapphist. It is likely, therefore, that women attracted to women
after 1770 when the new sapphist role had emerged, could either know
or not know the sexual content of their feelings. Those who knew,
were likely to be those who were stigmatized. But those who did not
know were still likely (like Butler and Ponsonby) to adopt some of the
external characteristics of the sapphist role.

The stigmatization, however, was never as great as that which male
sodomites experienced. Women's lives were never as public as men's.
There is no evidence of a female sexual subculture of taverns or public
places of assignation as there were for male sodomites. There were
some social nexus organized around prostitution and the meeting
places of the fashionable and the theatrical worlds. But more impor-
tantly, most women felt they were female because of their relationship
to men, and not because they had avoided contamination by the sapph-
ist's role. It is likely on the other hand that for men the avoidance of
contact with sodomites was at least as important as their relationship
with women in defining themselves as masculine. But the new sapphist's
role probably did begin to affect women's consciousness to some de-
gree, as the changing attitudes towards female cross-dressing shows.
By the late eighteenth century, actresses who took male roles and
dressed as men on stage were found less exciting than they had been
earlier in the century, as Kristina Straub's essay in this book shows.
And by the early nineteenth century (as Dugaw, and Dekker and van
de Pol suggest), women had greater difficulty in passing in real life as
men and the public became less interested in their stories. Women's
bodies had even more certainly been transformed and made more
similar to men's, since no one was likely to explain the behavior of a
sapphist by examining the size of her clitoris. Her clothes might be

hermaphroditic but not her body. By 1800, it was conceived in discussion both of men and women that there were only two types of bodies, male and female. But the variety of sexual acts in which human bodies might engage guaranteed that there were four genders, two of them legitimated, and two stigmatized. Consequently, in the modern western world, there were men and women, and sodomites and sapphists.

Notes

1. I began my study of sodomy with "London's sodomites: homosexual behavior and western culture in the eighteenth century," *Journal of Social History*, 11 (1977), 1–33. I subsequently discussed the new historiography: "Sodomitical subcultures, sodomitical roles, and the gender revolution of the eighteenth century: the recent historiography," *Eighteenth-Century Life*, 9 (1985) 109–121 and in *'Tis Nature's Fault. Unauthorized Sexuality during the Enlightenment*, ed. R. P. Maccubbin (New York, 1987); "Gender and the homosexual role in modern western culture: the 18th and 19th centuries compared," Dennis Altman et al., *Homosexuality, Which Homosexuality* (Amsterdam and London, 1989), 149–169. As preliminaries to the chapters on sodomy in my forthcoming *The Sexual Life of Eighteenth-Century London*, I have presented new evidence and argument in: "The birth of the queen: sodomy and the emergence of gender equality in modern culture, 1660–1750," *Hidden from History: Reclaiming the Gay and Lesbian Past*, ed. Martin B. Duberman, Martha Vicinus, George Chauncey, Jr. (New York, 1989), 129–140, 509–511; "Sodomitical assaults, gender role, and sexual development in eighteenth-century London," *Journal of Homosexuality*, 16 (1988), 407–429 and in *The Pursuit of Sodomy: Male Homosexuality in Renaissance and Enlightenment Europe*, ed. Kent Gerard and Gert Hekma (New York, 1988); "Sodomy transformed: aristocratic libertinage, public reputation and the gender revolution of the 18th century," *J. Homosex.*, 19 (1990), 105–124 and in *Love Letters between a certain late nobleman and the famous Mr. Wilson*, ed. Michael S. Kimmel (New York, 1990). I also in a short essay tried to place the eighteenth-century change in long-term cultural history: "England," *The Encyclopedia of Homosexuality*, ed. Wayne Dynes (New York, 1990), 2 vols., I, 354–358. I have been greatly helped in conceptualizing the number of bodies and genders that can exist in a society, and how they can be combined, by Gilbert Herdt, "Mistaken gender," *American Anthropologist*, 92 (1990), 433–446; Walter L. Williams, *The Spirit and the Flesh* (Boston, 1986).

2. Earlier studies: Sheridan Baker, "Henry Fielding's *The Female Husband*: fact and fiction," *PMLA* 74 (1959), 213–224; Elizabeth Mavor, *The Ladies of Llangollen* (1976); Lillian Faderman, *Surpassing the Love of Men* (New York, 1981); Terry Castle, "Matters not fit to be mentioned: Fielding's *The Female Husband*," *ELH* 49 (1982), 602–622; K. V. Crawford, "The transvestite heroine in 17th–century popular literature" (Ph.D. thesis, Harvard University, 1984); Diane Dugaw, "Balladry's female warriors: women, warfare and disguise in the 18th century," *Eighteenth-Century Life*, 9 (1985), 1–20; and her *Warrior Women and Popular Balladry 1650–1850* (New York, 1989); Lynne Friedli, " 'Passing women': a study of gender boundaries in the eighteenth century," *Sexual Underworlds of the Enlightenment*, ed. G. S. Rousseau and Roy Porter (Manches-

Body Guards

ter, 1987), 234–260. There are two general surveys: Martha Vicinus, " 'They wonder to which sex I belong': the historical roots of the modern lesbian identity," *Homosexuality, Which Homosexuality;* R. M. Dekker and L. C. van de Pol, *The Tradition of Female Transvestism in Early Modern Europe* (Basingstoke, 1989). I have tried to make some comments, "London's Sodomites," 13, in *Sexual Underworlds,* 75, 84 n. 13, and in *Homosexuality, Which Homosexuality,* 158–161: but my argument in the last of these is considerably modified in this present essay; I unwisely said what I did before I had sufficiently considered the material I had gathered. The existing historiography (on which I relied) was misleading in its emphasis on the late nineteenth century origins of the lesbian role. It is likely that an already existing role was becoming more important at that point in time. Women in the late nineteenth century must have begun to define themselves more as female as a result of their relations to other women than they had previously done.

3. *The Wandering Whore* (London, 1660–1663), 6 parts, part 4, p. 5, part 3, p. 9, Garland reprint, ed. R. Trumbach (New York, 1986); Joseph Addison, *The Drummer* (1716), iv. 1; [Jonathan Wild], *An Answer to a late insolent libel* (London, 1718), 30; Robert Halsband, *Lord Hervey* (Oxford, 1973), 109–111; Alexander Pope, *Poems,* ed. John Butt (New Haven, 1963), 607–8; Joseph Spence, *Observations, Anecdotes and Characters of Books and Men,* ed. J. M. Osborn (Oxford, 1966), 2 vols., I, 80, #188; *Oxford English Dictionary,* s.v. molly: cf. Trumbach, "Birth of the queen," 137.

4. *The Guardian,* ed. J. C. Stephens (Lexington, Kentucky, 1982), no. 149, 488; *The Spectator,* ed. D. F. Bond (Oxford, 1965), 5 vols., IV, 28–29, no. 435, II, 390, no. 229; see also Dugaw, *Warrior Women,* 133–4. For the eighteenth-century English Sappho: Lawrence Lipking, "Sappho descending: eighteenth-century styles in abandoned women," *Eighteenth-Century Life,* 12 (1988), 40–57; which does not deal, however, with Sappho in the more libertine tradition which makes clear her taste for girls. Joan De Jean, *Fictions of Sappho, 1546–1937* (Chicago, 1989), finds the eighteenth-century French Sappho to have been entirely domesticated into a tragic heterosexuality. But in the seventeenth and the nineteenth centuries, she was presented, as well, as either lesbian or whore. This fits the pattern of Enlightenment domestication of women's sexuality: however, this domestication was not necessarily oppressive, since it aimed to free women from the stigma of an irrational and irrepressible sexuality. But the emergence of the modern sapphic role at the end of the eighteenth century also meant that the "lesbianism" of the seventeenth and the nineteenth centuries had different meanings when attributed to Sappho: the first was likely to be combined with desire for men, the latter to be exclusively directed toward women. De Jean is aware of the late eighteenth-century libertine use of Sappho's name to describe the new sapphic role but she discounts its significance because it was not taken up into the fictionalized lives of Sappho, and because she presumes a continuous lesbian identity across time. She does say (120) that "before the late nineteenth century, the two traditions—fictions of Sappho and fictions of the lesbian—were never to intersect." It was probably a reflection of the varying public respectability of libertine as opposed to domesticated texts. Peter Tomory, "The Fortunes of Sappho: 1770–1850," *Rediscovering Hellenism,* ed. G. W. Clarke (Cambridge, 1989), is not helpful and invents a quotation from Addison. The complaints about women's hermaphroditical clothes went back to the early seventeenth century: Crawford, "Transvestite heroine," 146–152; and also, R. V. Lucas, "*Hic Mulier:* the female transvestite in early modern England," *Renaissance and Reformation,* 12 (1988), 65–84; Susan S. Shapiro, "Amazons, Hermaphrodites and plain monsters: the 'mascu-

136

line' woman in English satire and social criticism from 1580–1640," *Atlantis* 13 (1987), 66–76.

5. *Tractatus de Hermaphroditis: or a Treatise of Hermaphrodites* (London, 1718), 58, ii–iv, 14–16, 19–49; *The History of the Human Heart* (London, 1749), 20–21.

6. *Onania; or the heinous sin of self-pollution* (London, 1723) and its *Supplement* (n.d.), 151–162, Garland reprint, ed. R. Trumbach (New York, 1986).

7. *Ibid.*

8. *Onania, Supplement*, 162–166; James Parsons, *A Mechanical and Critical Inquiry into the Nature of Hermaphrodites* (London, 1741), 33.

9. *Gazetteer and New Daily Advertiser* (30 May 1770, 1 June 1771).

10. Parsons, *Hermaphrodites*, 2, 3, 9, xlvii; J. N. Katz, *Gay/Lesbian Almanac* (New York, 1983), 71–72.

11. Parsons, *Hermaphrodites*, 25, 28, xvii, xlvii; Nicholas Venette, *The Mysteries of Conjugal Love Revealed* (London, 1710). Traditional public attitudes toward hermaphrodites, and the mid-eighteenth-century change in opinion are discussed in: Pierre Darmon, *Trial By Impotence* (London, 1985), 40–51; Julia Epstein, "Either/or—neither/both: sexual ambiguity and the ideology of gender," *Genders,* no. 7 (1990), 101–142. For women's bodies as imperfect versions of men's, see Thomas Laqueur, "Orgasm, generation and the politics of reproductive biology," *The Making of the Modern Body,* ed. Catherine Gallagher and Laqueur (Berkeley, 1987), and his *Making Sex* (Cambridge, Mass., 1990).

12. Giovanni Bianchi, *[An] historical and physical dissertation on ... Catherine Vizzani* [translated with commentary by John Cleland] (London, 1751), 65–6. This was identified as Cleland's by Roger Lonsdale, "New attributions to John Cleland," *Review of English Studies,* 30 (1979) 276–280. Dekker and van de Pol, *Female Transvestism,* 47–72, agree with Cleland. But the English material I present does not, and in any case, Dekker and van de Pol's case is weakened by their failure to look for evidence of sexual relations between women outside of the context of cross-dressing. Such evidence exists for the Netherlands: see Theo van der Meer, *De Wesentlijke Sonde van Sodomie en andere Vuyligheeden* (Amsterdam, 1984), and more clearly in his "Tribades Tried: female same-sex offenders in late eighteenth century Amsterdam," *Journal of the History of Sexuality,* 1 (1991), 424–445.

13. Greater London Record Office (*hereafter* GLRO): MJ/SR/2344, New Prison list; Friedli, *Sexual Underworlds*, p. 259 n. 66; *Annual Register*, 16 (1773), 111, 20 (1777) 191–2; *London Chronicle* (22–25 March, 5–8 April 1760).

14. *London Chronicle* (16–18 February 1764); for East: *Annual Register*, 9 (1766), 116, 144; *London Chronicle* (7–9 September 1766).

15. GLRO: MJ/SR/2023, Westminster house of correction list; MJ/SR/3462, R.480; Corp. of London R.O.: Mansion House Justice Room Minute Book (30 June 1790).

16. John Ashton, *Eighteenth Century Waifs* (London, 1887), 177–202; *The Female Soldier* (London, 1750), 71–73, 141–2, 103–5, 121–130 (her courting of women); *The British Heroine* (London, 1742), p. v; John Dryden, *Poems 1693–1696,* ed. A. B. Chambers et al. (Berkeley, 1974), Satyr VI, 369–70. Since cases of passing women can be hard to find, I list some who are not discussed in my text. They were found mostly in the *London Chronicle* (LC) between 1759 and 1765 but some are from the *Annual Register* (AR). 1) A woman in Edinburgh who served three years as a soldier, married a wife, and was discovered when under a cure in the infirmary (LC [7–9 June 1759], 548). 2) Barbara Hill who worked as a stonecutter, a farmer's servant, and drove a postchaise in London, married a woman, and was discovered when she enlisted in the

army (LC [31 Jan.–2 Feb. 1760], 117). 3) Betty Blandford enlisted in a regiment of horse, was discovered, discharged and sent to Bridewell (LC [5–7 Feb. 1760], 134). 4) Hannah Whitney at Plymouth served five years as a marine and discovered her gender to escape prison (AR 4 [Oct. 1761], 170). 5) A woman discovered on a ship at Plymouth who was going to look for her husband (AR 4 [Aug. 1761], 144). 6) Ann Holt enlisted to search for her sweetheart whom she found and married (LC [21–23 July 1763], 79). 7) A girl in Surrey stole cattle when dressed as a boy; she was mad (LC [5–8 Oct. 1765], 336, [22–24 Oct. 1765], 392). 8) A woman enlisted in the East-India Company to go looking for her husband in India (AR 12 [Nov. 1769, 148]). 9) A woman on a man-of-war at Chatham came to London from Hull looking for her sweetheart (AR 14 [Jan. 1771], 71). 10) Mrs. Cole died at Poplar after serving on ships as a sailor; she became a woman again on inheriting a small fortune (AR 25 [Sept. 1782], 221). 11) A woman served for fourteen years in the dockyards at Deptford, but was now married and had children (LC [28–31 July 1787], 199). 12) A man convicted of horse-stealing at Stafford was a woman (LC [6–8 Sept. 1791], 238). 13) Jane Cox of Piddle was found drowned; she had been very tall and strong and had served for many years as a sailor and a soldier (LC [29 Jan.–1 Feb. 1791], 110). There are two patterns in this material: women searching for husbands and sweethearts; women looking for adventure or more interesting work. It is apparent that those women who stayed in civilian life were less likely to be found out than those who enlisted in the army or the navy. There is little evidence of attraction to women as a motive: two of the thirteen married women, one courted a young woman. Four of them were married to men.

17. *The Genuine History of . . . Sally Salisbury* (London, 1723), 33; *London Chronicle* (28–31 Jan. 1764); *Appleby's Original Weekly Journal* (8 August 1719); GLRO: DC/C/172, f. 105; Charlotte Charke, *Narrative of the Life* (London, 1755), 88, 90, 139, 273, Scholars' Facsimiles edition by L. R. N. Ashley (Gainesville, FL, 1969); Fidelis Morgan, *The Well-Known Troublemaker: A Life of Charlotte Charke* (London, 1988), 129–130, 206–207.

18. Charke, *Narrative*, 190–1, 198, 206, 214, 224, 226, 245, 274 (Mr. & Mrs. Brown); 106–113, 162–4 (courting women); 91–2, 94, 144 (a favorite with the whores); 17, 26, 29–33 (her early years); 51–77 (her first marriage); 139, 258 (her family's reaction). Friedli, *Sexual Underworlds*, 242 cites her novel *The History of Henry Dumont* (1756), 60, 66–7. See also, S. M. Strange, "Charlotte Charke: transvestite or conjurer," *Restoration and 18th-Century Theatre Research*, 15 (1976), 54–59, who tries to distance Charke from the transvestite role by stressing that she made her career playing breeches' parts (or male roles) on the stage. But going about constantly in male clothes was a quite different matter, as her family were aware. It was a practice that tied her to the patterns of life of the cross-dressing woman which were quite separate from those of the theatrical world. Furthermore, by transvestism Strange probably means the modern sapphic role not the eighteenth-century passing woman. On the breeches' part, see Pat Rogers in *Sexuality in Eighteenth-Century Britain,* ed. P. G. Boucé, (Manchester, 1982), and Kristina Straub in this present volume.

19. H. Montgomery Hyde, *The Love That Dared Not Speak Its Name* (Boston, 1970), 37–40.

20. Mary Delariviere Manley, *Novels,* ed. Patricia Koster (Gainesville, 1971), 2 vols.: I cite the pages of the 18th-century edition.

21. John Cleland, *Memoirs of a Woman of Pleasure* (1748–9), ed. Peter Sabor (New York, 1985); for "lying in state," see the expert testimony of that accomplished libertine, Colonel Francis Charteris, *Select Trials at the Sessions House of the Old Bailey* (London,

1742), 4 vols., III, 199, 206, Garland reprint, ed. R. Trumbach (New York, 1985); the numbers of men with two women come from my research on London prostitution; H. F. B. Compston, *The Magadalen Hospital* (London, 1917), 62, n. 2.

22. *Private Correspondence of Sarah Duchess of Marlborough* (London, 1832), 2 vols., I, 253; *Horace Walpole's Correspondence*, ed. W. S. Lewis, et al. (New Haven, 1937–1983), 48 vols. XX, 53, IX, 171 and n. 8.

23. *Tractatus*, 41–2; Henry Fielding, *The Female Husband* (London, 1746), 21, 23; Baker, "Fielding's *Female Husband*," 220, 222, 223. Jill Campbell's account of Fielding's interest in these matters misses two points. She fails to see: first that Fielding's concern with effeminate fops, beaus and castrati is to be set in the context of the emergence of the role of the effeminate male sodomite; and secondly that Fielding is trying to suggest that there is likely to appear a parallel role for women who have relations with other women, dress in men's clothes and use an artificial penis. The "Farinellos, all in wax" may explicitly have been (67) little dolls, but the pause in the dialog and the husband's hatred that his wife "should be fond of anything but himself," would strongly have suggested to the knowing that they were the same dildoes that figure so prominently in Mary Hamilton's story (" 'When men turn women': gender reversals in Fielding's plays," *The New Eighteenth Century*, ed. Felicity Nussbaum and Laura Brown [New York, 1987]). Terry Castle, "Matters not fit to be mentioned," notes Fielding's ambiguous feelings of attraction and disapproval toward the cross-dressing woman who uses a dildo.

24. Bianchi, *Vizzani*, trans. Cleland, 43, 34–35, 53–55. Faderman, *Surpassing Love*, saw that it was the usurpation of male prerogatives that was controversial. She was also aware that among libertines sex between women was acceptable when it did not exclude sex with men. But she placed the emergence of the lesbian role at the end of the nineteenth century and did not interpret her eighteenth-century material in the light of sodomite and sapphist roles.

25. *Thraliana; the diary of Mrs. Hester Lynch Thrale*, ed. K. C. Balderston (Oxford, 1951, 2nd ed.), 2 vols., pp. 595 n. 1, 949 and n. 3, 740, 850–1, 868 and n. 3, 922 (for women) and *passim* (for men).

26. Lewis, *Walpole's Correspondence*, XXIV, 234–5; Balderston, *Thraliana*, 1–2, 770, 949; *The Farington Diary*, ed. James Greig (London, 1921–7), 7 vols., I, 233–4; *A Sapphic Epistle from Jack Cavendish to Mrs. D***** ([1782]), 5. There is a biography of Mrs. Damer: Percy Noble, *Ann Seymour Damer: A Woman of Art and Fashion 1748–1828* (London, 1908): the tone of which is set on the first page by the statement that she was "irreproachable in moral character." The gossip about her sexual tastes may have begun as early as 1778 when Lady Sarah Lennox wrote that "as for the *abuse* she has met with, I must put such nonsense out of the question, and in everything else her conduct is very proper" (Countess of Ilchester and Lord Stavordale, *The Life and Letters of Lady Sarah Lennox 1745–1826* (London, 1902), 286). Mrs. Damer was the half-sister of the wife of Lady Sarah's brother. Lady Sarah seems to have been well informed about the details of the Damers' unhappy marriage and Mrs. Damer's early widowhood (250–252, 261–262). Horace Walpole, who was Mrs. Damer's godfather, was very circumspect in what he wrote of her. Walpole's biographers suppose that he fell in love with Mary Berry, but it is apparent that the really intense relationship in this circle was between Mary Berry and Mrs. Damer. See R. W. Ketton-Cremer, *Horace Walpole* (Ithaca, 1964); Brian Fothergill, *The Strawberry Hill Set* (London, 1983).

27. Mavor, *Ladies*, 73–99, 167–8, 196–9; on female friendship in the earlier period, see: Irene Q. Brown, "Domesticity, feminism, and friendship: female aristocratic culture and marriage in England, 1660–1760," *Journal of Family History*, 7 (1982), 406–424;

and also Janet Todd, *Women's Friendship in Literature* (New York, 1980). Faderman in her pioneering *Surpassing Love* began her discussion of the eighteenth century with a relatively brief treatment of hermaphrodites and passing women, but then dealt with most of her material under the rubric of romantic friendship. The sapphist role (and Mrs. Damer) was absent from her text. By contrast I devote the third section of this essay to sexual relations and not to friendship. It is likely that Butler and Ponsonby who figured so prominently in Faderman's account of friendship were in fact a sapphist development in the tradition of female friendship. Other female couples in the romantic tradition did not use the hermaphroditic dress that Butler and Ponsonby wore. Two other points in Faderman's discussion are open to question. She says that the libertine position on sex between women was a male one. But it is apparent that Mrs. Manley (who is not discussed by Faderman) was a libertine. Secondly, Faderman claims that romantic friendship was a psychic compensation in a world of loveless, arranged marriages. Brown argues on the contrary that such friendships should be understood in the contexts of domesticity and romantic marriage that Lawrence Stone and I have described: see Stone, *The Family, Sex and Marriage in England, 1500–1800* (New York, 1977), and Trumbach, *The Rise of the Egalitarian Family* (New York, 1978).

Some of the difficulties in interpreting female friendship when the language of male-female erotic love is used by one woman for another are laid out in Harriet Andreadis, "The sapphic-platonics of Katherine Philips, 1632–1664," *Signs* 15 (1988) 34–60. Alan Bray has tried to argue that the customs of male friendship can hardly be distinguished from those of erotic attraction between males: "Homosexuality and the signs of male friendship in Elizabethan England," *History Workshop Journal*, no. 29 (1990), 1–19: but he fails to distinguish friendship between two adult male equals from the desire of a man for an adolescent boy which was then the dominant form of sexual relations between males. Montaigne was aware that the inequalities of age in the latter sort of relationship made it more like the love of men for women than like the love between male equals: erotic attraction was presumed to flourish only across the divides of patriarchy—the old for the young, the male for the female, the powerful for the weak (see Montaigne cited in Faderman, 65). It may then be that Katherine Philips' use of the language of male-female love to describe her affection for women is not a sign of erotic attraction at all. Instead, it is an instance of a woman's acceptance of patriarchal subordination. Platonic friendships between women could not be described in the language of the non-erotic friendship between dominant male equals. Philips could use for women's friendship only the love language of subordination, which was usually an erotic language. Twentieth-century readers should always be aware that before 1700, the structures of patriarchy were in control of expressions both of friendship and of erotic attraction. The distinctions of heterosexuality and homosexuality, though they are so salient for us, did not exist for the seventeenth-century woman or man.

28. Isaac Kramnick, *The Rage of Edmund Burke* (New York, 1977), 83–87; *The Correspondence of Edmund Burke*, ed. T. W. Copeland and J. A. Woods (Chicago, 1958–78), 10 vols., VI, ed. Alfred Cobban and R. A. Smith, 130–2. Discussions of the sapphic tastes of Marie Antoinette may be found in two recent essays and the further literature they cite: Jeffry Merrick, "Sexual politics and public order in late eighteenth-century France: the *Memoires secrets* and the *Correspondence secrète,*" *Journal of the History of Sexuality* 1 (1990), 68–84; Lynn Hunt, "The many bodies of Marie Antoinette: political pornography and the problem of the feminine in the French revolution,"

Eroticism and the Body Politic, ed. Hunt (Baltimore, 1991). It is likely that some of this material is evidence for the development in France of a late eighteenth-century sapphist role. See Marie-Jo Bonnet, *Un choix sans équivoque* (Paris, 1981). For what it is worth, Marie Antoinette approved of Mrs. Damer when she met her: Lewis, *Walpole's Correspondence,* VI, 127.

6

The Guilty Pleasures of Female Theatrical Cross-Dressing and the Autobiography of Charlotte Charke

Kristina Straub

A curious shift in theatrical cross-dressing took place in late seventeenth-century England. For a variety of complex reasons still being explored by some of our most interesting critics of sexuality and gender in the theater,[1] the tradition of boys playing women's parts on the stage became at best an outmoded fashion and at worst an unacceptable breach of gender boundaries for contemporary audiences. At the same time, of course, women entered the acting profession to play women's characters. A growing capacity to perceive gender ambiguity and to find it troubling did not, however, result in the prohibiting of female theatrical cross-dressing, as it did in the limitation of the masculine version to travesty. The cross-dressed actress came into a fashion that lasted, not without changes, throughout the century. Whereas obvious travesty was crucial to the acceptance of male cross-dressing on the early eighteenth-century stage (the actor must be seen as a bad parody of femininity), it seems to have become so for female cross-dressers only in the second half of the century. At mid-century, commentary on female theatrical cross-dressers suggests that the ambiguity which was then intolerable when associated with a male was in fact part of the fun of seeing women in breeches. By the end of the century, discourse about the cross-dressed actress is both more condemnatory of the practice (which was still, however, tolerated) and more insistent that female cross-dressing, like the male, was mere travesty, an obvious parody which left gender boundaries unquestioned.

The cross-dressed actress of the early to mid-eighteenth-century seems to constitute an historical possibility for pleasure in sexual and gender ambiguities. This possibility calls into question the naturalness of an economy of spectatorial pleasure that works on the premise of rigid boundaries between categories of gender and sexuality—male/female, hetero/homosexual. It asks us to unpack dominant constructions of the commodified feminine spectacle as unambiguously oppositional and other to a spectatorial, consuming male gaze.[2] Pat Rogers argues that the eighteenth-century female theatrical cross-dresser was part of a specular economy that fits our present assumptions of an objectified femininity in binary opposition to a masculine gaze. While Rogers is correct up to a point, I will argue here that the commodification of the cross-dressed actress was in fact a good deal more complicated in its audience appeal and that, hence, the cross-dressed actress is less a confirmation than a challenge to modern assumptions about the gendering of spectacle.

Popular discourse about the cross-dressed actress suggests that in mid-century England the female theatrical cross-dresser did not fit the constructions of gender and sexuality that would seem to render natural two key concepts in the modern sex/gender system: 1. the subjugation of a feminine spectacle to the dominance of the male gaze, and 2. the exclusive definition of feminine sexual desire in terms of its relation to masculine heterosexual desire. The autobiographical *Narrative of the Life of Mrs. Charlotte Charke* (1745), a notorious account of an actress who carried her masquerades in male clothes into her life off the boards, is a particularly powerful example of how the cross-dressed actress might function in a way discursively at odds with these two concepts.

The obvious reason for dressing actresses in men's clothes at the end of the seventeenth century is virtually the same as one of the reasons for putting women on the stage at all: conventionally attractive female bodies sell tickets. Judith Milhous documents the popularity of female cross-dressing on the stage during the Restoration and links it to economic competition between the licensed London theaters.[3] Sometimes competing managers did not stop with casting single roles, but rather, as James Wright's history documents, presented whole plays "all by women, as formerly all by men" (cliii). The same incentive seems to have motivated John Mossop to cast the actress Catley as

Macheath during the keen competition between theaters in Dublin at mid-century (Hitchcock II: 135), and Tate Wilkinson, as a manager, clearly had receipts in mind when, in the 1795 *Wandering Patentee*, he refers to actresses who look well in the "small clothes." One might say truthfully that the cross-dressing actress was, in the last instance, economically motivated, an example of the commodification of women in emergent capitalist society. But this commodification itself cannot be reduced to the specularization of women within the structuring principle of the masculine observer and the feminine spectacle, an epistemological and psychological principle which may have been only emergent at this moment in history. The commodification of the cross-dressed actress embodied ideological contradiction about the nature of feminine identity and sexuality; contemporary discourse about this commodification yields a complex picture of what, exactly, is being marketed.

First, as long as the cross-dressed actress was "packaged" as a commodity for the pleasure of her audience, responses to her suggest that her marketability had as much to do with a playfully ambiguous sexual appeal as with the heterosexually defined attractions of her specularized feminine body. Duality is part of the sexual appeal of the cross-dressed Margaret Woffington, one of the eighteenth century's most written-about cross-dressers. Woffington's 1760 memoir records the reaction of both sexes to her first appearance as Harry Wildair in *The Constant Couple*; the men, it is said, were charmed, and the "Females were equally well pleased with her acting as the Men were, but could not persuade themselves, that it was a Woman that acted the Character" (22). Woffington's ambiguity is presented as a commodity in which the audience takes great pleasure:

> When first in Petticoats you trod the Stage,
> Our Sex with Love you fir'd, your own with Rage!
> In Breeches next, so well you play'd the Cheat,
> The pretty Fellow, and the Rake compleat—
> Each sex, were then, with different Passions mov'd,
> The Men grew envious, and the Women loved.
> <div align="right">(Victor III:4–5)</div>

Similarly, a 1766 memoir of James Quinn declares that "it was a most nice point to decide between the gentlemen and the ladies,

whether she [Woffington] was the finest woman, or the prettiest fellow" (67–8).

Some of the pleasure afforded by the spectacle of the cross-dressed actress arose, then, out of the doubling of sexual attraction. The actress in men's clothes appeals to both men and women—at least as a specular commodity. This double appeal, however, depends on its containment as a theatrical commodity; offstage in the "real" world, the cross-dressed actress was usually represented in the tradition of women who dressed as men for the arousal and/or gratification of heterosexual male desire (Dekker and van de Pol, 54). Popular stories about the adventures of actresses who cross-dressed out of role nearly always bracket their ambiguous sexual appeal in a narrative that privileges both an exclusively heterosexual desire and the actress' function therein. *The Comforts of Matrimony* reports that Susannah Maria Cibber cross-dressed off the stage in order to facilitate her amour with William Sloper (24). Susanna Centlivre's quasi-mythical affair with Anthony Hammond was allegedly carried out by her posing as his younger "Cousin Jack" and living with Hammond while he was a student at Oxford (Mottley 185–6; Dibden, *Complete History* II: 313). Catherine Galendo draws on this tradition when she accuses Sarah Siddons of learning the role of Hamlet in order to have the excuse to take fencing lessons from, and consequently to seduce, her husband Mr. Galendo (16).

In another story, Woffington is said to have caused her female rival for a male lover's affections to fall in love with her, but the narrative sets this "confusion" of gender roles and sexual object choice in the context of the actress' efforts to foil her lover's infidelities. These narratives effectively define the "safe" limits of the cross-dressed actress' ambiguous appeal; as a specular commodity, the gender and sexual confusion associated with the actress could be a source of pleasure as long as it did not contaminate or compromise dominant narratives of heterosexual desire.

Eighteenth-century discourse about the cross-dressed actress evinces an unqualified pleasure in sexual confusion only when that confusion is "for sale" as a theatrical commodity, an obviously artificial construction. A slightly guilty pleasure in the sexual and gender confusion embodied in the cross-dressed actress is balanced against recuperations of her gender-bending within dominant sexual ideologies. This recuper-

ative discourse often reveals, however, the very anxieties that it seeks to allay. By the mid-eighteenth century, the cross-dressed actress is the focus of rules and strictures that seek to confine her pleasurable ambiguities of sex and gender to a narrowly defined phenomenon, an illusion to be bought and kept within the marketplace of the theater. This discourse of containment voices a "monstrosity" with which the sexually ambiguous actress flirts and reveals an incipient threat to heterosexual male dominance implicit within the pleasurable ambiguity of the cross-dressed actress.

Despite the pervasiveness and popularity of the custom, commentators on cross-dressing actresses express an uneasiness about this phenomenon that can be read in their desire, by mid-century, to contain it within decorous rules, to defuse the threat of this otherwise entertaining ambiguity by referring it to a "natural" standard or social "law." This discourse of containment also speaks, however, the fears that it seeks to allay. Besides framing the pleasure afforded by the cross-dressed actress within proscriptive rules, it articulates, I would argue, the sources of anxiety about that pleasure. First, it gives voice to fears about the stability and certainty of an emergent dominant definition of masculine sexuality as it is reflected (and refracted) in the cross-dressed female's image. Second, it speaks fears that femininity may itself exceed the limits of privacy and domesticity that would seem, in dominant ideologies, to define it. In short, the cross-dressed actress is seen as threatening to the construction of a stable oppositional relationship between male and female gender and sexuality.

Biographical discourse about cross-dressing actresses becomes increasingly condemnatory by the early nineteenth century. James Boaden refers unequivocally to "vile and beastly transformations" in 1825 (*Kemble* II:334); his repulsion at female theatrical transvestism seems to reflect the emergent consciousness of a category for "deviate" female sexuality that is documented by Randolph Trumbach's essay in this volume. But even as early as 1761 one can read an incipient uneasiness with the ideological effects of female theatrical transvestism. Benjamin Victor, a London theater prompter and manager of one of the Dublin theaters during the age of Garrick, reveals even more clearly what is veiled in Boaden's Victorian prose on the subject: fears about the integrity and "naturalness" of feminine gender identity. His discussion of Woffington's famous role of Sir Harry Wildair candidly states

the economic motive—"she always conferred a Favour upon the Managers whenever she changed her Sex, and filled their Houses"—the cross-dressed actress as pleasurable and lucrative commodity. But he sets limits on this form of commodification: "And now, ye fair ones of the Stage, it will not be foreign to the Subject, to consider whether it is proper for you . . . to perform the Characters of Men. I will venture in the Name of all sober, discreet, sensible, Spectators . . . to answer *No*! there is something required *so much beyond the Delicacy of your Sex*, to arrive at the Point of Perfection, that, if you hit it, you may be condemned as a Woman, and if you do not, you are injured as an Actress" (my emphasis, II:4; 5–6). To masquerade as a man, and to do it too well, is to enter a no-woman's-land "beyond" femininity, to exceed the limits of "delicacy."

Furthermore, this trespassing beyond the limits of femininity may lead to ambiguities in sexual object choice that Victor plainly finds disturbing as he continues to address his hypothetical "fair ones of the Stage": "supposing you are formed in Mind, and Body . . . like the Actress in Question—for she had Beauty, Shape, Wit, and Vivacity, equal to any theatrical Female in any Time, and capable of any Undertaking in the Province of Comedy, nay of deceiving, and warming into Passion, any of her own Sex, if she had been unknown, and introduced as a young Baronet just returned from his Travels—but still, I say, admirable and admired as she was in this Part, I would not have any other Female of the Stage attempt the Character after her" (III:6). Victor's nervousness focuses on the sexual as well as gender ambiguity of Woffington in male dress; she is clearly an object of desire, but the question of who might desire her is carefully hedged in the hypothetical—"*if* she had been unknown." Finally, however, he does not, like Boaden, condemn actresses in male dress, but rather retreats from the hypothetical threat of Woffington as ambiguous sexual object to the relative safety of theatrical tradition and rule: "the wearing of Breeches merely to pass for a Man, as is the Case in many Comedies, is as far as the Metamorphosis ought to go, and indeed, more than some formal Critics will allow of; but that custom is established into a Law, and as there is great Latitude in it, it should not be in the least extended—when it is, you *o'erstep the Modesty of Nature*, and when that is done, whatever may be the Appearance within Doors, you will be injured by Remarks and Criticisms without" (III;7). Victor seems to have in mind

characters, such as Rosalind, whose masquerades as men are clearly represented *as* masquerades to the audience. By designating female transvestism as a specific form of theatrical illusion, Victor limits the threat of Woffington's ambiguous attractions; but he goes beyond this designation to demand that the illusion be presented as an illusion—further distancing the threat—and containing the ambiguity of the cross-dressed actress within a decorum of theatrical representation.

Later writers on the theater apparently want to exclude ambiguity altogether, not being content with containing it within rules. When ambiguity resists erasure, they often simply insist, all logic and evidence to the contrary, that it confirms the very gender definitions it would seem to problematize. William Cooke writes in 1804 that female cross-dressing should not leave room for any ambiguity. "Where a woman . . . personates a man *pro tempore* . . . the closer the imitation is made, the more we applaud the performer, but always in the knowledge that the object before us is *a woman assuming the character of a man*" (*Macklin* 126). Unlike Victor, however, who allows for ambiguous sexual attraction in Woffington's impersonation, Cooke dismisses even the possibility of the successful illusion of a woman assuming a masculine position in the sexual economy: "when this same woman totally usurps the male character, and we are left to try her merits merely as a man, without making the least allowance for the imbecilities of the other sex, we may safely pronounce, there is no woman, nor ever was a woman, who can fully supply this character. There is such a *reverse* in all the habits and modes of the two sexes, acquired from the very cradle upwards, that it is next to an impossibility for the one to resemble the other so as totally to escape detection" (*Macklin* 126). By 1800, theater historians and biographers tend to exclude the ambiguity that Victor barely admits within the "rules" of cross-dressing. Boaden writes of Siddons' Hamlet (which he never saw), that "the unconstrained motion would be wanting for the most part; modesty would be sometimes rather untractable in the male habit, and the conclusion at last might be, 'were she *but* man, she would exceed all that man has ever achieved in Hamlet' " (*Memoirs of Mrs. Siddons* I: 283). Of Dorothy Jordon playing the part of William in Brooke's *Rosina*, Boaden confidently asserts that "Did the lady really look like a man, the coarse *androgynus* would be hooted from the stage" (*Life of Mrs.*

Jordan I:46), and reads Woffington's famous Wildair through his observations of Jordan:

> When Woffington took it up, she did what she was not aware of, namely, that the audience permitted the actress to *purify* the character, and enjoyed the language from a woman, which might have disgusted from a man speaking before women. . . . I am convinced that no creature there supposed it [Woffington a man] for a moment: it was the *travesty*, seen throughout, that really constituted the charm of your performance, and rendered it not only gay, but innocent. And thus it was with Mrs. Jordan, who, however beautiful in her figure, stood confessed a perfect and decided woman; and courted, intrigued, and quarrelled, and cudgelled, in whimsical imitation of the ruder man. (*Life of Mrs. Jordan* I:127)

Rather incredibly, Boaden writes of Woffington's trespasses into the discourse of a rake as if they were attempts to clean up scenes in which the male character talks of sex to a woman. The cross-dressed actress is made to serve the dominant construction of separate spheres for men and women even as she would seem to trespass against that separation.

This erasure of sexual ambiguity is more characteristic of biographical texts late in the century. At mid-century, attempts to contain female cross-dressing within rules of tradition or "nature" tend more often to name what they seek to exclude. *The Actor* (1750) explicitly targets the sexual content of Woffington's impersonation as objectionable: "We see women sometimes act the parts of men, and in all but love we approve them. Mrs. Woffington pleases in Sir Harry Wildair in every part, except where she makes love; but there no one of the audience ever saw her without disgust; it is insipid, or it is worse; it conveys no ideas at all, or very hateful ones; and either the insensibility, or the disgust we conceive, quite break in upon the delusion" (202). The choice between "no ideas at all, or very hateful ones" sums up the two-pronged threat implied in female cross-dressing, a threat that is both expressed and contained by the biographical discourse we have been examining. First, the spectacle of women representing masculine sexuality summons the threat of a nondominant, nonauthoritative— even impotent—masculinity. Women assuming masculine sexual perogative are "insipid," and their love-making "conveys no ideas at all"; they are, in short, failed men, and, as such, would seem to offer no

threat whatsoever to masculine sexuality. But, as I will argue, the "castrated" figure of the cross-dressed actress is also capable of holding a mirror up to masculinity that reflects back an image of castration that cannot be entirely controlled by the mechanisms of projection. When the actress puts on masculine sexuality, even as she functions as its object of desire, she opens possibilities for challenging the stability and authority of that sexuality.

Second, the actress in male dress summons up, in the very act of specularizing the feminine object of desire, the "hateful" idea of a feminine sexual desire that exceeds the limits of "normal" heterosexual romantic love. The "Tommy," as Trumbach says, is a category for "deviate" feminine sexuality that seems to emerge late in the eighteenth century. Homophobia can certainly be seen, in chillingly recognizable forms, in Cook's denials of sexual or gender ambiguities in cross-dressed performances or in Boaden's disgust at "vile and beastly trans-formations." But even as early as mid-century, discourse about female theatrical cross-dressing evinces an awareness that feminine sexuality and gender identity could stray beyond the boundaries that were com-ing to define the sphere of feminine feeling and behavior as man's commensurate and oppositional other. The cross-dressed actress points to a feminine desire in excess of this role, and in this case that desire is explicitly sexual. The cross-dressed actress threatened the apparent naturalness and stability of what was becoming dominant gender ideol-ogy by suggesting a feminine sexuality that exceeded the heterosexual role of women.

Charlotte Charke's autobiographical *A Narrative of the Life of Mrs. Charlotte Charke* (1746) incorporates many of the characteristics of the cross-dressed actress in another commodity guise: Charke, badly in need of money, gives a textual performance of her adventures in male clothes. Charke was the daughter of the actor Colley Cibber, and an unsuccessful actress of male roles who went through an exhausting number of professions in her attempts to support herself and her daughter. Sausage-vender, puppet-master, pig farmer, waiter, and gen-tleman's gentleman, as well as actress and author, Charke was a self-proclaimed "Proteus" whose special talent seems to have been for acting out a complete instability of roles.

Instability also comes into play in the question of sexual object in

her text. After her marriage and separation at a young age, Charke's romantic encounters in the *Narrative* consistently involve a smitten woman who mistakes Charke's gender. While she claims never to have taken the "male perogative" in love, Charke's text refuses the common recuperative strategy of framing the sexually ambiguous cross-dressed woman in a heterosexual narrative. By refusing to resolve the sexual ambiguities of her textual performance by giving her audience either a heterosexually defined romantic heroine or a "monstrous" female husband, Charke fails to participate in what was becoming the dominant construction of feminine sexuality: the woman as oppositional, defining other to male sexuality. Her masquerades in male dress refuse dominant sexuality in two respects. First, they gesture towards the performative nature of male sexuality, questioning its "naturalness" through strategic mimicry. Second, they elude both the strategies of recuperation and marginalization by rhetorically evoking and refusing the most dangerous resolution of sexual ambiguity—the "monstrous" figure of the female husband.

Charke's actual as well as figurative cross-dressing in the text parodies masculinity in the specific form of her father, the infamous Cibber. Actors often embodied outlaw, at best ambivalent forms of masculine sexuality in the eighteenth century, and Cibber's old-fashioned rakishness, combined with his homoerotic subservience to aristocratic male patrons, had already established him as marginal to dominant masculinities at mid-century.[4] Charke's mimicry of what was already an increasingly marginalized version of masculinity resists the ideology of a dominant masculinity based on its authoritative opposition to the "feminine." Charke's textual cross-dressing acts out with a vengeance a threat posed by the cross-dressed actress as a reflection of "failed," ideologically inadequate masculinities. Feminist psychoanalytic theory provides a modern analogue to the implicit threat that the cross-dressed actress posed to the dominant version of masculinity. The "insipid," sexually impotent actress in rake's clothes calls attention to the conditional nature of virility in much the same way that the "castrated" woman gestures towards the instability of phallic masculinity in psychoanalytic theory.

Kaja Silverman writes that a potential for reminding men of the tenuousness of the connection between the penis and phallic control is implicit in the psychoanalytic mechanism by which men project their

fears of castration onto women as "castrated" men. "It is hardly surprising," she says, "that at the heart of woman's otherness there remains something strangely familiar, something which impinges dangerously upon male subjectivity. From the very outset, the little boy is haunted by this similitude—by the fear of becoming like his sexual other. That fear . . . indicates that what is now associated with the female subject has been transferred to her from the male subject, and that the transfer is by no means irreversible" (*Acoustic Mirror* 17–18). The cross-dressed woman would seem to be a particularly poignant reminder of this reversibility. If we think of the eighteenth-century phenomenon of anxiety about the cross-dressed actress in these terms, we can see why the actress who takes on a masculine role in the representation of sexuality must be doubly surrounded by a discourse that brands her as "insipid"—or castrated. Otherwise, she hints too strongly at the reversibility of transference and the instability of the sexual roles that make that transference possible.

The function of woman as the mirror in which man glimpses his own castration is useful in thinking about an eighteenth-century cultural phenomenon that intersects with that of the cross-dressed actress. Nancy Armstrong has convincingly argued that the eighteenth century saw the development of an oppositional system of sex and gender wherein the definition of masculinity is increasingly dependent upon its feminine other. What Silverman points out about the modern psychoanalytic relation between man and his "castrated" feminine counterpart suggests that anxiety about masculinity may be implicit in such oppositional structures of gender and sexuality as were emergent in the eighteenth century. Hence, it is not surprising to see in the latter half of the eighteenth century a recurrent, almost obsessive discourse against the "masculinization" of women. The widespread critique of women who dressed and behaved in too masculine a fashion is an aspect of the emerging construction of femininity along domestic and private lines. But the insistence that women conform to an increasingly rigid definition of femininity is also, as Armstrong suggests, linked to the formation of a masculinity increasingly posed as the opposite of that definition.[5] Mid-century discourse links anxieties about the masculinization of women to worries about the feminization of men—or, to be more precise, the latter's "deviance" from dominant masculinity.

The masculinized woman is, literally, a mirror image of the castrated man.

George Colman writes, just after mid-century, that "in the moral system there seems at present to be going on a kind of Country-Dance between the Male and Female Follies and Vices, in which they have severally crossed over, and taken each other's Places. The Men are growing delicate and refined, and the Women free and easy" (II: 87–88). Colman follows this statement with a series of gender reversals that culminate in a sexually "deviate" masculine figure which seems to be the dark heart of reversal. Women rape men, men are kept by women, but the figure that results from this "Country-Dance" is that of the macaroni: "There is a kind of animal neither male nor female, a thing of the neuter gender, lately started up amongst us. It is called a Macaroni" (II: 88–91). The primary fear that emerges from this discourse of anxiety about gender reversal is summed up in the figure of the "thing" that eludes dominant structures of gender definition: the male who fails to assume his "masculine" role, in Arthur Murphy's terms, "the pretty gentlemen, who chose to unsex themselves, and make a display of delicacy that exceeded female softness" (*Garrick* I: 118).

In this discourse of reversal, the masculinized woman is a divining rod for detecting the failure of men to live up to the demands of dominant masculinity. In *The Male Coquette* a cross-dressed female character exposes the falseness of the "male coquette"; the moral of the play, according to Murphy, is that while "Coquetting in the fair is loss of fame; / In the male sex [it] takes a detested name, / That marks the want of manhood, virtue, sense, and shame" (I:309). Aaron Hill's earlier prologue to *Euridice*, spoken by "Miss Robinson, in boy's cloaths," specifically makes the cross-dressed actress into a rhetorical device for attacking "failed" masculinity:

> ... farewell[l] to *petticoats*, and *stitching*; And welcome dear, dear *breeches*, more bewitching! Henceforth, new-moulded, I'll rove, love, and wander, And fight, and storm, and charm, like *Periander*. Born, for this *dapper age*, pert, short, and clever, If e'er I grow a *man*, 'tis now, or never. Should I *belov'd*—'gadson—how then—no matter, I'll bow, as *you* do—and *look foolish* at her. And so, who knows, that never

meant to *prove* ye, But I'm as *good a man*, as any of ye (*Works* II:334–35)

The encroachments of the cross-dressed actress upon the territory of masculine sexuality are especially threatening since they seem to imply the inability of men to hold that territory.

Charke's mimicry of Cibber plays on anxieties about masculine identity that are implicit in discourse about cross-dressed actresses. Sidonie Smith has argued that the *Narrative* reveals Charke's failure to "be a man" (110–11), to assume and use the authorial power invested in masculinity. I would suggest that Charke's "failures" at putting on masculinity are, in fact, parodic repetitions of some of her father's more infamous differences from an authoritative, heard-but-not-seen masculine subject. Charke puts on the guise of masculinity in order to put her father on, and in the process she gestures towards a performative, "unnatural" masculinity that unsettles newly dominant assumptions about gender as legitimized according to fixed and opposi-tional categories.

The theatrical contexts of Charke's *Narrative* were more than usu-ally hospitable to the production and reception of mimicry. First, an autobiography by an actress who was well known for playing parodic versions of her father for Henry Fielding at the Haymarket created its own context for reading Charke's cross-dressing in relation to Cibber. Second, the practice of players mimicking other players on stage was a well established custom in which Charke herself took an enthusiastic part. Finally, Charke simply joined something of a family tradition by mimicking her father in print. As a parody of Cibber's memoirs, Charke's *Narrative* followed Ralph and Fielding's "Apology" for the life of her brother, Theophilus, one of many print attacks on her father. After Theophilus's fake *Apology*, no emulation of Colley Cibber could go innocent into the world. Charke's literary cross-dressing works across the contexts of both theatrical mimicry and feminine theatrical cross-dressing. Both contexts frame her autobiography as an unsettling representation of a daughter aping a father whose masculinity was already becoming questionable within dominant gender ideology.

The *Narrative* repeats portions of Cibber's *Apology*, with Charke picking up and putting on many of her father's most distinctive pos-tures. Early in the text she literalizes these more literary imitations of

her father through the account of her cross-dressing in imitation of her father at "four Years of Age":

> Having, even then, a passionate Fondness for a Perriwig, I crawl'd out of Bed one Summer's Morning at *Twickenham*, where my Father had Part of a House and Gardens for the Season, and, taking it into my small Pate, that by Dint of a Wig and a Waistcoat, I should be the perfect Representative of my Sire, I crept softly into the Servants-Hall, in Order to perpetuate the happy Design I had framed for the next Morning's Expedition. Accordingly, I paddled down Stairs, taking with me my Shoes, Stockings, and little Dimity Coat which I artfully contrived to pin up, as well as I could, to suppy the want of a Pair of Breeches. By the help of a long Broom, I took down a Waistcoat of my Brother's, and an enormous bushy Tie-wig of my Father's, which entirely enclosed my Head and Body, with the Knots of the Ties thumping my little Heels as I marched along, with slow and solemn Pace. The Covert of Hair in which I was concealed, with the Weight of a monstrous Belt and large Silver-hilted Sword, that I could scarce drag along, was a vast Impediment in my Procession: And, what still added to the other Inconveniences I laboured under, was whelming myself under one of my Father's large Beaver-hats, laden with Lace, as thick and broad as a Brickbat. (17–18).

In one sense, cross-dressing in this passage is fraught with debilitating contradictions: Charke seems, literally, weighed down by her attempt to put on her father's authority. She marches up and down in a ditch to conceal her girl's shoes, and "walked myself into a Fever, in the happy Thought of being taken for the 'Squire" (19). The joke is on her, in that respect, but not only on her, I would argue.

In his *Apology*, Cibber also struts his stuff in a periwig which took on the status of a trademark in his career. Cibber recounts his meeting with the young blade Henry Brett as taking place on account of such a wig: "And though, possibly, the Charms of our Theatrical Nymphs might have their Share, in drawing him thither; yet in my Observation, the most visible Cause of his first coming, was a sincere Passion he had conceiv'd for a fair full-bottom'd Perriwig, which I then wore in my first Play of the *Fool in Fashion*, in the Year of 1695." Cibber goes on to eroticize the wig even further by comparing Brett's "attack" on his wig to that of "young Fellows . . . upon a Lady of Pleasure" (202). Charke's choice of her father's periwig as her object of desire is hard to read as innocent of these associations, particularly since the main

source of the joke on herself—the disparity between her little body and the huge wig—echoes a similar disparity between Cibber and his famous headpiece. Lord Foppington's periwig in Vanbrugh's play is spoken of as engulfing Cibber just as it engulfed his daughter; Cibber's character wears it down to his "heels," covering all, as he says, but his eyes. Pope trotted out the same wig in his notes to the 1742 *Dunciad*, quoting the passage above from the *Apology*, with the additional information that "This remarkable Periwig usually made its entrance upon the stage in a sedan, brought in by two chairmen, with infinite approbation of the audience" (728).

The joke was further compounded by the popular association of the full-bottomed periwig with actor's narcissism and exhibitionism. Joe Haines is depicted in an early eighteenth-century engraving speaking his famous prologue seated upon an ass; both actor and ass sport fine examples of the flowing wig. By Charke's time, the full-bottomed periwig was considered old-fashioned, and actors who continued to wear them were considered ridiculous. Charke's "fondness" for a periwig reads in this context more like a parodic comment on her father's earlier professional pose as Lord Foppington than like a serious desire to emulate her father.

Charke's parodic restaging of Cibber's masculine masquerade makes female transvestism as much about the ambiguity of masculine sexuality as about a woman's failed attempt to put on masculine authority. Her mimicry of her father's text marks her own distance from the masculine role she puts on, but it also marks that role *as a role*, gestures towards the artificiality—and tenuousness—of the masculinity that she, in turn, puts on. Charke's cross-dressing indicates her failure to be her father, but it also throws into relief the constructed, ambiguous, and even self-parodying nature of that father's authority.

Charke evokes the powerful trope of paternal authority (and her own daughterly devotion) only to present scenarios that explode the gendered constructions of father and daughter. She tells us, for example, of a rumor in circulation ("a most villainous Lye") that she had turned highwayman and robbed her father at gunpoint, reducing him to tears and promises of reconciliation by her threat to "discharge upon him." She comments that this is "a likely Story, that my Father and his Servants were all so intimidated, had it been true, as not to have been able to withstand a single stout Highwayman, much more

a Female, and his own Daughter too!" As Sidonie Smith points out, this ostensible attempt to save her father's reputation leaves Cibber "emasculated, even 'feminized' " (116). Charke's revenge on the conveyor of this story further confuses the question of what is proper daughterly behavior: "I rushed out from my Covert, and, being armed with a thick oaken Plant, knocked him down, without speaking a Word to him; and, had I not been happily prevented should, without the least Remorse, have killed him on the Spot" (114–15).

Similarly, Charke tells us another story about slapping her father in the face with a fish she was selling—to deny it, of course. All this flailing about with guns and fish contradicts her otherwise reverential tones towards her father's authority, but it is not that her performances in male drag are so successful; it is rather that they call into question whether *anybody's* are successful. If Charke fails to come across like a "real" man, Cibber also fails as a "real" father. In another imagined confrontation with her father, Charke takes his rejection of her attempts to reconcile like "the expiring *Romeo*, '——— *Fathers have flinty Hearts! No Tears, / Will move 'em! ——— Children must be wretched!*' " (118). From there she is "empowered to say, with *Charles* in *The Fop's Fortune*, "I'M SORRY THAT I'VE LOST A FATHER' " (118), and finally compares herself to a rejected Prodigal Son. In all of these cases, Charke turns to an absurd posturing in male roles that mirrors back the failed masculinity of the "real man" in her text.

Charke's denaturalization of gender roles is, we should remember, taking place in a historical context in which, as Lynne Friedli says, "standards of masculinity may not have been very high" (250); that is, when the boundaries designating gender difference may have been far more fluid than in the nineteenth and twentieth centuries. Charke's gender-bending self-representations should not, then, be read as conscious resistance to fixed categories of gender and sexuality. Rather, they demonstrate the incomplete dominance as well as the emergence of a gender system that polarized masculine against feminine. Whatever the intention behind Charke's cross-dressing, its effect in her autobiography is to reveal possible confusions within a supposedly "natural" oppositional relation between the genders.

This shape-shifting allowed Charke to negotiate through mimicry an emerging body of ideology that fixed sexual differences within a heterosexuality that was growing increasingly exclusive in its terms.

Female theatrical cross-dressing, particularly at mid-century, constitutes a site of cultural resistance to this narrowing of masculine and feminine down to certain opposite, prescribed roles, even as it serves as one of the grounds of its construction. In this context, Charke's mimicry of male roles unsettles the oppositional gender structure upon which the emergent form of dominant masculinity depends. Her cross-dressing exploits in the *Narrative* also effect a confusion in sexual object choice that resists the recuperation into dominant heterosexuality which is usually the fate of the cross-dressed actress's ambiguous appeal. Instead, Charke sustains her sexual ambiguity against either recuperation or marginalization as a "monstrosity." The result is a text that may irritate, frustrate, or delight for its intractibility to dominant sexual ideologies.

The intractibility of this text can be read in both the irritation of eighteenth-century readers at its transgressions against their standards of feminine behavior and in more recent attempts to "discipline" it by labeling it as definitively "lesbian" or "heterosexual." At the turn of the eighteenth century, Charles Dibden called Charke a female Chevalier D'Eon and dismissed her as a social outlaw (*Complete History* V:94). John Mottley saw her cross-dressing as "indecent," although more for its transgressions against her father than for what it might suggest about her sexual object choice (235). For Lillian Faderman, in 1981, the *Narrative* offers evidence of lesbian activity in the eighteenth century (57 – 58). Fidelus Morgan's 1989 biography of Charke, on the other hand, seems to go out of its way, as Terry Castle points out, to argue for Charke's heterosexual credentials.[6] If the sexual ambiguities of Charke's on and off-stage performances in men's clothes worry her eighteenth-century readers, they both demand and resist labeling from her later readers. Whether the sexual ambiguities of Charke's cross-dressing create an undefined uneasiness or they lead to the renunciation or acceptance of the word "lesbian" seems to depend on the specific historical context of its reception. These ambiguities may, in any case, be the "point" of Charke's text, the problem or conundrum to which readers gravitate.

This recalcitrant ambiguity works as rhetorical resistance to dominant, male-centered models for same-sex feminine sexuality: the female husband and "lesbianism" as a prelude to or extension of sex with a man. The female husband, on one hand, made sex without a man both

imaginable and punishable. As Faderman, Vicinus, and Friedli point out, sexuality between women was usually detected and punished only when a woman usurped the masculine role in sex and/or marriage.[7] Dekker and van de Pol argue on the basis of impressive historical evidence that, despite these dangers, many women prior to the nineteenth century posed as men in marriage because dominant sexual ideology made sex without at least the appearance of a man unimaginable (57). On the other hand, cross-dressed women, including the actress, were recuperable within heterosexual narratives. Desire between women was either constructed without a penis, in which case it was recuperable, or constructed with a "penis" (or penis substitute) and brutally suppressed as a fraud.[8] Charke plays with the perceptual field defined on one hand by the cross-dressed actress (no penis) and on the other by the dangerous identity of the female husband (substitute penis). By playing one context off against the other, Charke represents same-sex desire in terms of an ambiguity incompletely "explained" by either context. Her cross-dressing refuses definition as heterosexual adventurism, as with a Centlivre, while stopping short of the dangerous oppositionality of the female husband. This double negation in effect calls into question the ability of either context and, concurrently, the penis/no penis distinction, to define Charke's sexuality.

Fielding's *The Female Husband*, published in 1746, the same year as the first edition of Charke's autobiography, is a good illustration of a dominant model of sexual perception by which "lesbianism" is defined in terms of a desire to usurp the sexual privileges accorded to heterosexual masculinity. In Fielding's text, a woman's desire for a woman is only culturally visible if it is seen as an imitation of a masculine sexuality that is itself defined exclusively by "straight sex," a specific deployment of the penis. Fielding's sensational fictionalization of the well-publicized case of Mary Hamilton, a woman tried and punished for the fraud of passing both publicly and privately, gives us a contemporary's notion of what, at mid-century, might have rendered female same-sex desire a perceived threat to male-dominated heterosexuality. Hamilton's sexual activity depends on a dildo to render it action at all. Fielding tells us that when one of Hamilton's wives grows "amorous," the "doctor" had not "*the wherewithal* about her" and "was obliged to remain nearly passive" (39). The "nearly" seems a bit of a hedge, as if to suggest that Hamilton did something, but not

something that counts as action to Henry Fielding. Hamilton cannot decisively act "like a man" without her "wherewithal." It is the discovery of "something of too vile, wicked and scandalous a nature, which was found in the Doctor's trunk" that finally renders Hamilton's "crime" socially intolerable and leads to her punishment. *The Female Husband* provides an alternative context to that of the cross-dressing actress for thinking about the representation of same-sex desire in Charke's *Narrative*. Hamilton's attempt to assume the social and sexual privileges accorded to men renders sexual ambiguity freakish, a source of voyeuristic pleasure tainted with horror. Fielding's female husband marks the divide at which pleasurable ambiguity becomes transgression.

Charke's *Narrative* incorporates elements of the female husband model for representing female same-sex desire that we see in Fielding's text. The title page identifies the *Narrative* with such a model by suggesting that its contents go beyond the heterosexual excesses of the cross-dressing actress: "Her Adventures in Mens Cloaths, going by the Name of Mr. *Brown*, and being belov'd by a Lady of Great Fortune, who intended to marry her." The *Narrative* sets up Charke's claim to male social and sexual privilege in the mode of the female husband, but its follow-through reaches back to the less threatening realm of performance and theatricality. Her affair with the "Lady" combines elements of the female husband's usurpation of a masculine position in romance with the theatricality of the actresses' transvestite performance. Charke's off-stage "performance" as an attractive young man has "real" results. Charke "appeared as Mr. *Brown* . . . in a very genteel Manner; and, not making the least Discovery of my Sex by my Behaviour, ever endeavouring to keep up to the well-bred Gentleman, I became, as I may most properly term it, the unhappy Object of Love in a young Lady . . . " (106).

Charke's account of the affair moves from the actress's vanity in a good performance to the material forms of power to which that performance could give her access. The lady, Charke tells us in concrete terms, is worth "forty thousand Pounds in the Bank of *England*: Besides Effects in the *Indies*, that were worth about twenty Thousand more" (107). Besides her wealth, the lady herself "was not the most Beautiful I have beheld, but quite the Agreeable; sung finely, and play'd the Harpsichord as well; understood Languages, and was a Woman of real

good sense" (112). Unlike a female husband's sexual charade, Charke's performance inevitably reveals itself as performance before any "damage" is done. But even the terms of disclosure gesture back to material conditions and "real" desires, both on the part of the performer of masculinity and her deluded "victim": The young lady "conceived that I had taken a Dislike to her, from her too readily consenting to her Servant's making that Declaration of her Passion for me; and, for that Reason, she supposed I had but a light Opinion of her. I assured her of the contrary, and that I was sorry for us both, that Providence had not ordained me to be the happy Person she designed me; that I was much obliged for the Honour she conferr'd on me, and sincerely grieved it was not in my Power to make a suitable Return" (111–12). The incident ends in an odd mixture of romance and theatricality as, "With many Sighs and Tears on her Side, we took a melancholly Leave" (112). By keeping her transvestite[9] appearance and behavior on the level of performance, Charke diffuses the threat of the female husband's usurpation of male privilege. On the other hand, by evoking the model of the female husband, Charke embues that performance with an ambiguity more threatening than that of the cross-dressed actress. By neither claiming the penis substitute nor defining her sexuality as "castrated," Charke creates through negation an unspecified possibility for female same-sex desire.

While this negation is surely self-protective, it also situates her encounters with other women somewhere between the commodifiable and recuperable ambiguity of the cross-dressing actress and the dangerous and marginalized transgressiveness of the female husband. Charke uses these two contexts for female same-sex desire to define herself only to reject both as inadequate to the job. She is "somewhere else" on the field of sexual possibility, but cannot or will not specify where. Charke raises the question of why she cross-dresses only to refuse to answer. She assures us that "the original Motive proceeded from a particular Cause; and I rather chuse to undergo the worst Imputation that can be laid on me on that Account, than unravel the Secret, which is an Appendix to one I am bound, as I before hinted, by all the Vows of Truth and Honour everlastingly to conceal" (139). Charke reinforces her neither/nor position by this convoluted nonexplanation; she refuses to define herself explicitly and neither the "safe" nor the "dangerous" models of same-sex desire she alludes to will do the job.

In 1756, a year after the second edition of the *Narrative* was published, Charke published a novel, *The History of Henry Dumont*, in which she exhibits the opposite of this evasiveness in regard to sexual desire between men. *Henry Dumont* contains a viciously homophobic attack on male homosexuality that transforms the process of negation working in the *Narrative* from an implicit critique of two dominant definitions of female same-sex desire into a rather dreary confirmation of a definition of male same-sex desire as monstrosity. In *Dumont*, Charke defines herself as unequivocally on the side of homophobic exclusions of alternatives to dominant heterosexuality, at least so far as men are concerned. Charke's homophobic representation of a "molly" is less a reversal of the evasiveness of the *Narrative*, however, than a logical continuation of it. Homosexual men are the sexual other of eighteenth-century culture as "lesbians," whose generic name does not yet even exist, are not. Charke's strategy of self-definition by refusing models for sexuality between women permits her to avoid taking the dangerous position of sexual other which, in her novel, she situates at a definitive distance from herself. While her autobiography refuses sexual definitions, even marginal and ambiguous ones, the homophobia of her novel defines her negatively in the eighteenth-century context as *not* a "monster." One wonders if Charke didn't see the need to distance her earlier sexually ambiguous performance from "the vice which cannot be named." But since such motives can only be speculated on, one can more safely conclude that *The History of Henry Dumont* marks the difference between Charke's isolated, performative evasions of dominant sexual ideology and a concerted, politically self-conscious resistance to oppression.

In Charke's novel, the handsome hero, Henry Dumont, receives a mash note from "Billy Loveman," a particularly extreme example of the type of "pretty gentlemen" who were often railed against in the mid to late-century popular press. I would situate Charke's caricature in the context of this growing wave of homophobic discourse against effeminate men at mid-century. A 1747 pamphlet, *The Pretty Gentleman*, may well have provided Charke with a specific model for her homophobic caricature. This essay ironically praises a "Fraternity of Pretty Gentlemen," whose "grand Principle . . . is mutual Love, which, it must be confessed, they carry to the highest Pitch. In this Respect, they are not inferior to *The Sacred* Theban Band" (13). *The Pretty*

Gentleman offers sample letters between characters with names such as "Lord Molly" which seem to indicate that sodomy must necessarily involve a deterioration of orthographic skills. Charke's letter from Loveman to Dumont has similar problems with getting both spelling and sexuality "right": "When you dans'd last night, you gave the fatal blo, which will be my utter ruen, unless you koindly answer my bondless luf . . . " (38–9). The "Pretty Gentleman" of the pamphlet receives a verbal trouncing, and Billy Loveman is even more violently punished for his desires. Dumont conspires with his friends to ambush Loveman as one of "a set of unnatural wretches, who are shamefully addicted to a vice, not proper to be mentioned." He agrees to meet with Loveman, who appears in full drag: " 'I come, I fly, to my adored Castalio's arms! . . . '—stopping here, with a languishing air, said, Do my angel, call me your Monimia! then with a beastly transport, kissed [Dumont] with that ardour, which might be expected from a drunken fellow to a common prostitute" (65). Dumont's response aborts his "ardour": he "knocked him down, and disciplined him with his cane; till the monster was almost immoveable." The episode ends uncritiqued as a crowd joins Dumont in beating and ducking Loveman, who is finally rescued by his effeminate valet.

The violence with which Charke enacts this punishment of Loveman reflects not only the age's general homophobia, but a widely-held desire to purge the English theater of the homosexual associations attached to its boy-actors in the seventeenth century and transposed into charges of effeminacy against male players well up through the 1770s. Loveman's appearance as "Monimia" (ironically, the "manly" Charles Macklin's first role as a boy in school), ties the novel's homophobia to this "house-keeping" effort to cleanse the English theater of its homosexual associations. The pamphlet *Pretty Gentleman* also takes part in this campaign to disassociate the stage from homosexuality, ironically asking "Should not the Theatres be *absolutely demolished?*" since the "manly" entertainment of the stage was so obviously an impediment to the projects of the "Pretty Gentlemen" (31). By placing her novel within this discourse against homosexuality, Charke defines herself against the "monstrous," her culture's sexual other. The same process of negation by which Charke challenges the validity of models for female same-sex desire leads her to reinforce the construction of a homophobic model for male homosexuality.

My reading of Charke's autobiography is its own example of the difficulties and dangers—as well, I hope, of the virtues—of reading the ambiguities of past sexualities from the perspective of resistance to the social oppression that goes by the name of normative sexuality. Charke's self-definition by the process of negation allows her to resist the cultural construction of same-sex sexuality around the determining factor of the present or absent penis. On the other hand, it also leads to Charke's subscription to one of the most oppressive mechanisms of dominant heterosexuality's hegemony—homophobia against gay men. Ambiguity is slippery stuff on which to found a politically self-conscious reading practice, and yet faithfulness to the specific histories of sexuality often asks the feminist critic to assess such politically shifty materials. As Martha Vicinus notes, the dichotomizing of our present-day identity politics and past manifestations of same-sex sexuality may prevent us from understanding the "difficulties, contradictions, and triumphs of women within the larger context of their own times" (173). Perhaps this mixing of ambiguity with a clearly defined political reading is particularly pointed within the context of gay and lesbian studies. For lesbian and gay activists of the late twentieth century, "coming out" is one of the most significant models of political resistance to heterosexism and homophobia. Paradoxically, lesbian and gay critics and theorists define their politics by clearing up ambiguities—naming the "vice which cannot be named"—in the very act of investing with "resistance" the ambiguous texts of the past.

Notes

1. Much of this work goes on in Shakespeare studies. See, for instance, Greenblatt's "Fiction and Friction" in *Shakespearean Negotiations*, 66–93. Lisa Jardine's *Still Harping on Daughters* also takes up questions about the reception of boy actors in Renaissance England (9–36). Stephen Orgel's " 'Nobody's Perfect' " explores reasons for the endurance of the boy actors well into the seventeenth century.

2. The main body of work in which the influential concept of the female spectacle and the male gaze is developed was done by a group of feminist film theorists associated with *Screen*. See, for instance, Laura Mulvey's "Visual Pleasure and Narrative Cinema" and Mary Anne Doane's "Film and the Masquerade" for classic formulations of this concept.

3. Milhous sees female cross-dressing as a competitive strategy against the more expensive-to-stage audience draw of elaborate settings and spectacles (93).

Female Theatrical Cross-Dressing

4. See my study of eighteenth-century players and sexual ideology, *Sexual Suspects*, forthcoming from Princeton University Press.

5. See Armstrong, 3–27.

6. See Morgan's *Well-Known Troublemaker*. Castle's review in *TLS* points out the excessive zeal with which Morgan argues Charke's heterosexuality.

7. See Faderman and Vicinus for information about lesbianism in the eighteenth-century, and Friedli for more specific information about the nature of sanctions against cross-dressing women.

8. Friedli points out that when the female husband was punished, it was according to laws against fraud rather than the laws against sodomy which were confined to men.

9. I am using this term in the specialized sense defined by Doane's work on masquerade and female spectatorship. It is not to be confused with the clinical term which is usually confined to men.

Works Cited

Actor: or, a Treatise on the Art of Playing, The. London: R. Griffiths, 1750(?).

Armstrong, Nancy. *Desire and Domestic Fiction: A Political History of the Novel.* New York: Oxford University Press, 1987.

Boaden, James. *The Life of Mrs. Jordan.* 2 vols. London: Edward Bull, 1831.

———. *Memoirs of Mrs. Siddons.* 2 vols. London: Henry Colburn, 1827.

———. *Memoirs of the Life of John Philip Kemble, Esq.* 2 vols. London: Longman, Hurst, Rees, Orme, Brown, and Green, 1825.

Castle, Terry. "Trials *en travesti.*" *TLS* Feb. 17–23, 1989.

Charke, Charlotte, *The History of Henry Dumont, Esq: and Miss Charlotte Evelyn.* London: H. Slater, Jun., and S. Whyte, 1756.

———. *A Narrative of the Life of Mrs. Charlotte Charke.* 1755. Ed. Leonard R. N. Ashley. Gainesville, FL: Scholars' Facsimiles and Reprints, 1969.

Cibber, Colley. *An Apology for the Life of Mr. Colley Cibber.* Ed. B. R. S. Fone. Ann Arbor: University of Michigan Press, 1968.

Colman, George. *Prose on Several Occasions.* 3 vols. London: T. Cadel, 1787.

Comforts of Matrimony; Exemplified in the Memorable Case and Trial, Lately heard Upon an Action brought by Theo—s C—r against —— S——, Esq; for Criminal Conversation with the Plaintiff's Wife. London: Sam Baker, 1739.

Cook, William. *Memoirs of Charles Macklin, Comedian.* London: James Asperne, 1804.

Dekker, Rudolf and Lotte C. van de Pol. *The Tradition of Female Transvestism in Early Modern Europe.* New York: St. Martin's Press, 1989.

Dibden, Charles. *A Complete History of the English Stage.* 5 vols. London: 1797–1800.

Doane, Mary Ann. "Film and the Masquerade: Theorizing the Female Spectator." *Screen* 23 (1982): 74–88.

Faderman, Lillian. *Surpassing the Love of Men: Romantic Friendship and Love between Women from the Renaissance to the Present.* New York: William Morrow and Company, Inc., 1981.

Fielding, Henry. *The Female Husband: or the Surprising History of Mrs. Mary, Alias Mr. George Hamilton.* London, 1746.

Fielding, Henry and James Ralph. *An Apology for the Life of Mr. T—— C——, Comedian.* London: J. Mechell, 1740.

Friedli, Lynne. " 'Passing women': a Study of Gender Boundaries in the Eighteenth Century." *Sexual Underworlds of the Enlightenment.* Ed. G. S. Rousseau and Roy Porter. Chapel Hill: University of North Carolina Press, 1988, 234–260.

Galendo, Catherine. *Mrs. Galendo's Letter to Mrs. Siddons: Being a Circumstantial Detail of Mrs. Siddon's Life for the last seven years.* London, 1809.

Greenblatt, Stephen. *Shakespearian Negotiations: The Circulation of Social Energy in Renaissance England.* Berkeley: University of California Press, 1988.

Hill, Aaron. *The Works.* Vol. III, London, 1754.

Hitchcock, Robert. *An Historical View of the Irish Stage.* 2 vols. Dublin: R. Marchbank, 1788.

Jardine, Lisa. *Still Harping on Daughters: Women and Drama in the Age of Shakespeare.* Sussex: Harvester Press, 1983.

Life of Mr. James Quinn, Comedian, The. London: S. Bladon, 1766.

Memoirs of the Celebrated Mrs. Woffington, Interpersed with Several Theatrical Anecdotes; The Amours of Many Persons of the First Rank; and some Interesting Characters Drawn from Real Life. London, 1760.

Milhous, Judith. *Thomas Betterton and the Management of Lincoln's Inn Fields 1695–1707.* Carbondale: Southern Illinois University Press, 1979.

Morgan, Fidelis. *The Well-Known Troublemaker: A Life of Charlotte Charke.* London: Faber & Faber, 1988.

Mottley, John. *A Complete List of all the English Dramatic Poets.* London: W. Reeve, 1747.

Mulvey, Laura. "Visual Pleasure and Narrative Cinema." *Screen* 16 (1975): 6–18.

Murphy, Arthur. *The Life of David Garrick, Esq.* 2 vols. London: J. Wright, J. F. Foot, 1801.

Orgel, Stephen. " 'Nobody's Perfect': Or Why Did the English Stage Take Boys for Women?" *South Atlantic Quarterly* 88.1 (1989): 7–30.

Pope, Alexander. *The Poems of Alexander Pope.* Ed. John Butt. New Haven: Yale University Press, 1977.

Pretty Gentleman: or Softness of Manners Vindicated, The. London, 1747.

Rogers, Pat. "The Britches Part." *Sexuality in Eighteenth-Century Britain.* Ed. Paul-Gabriel Bouce. Manchester: Manchester University Press, 1982, 244–58.

Silverman, Kaja. *The Acoustic Mirror: The Female Voice in Psychoanalysis and Cinema.* Bloomington: Indiana University Press, 1988.

Smith, Sidonie. *The Poetics of Women's Autobiography: Marginality and the Fictions of Self-Representation.* Bloomington: Indiana University Press, 1987.

Vicinus, Martha. " 'They Wonder to Which Sex I Belong': The Historical Roots of the Modern Lesbian Identity." *Homosexuality, Which Homosexuality?.* International Conference on Gay and Lesbian Studies. London: GMP Publishers, 1989, 171–198.

Victor, Benjamin. *The History of the Theatres of London and Dublin From the Year 1730 to the Present Time.* 2 vols. London: T. Davies, R. Griffits, T. Becket, and P. A. de Hond, G. Woodfall, J. Coote, G. Kearsley, 1761.

Wilkinson, Tate. *The Wandering Patentee: or a History of the Yorkshire Theatres, from 1770 to the present time.* 4 vols. York: Wilson, Spence, and Mawman, 1790.

Wright, James. *Historia Histrionica: An Historical Account of the English Stage.* London: G. Groon, for William Hawes, 1699.

7

D'Eon Returns to France: Gender and Power in 1777

Gary Kates

The printer of this paper is authorized to assure the public, that an eminent banker has in his hands ten thousand pounds, which have been deposited on purpose to enable him to make the following proposal:

This gentleman declares d'Eon (alias the Chevalier d'Eon) a WOMAN, in the clearest sense of the word; this declaration he supports with a bet of any such sum of money from one to five thousand guineas, or he proposes to any one, who will deposit five thousand guineas in the hand of his banker, to pay ten thousand pounds if d'Eon proves herself either a MAN, and HERMAPHRODITE, or any other animal than a WOMAN.

Westminster Gazette, September 7–10, 1776

In 1772 French King Louis XV sent one of his spies, a M. Drouet, on a secret mission to England. But Drouet was not sent to spy only on the English. In addition, his mission was to investigate one of Louis' own men, the well-known but highly controversial diplomat, the Chevalier d'Eon, who himself had been spying on the English for the king since his official diplomatic career had ended in 1763. It seems that London was full of rumors that d'Eon was actually a woman. At first such gossip was taken as nothing more than a mere bagatelle by the French government. But when the rumors persisted, and especially when they were followed by bets wagered over d'Eon's sex, the king became increasingly alarmed. He sent Drouet to get to the bottom of these odd tales once and for all.[1]

When Drouet returned to France he confidently assured his superiors that d'Eon was indeed a biological woman posing as a man. What proof Drouet found remains a mystery. But it apparently was enough to convince the king. From that point on, the French government thought of its wayward spy as a woman. And not just the French. After

a British court arrived at the same conclusion in 1777, all Europe thought d'Eon to be female. And what a woman d'Eon was thought to be! "It must be acknowledged," announced Burke's *Annual Register*, "that she is the most extraordinary person of the age." After all, what other eighteenth-century woman had become a diplomat, spy, military hero, and author of several books? "We have several times seen women metamorphosed into men, and doing their duty in the war; but we have seen no one who has united so many military, political, and literary talents."[2]

We now know that the *Annual Register* was mistaken about one thing: d'Eon was anatomically a male with ordinary genitalia.[3] But that does not necessarily mean that d'Eon was anything less than "the most extraordinary person of the age." For what made d'Eon so extraordinary was not that he was a woman who passed for a man during the first half of his life, but rather precisely the opposite: d'Eon was a man who successfully passed for a woman during the second half of his life. As the *Annual Register* suggests, women posing as men were rather common in the early modern world, but a man who lived as a woman—and one who made such a public display of it—was much more unusual.[4]

Throughout modern history there are scores of examples of well-known men who dressed in public as women.[5] However, the Chevalier d'Eon was unique in that he did not simply dress as a woman (indeed, as we shall discover, d'Eon despised women's clothes), but assumed the identity of a woman every single day between August 1777 (when he was already forty-nine years old) until his death thirty-three years later in 1810. Nor was d'Eon unique for the eighteenth century alone. It is very difficult to think of similar cases in our own era, in which men have passed as women for decades. Even in fiction it is rare to find a male character who voluntarily embraces womanhood.[6]

Of course, as Sandy Stone, Judith Shapiro, and Marjorie Garber discuss elsewhere in this book, one way that men become women in our society is through "reassignment" surgery: they biologically pass from one sex to the other. Surgery is recommended, however, only if transsexualism has been diagnosed by a trained psychiatrist, usually within the context of a gender identity clinic. This means that the only men that are usually allowed such surgery are men

who, in the words of one transsexual, "feels he is in the body of the wrong sex."[7]

In recent decades gender identity clinics have sprouted across North America to counsel men and women confused about their gender identity. The growth of such clinics and the popularity of reassignment surgery reflects the medical profession's acceptance of "transsexualism" and "transvestism" as psychosexual disorders.[8]

Judith Shapiro's perceptive discussion of Janice Raymond's *The Transsexual Empire* makes clear the ambivalent attitudes some feminists share towards transsexuals. When men pass for women, do they reinforce patriarchy or undermine it? Of course, to some extent the answer depends upon what kind of women such men become. Despite the efforts of some transsexuals to transcend patriarchal images of women (see Sandy Stone's contribution) Shapiro reminds us that too many transsexuals embrace a disturbingly stereotypical image of womanhood discarded by feminists long ago. The well-known journalist and writer Jan Morris certainly seems to support this conclusion. When a taxi driver assaulted her with an embrace, fondle, and forced kiss, "all I did was blush."[9]

For at least the past fifty years, it has become virtually impossible for anyone to write about the Chevalier d'Eon without assuming that he was either a transvestite or a transsexual. Jan Morris certainly identified herself with the Chevalier d'Eon. "He was four years older than I was when I entered the same experience, and a good deal worldlier, but what happened to him, happened to me."[10] Indeed, as I shall show below, d'Eon's behavior—or supposed behavior—became the classic case for defining gender identity disorders.

The problem, however, with pinning a psychosexual disorder on d'Eon is that it minimizes his own will and cognition in the process of his gender transformation. Interpreting d'Eon as a sort of eighteenth-century transsexual renders him passive in two very different but complimentary ways: on the one hand, by assigning him a psychosexual disorder, d'Eon's gender transformation is interpreted as something that happened to him, the result of childhood experiences, rather than a process that he freely brought upon himself as a mature adult. Second, since his passage to womanhood effectively spelled the end to d'Eon's political career, his behavior can too easily be interpreted as a retreat into a kind of

retirement. D'Eon, writes one recent biographer, "had no other recourse but his own understanding of his nature. His only hope was to wrest from society such toleration as would make his life bearable."[11]

But just what did happen to d'Eon? Any concept of transsexualism is itself dependent upon a "fact of nature" that seems obvious to most of us: human beings are divided into two opposite sexes, male and female. But what if d'Eon did not believe in the existence of two opposite sexes? In a recent book, Berkeley historian Thomas Laqueur brilliantly argues that the notion of a "one sex model" was pervasive in early modern European culture, and had a rich heritage stemming back to antiquity. Laqueur convincingly shows the extent to which early modern elites believed that there was only one sex among humans, and that a woman's body was more of a variation of a man's than its opposite. Perhaps more important, Laqueur demonstrates that the eighteenth century witnessed the last great debate between proponents of the competing models until the two sex model became dominant during the early Victorian period.[12]

Laqueur's discussion of the one sex model has important implications for interpreting d'Eon's behavior. If d'Eon saw the boundaries between the sexes as cultural rather than natural; if he viewed sexual differences within a matrix that included religion, morality, and politics, then his gender behavior—his decision to assume the identity of a woman—may be reinterpreted very differently than the kind of transsexualism assumed by Morris and others.

My intention here is to show that at least one eighteenth-century man at a relatively late point in his life began to think of gender identity as something to be explored and achieved. That he did so may have had much to do with his particular culture. D'Eon lived at the end of an era in which aristocratic women had more power than their counterparts would experience for at least 200 years; an era in which sexual differences were infused with moral meaning, and were not yet under the hegemony of the biological sciences. This *ancien régime* world would, of course, soon vanish; and with it disappeared certain concepts about gender that stemmed from its aristocracy. The story of the Chevalier d'Eon's passage to womanhood may challenge pervasive Western ideas about gender; certainly at the very least it constitutes a critique of bourgeois notions about the meaning of sexual differences.

Gender and Power in 1777

D'Eon's Life

A brilliant child from a provincial noble family, d'Eon was born in 1728 in Tonnerre, a Burgundian town located about 100 miles east of Paris. At thirteen, he went away to school in Paris, where he lived with his uncle, a well-known aristocrat with close ties to the government. By twenty-five, he had picked up a law degree, was working as a royal censor, and had himself published a few articles in literary journals and an important treatise on financial matters. During the 1750s he became a spy for Louis XV, and was sent on important business to Russia. The early biographies insist, as d'Eon himself did at one point, that d'Eon dressed as a woman in Russia in order to become the French tutor and friend of Czarina Elizabeth.[13] But such a tale has no basis in fact.[14]

At any rate, back from Russia, he became a military hero during the Seven Years War (1756–1763) and achieved the rank of Captain in the elite corps of the Dragoons. Later, he was awarded the prestigious Cross of Saint Louis for his valor. At the war's conclusion, he was appointed to the diplomatic team sent to London to negotiate peace with England. While there the French government made him temporary ambassador to England, and he expected to be appointed a permanent ambassador. But because of personal feuds within the French aristocracy, d'Eon was denied the position, and it went to the Comte de Guerchy, whom d'Eon despised.

Within weeks of Guerchy's arrival their own feud had become the gossip of London, especially when d'Eon accused the new ambassador of trying to poison him. When French Foreign Minister Praslin recalled d'Eon the latter refused to return, claiming that the king himself wanted d'Eon to stay in London. And d'Eon was right: in a bizarre twist that reflects the absurd nature of eighteenth-century diplomacy, Louis XV secretly ordered d'Eon to remain in London in order to spy on the English, even though the king's own foreign minister was in the dark about this order and wanted to throw d'Eon in jail for treason. So d'Eon spent the rest of the 1760s in London living the life of a famous— or infamous—diplomat in exile, all the time spying for Louis XV behind the backs of his English aristocratic friends. D'Eon's reports on the activities of the infamous John Wilkes provided France with its

most valuable information on the first major effort to reform the British parliament along more democratic lines.[15]

When Louis XVI ascended the throne in 1774, he ended his grandfather's system of spies and retired them one-by-one. But d'Eon posed special problems because of his ambiguous political and gender status. The playwright Beaumarchais—then between writing his famous plays *Le Barbier de Seville* and *Le Mariage de Figaro*,[16] was sent to London to negotiate d'Eon's return to France. The result was one of the most curious royal contracts of the eighteenth century: d'Eon was given a life pension, guaranteed safety and security while travelling in France, and most important, declared to have always been a biological female.

It took the English a few years longer than the French to be convinced of d'Eon's "true sex." By the mid-1770s, the London papers were full of articles debating d'Eon's gender status. Members of the London Stock Exchange took out bets on d'Eon's sex (using annuity policies as collateral) that reached hundreds and thousands of pounds sterling. D'Eon himself was offered huge sums of money if he would submit himself to a physical examination that would resolve the dispute. But he would do no such thing. Claiming that disrobing or even commenting directly on the dispute would tarnish his honor as a French nobleman, his silence—and increased vacations from London into the countryside—only fueled speculation. Finally, in 1777, when gamblers sued each other in a civil dispute over payment, a high British court ruled that d'Eon was a woman.

In August 1777 d'Eon returned to France with everyone now thinking d'Eon a woman, and indeed, with d'Eon himself admitting his "true sex." He was introduced to the king and queen in Versailles, partied at lavish balls with such celebrities as Benjamin Franklin, and went through a religious conversion that led d'Eon to the brink of joining a convent.[17] But d'Eon soon began to experience problems with the administration of Louis XVI and his foreign minister Vergennes. The new king, so much more puritanical than his grandfather, was embarrassed by d'Eon's presence in Versailles and Paris, and by 1779 had exiled him to the provinces. D'Eon tired quickly of life in boring Burgundy, and after 1783 decided to move back to London, where he lived for the next twenty-seven years.

The French Revolution put an end to d'Eon's lavish life pension and reduced him to poverty. For most of the 1790s he lived quietly, working

on his memoirs and reading books. But occasionally poverty would drive him into the public spotlight. For a time this septuagint chevalière would go on fencing exhibitions, defeating male opponents to the applause of large audiences. But an injury sustained in one match left d'Eon too feeble to continue such demanding work.

When d'Eon died in 1810, he was eighty-two and impoverished. It was only then, when d'Eon's roommate laid out the body for burial, that she saw his genitals and discovered what had eluded two nations: d'Eon had the ordinary body of a male.[18]

Eonism

So long as d'Eon was perceived as a woman passing for a man, his story was considered significant and discussed by important writers. But once Europeans discovered him to be a man passing for a woman, he was all but forgotten for about seventy years. After all, there was already a popular tradition of women passing as men in order to empower themselves. Indeed a female-to-male transvestite in its own way reaffirmed patriarchal authority.[19] But why would a biological man pass half his life as a woman? Why would a man, particularly a noble diplomat, soldier, and spy, move from a position of power and influence to a status of relative powerlessness? Such issues were apparently too threatening to the emerging gender regime that helped to define early Victorian society.

A biography was published during the 1830s, but later the author admitted that it was full of fabrications. Only near the end of the century did popular biographers, such as Buchan Telfer and Ernest Vizetelly, begin to look at his life in close detail. But while they disagreed over facts concerning his life, they all believed that d'Eon's case was "strange" and unique, certainly in no way typical of the eighteenth century. D'Eon, they agreed, was one of history's greatest liars: he had managed to deceive—quite intentionally—all of Europe as to one of the most fundamental qualities of his life: his own sex. Consequently, d'Eon was sometimes admired and sometimes despised for pulling off what was certainly the greatest hoax of the eighteenth century. Why d'Eon should do such a thing was never seriously analyzed. Some

writers thought he did it for publicity, others to rehabilitate a failed political career; still others thought he was simply mad.[20]

During the years surrounding the First World War, the pioneering British psychologist Havelock Ellis developed an original interpretation of d'Eon's behavior that not merely affected the course of literature on d'Eon, but helped to conceptualize an entirely new way of thinking about gender identity. Unlike previous writers, Ellis did not believe that d'Eon had deceived anyone in passing from man to woman. Ellis contended that it was not d'Eon's intention to produce a hoax. D'Eon was no liar. Rather, his passage from man to woman reflected a "pathologic" condition. On the one hand, Ellis showed that d'Eon was not trying to deceive anyone, but rather he was trying to be himself: he was acting out an obsessive impulse "to live as a woman." On the other hand, Ellis broke new ground by arguing that d'Eon's effeminate ways had nothing to do with sexual behavior; in no way, Ellis argued, could d'Eon be considered a homosexual. Furthermore, Ellis correctly perceived that cross-dressing had little to do with the disorder: "The inversion here is in the affective and emotional sphere, and in this large sphere the minor symptom of cross-dressing is insignificant." Finally, Ellis speculated that the original cause of d'Eon's condition had nothing to do with the events that occurred during his life, but was probably organic, involving a slight "disturbance in the balance of the play of hormones."[21]

The impact of Ellis's ideas can hardly be overestimated. During the interwar years he was the most influential psychologist in the English speaking world. Based upon what he found in the case of d'Eon, he came up with the term "Eonism" to refer to anyone who exhibited similar behavior. While he recognized that other sexologists, such as Magnus Hirschfeld, had developed the concept of "transvestism" to describe a similar behavior, Ellis preferred Eonism because it minimized the roll of cross-dressing (transvestism literally means cross-dressing). In terms of the history of sexuality, then, Ellis's most important contribution was to develop a medical language to describe behavior that had hitherto been seen as primarily moral.[22]

Nonetheless, despite the enormous influence of Ellis's concept, the term Eonism did not stick, and after the Second World War, psychologists used the term "transvestite" and then "transsexual" to mean

roughly the same kind of condition first discovered by Ellis. Thus it is no wonder that practically all of the biographies written since the time of Ellis have incorporated his psychological theories as the core interpretive mode for understanding d'Eon's behavior.[23] The nineteenth-century portrayal of d'Eon as a trickster trying to play a gigantic prank upon Europe has given way to a more sympathetic view of him as a confused character with a psychosexual disorder that neither he nor anyone in his society understood.[24]

The story of the Chevalier d'Eon therefore became the paradigmatic case in the burgeoning field of gender identity disorders, whose origins go back to Ellis and his followers. But was d'Eon an Eonist? Did he think of himself as a woman trapped in a male body? Did he, in fact, exhibit the kind of dysphoric behavior that would lead a physician today toward a diagnosis of transsexualism? Or, perhaps d'Eon was self-consciously trying to act out an iconoclastic ideology. Is it possible that this aristocratic intellectual—the author of more than fifteen volumes—might have freely chosen (in the sense of willfully and cognitively) to abandon manhood for womanhood? If so, would it be too far-fetched to view d'Eon as not something strange and unique, but part of a culture (or at least a subculture) that was in the midst of a fundamental redefinition of the social roles to be played by men and women?

In order to address such a question we would need to know not only many more intimate details about d'Eon's life, but equally, we must know how d'Eon felt about himself and about what was happening to him. Rarely do scholars of the eighteenth century get that kind of a glimpse into a person's psyche. But in the case of d'Eon we are fortunate. Towards the end of his long life, he spent many years writing and rewriting drafts for an autobiography that was never published. Most of these manuscript pages, in a long-hand French often with many cross-outs and corrections, have been ignored by biographers.[25]

Like any autobiographer, d'Eon devoted more energy to writing about some parts of his life rather than others. In particular, he reveals much about the summer and fall of 1777, when he returned to France for the first time in fourteen years, and lived openly as a woman for the first time in his life. By focusing on this brief but seminal period in his life, we should gain some understanding of what d'Eon's gender behavior meant for him and for the public that surrounded him.

D'Eon in France

When d'Eon landed in Boulogne in August 1777, he was finally a free woman. But he still insisted upon dressing himself in the uniform of a Dragoon Captain. According to the contract signed between King Louis XVI and himself, d'Eon was a woman according to French law. Indeed, all of Europe believed d'Eon to be a woman. Nor did d'Eon himself dispute the matter. Nonetheless, he was determined to wear the obviously male uniform of a Dragoon officer.

D'Eon immediately made his way for Paris, stopping for a night in the outlying town of St. Denis, famous for its stunning Gothic cathedral, and noted throughout the country as an important religious center. There d'Eon visited Dom Boudier, abbot of the town's Benedictine monastery. Because d'Eon was considered a woman, he could not sleep there for the night, so the abbot arranged for d'Eon to stay at the nearby Carmelite convent, well known because its pious Mother Superior, Madame Louise, the daughter of Louis XV, had entered the convent in 1771 after the death of her mother.[26]

But d'Eon's arrival at the nunnery caused a major disturbance. As d'Eon walked through the convent, the sisters broke from their rigid routine to catch a glimpse of the former diplomat. Their giggles could hardly be contained. What seemed funny at least to the Carmelite Nuns outraged their Mother Superior. While she had agreed to put up d'Eon for the night, she assumed that he would be dressed in the garb of an aristocratic lady. How could she allow a woman dressed as a soldier to spend the night in her nunnery?

The abbot urged d'Eon to change clothes. "I have made a great mistake," he admitted, "in bringing Mlle. d'Eon in the clothes of a man to Madame Louise's convent without her permission." But d'Eon did not see it that way and refused to change clothes. Boudier, now provoked, began to lecture d'Eon. As a man d'Eon may have been used to doing everything in "the grand style." But as a woman she would learn that it was impossible to live like that. "Without doubt she will become more common when she retakes her cornet, dress, and skirt." D'Eon's clothes must reflect "the modesty and decency so suitable to her sex." Boudier recognized that while d'Eon could retake the identity of woman, it would be more difficult to reassume the ordinary character traits appropriate to womanhood. He suggested that the Chevalière

enter a convent to learn female manners and habits. Like a good priest, Boudier tried to channel his anger into positive suggestions. "I hope," he said in a final plea, that d'Eon "will lose the spirit of a Captain in the Dragoons."

D'Eon would do nothing of the kind. Still, the issue of d'Eon's clothes would not go away. When he entered Paris a few days later a storm of gossip made him the star attraction on Paris' aristocratic stage. "Everyone talks incessantly of M. or Mlle d'Eon," wrote Mme. du Deffand to Horace Walpole.[27] Immediately a small industry mushroomed that mocked d'Eon's determination to wear his military uniform. In Paris' Palais Royal, soon the center of political radicalism, vendors hawked songs, broadsides, and prints that poked fun at the Chevalière. Even the literati were swept up into the frenzy. At the Comédie italienne a play called *Sans dormir* [Without Sleep] was hastily put together. The venerable critic Grimm described it as an hilarious "vaudeville," where "the principal artifice of the author is to change the role of women to men, and that of men to women." Obviously, Grimm noted, the plot was a parody on d'Eon.[28]

The government did not feel that it could allow this sort of gender confusion under its nose. For Louis XVI, the former diplomat d'Eon was a reminder of the extraordinary decadence and mismanagement of his grandfather's—Louis XV—reign.[29] He had allowed d'Eon to enter France as a woman because he thought it would put an end to d'Eon's controversial political career and silence him forever. But so far, as d'Eon paraded around the capital in the clothes of a military officer, it was having the opposite effect.

This is what led Foreign Minister Vergennes to summon d'Eon to a meeting at Versailles. D'Eon had every reason to anticipate the meeting with excitement and optimism. For years under Louis XV, the foreign ministry had been held in the palm of the Duc de Choiseul, who not only despised d'Eon and his patrons, but did not know about his earlier espionage activities for the king. Vergennes, on the other hand, had always gotten along with d'Eon and his friends, and had had a similar kind of career as a spy that Choiseul did not know about. When Vergennes had served as Ambassador to Constantinople and to Stockholm many years earlier, he had taken his cues from the Comte de Broglie, who was at the same time, d'Eon's principal patron. Therefore, since Vergennes' appointment as foreign minister in 1774, d'Eon had

felt much sympathy for him. Indeed, it was only because d'Eon trusted Vergennes that the deal could be struck which permitted d'Eon's safe return to France in the first place.[30]

The meeting started pleasantly enough. The two diplomats compared notes about various statesman that they had known. This pleased d'Eon well enough, and it seemed to d'Eon not completely unreasonable to hope that Vergennes might offer him a new diplomatic assignment. But then came a bomb from Vergennes that put d'Eon, as he later described it, "in a state of confusion without any parallel."[31]

"Mademoiselle," began Vergennes. "I beg you to retake immediately your dress or submit yourself to the law. You will win the affection of women and the respect of men. This indispensable change will allow your character and your behavior to become sufficiently moderate insuring your tranquility and happiness." And then, if only to underscore the importance that the government placed on the matter, Vergennes handed the shocked d'Eon a hand-signed order from the king himself that commanded him to "lay aside the uniform of a dragoon" and forbid him "to appear in any part of the kingdom in any other garments than those suitable to females."[32]

D'Eon immediately protested such an order and tried to get it reversed. He reminded Vergennes of his great service to France and to his king. Had he not served valiantly under the Marshall de Broglie during the Seven Years War? Had he not won accolades in his tenure as a diplomat to the Court of the Russian Empress, Elizabeth? Had not the king freely made him a captain in the elite corps of the Dragoons? Had he not been instrumental in negotiating the Peace of Paris? And had the king not rewarded his service with the office of Acting Ambassador to London? Finally (and most astonishing for a woman), had not d'Eon received the rare and coveted Cross of Saint-Louis for his public service? Given that record, d'Eon asked, why should he be forced to remove his uniform and retake female clothes? There was no reason, d'Eon insisted, why his admission of being a woman should permanently exclude him from future diplomatic activities.[33]

Meanwhile, the royal court realized that they could not simply let d'Eon go and expect that he would carry out the order. The king's order, it was understood, would have to involve a program to retrain d'Eon in the ways of French aristocratic ladies. The king made generous funds available for d'Eon to acquire an expensive new wardrobe, and

he was invited to stay at the Versailles home of M. Genet, the chief administrator at Foreign Affairs. Along with his wife and his three lovely daughters (two of whom were Marie-Antoinette's Ladies-in-Waiting), d'Eon was given an education among women at the zenith of social life in France. D'Eon agreed to stay in the Genet household, but only after visiting his mother in Tonnerre.

On his way to Tonnerre he reflected upon the king's new order. "This royal decision," he later wrote, "was regarded at Versailles and Paris, and throughout France and Europe, as the judgment of Solomon." He was terribly confused. On the one hand, d'Eon realized that the king's decree implied a kind of death . . . and simultaneously a rebirth. By forcing d'Eon to retire his military uniform, "this change completely transformed her mind, her heart, her conduct, her manners, her habits, and her inclinations. It forced her to come alive, move forward, and act as an entirely new creature. Resuscitated as the daughter of Saire, she has been, in a short time, resuscitated to all the decency, wisdom, and dignity of her sex."[34]

In some respects, becoming reborn as a woman is precisely what d'Eon was after.[35] But he wanted it done his way on his terms. "Only my extreme desire to be irreproachable in the eyes of the King and of my protectors, such as yourself and the Comte de Maurepas," he wrote to Vergennes, "can give me the necessary strength to conquer myself and assume this character of meekness suitable to the new existence *I have been forced* to adopt. The part of lion would be easier for me to play than that of the sheep; and that of a Captain of Volunteers in the army than that of a meek and obedient girl."[36] D'Eon did not merely want to be known as a woman, but as a woman made in his own image. The struggle between d'Eon and the king, then, was not over his sex, but rather what kind of woman d'Eon would become. D'Eon insisted upon assuming a role that mixed masculine and feminine features into a uniquely Amazonian blend.

When he arrived in Tonnerre, he found that his mother sided with Vergennes and the king. "The court is certainly correct," Mother exclaimed. "Society knows that London and Versailles have determined you to be a girl. This masquerade must not be allowed to serve only gossip and scandal." Clearly Mother believed that d'Eon had no choice but to give up forever his military uniform and take the normal clothes of an aristocratic lady. "A person must be one or the other.

Your fate is to become the girl that is in you. Just as you had the weakness to assume an [officer's] uniform during war, you should have the strength to assume your dress in peacetime."

"What? So today my mother is against me." d'Eon angrily responded. A Dragoon Captain is about to die and you cannot bring yourself to console him! D'Eon demanded sympathy if not understanding from his mother. She broke out into tears and anxiously remarked, "Praise God that His will be done, just as with the king and the law." D'Eon had not realized the extent to which his own mother would oppose him, and her attitude further plunged him into a state of confusion and depression.

During the next several days a "small civil war" broke out among Tonnerre folks over whether d'Eon should get rid of his uniform and wear the normal clothes of a woman. On one side were members of the local clergy who "wanted the court to force me to retake my dress. On the other side were local notables and military men who passionately hoped that the court would allow me to maintain the privilege of wearing my uniform in order to continue my military service."[37]

To read only d'Eon's account one would think that these military officers were supporting the introduction of women into the French army. Rather, they were upholding the dignity and status of a military officer. An appointment to the officer corps of the Dragoons was considered a commitment and honor of unlimited duration. One was appointed for life and expected to wear the military uniform of a Dragoon every time that one stepped before the public. It was rare for such an honor to be rescinded. Such was, after all, the law as set down by an absolute king. Could that king violate even his own laws? That, eighteenth-century aristocrats thought was precisely the difference between a legitimate monarchy and a despotism: the former was ruled by laws, the latter according to the whim of the monarch. If Louis could take away d'Eon's rank and office, he could do it to anyone. "Our brave compatriot Dragoon Captain," exclaimed one military officer in a letter to d'Eon, "continue to wear a uniform that you have honored in our presence in war. Know for sure that under whatever costume that you appear before our eyes, you will always be dear to the hearts of your brave compatriots of the town and region of Ton-

nerre." Such fan mail could not have made d'Eon's struggle any easier. The "civil war" d'Eon described in the town obviously reflected one going on in his heart.

D'Eon also received mail from aristocratic ladies who urged him to go through with his transformation. Why are you delaying a process that is obviously to your advantage and ultimately to our glory, one female correspondent wrote to "our dear and brave heroine. The ladies of Burgundy stand ready to welcome you not only through the doors of their mansions, but naturally through their affectionate hearts as well."

But the most intense campaign was waged by local priests, who warned d'Eon "to no longer visit our churches in the clothes of a man or uniform because all of the attentions of the faithful that should be devoted only to God would be turned solely upon our Chevalière, even though her virtue and her courage," they added sarcastically, "has not yet been canonized by the Church of Rome."

This view was loudly echoed by Tonnerre's parish priest, Father Labernade, who visited d'Eon a few days after the parade, hoping to get d'Eon to make confession to him. Labernade was well known to the d'Eon family. Eighty-four years old, he was not only the confessor to d'Eon's mother and sister, but he had been the confessor to d'Eon's grandmother forty years earlier before she died in 1738! Given that record, it was not unreasonable for Labernade to ask d'Eon, "Why are you not taking confession with me? I could offer some help for your condition."

"My reverend father," replied d'Eon coldly, "I have not prepared myself for that. I make my confessions to God before confessing to other men; for there is not one man that I have wronged."

"But yours is an habitual sin," countered the priest, "which, I would want to see you get rid of."

"And what is that, my reverend father?", d'Eon sarcastically asked.

"It is to take on the clothes of a man. You yourself know quite well," Labernade added, "that the suspicion around your birth and education is no mystery to me."

"Do not judge solely on a person's appearance," warned d'Eon, "but judge with good reason."

While Labernade may have failed with d'Eon he certainly had a

close ally in d'Eon's mother. "She agonized evening and morning," exclaimed the anguished chevalière, "and to encourage me, she made me beautiful lace presents."[38]

"I would feel one-hundred times better seeing you in a dress," she told him one day, "than seeing you suffer like this and being a passive object of public scandal. A little bit of disgrace is easily forgotten. Retake your dress and live happily close to me in tranquillity."[39]

D'Eon fervently, if anxiously, tried to explain to his mother that he was not made for a tranquil life. God had given him special talents. Whatever be his gender status, he felt a calling for political life. "I have the rare advantage," he told her, "to have been involved with many important men in times of peace and war, and I have seen ministers who did not know how to read and ambassadors who did not know how to write." What sense did it make for d'Eon to waste his own God-given talents?

"Happier is the girl," Mother responded to her son, "who like you has seen the most vile part of herself and who like you would protect herself until her death."

D'Eon was confused, and at his wit's end. On the one hand, he did not want to buck his king. But on the other, he believed that taking off the uniform of a Dragoon and putting on women's clothes would mean "the total ruin of my liberty." "A girl easily accustoms herself to obey and my obedience to the court is the order of the day," he explained in his autobiographical fragments. But "blind obedience is the mother of despotism and superstition." D'Eon's aversion to women's clothes, then, was based on a theme familiar to eighteenth-century aristocrats (from their reading of Montesquieu's *De l'esprit de lois* to mention only the greatest account): the loss of a noble person's honor and freedom was a sign of impending despotism. D'Eon did not see why his gender transformation had to mean the loss of significant privileges, since he had only brought honor to his uniform and rank.

For example, to the Count de Broglie, d'Eon wrote from Tonnerre that the king was committing a "public indecency by forcing into skirts an old chevalier" who had served as a "Plenipotentiary Minister of France;" especially since that king had "had the goodness to grant me the right to wear publicly my royal and military dress" of a Dragoon Captain and recipient of the coveted medal of Saint Louis.[40]

These autobiographical accounts suggest that d'Eon saw himself

negotiating between two major conflicts. On the one hand, the clash was between rigid gender distinctions and d'Eon's view of gender as multivalent. Whatever his mother's real attitude, d'Eon suggests that she wanted him to assume the gender identity associated with one particular sex. On the other hand, there was also a conflict between two different political languages, the language of aristocratic honor (represented in the letters from military officers), and the discourse of royal justice (represented by the king's order). What is fascinating about this convergence of ideologies is d'Eon's use of aristocratic honor to defend his more fluid approach to gender.

After a few weeks, d'Eon left Tonnerre to visit his friend and patron, Bertier de Sauvigny, the Intendant of Paris. Surely Bertier—among the most powerful men in France—would help him. But Bertier was disappointed to see that he was still dressed in his military garb. "Despite your uniform," Bertier told him, "I am obliged to call you Mademoiselle; for the retaking of your dress is an urgent matter. It is the order of the day in the cabinet of the prime minister."[41] Still, Bertier welcomed his friend, and treated him well. He tried to get d'Eon to see the bright side of his situation. By remaining a woman-dressed-as-a-man, d'Eon was destined to remain a freak, one not well tolerated by those executing the royal will. But by assuming a more orthodox female identity, "your glory as a woman will begin to be appreciated," he predicted. "Otherwise," he warned, "you run the great risk of retiring for a long time in a sad convent."

D'Eon was backed into a corner with few choices remaining to him. So long as he remained in France, he could not escape the king's orders. Besides despite some aristocratic support, both his mother and friends in powerful positions urged him to follow the king's order to "retake the dress" of a woman. That finally happened on morning of October 21, 1777 in the Versailles home of the Genet's. But this wasn't simply a change of dress. It marked a remarkable transformation for d'Eon, a coming out, in the presence of the Genet family and a few close friends. Since returning to France, d'Eon had lived just as he wanted: as a person whom the world thought was a biological woman that was presenting "her" self as a man. The significance of October 21, 1777, is not simply that this was the first time that d'Eon had assumed female dress as a woman, but that this signaled a transformation in how she would present herself. So, for example, when d'Eon wrote to Vergennes

on August 29, he signed his name *Le Chevalier d'Eon*, but a letter of November 3 is signed *La Chevalière d'Eon*.[42]

Queen Marie Antoinette's Wardrobe Directrice, Rose Bertin, had prepared a blue satin skirt for the occasion. "This passage," wrote d'Eon, was comparable to "that of the Rubicon." But surely it took Caesar's army less time than this one aristocratic chevalière. "My first toilette . . . was accomplished in less than four hours and ten minutes!"[43] During this time d'Eon and Bertin had an opportunity to talk tête-à-tête:[44]

Mlle. Bertin tried to make him feel good about his decision. Of course you realize, she told him, that we could not have "everyday in Paris a famous girl in the uniform of a Dragoon giving public lessons in military matters." No one could allow that. What is happening should not be considered as a loss but as a gain. "It is necessary that the bad boy become a good girl."

"You can talk with such certainty," replied d'Eon, "But when I reflect upon my past and present condition, I would never have had the courage to leave the state in which I placed myself."

After Bertin was done making up d'Eon's face, he ran to his bedroom where he "cried bitterly." Mlle. Bertin ran after him, and tried to comfort him with handkerchiefs and kind words. But nothing she did could calm him down. "I did not stop crying until my tears were naturally exhausted."

Later Mlle. Bertin told d'Eon that she had been to talk with Marie Antoinette about his condition, and had informed the queen that "through shedding the skin of a Dragoon, she had seen that I was more courageous as a girl than as a captain."[45]

That night d'Eon had to sit through a sumptuous dinner given in his honor by Madame Falconnet, the wife of a wealthy lawyer. D'Eon had still not climbed out of his depression. "You have killed my brother the Dragoon," he told Mlle. Bertin. "My heart is broken. My body is like my spirit. It does not like to be tied up in lace." Clearly cross-dressing brought d'Eon much anguish. He did not want to give up the hope that so long as he presented himself as a man, he could continue to serve his government in some public capacity, an absurd notion to be sure at this late juncture, but one nonetheless close to D'Eon's heart. "My sustenance is to do the king's will in order to carry out the law."[46]

Conclusion

These stories demonstrate that d'Eon was neither a transvestite nor a transsexual. First, d'Eon had no intense desire to dress as a woman; in fact, he struggled against it, and began dressing as a woman only when compelled to by the French king. "I find the dress of a woman too complicated for quickly dressing and undressing," remarked d'Eon. "Full of inconveniences, unseasonable in winter, inflexible in all times, uniquely made only for vanity, luxury, other vices, and the ruin of husbands."[47]

Second, there is no evidence to indicate that d'Eon ever used women's clothes for erotic purposes, as is usually necessary for a diagnosis of transvestism. So far as we can tell, d'Eon had no erotic life at all. At least this much is certain: in the era of Sade, Laclos, Restif, Casanova, and Rowlandson, when discussions of sexuality could be quite explicit, no one spoke of d'Eon's possible sexual entanglements, nor did any of the hundreds of illustrations about him suggest that his condition was tied to some particular sexual behavior.[48]

Third, d'Eon did not exhibit an intense discomfort with masculine clothes and activities, as is normal in male-to-female transsexuals. He wanted to dress in male garb and to continue his diplomatic and military activities, which, in the context of eighteenth-century Europe, were reserved for men. Unlike today's transsexuals, who take on an exaggerated and a stereotypical female role, d'Eon fashioned himself as an amazon—an extraordinarily masculine woman. Also unlike today's transsexuals, d'Eon did not see his transformation as a fundamental change in his identity.[49] The Chevalier Charles d'Eon de Beaumont merely became known as the Chevalière Charlotte d'Eon de Beaumont, but it was clear—and d'Eon reminded everyone—that this same person had served France as a diplomat and soldier for decades. D'Eon was as proud of his masculine past as he was worried about his feminine future.

Finally, d'Eon was certainly no Eonist. Havelock Ellis and his followers misunderstood one fundamental feature regarding d'Eon's intentions: d'Eon did not want to "live as a woman," but rather, he wanted to be known as an anatomical woman pursuing the traditional male roles of soldier and statesman. D'Eon conceived of the distinctions

among the sexes as fluid, mutable, and elastic. His behavior was not a hoax or a prank, but a radical challenge to more dominant notions of gender. D'Eon refused to accept a birth-assigned gender as the only natural possibility, and instead sought an achieved gender status.[50] *"God has no regard for the appearance of persons,"* d'Eon underlined in his autobiography,

> it is to the heart alone that He directs His judgments; He praises only the charity that reigns there; He punishes only the greed that rules there, without any regard for titles, dignities, or ranks, nor any other qualities of men. Sexual difference has nothing to do with salvation.[51]

D'Eon was then neither a transvestite nor a transsexual, nor for that matter was he a "homosexual" anymore than he was a "heterosexual", or even a "man" nor "woman." The fact is that contemporary theorists of gender identity cannot help us understand d'Eon because d'Eon does not fit into any of the categories used by modern psychology. Originally Havelock Ellis had intended to use the d'Eon case to reveal gender identity disorders in previous epochs. But actually, the d'Eon case teaches us less about psychiatric disorders and more about relations between the sexes of the upper classes in the decades preceding the French Revolution.

Such a conclusion becomes clearer when we realize how tolerant the public—especially the French public—was concerning d'Eon's gender ambiguity. D'Eon presented the French government with a *political* problem: the king could not let a former spy known for his controversial political escapades gallivant around France dishonoring the Dragoons. But beyond that, it is difficult to find much evidence of social discrimination: The powerful Gallican Church left him alone, and he was entertained by the most influential figures in the kingdom, including the king and queen. The French government may have been troubled by d'Eon's behavior, but most of Parisian salon society was fascinated by him.

The fact that d'Eon was not considered either as a criminal or psychologically disturbed by those who knew him is itself a strong indication that when looking at late eighteenth-century Europe, particularly at the upper classes, we see a "sex/gender system" vastly different from our own.[52]

What Ellis and his followers missed in their diagnosis of Eonism is that while all societies include males and females, manhood and womanhood are socially constructed. Ideas about what it means to be a man and a woman may change from one period to another. Thus it is at best anachronistic to perceive d'Eon's gender behavior from the viewpoint of twentieth century gender roles. "Masculinities and femininities can be re-constructed historically," R. W. Connell has recently argued,

> new forms can become dominant. It is even possible for a whole new gender category to be constructed, as with the emergence of "the homosexual" in the late nineteenth century, and perhaps "the transsexual" now.[53]

Just as eighteenth-century Europe contained a social and political structure fundamentally different from our own, so we ought not to be surprised to find that the cultural meanings assigned to "male" and "female" are alien to our Victorian and post-Victorian mores. No historian would ignore Enlightened Despotism in trying to make sense of the political behavior of Louis XV. Likewise, the most fruitful way of understanding d'Eon's behavior would be to reconstruct the gender system operative during his time.

The history of such gender systems in European history has yet to be written, but given the superb recent work by primarily feminist scholars, the rough outlines towards such a history are just coming to light. Writing in *Signs*, Joan Kelly brilliantly showed that during the early modern period the status and character of women became a burning debate known as the *querelle des femmes*. Likewise, Carolyn Lougee and Dena Goodman have shown how this debate was not simply a theoretical one; at least in France, aristocratic women really did improve their status during the seventeenth and eighteenth centuries. Writing in a related but separate vein about England, Stephan Greenblatt has imaginatively discussed the blurring of gender lines in various kinds of texts, from Shakespeare to medical literature. Randolph Trumbach has also demonstrated that modern notions of sexual roles were only in their infancy before the era of the French Revolution. The idea that sexual behavior formed the core of one's gender identity—that one could speak of a homosexual person rather than homo-

sexual behavior—was a relatively new and unusual idea in the late eighteenth century. Similarly, Joan Landes has charted how the attitudes of eighteenth-century French aristocrats were often much looser toward gender roles than their counterparts during the French Revolution. Indeed, her book suggests that for all the talk of women's rights during that revolution, the Jacobins—dimly recognizing the relatively loose gender relations among upper class Frenchmen before 1789— associated femininity with aristocracy and narrowed any public role that women could play. These scholars seem to agree that before the French Revolution, the gender system operating among Europe's upper classes was a good deal looser and more flexible than its Victorian counterpart.[54]

The debate over the nature of women—reflecting the increasing authority of aristocratic ladies—runs throughout the eighteenth century. Unfortunately we have often paid attention to those who were threatened by it, ignoring its supporters. When Montesquieu jotted down in his private notebooks that "there is only one sex left; we are all women in spirit,"[55] he was as much worried about the trend as he was impressed by it. Of course, what was a secondary concern for Montesquieu became obsessive for Rousseau, who used the feminization of the Old Regime as a fundamental tool to condemn it.[56] But for every Montesquieu and Rousseau, there was also a Boudier de Villemart, Antoine-Leonard Thomas, or Alphonse Le Roy, who celebrated the status of women.[57] Likewise in England, the popularity of Richardson's *Pamela* illustrated that many readers were willing to consider the notion that virtue stemmed not from virility, but from a distinctively feminine source. Even as unlikely a source as Adam Smith reveals a new appreciation for the role of women. "Their company should inspire us with more gaiety, more pleasantry, and more attention," he wrote in 1759, "and an intire [sic] insensibility to the fair sex, renders a man contemptible in some measure even to the men."[58]

There can be no doubt that d'Eon was influenced by the *querelle des femmes* literature. On the one hand, his library contained a vast number of feminist books, including the work of Boudier, Thomas, and Le Roy.[59] Likewise, the Leeds archive is full of such language as well. "During all ages the French have respected the courage particularly of women," reads one memoir written in 1805.

Their ancestors, the Gauls, would not go to war without women, nor
ever go to battle without their advice. So, can I become a man without
becoming a woman? What foolishness! If man has bodily strength and
courage, woman has virtue and prudence. She possesses a special spirit
that allows the quick perception of things that are difficult to understand.
She sees through the most hidden deception of a common enemy; and
through the court intrigue of an ambitious minister. A woman who has
made war and peace must be as wise as Thales, Solon, Bias. . . . In
addition, she must have the virtue and courage of Judith, and of Deborah,
and of Joan of Arc, and of Jeanne Hachette.[60]

We have not yet solved the d'Eon riddle; we still do not know why
he decided to fashion himself as a woman and then insist upon doing
activities common to male aristocrats. But diagnosing d'Eon as an
Eonist, transvestite, or transsexual certainly won't help solve that prob-
lem. Rather, we need to think more carefully about why an eighteenth-
century nobleman might think it important to present himself as a
woman. D'Eon's legacy for our own times is not that he was one of
the first known transsexuals. Far from accepting notions of sexual
differences, implicit in d'Eon's behavior and ideology was the desire
to be rid of gender distinctions based upon biology and to narrow (if
not close) the gap between the sexes. After all, as a woman d'Eon
infiltrated the last bastion of male segregated space in aristocratic
Europe: the world of diplomacy and the military officer corps. If d'Eon
has any intellectual heritage it is not transsexualism but androgyny.[61]

The Chevalier d'Eon may have dreamed of a world where someone's
biological sex might not predetermine their gender identity; a world in
which gender identity might be considered fluid and malleable; a world
in which one explored gender identity as a moral choice; a world in
which femininity was infused with virtue—a virtue wholly different
than its linguistic cousin, virility. Two-hundred years ago the Chevalier
d'Eon may have dreamed about such a futuristic world; but if he had,
it bore more resemblance to his society than to our own.

Notes

I appreciate the valuable suggestions on earlier drafts of this paper by Nannette Le
Coat, John Martin, Jeffrey Merrick, Char Miller, and Elizabeth Marvick.

Body Guards

1. Denis Ozanam and Michel Antoine, eds. *Correspondance secrète du comte du Broglie avec Louis XV*, 2 vols. (Paris, 1956–61), 2:356.

2. *Annual Register 1781*, 81.

3. [Thomas Plummer], *A Short Sketch of Some Remarkable Occurances During the Residence of the Late Chevalier D'Eon in England* (London: John Booth, 1810).

4. On women see Rudolf M. Dekker and Lotte C. Van de Pol, *The Tradition of Female Transvestism in Early Modern Europe* (New York: St. Martin's Press, 1989).

5. Oscar Paul Gilbert, *Men in Women's Guise. Some Historical Instances of Female Impersonation*, trans. Robert B. Douglass (London: J. Lane, 1926); Peter Ackroyd, *Dressing Up; Transvestism and Drag: the History of an Obsession* (New York: Simon and Schuster, 1979).

6. Virginia Woolf, *Orlando: A Biography* (New York: Harcourt, Brace, 1928) is a rare example.

7. Anne Bolin, *In Search of Eve: Transsexual Rites of Passage* (South Hadley, MA: Bergin and Garvey, 1988), 15.

8. In addition to Stone, Shapiro, and Garber see *Diagnostic and Statistical Manual of Mental Disorders (Third Edition) [DSM-III]* (Washington, D. C.: American Psychiatric Association, 1980), 261–264, 269–270.

9. Jan Morris, *Conundrum* (New York: Harcourt, Brace, Javonovich, 1974), 151.

10. Morris, *Conundrum*, 147.

11. Edna Nixon, *Royal Spy: The Strange Case of the Chevalier D'Eon* (New York: Reynal & Company, 1965), 165.

12. Thomas Laqueur, *Making Sex: Body and Gender From the Greeks to Freud* (Cambridge, MA: Harvard University Press, 1990).

13. La Fortelle, *La Vie militaire, politique, et privée de Mademoiselle d'Eon*. Nouvelle édition (Paris, 1779); Frederic Gaillardet, ed., *Mémoires du Chevalier d'Eon*, 2 vols (Paris, 1836), which has been recently translated as *The Memoirs of the Chevalier D'Eon*, trans. Antonio White (London: Anthony Blond, 1970). Both works should be used with extreme caution since they include numerous errors.

14. Standard biographies including Captain J. Buchan Telfer, *The Strange Career of the Chevalier d'Eon de Beaumont* (London: Longman's, 1885); Ernest Alfred Vizetelly, *The True Story of the Chevalier d'Eon* (London, 1895); Octave Homberg and Fernand Jousselin, *Un Aventurier au 18th siècle, le Chevalier d'Eon 1728–1810* (Paris: Plon, 1904); Letainturier-Fradin, *La Chevalière d'Eon* (Paris: Flammarion, 1901); Armand Charmain, *La Vie étrange de la Chevalière d'Eon* (Paris: N. R. C., 1929); Jean Moura and Paul Louvet, *Le Mystère du Chevalière d'Eon* (Paris: Gallimard, 1929); Marjorie Coryn, *The Chevalier d'Eon, 1728–1810* (London: T. Butterworth, [1932]); Cesare Giardini, *Lo Strano caso del cavaliere d'Eon* (Milan, 1935); Pierre Pinsseau, *L'Etrange destinée du Chevalier d'Eon 1728–1810*, 2nd ed. (Paris: n.p., 1945); André Frank, *D'Eon: Chevalier et chevalière. Sa confession inédite* (Paris: Amiot Dumont, 1953); Dascotte-Maillet, *L'Etrange demoiselle de Beaumont* (Paris: Fayard, 1957); Edna Nixon, *Royal Spy: The Strange Case of the Chevalier d'Eon* (New York: Reynal & Co., 1965); Cynthia Cox, *The Enigma of the Age: The Strange Story of the Chevalier d'Eon* (London: Longman's, 1966); Michel de Decker, *Madame le Chevalier d'Eon* (Paris: Perrin, 1987). The following biographical events are drawn from these books.

15. Among those reports see especially Archives de la Ministère de Affaires Etrangères, Correspondence Politique, Angleterre, 484: 27–36; and Mémoires et Documents, 540: 44. For evidence of the close friendship between d'Eon and Wilkes, see the thirty dinner

invitations from Wilkes to d'Eon in University of Leeds Brotherton Collection 48: 71–106, and British Library, Additional Manuscripts, 30, 877.

16. For possible connections between the writing of *Figaro* and the d'Eon affair, see André Frank, "Le Chevalier d'Eon a-t-il servi de modèle à Beaumarchais pour Cherubin?," *Paris-Comoedia* June 16, 1953, p. 115. On Beaumarchais' connection with d'Eon see Margaret Leah Johnson, *Beaumarchais and His Opponents. New Documents on His Lawsuits* (Richmond, VA: Whittet & Shepperson, 1936), 96–142.

17. Archives Nationales 277 AP 16, File 5, Book 1 contains a record of over twenty pious book titles that d'Eon jotted down as he read book reviews, leaving no doubt about his sincerity in Christianity.

18. The post-mortem discovery of d'Eon's genitalia is recounted in Plummer, *Short Sketch*.

19. Dekker and Van de Pol, *Tradition of Female Transvestism*.

20. See the biographies published before 1945 listed in note 14.

21. Havelock Ellis, "Eonism," in *Studies in the Psychology of Sex. Volume II* (New York: Random House, 1936), 78, 100, 110.

22. Jeffrey Weeks, *Sex, Politics, and Society: The Regulation of Sexuality Since 1800*, 2nd ed. (London: Longman, 1989), 145–152; Janice Irvine, *Disorders of Desire: Sex and Gender in Modern American Sexology* (Philadelphia: Temple University Press, 1990); and for a sharp critique of Ellis, see Margaret Jackson " 'Facts of Life' or the Eroticization of Women's Heterosexuality," in Pat Caplan, ed., *The Cultural Construction of Sexuality* (London: Tavistock, 1987), 52–81.

23. In addition to those biographies published after 1945 listed in note 14, see M. Cadéac, *Le Chevalier d'Eon et son problème psycho-sexuel, Considérations sur les états psycho-sexuels et sur le "travestisme"* (Paris: Maloine, 1966).

24. Betty W. Steiner, "From Sappho to Sand: Historical Perspective on Crossdressing and Cross Gender," *Canadian Journal of Psychiatry* 26 (November 1981): 505; Vern L. Bullough, "Transsexualism in History," *Archives of Sexual Behavior* 4 (1975): 561–571; John Money and Patricia Tucker, *Sexual Signatures: On Being a Man or a Woman* (Boston, 1975), 29; Peter Ackroyd, *Dressing Up: Transvestism and Drag: The History of an Obsession* (New York: Simon and Schuster, 1979), 77.

25. These autobiographical fragments have been in the University of Leeds Brotherton Collection (hereafter ULBC) since the 1930s. Before that time, they were in private hands. For an inventory see "The manuscripts of J. Eliot Hodgkin, Esq., F. S. A.", *Historical Manuscripts Commission, 15th Report* (London, 1897), 352–368. The Brotherton Collection itself has an unpublished typed inventory that is more complete, but still leaves out many important details about the collection.

D'Eon's autobiography is a problematic text because he assumes a public that believes him to be an anatomic woman. Thus there is a "lie" at the very core of the text. To some extent, such deceit places the entire work in jeopardy: why should we believe any of it? This is especially true, as we shall see below, when d'Eon cites letters from his mother and others. Nowhere have I been able to locate the actual letters d'Eon's mother wrote to her son. What we have are transcriptions or large excerpts in d'Eon's own hand. Since these letters assume a mother who thinks of her son as an anatomic woman, we know that at least to some extent the "lie" about d'Eon's womanhood extends to these letters. Nonetheless, I feel free to use this autobiography to interpret d'Eon's behavior for the following reasons: first, there is much in these letters that is certainly true. For example, in the mother-son correspondence, I have corroborated names of people and dates of visits with outside sources and they all blend with d'Eon's account. Thus to dismiss the

Body Guards

correspondence as fiction would be to throw out much that can be considered historically accurate. Second, the autobiography can be read as a true confession of d'Eon's feelings about his curious behavior. He presents an honest and intimate view of himself and his feelings, which even if not true in the narrowest sense, may be viewed as a true representation of his heart. So, for example, even if the mother-son correspondence was completely fictionalized (which I do not think is the case), the fact that d'Eon would choose to develop such a correspondence in his autobiography, a correspondence that concentrates on the issue of his gender status, is itself of no small significance.

26. This incident is described in ULBC I, Chapter 3, "Continuation des principaux accidents de ma vie", 5–13. See also XVIII: 233.

27. Horace Walpole, *Correspondence*, ed. W. S. Lewis, 48 vols. (New Haven, 1932–1983), 6:474.

28. *Correspondance littéraire* (October 1777), 12:6. See also A. J. B. A. d'Origny, *Annales du Théâtre italien depuis son origine jusqu'à ce jour*, 3 vols. (Paris, 1788), 2:115.

29. For one recent account see Michel Antoine, "Les Bâtards de Louis XV," in *Le Dur métier du roi: Etudes sur la civilisation politique de la France d'ancien régime* (Paris: P.u.f., 1986), 293–313.

30. On Vergennes see Orville Murphy, *Charles Gravier, Comte de Vergennes: French Diplomacy in the Age of Revolution 1719–1787* (Albany: State University of New York Press, 1982).

31. ULBC XIX: 10.

32. ULBC I, chapter 3: 15; copy of king's August 27, 1777 order in Archives du Ministère des Affaires Etrangères, Correspondance Politique, Angleterre, Supplement 17: 45; trans. Telfer, *Strange Case*, 289.

33. ULBC II, "Extraits pour la vie de Mlle. D'Eon en 1777 et 1778. Son retour en France," 111; and ULBC XLVI: 1659.

34. ULBC VII, "Préface général de l'éditeur de Paris, qui en 1798 . . .", 59.

35. D'Eon wanted the date of his contract with the king to be on his birthday, symbolizing the rebirth. See Bibliothèque Municipale de Tonnerre, D'Eon Papers, R7 and R8.

36. D'Eon to Vergennes, August 29, 1777, Archives de la Ministère des Affaires Etrangères, Correspondance Politique, Angleterre, Supplement 17: 49–50 (copy); reprinted in *The Memoirs of Chevalier d'Eon*, trans. Antonio White (London, 1970), 283–284.

37. This section is based upon the ten-page manuscript, "Episode à part survenu pendant l'interval de mon séjour à Tonnerre et de mon depart subit pour retourner à Paris . . . 2 octobre 1777," in ULBC, I, chapter 5.

38. ULBC, I, Chapter 4: 4.

39. ULBC, I, chapter 4: 4–8.

40. ULBC I, Chapter 6: 6.

41. The visit is described in ULBC, I, chapter 6: 5–6.

42. Archives de la Ministère des Affaires Etrangères, Correspondance Politique, Angleterre, Supplement 17: 49–55.

43. ULBC, I, chapter 7: 1–3.

44. ULBC, I, chapter 8 ("Extrait de la grand conférence entre Mlle. Bertin et Mlle. d'Eon à Paris 21 octobre 1777"): 1–12. On Bertin see Emile Langlande, *Rose Bertin: the Creator of Fashion at the Court of Marie Antoinette*, trans. Angelo S. Rappoport (London: John Long, 1913).

45. ULBC, I, Chapter 9: 1.
46. ULBC, I, Chapter 7: 7.
47. ULBC, XVIII: 263
48. There were, however, satirical examples that assumed d'Eon a woman who had heterosexual affairs with men such as Benjamin Franklin. Examples include Delauney, *History of a French Louse* . . . (London: T. Becket, 1779); Lucretia Lovejoy [pseud.], *An Elegy on the Lamented Death of the Electrical Eel* . . . (London: Fielding and Walker, 1777); *Matrimonial Overtures From an Enamour'd Lady* . . . (London: J. Bew, 1778).
49. Bolin, *In Search of Eve*: 103 and 147: "After surgery transsexuals try to forget about their male history . . . systematic destruction of their former male persons is also expressed by transsexuals' riddance of their male clothing."
50. On this general approach see Mike Brake, " 'I May Be a Queer, But At Least I Am a Man': Male Hegemony and Ascribed Versus Achieved Gender," in D. L. Barker and S. Allen, eds. *Sexual Divisions and Society: Process and Change* (London, 1976).
51. ULBC, XIX: 14–15.
52. On this and related terms see Gayle Rubin, "The Traffic in Women: Notes on the 'Political Economy of Sex'," in Rayna R. Reiter, ed., *Towards an Anthropology of women* (New York: Monthly Review Press, 1975): 157–210; Joan Scott, *Gender and the Politics of History* (New York: Columbia University Press, 1988): 24–27; Linda J. Nicholson, *Gender and History: The Limits of Social Theory in the Age of the Family* (New York: Columbia University Press, 1986); Sherry B. Ortner and Harriet Whitehead, eds., *Sexual Meanings: the Cultural Construction of Gender and Sexuality* (Cambridge: Cambridge University Press, 1981).
53. R. W. Connell *Gender and Power: Society, the Person, and Sexual Politics* (Stanford: Stanford University Press, 1987): 81. See also Judith Butler, "Variations on Sex and Gender: Beauvoir, Wittig, and Foucault," in Seyla Benhabib and Drucilla Cornell, eds., *Feminism as Critique: On the Politics of Gender* (Minneapolis: University of Minnesota Press, 1987): 128–142; and the important articles on the history of sexuality by John Boswell, David M. Halperin, and Robert Padgug reprinted in Martin Bauml Duberman, et. al., eds., *Hidden From History: Reclaiming the Gay and Lesbian Past* (New York: New American Library, 1989): 17–66.
54. Joan Kelly, "Early Feminist Theory and the Querelle des Femmes 1480–1789," *Signs* 8 (Autumn 1982): 4–28; Carolyn Lougee, *Le Paradis des femmes: Women, Salons, and Social Stratification in Seventeenth-Century France* (Princeton: Princeton University Press, 1976); Dena Goodman, "Enlightenment Salons: the Convergence of Female and Philosophic Ambitions," *Eighteenth-Century Studies* 22 (Spring 1989): 329–367; Stephan Greenblatt, "Fiction and Friction," in *Reconstructing Individualism* ed. Thomas C. Heller, et. al. (Stanford: Stanford University Press, 1986): 30–52, reprinted in a different version in *Shakespearean Negotiations* (Berkeley and California: University of California Press, 1988): 66–93; Randolph Trumbach, "Sodomitical Subcultures, Sodomitical Roles and the Gender Revolutions of the Eighteenth Century: The Recent Historiography," in Robert Purks Maccubbin, ed., *'Tis Nature's Fault: Unauthorized Sexuality During the Enlightenment* (Cambridge: Cambridge University Press, 1987): 109–121; idem., "The Birth of the Queen: Sodomy and the Emergency of Gender Equality in Modern Culture, 1660–1750," in Martin Bauml Duberman, et. al., eds., *Hidden From History: Reclaiming the Gay and Lesbian Past* (New York: New American Library, 1989); Joan B. Landes, *Women and the Public Sphere in the Age of the French Revolution* (Ithaca: Cornell University Press, 1988). See also Nancy K. Miller, "I's in Drag: The Sex of Recollection," *The Eighteenth Century* 22 (1981): 47–57; Terry

Castle, *Masquerade and Civilization: The Carnalvalesque in Eighteenth-Century English Culture and Fiction* (Stanford: Stanford University Press, 1986); and Lynne Friedli, " 'Passing Women'—A Study of Gender Boundaries in the Eighteenth Century," in G. S. Rousseau and Roy Porter, eds., *Sexual Underworlds of the Enlightenment* (Manchester: Manchester University Press, 1987): 234–260; Barbara Pope Corrado, "Revolution and Retreat: Upper-Class French Women After 1789," in Carol R. Berkin and Clara M. Lovett, eds., *Women, War, and Revolution* (New York: Holmes and Meier, 1980: 215–236.

55. Montesquieu, *Oeuvres complètes*, ed. Rogert Caillois, 2 vols. (Paris, 1949 and 1951), 2: 1234.

56. Joel Schwartz, *The Sexual Politics of Jean Jacques Rousseau* (Chicago: University of Chicago Press, 1975).

57. David Williams, "The Fate of French Feminism: Boudier de Villemart's *Ami des Femmes*," *Eighteenth-Century Studies* 14 (1980–81): 37–48. But even Williams minimized the feminist argument of this work. Antoine-Leonard Thomas, *Essai sur le caractère, les moeurs et l'esprit des femmes dans les differens siècles* [1772], ed. Colette Michel (Paris and Geneva: Champion/Slatkine, 1987). Alphonse Le Roy, *Recherches sur les habillemens des femmes et des enfans; ou Examen de la manière dont il faut vêtir l'un et l'autre sexe* (Paris, 1772).

58. Adam Smith, *The Theory of Moral Sentiments* (Indianapolis: Liberty Classics, [1759] 1982): 28.

59. See my article, "D'Eon's Books: The Library of an Eighteenth-Century 'Transvestite' ", forthcoming in *Primary Sources*, 1 (Spring 1991).

60. ULBC XIX: 7.

61. For one stimulating analysis of androgyny see the introduction to Carolyn G. Heilbrun, *Toward A Recognition of Androgyny* (New York: Alfred A. Knopf, 1973).

8

"Sans les femmes, qu'est-ce qui nous resterait": Gender and Transgression in Bohemian Montmartre

Michael Wilson

"Bohemia" names what is, in modern Western societies, an indistinct social and conceptual space. It marks a self-chosen subculture, loosely associated with marginality, youth, poverty, devotion to art, and a shifting set of rebellious behaviors and attitudes. Indeed, bohemia seems so amorphous a social formation that its boundaries, its very identity, can conventionally be conceived only negatively, defined by violations of prevailing social, cultural or artistic norms. Thus, a commonplace assumption holds that bohemian subcultures are, and historically have been, a privileged site of transgressive behavior. At its most condensed and emblematic, this presumed transgression is expressed in the familiar opposition of bohemian and bourgeois. In recent historical work, however, this founding opposition has been displaced in favor of more complex relations of mutual affirmation and denial, reinforcement and subversion.[1] Still, what has consistently escaped critical attention is the most obvious complication of bohemia's transgressive claims: bohemia is constructed around the most conventional, pervasive and invidious norms, those of gender and sexuality.

This essay explores the role of gender and gender transgression in a specific bohemian community. It is drawn from a larger study of the subculture which, from approximately 1880 to 1910, made Montmartre a center of bohemian life equal to, if not more important than, that of the *quartier latin*. Bohemian Montmartre is remarkable for its attempt to appropriate the tools of the modern consumer economy, an

economy organized around the large-scale production of disposable commodities for a mass market.[2] In bohemian Montmartre the early institutions of this commodity culture—advertising, newspapers, and commercialized leisure—were used in order to represent social and artistic rebellion. The bohemians established their own cafés and cabarets, many of which published their own journals. These publications made satirical and critical use of the dominant discourses of newspapers, literary journals and advertising; they promoted the work of the artists who frequented the establishments as well as the cafés themselves, trying to attract a public for both. The newspapers were a crucial forum in which bohemian Montmartre constructed its image and identity for itself and for a wider, perhaps unknown audience.

These papers and other commercial ephemera can be read as a "counter-discourse," as an appropriation and critical transformation of established discourses. Counter-discourses attempt to exploit the fissures and contradictions inherent in dominant discourses, mounting a critique from within their own discursive space.[3] The counter-discourse of bohemian Montmartre reveals a good deal about how these men saw their community, its social relations and its differences from bourgeois and working-class culture. Like previous generations of bohemians, they saw as central to their identity the *"misère fraternelle"* of being artists; but for *la bohème montmartroise* the term "artist" had, as a member admits, *"une signification plus élastique qu'ailleurs."*[4] To be an artist in this context means more than and is not dependent upon the production of art, literature, or music; the artist is, rather, one who possesses certain philosophical and social attitudes (anti-bourgeois, anti-capitalist, favoring pleasure and spontaneity) and expresses them through particular forms of behavior (unconventional dress, irregular employment, participation in festive nightlife). The unarticulated assumption is that such a state of being could only be experienced by a male. Transgressive creativity forms the basis for a new model of masculinity, one not available to (or understood by) bourgeois or working-class men; as such, it necessarily excludes women. *"Les femmes,"* Francis Carco notes, *"n'ont pas tenu un grand rôle dans notre bande."*[5] Bohemia conceives itself as a community of exceptional men.

Women are a part of bohemian life—indeed crucial to its daily survival—yet are not themselves considered bohemians. Instead, in a clearly gendered division of labor, men are artists and women provide

for artists' needs. The subordination of women to men in all spheres of activity is assumed by the bohemians of Montmartre, as it is by all French men of this period. Bohemians, however, reject bourgeois notions of appropriate female behavior. The *femme au foyer*—devoted to maternity and domesticity, modest and pious—has no place in bohemia.[6] Instead, bohemians favor what they consider the "freedom" of working-class women: the liberty to work outside the home, to engage in pre- and extra-marital sexual relations, and to enter into *unions libres*. Such "freedoms," in the absence of legal or political rights for women, work largely to the benefit of men. By valorizing them, bohemian discourse challenges a particular class-bound model of "femininity," while it also retains and forcefully reasserts the normative gender hierarchy.

The precise place imagined for women in bohemia is made clear in the first issue of *Le Chat noir*, the first and longest-lived of the bohemian journals; the envoi of a poem entitled *"Ballade de joyeuse bohème"* addresses women directly:

> Femme, ne nous soyez point dure:
> L'artiste, en vos bras de satin,
> Ne fait pas mauvaise figure,
> Peintre, poète ou cabotin.

> [Woman, don't be hard on us:
> The artist, in your satiny arms,
> Doesn't cut such a bad figure,
> Whether painter, poet or actor.][7]

Like this verse, the literary and visual contributions to the bohemian journals represent women in a series of conventional, highly sexualized roles: muse, object of desire, wife (faithful or not), mistress, whore. The figure of the prostitute is particularly prominent and important.[8] Overrepresented in bohemian discourse, prostitution's conjunction of economics and sexuality produces a highly ambivalent significance. In moments of sympathetic identification, the prostitute is seen as proof of the hypocrisy of bourgeois morality and living testament to the harsh inequalities of capitalism. More often, however, the prostitute is seen as making explicit the dynamic underlying *all* heterosexual relations: women use their bodies, or the promise of their bodies, to

manipulate men. The fear and loathing of what female flesh extracts from the male spirit pervades bohemian discourse, expressed as a facile and cynical misogny:

> Au fond . . . toute la question est de savoir si le mal qu'elles nous auront fait équilibre suffisamment les heures de bonheur qu'elles nous auront données, et si la cruauté de leurs ingratitudes doit effacer de nos âmes reconnaissantes les joies qu'y ont semées leur caresses, mêmes passagères et trompeuses.

> [At bottom, it's all a question of whether the harm they will have caused us sufficiently balances the hours of happiness they'll have given us, and whether the cruelty of their ingratitude must erase from our thankful souls the joys spread there by their caresses, even the fleeting and deceitful ones.][9]

Given such an understanding of the possible relations between men and women, it is hardly surprising that one article counsels artists to avoid all but the most transitory encounters:

> Les vrais heureux,—les malins,—ce sont les incurables célibataires. Ceux-là ont prévu le danger et se défendent à outrance.

> [The truly happy ones—sly devils—are the incurable bachelors. They've foreseen the danger and defended themselves to the utmost.][10]

The author admits, though, that few men are so lucky; most enter into some sort of alliance with a woman. Heterosexual relations are seen to be inevitable but riven by risk and uncertainty.

The memoirs left by members of bohemian Montmartre only confirm that the gender relations portrayed in these texts largely corresponded to those operating in everyday life. Rodolphe Salis, founder of the first Montmartre *cabaret artistique* and "inventor" of bohemian Montmartre, ran the Chat Noir with his wife, but she is rarely mentioned and never named except as Mme. Salis. One contemporary observer even congratulated Salis on his refusal to allow women unaccompanied by a man to enter the cabaret.[11] Recollecting bohemian Montmartre, the memoirists seem equally unwilling to admit women. Of the eighty artists and writers listed by Jean-Emile Bayard as constitu-

tive of bohemian Montmartre, only one, Marie Krysinska, is a woman.[12] Other women making an appearance in the memoirs—mostly prostitutes, dancers, laundresses and other working-class women—do so only briefly and exclusively in the role of *petite amie*, infatuation or *femme galante*.

The extreme homosociality of this subculture—and the fragility of the notions of gender around which its identity is structured—may be seen even more clearly by examining violations of the canon of bohemian gender behavior. The most immediate transgression is enacted by women who assume the male perogative of creation and are identified by the hyphenated, hermaphroditic appellations of *femme-artiste, femme-peintre*, or *femme-auteur*. Bohemian discourse suggests that the *esprit artistique* can dwell only uneasily within the female[13]; in this unnatural accommodation, one identity must dominate at the expense of the other. Should artistic ambition prevail, the woman will, at the least, be unsexed. Camille de Sainte-Croix describes a *femme-artiste* who in her "*chasteté profane*" cannot sustain any feelings for others save a "*vague sentiment.*" Instead, alone, "*elle aimait aller voir des tableaux / Au Louvre, et s'enfermer ensuite dans sa chambre*" [She loved to go see the paintings / at the Louvre, and then to shut herself in her room].[14]

A more unsettling possibility is that women artists will come to resemble men in more than their vocation:

La femme peintre n'a rien de féminin. Elle porte le col droite et le veston masculins. Les plis de sa robe sont roides et disgracieux. Tous ses mouvements sont brusques et dépourvus d'élégance.

[There is nothing feminine about the woman painter. She wears a masculine stand-up collar and jacket. The wrinkles in her dress are stiff and disgraceful. All her movements are brusque and devoid of elegance.][15]

Such masculinization need not signal a lack of artistic merit—quite the opposite. For example, in a much-circulated anecdote, the poet Marie Krysinska, the only woman in bohemian Montmartre to be treated as an artistic peer, is revealed to wear men's shoes and undergarments.[16] Similarly, the Hydropathes, a Latin Quarter literary club whose membership formed the core of early Montmartre bohemia, admitted Sarah

Bernhardt to their meetings only if she took the title of *Monsieur* Bernhardt. The original occasion for this *travesti* was to elude police regulations, but even the investigating official declared of Bernhardt, "*Ce n'est pas une femme, c'est la grande artiste.*"[17] The charade continued after its legal necessity, becoming both an inside joke and an honorific. The sixth issue of the Hydropathe's journal devoted its cover to Monsieur Bernhardt, and inside proclaimed, "*Quel bon garçon, et quel singulier garçon!*"[18] *Le Chat noir* took up the joke, even announcing Bernhardt as the Messiah. This masculine identification is meant as tribute not just to Bernhardt's dramatic skill but to her work in sculpture and painting. Yet, as Bernhardt withdrew from bohemian circles, she was increasingly feminized, appearing as the paper's wire service (that is, as a gossip) and finally as "reine de la bourgeoisie."[19]

Bernhardt's fall from grace represents what, for the bohemians, is the debilitating potential within every *femme-artiste*: femininity is always in danger of smothering creativity.[20] Second-rate women's work becomes personified in bohemian discourse by the Société (later, the Union) des Femmes Peintres et Sculpteurs, whose annual exhibitions at the Palais de l'Industrie were routinely reviewed in Montmartre's journals. While not as openly contempuous as their Left Bank counterparts—*La Revue blanche* judged one show "*un très désagréable contrefaçon de l'autre, du véritable, du Salon des hommes*"[21]—the *monmartrois* treated these artists with irony and skepticism. The tone of the reviews is light, their attitude condescending:

> Eh bien! tout considéré, il reste vraiment de quoi charmer le visiteur et lui laisser, même s'il était moins galant que nous ne le sommes au *Chat noir*, une occasion nouvelle d'applaudir aux aimables efforts des sociétaires.

> [Well, all things considered, there remains enough to charm the visitor and to grant him, even if he's less galant than we are at the *Chat noir*, a new occasion to applaud the amiable efforts of the society's members.][22]

Each exhibition is hailed as an improvement over the previous, yet eight years later the same reviewer's highest praise is "*que cette douzième exposition-là est intéressante au possible.*"[23] The perceived lack of

quality is attributed directly to the gender of the artists. The exhibition is described as "*cette petite fête de mères de famille*" and, in an over-wrought conceit, as an "*opération césarienne*" after which "*les cent cinquante-cinq mamans des nouveaux-nés exposés*" can find comfort that "*les 356 enfants sont nés viables.*"[24] Moreover, the subjects of the works themselves are too feminine for *Le Chat noir*: "*nous continuons à déplorer l'absence absolue des tableaux de genre. Les natures mortes, les paysages, les fleurs (oh! trop de fleurs!).*" The critic in *Le Courrier français* expresses the same sentiment in a single sentence review: "*Que c'est comme un bouquet des fleurs!*"[25] The bohemian gender ideology which equates artistic merit with masculinity cannot address the *femmes-artistes* as simultaneously female and creative: insofar as they are women they cannot be true "artists" and insofar as they are artists they cannot be true "women."

I would stress here the conceptual impasse exemplified by the *femme-artiste*. Her refusal to accept particular activities or behaviors as gender-specific fails to provoke in the bohemians any uncertainty or ambiguity about gender binarism or the categories it produces. Rather, the critical potential of gender transgression is reduced in bohemian discourse to gender *inversion*. The trope of inversion serves to retain the contested terms and to assimilate particular "exceptions" to them; but it can also function to exclude the threatening and anomalous. This normative deployment of gender inversion is prominent throughout bohemian discourse; and it is prominent as well in the dominant dis-courses the bohemians sought to question. Of particular importance is the construction during this period of a new medico-juridical category, the *sexual invert*, marked by "a certain way of inverting the masculine and the feminine in oneself."[26] Sexual inversion was used to describe (and proscribe) a wide range of behaviors seen as transgressive of "normal" gender roles, including what we would now term homosex-ual relations. Inverts were seen as "*hermaphrodites moraux*"[27] whose manifestations of the characteristics of the "wrong" gender only made clearer the distinctions between the sexes.[28] It is hardly surprising in this context that the sexual invert emerges as a figure who tests the limits of bohemia.

The male homosexual and the lesbian play differing but complemen-tary roles in the discourse of bohemian Montmartre. In many of the memoirs, the decline of Montmartre into a simple pleasure-ground

after the turn of the century is symbolized by the open presence of homosexuality. Montmartre is frequented by *"petites jeunes gens de sexe assez peu déterminé,"* has become *"le pays de la coca, des bars pour pédérastes,"* is home to *"le vice des pays de neige."*[29] Yet the memoirs also confirm that fin-de-siècle Montmartre was already an important locus of the homosexual subculture of Paris.[30] One cabaret, the Clair de Lune, was advertised in *Le Chat noir* as the *"rendez-vous de plus curieuses personnalités de l'époque."* For the bohemians, this ambiguous phrase signaled that *"autrement dit, Madame y poursuivait Delphine et Monsieur, Corydon."*[31] Francis Carco also recounts that

> Dans les parages de la rue Rochechouart, la police venait de fermer un cercle et d'arrêter de jeunes personnes du sexe masculin ... qui se réunissaient pour des jeux dit de "commerce." Elles se donnaient des petits noms d'amitié: la Duchesse de Berry, la Reine des Boulevards, la Belle Bouchère, la Chatte, la Princesse.

> [In the vicinity of the rue Rochechouart, the police had just closed a social circle and arrested some young men who met for games of "commerce." They gave one another nicknames: Duchess of Berry, Queen of the Boulevards, Beautiful Butcheress, Pussycat, Princess.][32]

Despite the distance and disdain with which the memoirists recall Montmartre's homosexual enclaves, bohemia included at least a few homosexual men within its fraternity. Jean Lorrain, dubbed *"l'ambassadeur de Sodome à Paris"* by his biographer, was an early habitué of the Chat Noir and a contributor to its paper[33]; and Gustave Charpentier, whose opera *Louise* celebrated the love of young poets for working-class *montmartroises,* was, it has been suggested, more interested in their brothers.[34] For lack of evidence, it is impossible to determine how many other bohemians enjoyed same-sex relations, whether these were common knowledge, or how gay bohemians were regarded and treated. We may speculate, though, that, because there do not appear to have been any sexual relations between bohemians, the homosexual could be sharply differentiated from the homosocial and the image of bohemia as an asexual brotherhood could be reinforced and maintained.[35]

The most obvious strategy for instituting this cleavage is silence and denial, and bohemian discourse accordingly almost never speaks of

desire between men. But in the scattered traces of homosexuality in bohemian journals we may also glimpse other strategies of homophobic regulation. The voice of homosexual desire speaking itself is heard only twice, in poems by Jean Lorrain and Paul Verlaine.[36] Lorrain's poem, "*Bathylle,*" is the more openly homoerotic, describing the physical charms of a Thracian youth who dances for sailors:

> Et, tandis qu'il effeuille en fuyant brins à brins
> Des roses, comme un lys entr'ouvrant ses pétales,
> Sa tunique s'écarte aux rondeurs de ses reins.
> Sa tunique s'écarte et la blancheur sereine
> De son ventre apparaît sous sa toison d'ébène.

> [And, while he strips, fleetingly, bit by bit,
> Rose blossoms, like a lily's half-opened petals,
> His tunic parts over the curves of his back.
> His tunic parts and the serene whiteness
> Of his belly appears covered by his ebony fleece.][37]

By setting the poem in the ancient world, and invoking the classical model of Anacreon's verses celebrating Bathylle of Samos, Lorrain renders ambiguous his relation to the poem's subject. We cannot be sure that the desire he speaks is his own, that ancient pederasty signifies contemporary homosexuality. However, given the overcoding of "Greek love" for educated readers like the bohemians this ambiguity is too easily resolved as a confession of same-sex desire. Thus, the poem appears in *Le Chat noir* even further distanced; it is published not as a work of literature comparable to other contributions but within the column announcing forthcoming books. Moreover, it is prefaced by a sardonic invitation to readers to judge "*des qualités et aussi des audaces de l'auteur.*"[38] Clearly, the voice speaking in this poem is not to be understood as emanating from within the bohemian community.

A similar set of ambiguities and distanciations surround Verlaine's well-known poem, "*Langueur,*" which appeared in *le Chat noir* almost a year later.[39] "*Langueur*" also suggests the ancient world, "*l'Empire à la fin de la décadence,*" and implies the homosexuality of its speaker in his cry, "*Bathylle, as-tu fini de rire?*"[40] The obscurity of the poem and Verlaine's reputation evidently provided insufficient distance for

the journal, which published the poem, sandwiched between two others by Verlaine, under the collective heading of "*Vers à la manière de plusieurs.*" That the others who speak in these poems are decidedly not bohemians is further stressed by the texts' conflation of homosexuality with gender inversion. Lorrain's Bathylle is coded, from makeup to performance manner, as "feminine"; and the languor of Verlaine's text is implicitly linked with a loss of virility. The assumed opposition between femininity and creative production in the surrounding bohemian discourse here works to undercut or disavow any experiential link between these texts and their authors.

In contrast to these masked and marked displays of alterity, most references to homosexuality in bohemian discourse take the form of humor at the false imputation of same-sex desires. I will cite only three examples. The first, a cartoon in *Le Chat noir*, shows a man becoming increasingly enamored of the exotic creature performing the *danse de ventre*, only to discover under the final veil a large, bearded man.[41] A second cartoon, titled "Au Musée," depicts two bourgeois women examining a statue (Fig. 1); as one turns away in horror, the other proclaims "*Mais non, mon chère, ce sont des lutteurs.*"[42] Finally, in a short story signed by Willy, a naive aspiring bohemian falls in love, sight unseen, with the *grisette* he imagines to live in the neighboring garret, but learns that his "Mimi" is actually "*un garçon boulanger.*"[43] What is most striking about these "jokes" is the gender asymmetry of the lessons they teach (that is, of the anxieties they disguise): women see homosexuality where there is none; while men are led by their romanticizing desire for women into unwittingly homoerotic attachments. This asymmetry suggests that women ought to suspend their suspicion of homosocial arrangements but that men should be increasingly critical of the objects of their desire.

The anxiety, and attendant hostility, evoked in the bohemians by male homosexuality appears relatively infrequently when compared to the more common and more extreme condemnation reserved for lesbians. During the late nineteenth century, the three dominant discourses which took homosexuality as their object—"a common discourse, scarcely spoken; a scientific discourse . . . and a literary discourse"[44]—devoted unequal attention to the male and female variants of "sexual inversion." Scientific discourse focused almost exclusively on male homosexuality, while literary discourse became obsessed with

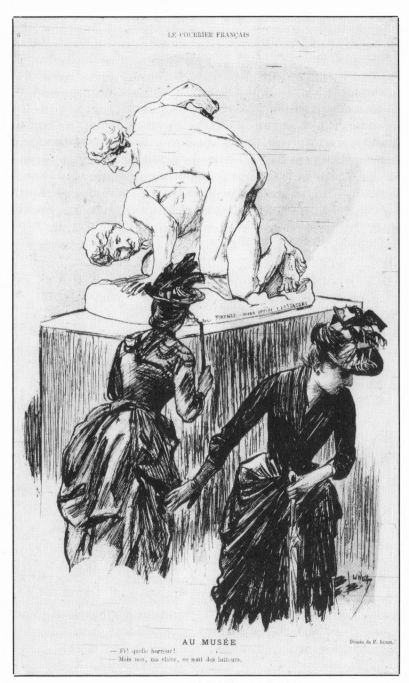

AU MUSÉE

— Fi! quelle horreur!
— Mais non, ma chère, ce sont des lutteurs.

Dessin de F. Lunel.

Fig. 1: Lunel, "Au Musée." *Le Courrier français* 28 April 1889. Courtesy of the Library of Congress.

lesbianism. Fin-de-siècle France in particular produced a huge number of literary and pictorial texts representing love and sex between women.[45] This vast corpus, it bears stressing, is entirely the work of men, phallocentric and factitious.[46]

Bohemian Montmartre contributed to this vogue, and the bohemian journals are filled with stories and poems concerning Sappho and Lesbos. These texts conform to contemporary conventions for representing lesbianism. "The discourse on lesbians," Elaine Marks notes, "tends to reproduce some culturally accepted derogatory point of view on women loving women . . . [or] to represent the lesbian as synonymous with a mysterious world of feminine pleasure."[47] Thus, sapphism is imagined as a sign of either moral degeneracy or of *jouissance* without end.

This latter, pornographic depiction of lesbianism is relatively uncommon in bohemian discourse. One of the few examples is the story *"Pierrot à Lesbos."* In this tale, the bohemians' favored everyman, Pierrot, sails to Lesbos, the island whose atmosphere is *"impregnée de plaisir."* Once there:

> Pierrot, en parcourant Lesbos ressentit quelque aise à voir ainsi de jeunes et belles femmes s'adonner à Venus et faire servir leur chair à des multiples plaisirs.

> [Pierrot, travelling about Lesbos, felt some comfort in seeing young and beautiful women devoting themselves to Venus and making use of their flesh for multiple pleasures.][48]

Predictably, the women soon offer Pierrot *"la science de leurs étreintes passionnées."* In the end, however, since it is Pierrot's fate always to be undone by women, he cannot compete with the sexual stamina of the great courtesan Thaïs. The story deploys a slight irony about the voyeuristic fantasy it offers, an awareness often found in *Le Courrier français* that the sexually titillating is being presented in the guise of artistic expression. This sense of sapphic desire as *"un aphrodisiaque sans danger"* finds its most telling expression in a poem, *"Sarah à Sapho,"* that is actually a *réclame*:

> Soigne bien tes jeunes appas;
> Les fleurs qui naissent sous tes pas

Sonts moins fraîches, moins parfumées
Que ton sein, tes lèvres aimées
Et toute la chair, ô Sapho,
Quand tu sors d'un bain de *Congo*.

[Take special care of your young charms;
The flowers that bloom beneath your step
Are less fresh, less fragrant
Than your breast, your adored lips
And all your flesh, O Sappho,
When you emerge from a bath of *Congo*.][49]

The advertisement turns on a sudden deflation of rhetoric, from the poetry of sapphic love to selling soap. The "joke" here is on the triviality of lesbian desire. Both these texts, like the genre to which they belong, betray a profound devaluation of female sexuality, the counterpart to an equally profound hostility to female sexuality outside the economy of phallic desire.

It is this hostility, expressed in the stereotype of lesbian depravity, which is most prominent in bohemian discourse. The thematics of lesbian decadence are encapsulated in an early sonnet by Emile Goudeau entitled "*Sapho-Lorette à Lesbie-Trinité*." The title itself locates the ancient "vice" within the specific social geography of Paris: *lorette* and *trinité* are slang terms for casual prostitutes taken from the names of two streets in lower Montmartre where such women were believed to reside in great numbers; the terms are meant to convey a certain irony since both streets are themselves named after churches. The association of lesbianism with prostitution is, of course, one of the great nineteenth-century clichés; by invoking it, Goudeau mobilizes associations between the whore, duplicity and perversion. The title signals a crucial, gendered distance between the voice speaking in the text and the text's author and audience. The voice of Sapho-Lorette is not to be trusted, and her claims must always be tested against male knowledge. The sonnet thus takes the form of a love poem but can imagine the lesbian lyric only as a malevolent seduction away from men. The first line sets the tone:

Pourquoi ne pas haïr les hommes, comme moi?
[Why not hate men, like me?][50]

The rest of the poem follows through the double work of this first sentence: creating the lesbian as the inverse of accepted terms (woman-loving must be man-hating) and then condemning female inversion. Heterosexual relations seen from the false perspective of the lesbian can thus only be figured as female debasement at the hands of men:

> L'âcre brutalité, peux-tu l'avoir subie,
> Sans un dégoût pour la souillure, et sans effroi?

> [The acrid brutality, were you able to submit to it
> Without disgust at the stain, and without dread?]

This is precisely the *inverse* of what bohemian discourse holds to be true; the more Sapho-Lorette insists—"*Je veux ton feu secret; sois froide pour les mâles*"—the more for a bohemian reader she impugns herself and her love. Only in the last lines of the poem is it suggested what lesbian relations might be beyond a rejection of male sexuality:

> De ta crinière blonde à tes talons rosés
> Laisse-moi promener d'*infécondes* caresses.

> [From your blonde mane to your rosy heels
> Let me cover you with *sterile* caresses.]

In this final moment the authorial voice interpellates what is assumed to be the single truthful word in the poem: *inféconde*. Goudeau, by highlighting this word, attributes to the lesbian a knowledge, which could be only be called perverse, of the emptiness of her desire.

The sterility Goudeau attributes to lesbian relationships derives not merely from the assumption that lesbians do not bear children, but from the belief that experiences between women have no attributable meaning of their own: they come to nothing. Female sexuality for the bohemians is conceptually dependent on male desire, on accepting or, inversely, rejecting it; lesbian desire cannot be conceived in its own terms, for it has none. Thus, the "failure" of lesbians to reproduce is linked to semiotic sterility, an inability to produce meaning. This presumed inability of lesbianism to signify is at times directly thematized in bohemian discourse, as in Goudeau's sonnet; but more

often it is suggested metaphorically: as beauty wasted, ripeness which withers, spring blossoms lost to frost.[51] As these examples indicate, although sapphism lacks meaning, bohemian discourse reinscribes that lack as itself meaningful. Indeed, the most generous significance bohemians are able to attribute to lesbians is what may be said about them. As one writer suggests, sapphism can, if its perversity allows nothing else, be the subject of literature:

> Comme nous comprenons, exquises créatures,
> Le mal dont vous souffrez et vos amours pervers!
> N'êtes vous pas nos soeurs, femmes, par vos tortures,
> Coeurs pantelants épris des débauches futures
> Dont l'image sans cesse apparait en nos vers!

> [How we understand, exquisite creatures,
> The evil that you suffer and your perverse love!
> Aren't you our sisters, women, in your tortures,
> Your heaving hearts enamored of future debauches
> Whose image appears ceaselessly in our verse!][52]

Yet even in this poem we can observe how bohemian discourse fails to recognize or acknowledge its own role in creating the object of its fascination and scorn.

The construction of "*saphisme*" within nineteenth-century French culture was carried on without reference to or accommodation for the experience of women who loved women; what it represents is, in Teresa de Lauretis' formulation, the labor of sexual (in)difference.[53] At the same time, however, lesbians were themselves building a woman-centered subculture of social networks and commercial institutions.[54] To the extent to which they were successful in doing so, lesbians were also increasingly subject to being recognized, understood and judged in the terms of prevailing gender ideology. Further, although there loomed an "immense, unbridgeable chasm separating men's perceptions of lesbian women and lesbian women's perceptions of themselves,"[55] women who loved women could conceive and express their experience, and could contest the dominant cultural understanding of it, only by using the very discourses which condemned and denied that experience.[56] Paris became known during this period as "Paris-Lesbos," a double-edged reputation which offered the possibility of

both "free sexual expression and oppressive sexual stereotyping."[57] Lesbian restaurants and cafés provided new opportunities for sociability between women, but they were also known to police and blackmailers and could be identified to tourists as a *"curiosité pathologique."*[58] Montmartre, as the site of most lesbian gathering places, plays a special role in this social and semiotic struggle to constitute (and to constitute the meaning of) a lesbian subculture.

The bohemians were uncomfortably aware of the increased visibility of lesbians; and appearance of literary sapphism in bohemian periodicals during the mid- to late-1880s coincides with a struggle between bohemians and lesbians for control of social space in Montmartre. Most lesbian spaces were uncontested, likely because they were hidden and not easily accessible. These restaurants and cafés were largely unchanged when, twenty years later, Colette frequented them with Missy de Belboeuf:

> There was also a cellar in Montmartre that welcomed these uneasy women, haunted by their own solitude, who felt safe within the low-ceilinged room beneath the eye of a frank proprietress who shared their predilections, while an unctuous and authentic cheese fondue sputtered and the loud contralto of an artiste, one of their familiars, sang to them the romantic ballads of Augusta Holmès.[59]

The bohemians sometimes visited these lesbian venues, where they were, if not particularly welcome, at least left alone. It was quite another matter, though, when lesbians visited larger, more public establishments, especially those the bohemians thought of as "theirs," such as the Tambourin and the Rat Mort.

We know little about the confrontations between bohemians and lesbians at the Rat Mort beyond their results. The café was a Montmartre landmark; opened during the Second Empire, it always welcomed a varied local clientele. During the 1880s the habitués were increasingly either bohemians or lesbians. Whatever transpired between the two groups led by the end of the decade to an uneasy segregation: bohemians dominated the café's ground floor during the day and evening, lesbians from dinner to closing. The bohemians, however, seem to have enjoyed privileged access to the café's basement, and opportunities for encounters appear to have been sufficiently frequent for relations to

remain tense. The bohemian memoirs record only that insults were exchanged, not the least being that "*la coutume était de dire pour désigner une lesbienne—'C'est un rat mort!'* "[60] This pattern of tension and feigned indifference seems to have been typical, so common as to be unremarked.[61]

In contrast, the Tambourin occasions a singular and dramatic story which, in the bohemian memoirs, takes on symbolic weight: for one writer "*l'aventure du Tambourin résume assez bien l'histoire de ce quartier parisien.*"[62] Run by Agostina Segatori, a former model for the painter Gérôme, the Tambourin was a combined Italian restaurant and gallery, and tried to attract customers with the decor as much as the cuisine:

> C'est un *buen retiro* chaud et gai, plutôt musée que café ... Mme Augustina Segatori a réuni, classé, placé, avec un sentiment artistique exquis les oeuvres de Maîtres qui ont transformé son établissement en une des plus intéressantes galeries de tableaux qui se puissent visiter.

> [It's a *buen retiro*, warm and festive, more a museum than a café. Augustina Segatori has gathered, sorted through, and hung with exquisite artistic feeling the works of the Masters, which has transformed her establishment into one of the most interesting picture galleries that it's possible to visit.][63]

The café was successful in attracting a clientele of painters, many of whom displayed their works there; but it also began to attract some lesbian customers. What happened then varies in different accounts, but the most telling version is provided by Jehan Sarrazin:

> [U]n soir, une femme célèbre dans les fastes de la Garde Nationale, vint souper, elle admira sans doute fort la maîtresse de la maison, car le lendemain elle revint avec la colonelle du même régiment, nouvelle admiration, le surlendemain l'Etat Major au complet envahit le Tambourin, bref à la fin de la semaine le régiment entier avait déserté ses campements du Clair de lune, du Rat Mort, de la Souris et autres lieux et s'était caserné au Tambourin.
> Les artistes désertèrent en masse, cela va sans dire.

> [One night, a woman celebrated in the annals of the National Guard came to have supper. No doubt she strongly admired the owner of the

café, because the following day she returned with the "colonel" of the same regiment. More admiration. The day after that, the complete general staff invaded the Tambourin. In short, by the end of the week the entire regiment abandoned its encampments at the Clair de Lune, Rat Mort, Souris and other places, and was barracked at the Tambourin. All the artists, it goes without saying, deserted.][64]

Sarrazin's extended military conceit is built around the image of lesbians as communards.[65] But even when this association is not invoked, a masculinized, militarized language prevails: "*Lesbos envahi la maison*"; the café "*fut bientôt assiégé par des ferventes du culte de Sapho.*"[65] Such descriptions serve an ambiguous purpose; for, if this was a battle, the bohemians were easily routed. More importantly, it obscures that the bohemians were not forced out of the Tambourin but chose to flee. In some accounts, Segatori herself doesn't comprehend the change in her clientele until she is invited to join the "regiment," but in all the bohemian accounts the lesbian "invasion" causes her to close the Tambourin.[67]

As these two examples indicate, encounters with actual lesbians did not force bohemians into any significant reconsideration of their gender norms. Indeed, representations of lesbians as dead rats or an invading army only reiterate themes from literary sapphism: hatred of men, perversity, sterility, degradation. What they add, or more accurately foreground, is a pronounced gender inversion: these lesbians look and act "like" men. They wear vests and bowlers; they have fights; they desire and pursue women. Perhaps most importantly, they claim and occupy *public* space. The "masculinity" of sapphism is stressed not only in the the memoirs but in the "documentary" accounts of lesbians found alongside literary depictions in bohemian journals. While intended by the bohemians as confirmation of the veracity of their literary efforts, the representation of "real" lesbians is instead an elaboration of fictional models. However, what the anecdotes in the memoirs and journals do clarify are the bases on which the bohemians imagined their disapprobation to be justified.

Typically, bohemian scorn for lesbians takes the same form as that in the dominant culture. Emile Goudeau, in an article on the Rat Mort, describes what happens after the nightly arrival of "*le bataillon de Lesbos.*"[68] He is disturbed first by their indifference to him—in his inverted formulation, "*pour elles un homme ou un canapé c'est la*

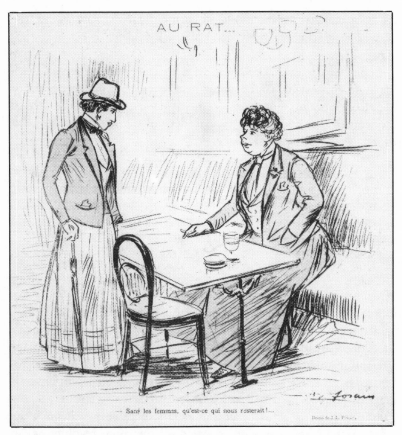

Fig. 2: Jean-Louis Forain, "Au Rat." *Le Courrier français.* 14 December 1890.
Courtesy of the Library of Congress.

même chose: on s'asseoit dessus"—and he is shocked to observe one
of the lesbians bargain with a prostitute for her services. He is affronted,
not merely by what he has seen, but by its taking place where *"on avait
disserté puissamment sur . . . l'avenir de notre race, le rôle de la poésie
et du commerce."* This transgression of male and female behavior, of
public and private, of intellect and physicality he considers a *"mélange
incroyable de toutes les grandeurs et de tous les vices."* A simpler, more
direct critique can be found in a cartoon published in the same paper
in 1890 (Fig. 2). Titled *"Au Rat,"* it shows one "masculine" woman
asking another, *"Sans les femmes, qu'est-ce qui nous resterait?"*[69] For

the bohemian, as for his supposed enemy, *l'homme des affaires*, the answer to this question is comically self-evident: everything that matters.

Bohemian discourse could also paradoxically identify lesbians with the bourgeoisie while condemning their behavior in the very terms of bourgeois morality. For example, the bohemians gave a nickname to the woman they took to be the "leader" of the lesbians at the Rat Mort:

> La plus effrénée de ces pauvres inassouvies, prétendant à la dignité masculine, n'avait pu arriver qu'à la parfaite ressemblance de l'horrible critique d'art du *Figaro*, aussi l'appelait-on Albertine Wolff!

> [The most unbridled of these poor insatiable women, trying to claim the dignity of a man, had been able only to achieve a perfect resemblance to the horrible art critic of the *Figaro*, and so was called Albertine Wolff!][70]

Gender inversion here is doubly damned. The appellation "Albertine" conflates the unnatural pretense of masculinity and its pathetic model: ugly, obese, reactionary Albert Wolff. The same scenario—lesbians attempting to mimic the worst attributes of bourgeois men—is rehearsed in an article titled "*Les Obsèques à Lesbos.*" Purporting to be the true story behind a death and funeral recently covered in the daily papers, it is actually an anti-Semitic parable which finds the hypocrisies of bourgeois life rendered all the more revolting when enacted by two women, "*Irma et 'sa femme.*'"[71] The two women "*vivaient 'maritalement,*'" meaning here that Irma—"*male né et mal éduqué et . . . riche*"—supported them both and that her lover was suspected of infidelity. One night, in the company of a male guest, the two women became drunk and "*se comportèrent comme deux simples notaires qui, après dîner, font une escapade.*" As a souvenir of this evening both women find themselves impregnated, "*ainsi que des petites bourgeoises de très bonnes moeurs.*" The consequence of this "*faute qu'elle avait commise*" is that Irma dies in childbirth, "*bien sévèrement punie.*" Her funeral proves to be a set-piece in which all bourgeois relationships are shown to be merely monetary: the stereotypical rabbi's pious banalities "*était payé à la phrase*"; and the mourners, all lesbians, bicker over who was remembered in Irma's will. In

this narrative, the penalty meted out to lesbians who imitate bourgeois heterosexuality is to suffer its dreary realities.

This complex intertwining of anti-bourgeois, anti-Semitic, misogynist, and homophobic sentiments is rare in bohemian discourse, but it demonstrates both the contradictions and fissures within bohemian gender ideology and the impossibility of completely assimilating that ideology to its bourgeois counterpart. Of course, gender relations are figured in bohemian discourse in ways that seem identical with those dominant in bourgeois society. Both assume a gender hierarchy in which men are superior to women and in which female sexuality is bound to male desire and to maternity. Moreover, bohemian understanding of gender transgression itself seems a variant of or contribution to wider public discourses. The representation of the *femme-artiste* forms part of the debates, provoked in large part by the French feminist movement, about the place of (bourgeois) women in the public sphere and particularly about the dangers of the masculinization of women who compete economically with men.[72] Bohemian attitudes toward and representations of "sexual inversion" in men and women are entirely consonant with both popular and medical conceptions; indeed, the three models of lesbianism operating in bohemian discourse correspond to sexological taxonomies of degrees of female inversion.[73]

While these similarities are striking, they are also misleading. Bohemian discourse deploys these prevailing gender norms to a different end; they form part of an assault *against* marriage and the bourgeois family, *against* propriety and respectability. They are integral to the counter-discourse of bohemia, the effort to mount a critique of bourgeois society from within its own discursive space. Crucial to our understanding of the place of sex and gender within this effort is social *class*. As Eve Sedgwick has stressed, "the meanings of 'masculinity' and 'femininity' themselves are produced within a context of class difference."[74] Yet class is precisely what bohemia occludes: in my analysis bohemia attempts to constitute a community, an identity, a model of masculinity *outside* class.[75] Rejecting the institutions and practices that articulate and undergird the particular masculinities of the bourgeoisie and working class, bohemians construct their sense of male privilege around an imagined monopoly on intellect and imagination.

This fragile and unstable formulation of bohemian identity—trans-

gressive genius as the ground of masculinity and vice versa—must be defended, on the one hand, against class-identified masculinities and, on the other, against "femininity." Thus, bohemian discourse constructs its relations of difference asymmetrically, in terms of either class or gender. Homosexual men, for example, cannot be identified as embodying any of the available models of masculinity and are instead condemned by the bohemians for the "appearance" of femininity. This condemnation is all the more forceful because the bohemians' same-sex enclaves, too, are outside conventional masculine norms.[76]

While bohemian discourse must defend against admitting femininity, bohemians also have need—conceptually, emotionally, practically—of women. Yet they are unable to imagine any positive identity for women which would be counterpart, not to say equal, to the artist. Bohemian discourse represents a range of female grotesques—the *femme-artiste*, the lesbian, the bourgeois mother, the domineering wife, the virago-concierge—who, in Mary Russo's terms, perform the hidden signifying labor to produce an acceptable femininity.[77] The femininity that remains outside the grotesque is characterized by the bohemians as sexually accessible, "purely" physical, and unthinking; in other words, the working class women represented as desirable in the bohemian journals and memoirs. Yet, as we have seen, even these women are suspected of undermining the "*esprit*" which grounds bohemian identity. This disjuncture was undoubtedly negotiated in lives of the bohemians, but we are confronted in their discourse by the irresolvable paradox of heterosexuality both compulsory and undesired.

Here bohemian gender relations would seem to merge once again with those of the bourgeoisie, or at least with those relations bourgeois men had with working-class women. Of course, it would be fair to locate this collapse—inevitable, given the dependence of a counter-discourse on that which it critiques—in the moment when bohemian transgression is seen as recuperating, rather than repudiating male privilege. That is, from its formation. We may understand the inability of the bohemians to conceive identity outside of the existing gender system as historical: of the discourses and practices they engaged, those clustered around gender seemed at the time the most immutable and "natural" and were becoming ever more naturalized under the imprimatur of science. However, the failure (of the will, of the imagination) to envision a community which could recognize and challenge norms

of gender and sexuality with the same force it brought to those of cultural production or social relations marks the limits of bohemian Montmartre; and it has continued to mark bohemian subcultures throughout this century.[78] The case of bohemian Montmartre suggests the tradition of male cultural transgression valorized by modernism and postmodernism alike could bear closer scrutiny and critical reexamination. It argues for the pervasiveness of gender as the ground for all their articulations of identity and difference, no matter how "subversive" their claims.

Notes

1. See especially Jerrold Seigel's influential survey, *Bohemian Paris: Culture, Politics, and the Boundaries of Bourgeois Life, 1820–1930* (New York: 1986). Earlier, Walter Benjamin effected an equally important and radically different displacement in *Charles Baudelaire: A Lyric Poet in the Era of High Capitalism* (trans. Harry Zohn. London: 1983): 11–34.

2. On the advent of the culture of mass consumption in France see Benjamin, *Charles Baudelaire*; Michael B. Miller, *The Bon Marché: Bourgeois Culture and the Department Store, 1869–1920* (Princeton: 1981); Rosalind H. Williams, *Dreamworlds: Mass Consumption in Late Nineteenth-Century France* (Berkeley: 1982); and William M. Reddy, *The Rise of Market Culture: The Textile Trade and French Society, 1750–1900* (Cambridge: 1984).

3. Richard Terdiman argues that, in nineteenth-century French culture, counter-discourses are "the principal discursive systems by which writers and artists sought to project an alternative, liberating newness against . . . established discourses." See Terdiman, *Discourse/Counter-Discourse: The Theory and Practice of Symbolic Resistance in Nineteenth-Century France* (Ithaca: 1985): p. 13.

4. Roland Dorgelès. *Quand j'étais montmartrois* (Paris: 1926): 18.

5. Francis Carco, *Montmartre à vingt ans* (Paris: 1938): 47. Carco is writing of the next generation, that of Picasso and Apollinaire, but his observation is equally true of the earlier generation of bohemia.

6. For a general account of the norms of bourgeois "ladyhood" during this period, see Bonnie S. Anderson and Judith P. Zinsser, *A History of Their Own: Women in Europe from Prehistory to the Present* Vol. II (New York: 1988): 132–163. A more detailed study of a particular group of French *bourgeoises* is to be found in Bonnie Smith's *Ladies of the Leisure Class: The Bourgeoises of Northern France in the Nineteenth Century* (Princeton: 1981).

7. Eugène Torquet, "Ballad de joyeuse bohème," *Le Chat noir* 14 January 1882.

8. The phenomenon of prostitution was accorded great prominence in the imagination and social relations of nineteenth-century Paris. The extensive system of regulating and policing prostitution focused a variety of official, medical and legal discourses upon the prostitute. These were supplemented by the scrutiny of a series of moral hygienists and reformers beginning with Parent-Duchâtelet's 1836 study, *De la prostitution dans la*

ville de Paris. The discourse and practices governing nineteenth-century prostitution are amply documented in Alain Corbin, *Les Filles de Noce: misère sexuelle et prostitution aux XIXe et XXe siècles* (Paris: 1978). See also Jill Harsin, *Policing Prostitution in Nineteenth-Century Paris* (Princeton: 1985).

For nineteenth-century writers and artists, the prostitute was an exemplary figure of modernity, representing the alienation of all social and sexual relations. See Charles Bernheimer, *Figures of Ill Repute: Representing Prostitution in Nineteenth-Century France* (Cambridge: 1989). See also T. J. Clark's discussion of Manet's "Olympia" in *The Painting of Modern Life* (Princeton: 1984) and Walter Benjamin, *Charles Baudelaire*: 151, 171, passim.

In all these discourses, the prostitute comes to represent the larger "problem" of female sexuality. As Mary Poovey has suggested, nineteenth-century discussions of prostitution occlude differences between social classes (as well as between women) in favor of binary gender difference. Thus, "the class difference that might be seen as a *cause* of social unrest has been translated into a gender similarity than can ideally serve as the *solution* to immorality." See her "Speaking of the Body" in *Body/Politics: Women and the Discourses of Science*, ed. Mary Jacobus, Evelyn Fox Keller and Sally Shuttleworth (New York: 1990): 33–34.

9. Georges Courteline, "Sanguines et Fusains," *Le Mirliton* 1 August 1886.

10. Jules Bois, "Petites décadences: Femmes d'artistes," *Le Courrier français* 17 August 1890.

11. Charles Virmaitre, *Paris impur* (Paris: 1900): 211.

12. Jean-Emile Bayard, *Montmartre, hier et aujourd'hui* (Paris: 1925): 9–10. Léon de Bercy, who has a more expansive conception of the community, profiles 3 women in his *Montmartre et ses chansons, poètes et chansonniers* (Paris: 1902).

13. "Il est vraiment incroyable qu'un pareil tempérament d'artiste ait pu s'être logé dans aussi jeune et aussi charmante enveloppe!" E. Ch., "Femmes peintres et sculpteurs!" *Le Chat noir* 28 February 1885.

14. Camille de Saint-Croix, "Femme-Artiste," *Le Chat noir* 23 November 1889.

15. Toto Carabo, "Types montmartrois: La Femme peintre," *La Lanterne Japonaise* 10 November 1888. See also the drawing by George Auriol, "La femme peintre," *Le Divan Japonais* 18 July 1891.

16. Anne de Bercy & Armand Ziwès, *A Montmartre . . . le soir: Cabarets et chansonniers d'hier* (Paris: 1951): 23. The respect accorded Krysinska is, of course, relative. She appeared in *Le Chat noir* only 17 times in the journal's fourteen years of weekly publication; four other women were published, each no more than twice.

17. Emile Goudeau, *Dix ans de Bohème* (Paris: 1888): 171. See also Raymond de Casteras, *Avant le Chat Noir, les Hydropathes* (Paris: 1945) : 62.

18. Georges Lorin, "Monsieur Sarah Bernhardt," *Les Hydropathes* 5 April 1879.

19. *Le Chat noir* 15 April 1882; 27 May 1882.

20. The belief in the opposition between "femininity" and "creativity" and the attendant ascription of inferiority to art produced by women is by no means limited to bohemian Montmartre and has been forcefully challenged by feminist art historians beginning with Linda Nochlin's "Why Have There Been No Great Women Artists?" in *Art and Sexual Politics*, ed. Elizabeth C. Baker and Thomas B. Hess (New York: 1973). For a more recent exploration of this problematic see Griselda Pollock, *Vision and Difference* (New York: 1988). Anne Higonnet has suggested that all nineteenth-century critical discussions of artists and art works were conducted in gendered terms in "Writing

the Gender of the Image: Art Criticism in Late Nineteenth-Century France" *Genders* 6 (Fall 1989).

21. Thadée Natanson, "Expositions," *La Revue Blanche* Vol. 10 (Premier semestre, 1896): 186.

22. E. Ch. "Femmes Peintres et sculpteurs!" *Le Chat noir* 28 February 1885.

23. E. Ch. "XIIe Exposition de l'Union des Femmes Peintres et Sculpteurs," *Le Chat noir* 11 March 1893.

24. E. Ch. "Union des Femmes Peintres et Sculpteurs." *Le Chat noir* 25 February 1888: E. Ch. "Les Femmes Peintres et Sculpteurs," *Le Chat noir* 20 February 1886.

25. E. Ch. "Union des Femmes Peintres et Sculpteurs," *Le Chat noir* 25 February 1885; Pierrot [Adolphe Willette], "Union des Femmes Peintres et Sculpteurs," *Le Courrier français* 28 February 1886.

26. Michel Foucault, *The History of Sexuality* Vol. I. *An Introduction* (trans. by Robert Hurley. New York: 1980): 43. The principle works of French sexology concerned with *sexual inversion* include Ambroise Tardieu, *Etude médico-légal sur les attentats aux moeurs* (Paris: 1878); Paul Moreau, *Des aberrations du sense génésique* (Paris: 1880); Julien Chevalier, *Inversion sexuelle* (Paris: 1893); Marc-André Raffalovich, *Uranisme et unisexualité* (Paris: 1896).

27. Julien Chevalier, *De l'inversion de l'instinct sexuel au point de vue médico-légal* (Paris: 1885): 168.

28. This is not to suggest that gender inversion can only function normatively. Esther Newton has demonstrated how, in the early twentieth century, the myth of the "mannish lesbian" enabled some women to imagine and enact sexual identities and relationships. See "The Mythic Mannish Lesbian: Radclyffe Hall and the New Woman," in *Hidden From History: Reclaiming the Lesbian and Gay Past*, ed. Martin Bauml Duberman, Martha Vicinus, and George Chauncey, Jr. (New York: 1989). In the course of the twentieth century, gender inversion has served socially important and transgressive roles in the creation of lesbian and gay identities and communities. See Joan Nestle, *A Restricted Country* (Ithaca: 1987); Sue-Ellen Case, "Toward a Butch-Femme Aesthetic," in *Making a Spectacle: Feminist Essays on Contemporary Women's Theatre* ed. Lynda Hart (Ann Arbor: 1989); and Michael Bronski, *Culture Clash: The Making of Gay Sensibility* (Boston: 1984).

29. André Warnod, *Le vieux Montmartre* (Paris: 1911): 23; Adolphe Willette, *Feu Pierrot* (Paris: 1919): 105, 107.

30. Montmartre is often named as a gathering place for homosexuals in the literature condemning the Parisian demi-monde. See Charles Virmaitre, *Paris impur*: 233 and 293; and Ali Coffignon, *La corruption à Paris* (Paris: 1889): 330–36; 346–48. My reliance on two such untrustworthy texts indicates a significant historiographical lacuna. The social history of Parisian gay life between 1870 and 1920 remains unwritten. For the periods immediately preceding and following this gap, see Pierre Hahn, *Nos ancêtres, les pervers* (Paris: 1979) and Gilles Barbedette and Michel Carassou, *Paris Gay 1925* (Paris: 1981).

31. Francis Carco, *La Belle Epoque au temps de Bruant* (Paris: 1954): 147. See also, Jehan Sarrazin, *Souvenirs de Montmartre et du Quartier latin* (Paris: 1895): 219–224; and Gabriel Astruc, *Le pavillon des fantômes: souvenirs* (Paris: 1929): 107.

32. Carco, *La Belle Epoque*: 146.

33. Philippe Jullian, *Jean Lorrain, ou le "Satiricon" 1900* (Paris: 1974): 60.

34. "Louise ait été un Louis comme Albertine, l'Albertine de Proust, fut un Albert." Pierre Villoteau, *La Vie Parisienne à la Belle Epoque* (Geneva: 1968): 296.

35. I owe to the pioneering work of Eve Kosofsky Sedgwick my understanding of the role of homophobia in policing the continuum of male homosocial experience. See her *Between Men: English Literature and Male Homosocial Desire* (New York: 1985).

36. Lorrain and Verlaine are among a very small number of French men during this period who wrote of and from the experience of homosexuality, and most of Verlaine's homoerotic poetry was published posthumously. The literature of homosexuality flowers only early in the twentieth century. See Jeffrey Meyers, *Homosexuality and Literature, 1890–1930* (Montreal: 1977).

37. Jean Lorrain. "Bathylle," quoted in "Bibliography," *Le Chat noir* 1 July 1882.

38. Ibid.

39. Verlaine published often in Montmartre's journals during this low point in his career, but he only rarely visited Montmartre's *cabarets artistiques*. See Albert Lantoine, *Paul Verlaine et quelques-uns* (Paris: 1920): 103–135.

40. Paul Verlaine, "Langueur," *Le Chat noir* 26 May 1883.

41. Doës, "La Danse de Ventre," *Le Chat noir* 8 February 1890.

42. Lunel, "Au Musée," *Le Courrier français* 28 April 1889.

43. Willy, "L'Amour à la Murger," *La Lanterne de Bruant* No. 62 (1899).

44. Jean-Paul Aron and Roger Kempf, "Triumphs and Tribulations of the Homosexual Discourse," in *Homosexualities and French Literature: Cultural Contexts / Critical Texts* eds. George Stambolian and Elaine Marks (Ithaca: 1979): 150.

45. The best account of the vogue for "lesbian" literature is still to be found in Jeanette H. Foster's 1954 classic, *Sex Variant Women in Literature* (Baltimore: 1975), Chapter 4. The corresponding trend in the visual arts is documented in Bram Dijkstra, *Idols of Perversity* (New York: 1986), Chapter 5.

46. A literature about lesbians by lesbians emerges in the twentieth century within the context of what Shari Benstock has termed sapphic modernism. See her *Women of the Left Bank: Paris, 1900–1940* (Austin: 1986). Benstock's text documents the marginalization of these writers, most of them British and American expatriates, by their male peers and subsequent cultural history. We should note, however, that these women had highly limited interaction with the bohemian and lesbian subcultures of Paris.

47. Elaine Marks, "Lesbian Intertextuality," in Stambolian and Marks, *Homosexualities and French Literature*: 361. Marks correlates prose with the former view and poetry with the latter, but I have not found this to be true in bohemian discourse:

48. Lucien Merlet, "Pierrot à Lesbos," *Le Courrier français* 16 January 1898.

49. "Sarah à Sapho." *Le Courrier français* 1 June 1890. A milder example of this same trivializing "humor" is the following fake "petite correspondance" from *Le Chat noir* of 17 May 1882: "Sapho.3.—Je t'aime, tu le sais! O Montmartre! pays de rêves, au revoirs.—Lesbie.4."

50. Emile Goudeau, "Sapho-Lorette à Lesbie-Trinité." *Le Chat noir* 22 December 1883.

51. Jean Lorrain, "Modernité," *Le Chat noir*. 2 September 1882; Jean Floux, "L'Espoir de Lesbos," *Le Chat noir* 15 January 1887; Marcel Bailliot, "Les Communiantes de Lesbos," *Le Courrier français* 15 August 1886.

52. Georges d'Ale, "Les Amies," *Le Courrier français* 10 August 1890.

53. "It thus appears that 'sexual difference' is the term of a conceptual paradox corresponding to what is in effect a real contradiction in women's lives: the term, at once, of a sexual *difference* (women are, or want, something different from men) and of a sexual *indifference* (women are, or want, the same as men)." De Lauretis uses *sexual (in)difference* to mark this "phallic regime of an asserted sexual difference between man

and woman which is predicated on the contrary, on a complete indifference for the 'other' sex, woman's." Teresa de Lauretis, "Sexual Indifference and Lesbian Representation," *Theatre Journal* Vol. 40, No. 2 (May 1988): 155, 156.

54. We have very little knowledge of lesbian social history, due to the invisibility of lesbianism (relative to male homosexuality as well as to heterosexuality) and the silence imposed on women who loved women. The most useful study of late nineteenth-century Paris is Catherine van Casselaer, *Lot's Wife: Lesbian Paris, 1890–1914* (Liverpool: 1986). This work relies almost exclusively on literary and anecdotal evidence, as do the two surveys of lesbian history which address fin-de-siècle France: Marie-Jo Bonnet, *Un choix sans équivoque: Recherches historiques sur les relations amoureuses entres les femmes, XVIe – XXe siècle* (Paris: 1981), Chapter 3; Lillian Faderman, *Surpassing the Love of Men: Romantic Friendship and Love Between Women from the Renaissance to the Present* (New York: 1981), Part II.

55. Elyse Blankley, "Return to Mytilène: Renée Vivien and the City of Women," in *Women Writers and the City* ed. Susan Merrill Squier (Knoxville: 1984): 49.

56. My own discussion is marked by this problem. I am forced to use a single vocabulary in referring both to the historical experiences of women who loved women and to the various construals of the meaning of that experience within medical and literary discourses.

57. Ibid.

58. *Guide des Plaisirs à Paris* (Paris: 1899): 116. Guides to the Parisian demi-monde betray considerable interest in lesbian gathering places; often, descriptions of lesbian and bohemian *boîtes* are mingled. See *Guide complet des plaisirs mondains et des plaisirs secret à Paris* (Paris: n.d.): 74–76; Rodolphe Darzens, *Nuits à Paris* (Paris: 1889): 91; J. R. Cicerone, *A travers les plaisirs parisiens: guide intime* (Paris: 1900): 105; Victor Meusy and Edmond Depas, *Guide de l'étranger à Montmartre* (Paris: 1900): 57–58.

59. Colette, *The Pure and the Impure* (trans. by Herma Briffault. New York: 1967): 77–78.

60. Willette, *Feu Pierrot*: 107.

61. See Willette: 106–7; Astruc: 103; Bayard: 140; Carco: 135–6; André de Fouqières, *Pigalle, 1900* (Paris: 1955): 217. See also John Grand-Carteret, *Raphaël et Gambrinus* (Paris: 1886): 131; Julis Price, *My Bohemian Days in Paris.* (London: 1913): 111; William Rothenstein, *Men and Memories* (New York: 1931): 59.

62. Fouquières: 82.

63. Advertisement for Le Tambourin. *Gazette du Bagne* 15 November 1885.

64. Sarrazin: 215.

65. The association of lesbians and the Commune is also made by Raoul Ponchon in his description of the Rat Mort in "Cafés Artistiques de Paris," *Le Courrier français* 14 July 1889. On the frequent linkage of communards and gender inversion see Marie Marmo Mullaney, "Sexual Politics in the Career and Legend of Louise Michel," *Signs* Vol. 15, No. 2 (Winter 1990).

66. Fouquière: 82; Carco: 108. See also Bayard: 87; and André Warnod, *Bals, cafés et cabarets* (Paris: 1913): 160.

67. The letters of Van Gogh, who had personal and professional relations with Segatori, suggest that the closure of her café was due, instead, to business pressures from unnamed men. See *The Complete Letters of Vincent Van Gogh* Vol. 2. (Greenwich: 1958) Letters #461, 462, and 510.

68. Emile Goudeau, "Le Rat Mort," *Le Courrier français* 24 October 1886.

69. Jean-Louis Forain, "Au Rat," *Le Courrier français* 14 December 1890.

70. Willette: 107. See also Bayard: 140; and Fouqières: 217.

71. Mermeix, "Les Obsèques à Lesbos," *Le Courrier français* 2 October 1887.

72. See Angus McLaren, *Sexuality and Social Order: The Debate over the Fertility of Women and Workers in France, 1770–1920* (New York: 1983), Chapter 10; and Karen Offen, "Depopulation, Nationalism and Feminism in Fin-de-Siècle France," *American Historical Review* Vol. 89, No. 3 (June 1984).

73. See especially Julian Chevalier, *Inversion sexuelle*; and the French translation of Krafft-Ebing's *Psychopathia sexualis, avec recherches spéciales sur l'inversion sexuelle* (Paris: 1895). A summary of contemporary medical discourse on lesbianism can be found in Bonnet and Faderman. For the corresponding views on male homosexuality see Antony Copley, *Sexual Minorities in France, 1780–1980* (New York: 1989), Chapter 6.

74. Sedgwick: 214.

75. As I argue in the longer version of this project, most bohemians are bourgeois in origin but have rejected or failed to maintain the social concomitants of that economic identity. They live among and at the standard of living of the working class, yet are neither forced into manual labor nor integrated into working-class culture. They feel a deep sense of identification with the socially marginalized, but that relation is largely imaginary and based in the romantic valorization of bohemian sensibilities.

76. I would speculate that the more frequent appearance of lesbianism in bohemian discourse, rather than indicating greater tolerance for male homosexuality, is evidence of acute homophobic panic. See Sedgwick: 86–90.

77. See Mary Russo, "Female Grotesques: Carnival and Theory," in Teresa de Lauretis, ed. *Feminist Studies/Critical Studies*. (Bloomington: 1986). Russo has explored this subject at length in *The Female Grotesque: The Spectacle of "Femininity"* (New York: Routledge, forthcoming). See especially Chapter 1, "Trilby's Foot."

78. There appear to be rare exceptions, but as Catharine R. Stimpson has demonstrated in the case of the Beats, even a bohemian enclave which admits of homoerotic relations remains strictly governed by gender norms. "The Beat Generation and the Trials of Homosexual Liberation." *Salmagundi* 58/59 (Fall 1982/Winter 1983).

9

The Chic of Araby: Transvestism, Transsexualism and the Erotics of Cultural Appropriation

Marjorie Garber

In July, 1972, James Morris, the noted British travel writer and foreign correspondent, booked himself a round trip ticket to Casablanca, where he would visit the clinic of the famous Dr. B— and undergo the surgery that transformed him from a man into a woman.[1] Morris had been approved for surgery at home, in England, at the Charing Cross Hospital in London. In the narrative of this transformation, *Conundrum*, the woman who is now Jan Morris explains that the London surgeon would have required that James Morris divorce his wife before undergoing the operation, and that Morris, although willing to get a divorce eventually, resisted doing so as a condition of his surgery.

It seems clear, however, that for Morris, who had journeyed so extensively in Africa, North and South, Casablanca was a special, liminal place, the geographic counterpart of his/her psychological and physiological condition. S/he required a more exotic setting than Charing Cross for this most exotic of crossings: "I sometimes heard the limpid Arab music, and smelt the pungent Arab smells, that had for so long pervaded my life, and I could suppose [Casablanca] to be some city of fable, of phoenix and fantasy, in which transubstantiations were regularly effected, when the omens were right and the moon in its proper phase."[2]

For Renée Richards, another transsexual who travelled to Casablanca for the surgery, the city's exoticism evoked an opposite response; twice Richards, at that point still a man named Richard

Raskind, traveled to the door of the Casablanca clinic, this "fantasy place" whose address he had long known by heart, and twice he left without entering.³ When Dr. Raskind finally had the operation it was at home, in New York, on familiar ground. But for Jan Morris, the lure of Casablanca was part of the process of transformation.

In the long period of probation before his surgery, when he took female hormones to change the contours and chemistry of his body, Morris imagined his indeterminate gender identity as a veil. "I first allowed my unreality to act as its own cloak around me," she writes, "or more appositely perhaps as the veil of a Muslim woman, which protects her from so many nuisances, and allows her to be at her best or her worst inside."⁴ For her, gender crossing is also imagined as culture crossing. What she describes as "our pilgrimage to Casablanca"⁵ (where the plural denotes "mine and that of other transsexuals," but the implication of "James's and Jan's" remains latently powerful) is a literalization of a cultural fantasy that played itself out in crossdressing as well as in homo- and bisexual relations between East and West, European and Arab.

"Paradoxically," writes Elizabeth Wilson in her book *Adorned in Dreams*, "in Islamic cultures women wear trousers and men robes."⁶ The paradox, of course, is seen through Western eyes; it is likely that Western dress conventions seem equally paradoxical when viewed from some vantage points in Kabul or Algiers. Nonetheless, this simple reversal of expectation has enabled, in that part of the world often called the West (in practice, certain regions of Western Europe and North America) a wide range of transvestic practices and behaviors, from disguise to drag, from passing to protest.

That Jan Morris's pilgrimage should have as its ultimate destination not the heights of Eastern exoticism but a "flat in Bath"⁷ underscores the fundamentally ideological nature of the "conundrum" which she describes in biographical and biological terms. Morris is only exotic, magical, set apart, in the middle stages of the journey, as neither man nor woman, when the hormones have arrested and even reversed signs of age, have produced the illusion of a kind of Fountain of Youth or Shangri-La. Once transformed, returned from Casablanca, Morris no longer inhabits that exhilarating no man's land. The biological clock, its works tinkered with but replaced, begins again to tick, and Morris finds herself, to her delight, transformed into a middle-aged suburban

matron, who "wear[s] the body of a woman."[8] What seems so striking to me, though, is that James Morris sought to realize his dream in Casablanca. Transsexualism here presents itself as a literalization of the Western fantasy of the transvestic, pan-sexualized Middle East, a place of liminality and change.

Appointment in Morocco

There is, in fact, more than a little appropriateness to the fact that Marlene Dietrich's signature costume of top hat and tails, the costume that signifies cross-dressing not only for her, in her own subsequent films and performances, but also for the legions of female impersonators who have since "done Dietrich" in drag, made its first appearance in a film called *Morocco*. Why cross-dressing in Morocco? Because the one was already, in European as in North American eyes, the figure for the other. Araby was the site of transvestism as escape and rupture.

Joseph von Sternberg's 1930 classic is the scene of multiple transvestic motifs—motifs that insistently put the sartorial rhetoric of gender in question. Dietrich, as the nightclub singer Amy Jolly, elegantly attired in her men's clothes, casually leans down to kiss a woman in the audience on the lips, and then reappears for her next stage turn dressed "as a woman," in a bathing suit and a feather boa. Her nightclub act is introduced by a bumbling male impresario in formal dress sporting a large hoop earring. Gary Cooper, as legionnaire hero Tom Brown, tucks a rose—Dietrich's gift to him—behind his ear. The master of ceremonies in his tuxedo begins to look like a drag version of Dietrich. So—although in a different tonal register—does Adolph Menjou when he comes to her dressing room in white tie and tails. The question of an "original" or "natural" cultural category of gender semiotics here is immediately put *out* of question. There is in the nightclub in Morocco nothing *but* gender parody.

The apparition of a woman in men's formal clothes (a spectacle that makes it clear that such "civilized" dress is *always* in quotation, no matter who wears it) is in this landmark film combined with a place, Morocco, and an object of clothing, the veil, that together constitute an interposition or disruption. The veil is to clothing what the curtain is to the theater. It simultaneously reveals and conceals, marking a

space of transgression and expectation; it leads the spectator to "fantasize about 'the real thing' in anticipation of seeing it."[9]

The veil as a sign of the female or the feminine has a long history in Western culture, whether its context is religious chastity (the nun, the bride, the orthodox Muslim woman) or erotic play (the Dance of the Seven Veils). But presuppositions about the gendered function of the veil—that it is worn to mystify, to tantalize, to sacralize, to protect or put out of bounds—are susceptible to cultural misprision as well as to fetishization. Thus a German ethnologist, who traveled for six months with the Tuareg of the North African desert, a tribe of veiled *men*, felt called upon to report that there was "nothing effeminate about these Tuareg nobles . . . on the contrary, they are shrewd, ruthless men with a look of cold brutality in their eyes."[10] Although the Tuareg were known as fierce warriors, the fact that their men wore veils at all times while Tuareg women freely showed their faces was clearly a puzzle. The men's eyes, however, were still visible through a slit in the veil, and could be construed, at least by those who expected or hoped to find such a thing, as showing "cold brutality"—in other words, manliness. This Eurocentric obsession with the veil as female—with what is veiled as "woman"—is established early in *Morocco* as itself a mystification and a coded sign.

At the beginning of the film Arab women unveil themselves flirtatiously at Gary Cooper from the tops of city buildings. On shipboard en route from Europe Dietrich wears a fashionable *Western* veil of sheer black netting attached to a perky black hat, before making her appearance in male formal dress. Her sexual rival, the wife of the adjutant (superbly named "Madame Caesar" although—or because—she is emphatically *not* above suspicion), disguises herself in a Moroccan robe and veil in order to pursue Cooper. The distinction between the two women is both gendered and nationalized, though Madame Caesar's "Arab" costume is manifestly a kind of adventurer's fancy-dress, a colonial appropriation, not an acknowledgment of cross-national (or cross-racial) sisterhood. In the famous final scene, kicking off her sandals and tying her stylish neck-scarf around her head like a peasant kerchief, Dietrich joins the Arab women in the trek across the desert. Class markers are thus tied both to gender and to race; Dietrich "descends" from upper-class white tie and tails—the sign of the male, the aristocrat, or the high-style lesbian—to the status of a native camp

follower. But what is most striking is the way in which von Sternberg's film puts the signification of gender in question, and does so in a particular locale.

Thus, in von Sternberg's *Morocco*, the "Foreign Legion," that colonial fantasy of amnesic brotherhood in which a recruit is permitted to put his past under erasure, is another version of this medial space. And so too is the boat that brings "Amy Jolly," the quintessential *jolie amie*, to Casablanca. That Amy Jolly's journey is twinned historically with Dietrich's (and von Sternberg's) passage from Germany to Beverly Hills underscores the transitional moment marked and encoded in the film. For Hollywood *was* Morocco, *was* Casablanca, as cross-dressing itself became, in the years that followed, nothing less than the radical of representation in film.

In cinematic representation the word "film" interposes itself, *like* a veil, as a space of multiple meaning: membrane or covering; photographic transparency; motion picture. The veil is a film, the film is a veil. What is disclosed *is* what is concealed—that is, the fact of concealment.

Here it is useful to recall not only Jacques Lacan's figure of the veil as a sign of latency,[11] but also the observations of Heinz Kohut, the pioneer theorist of narcissism, on theater and reality. Kohut notes that people "whose reality sense is insecure" resist abandoning themselves to artistic experiences because they cannot easily draw a line: "They must protect themselves, e.g., by telling themselves that what they are watching is 'only' theater, 'only' a play." So too with the analysand; only analysands "whose sense of their reality is comparatively intact will . . . allow themselves the requisite regression in the service of the analysis"— a regression that "takes place spontaneously, as it does in the theater."[12] This fear of blurring the line, of not being able to distinguish "reality" from "theater," this susceptibility to fantasy—to *cultural* as well as to intrapsychic fantasy—is, precisely, the stage, stage in both senses, both the process and the playing space, of the transvestite.

Any Way You Slice It, It's Still Salome

The picture is almost too eloquent. His wrists, fingers and upper arms circled with jewels, his flowing locks adorned with an "Oriental"

headdress, a jeweled belt at his ample waist, he kneels, with some little difficulty balancing his long skirt on his hips, and, all concentration, reaches out toward the head on the platter at his feet. The wig on the platter seems the mirror of the one that sits on his own head and cascades down his back, like a Burne-Jones in drag. It is Oscar Wilde in the costume of Salome.

The drag Salome is not a send-up, but a radical reading that tells the truth. For the binary myth of Salome—the male gazer (Herod), the female object of the gaze (Salome), the Western male subject as spectator (Flaubert, Huysmans, Moreau, Wilde himself) and the exotic, feminized Eastern Other—this myth, a founding fable of Orientalism, is a spectacular disavowal. What it refuses to confront, what it declines to look at and acknowledge, is the disruptive element that intervenes, the scandal of transvestism. It is no accident that the Salome story conflates the myths of Medusa and Narcissus, the decapitated head and the mirror image. This conflation was known to Donatello, who gave his Perseus the same face as his Medusa; it was known to Aubrey Beardsley, whose illustrations for Wilde's text clearly show Salome, in the act of kissing Iokanaan's dead lips, holding aloft the head with its snaky locks, transfixed by self-love on the bank of a reflecting pool. Self-love, and self-hatred.

The story of Salome and her mesmerizing Dance of the Seven Veils has become a standard trope of Orientalism, a piece of domesticated exotica that confirms Western prejudices about the "Orient" and about "women" because it is produced by those prejudices, is in fact an exercise in cultural tautology. In order to see what the story represses, let us first see what it purports to tell, and then take note of the ways it has been read and appropriated in European texts.

Here, in brief, is the familiar Salome story as it is reported by the Jewish historian Josephus and in the Gospels of Matthew and Mark. Herod watches Salome dance the Dance of the Seven Veils and is enraptured, inflamed. He says he will give her anything she wants, and she asks for the head of John the Baptist on a platter. Herod is dismayed by the request, but capitulates—yields up the head. Salome takes it, and gives it to her mother.

Matthew's Gospel says she was prompted by her mother Herodias to ask for the Baptist's head in the first place. Mark tells it a little

differently; her mother did not prompt her in advance, but was consulted on the spot. In both cases, though, the death of John is seen as the desire of the mother, not the daughter. The female subject is split, and the trajectory of the gaze doubled: Herodias gazes on Herod gazing on Salome. But John has already seen—and seen through—Herodias, denouncing her as an adulteress because she has married Herod after being married to his brother. The decapitation of the prophet is Herodias's revenge; she renders him powerless, and silences his tongue.

In neither Gospel, significantly, is Salome named; she is described only as the daughter of Herodias. Josephus mentions her name, but does not connect her with the death of John, nor does he record that she danced for Herod. Though both Gospels say she danced, neither mentions the famous Dance of the Seven Veils or, indeed, characterizes the dance at all: they say only that "the daughter of Herodias danced." Out of this thin stuff grew up the legend.

What is there here to stir cultural and sexual fantasy? Too much: parents and a willful child; incestuous desire; taboo; and a gap.

French writers and painters of the nineteenth century had a field day with Salome, and both feminists and deconstructive critics of the twentieth century have had a field day with them. A rich literature has grown up around the Salome story, filling in the blanks in the biblical account. Moreau's paintings, Huysmans's *A Rebours* and Flaubert's *Herodias* all focus largely on the dance itself.[13] Salome and her dance become a figure for that which can—and cannot—be represented, as well as for the putative cruelty and inscrutability of Woman.[14] "Salome's dance becomes the blind spot of writing to its own repression" suggests Françoise Meltzer, reading Salome's dance as an *aporia* which confounds logocentric "meaning" and puts the possibility of such meaning in question.[15] In its nondescription, in its indescribability, lies its power, and its availability for cultural inscription and appropriation. "The ultimate veil," as Mallarmé declared, "always remains."[16]

In Egypt Flaubert watched the dance of the famous courtesan Kuchuk Hanem, and used her, it is claimed, as the model for his Salome, as well as for Tanit and Salammbô. Edward Said describes Kuchuk as a "disturbing symbol of fecundity, peculiarly Oriental in her luxuriant and seemingly unbounded sexuality,"[17] the embodied object of Flaubert's fantasies about the sensual, self-sufficient, emotionally careless

Oriental woman. Yet Said overlooks or represses the fact that it is "not the female Kuchuk but a homosexual *male* who first catches the traveler's eye":[18]

> a male dancer—it was Hasan el-Belbeissi—in drag, his hair braided on each side, embroidered jacket, eyebrows painted black, very ugly, gold piastres hanging down his back; around his body, as a belt, a chain of large square gold amulets; he clicks castanets; splendid writhings of belly and hips; he makes his belly undulate like waves; grand final bow with his trousers ballooning.[19]

Hasan el-Belbeissi, like Kuchuk, could be induced to dance "the Bee,"[20] a celebrated performance in which the dancer sheds clothing as he or she dances, winding up, as Kuchuk does, "naked except for a *fichu* which she held in her hands and behind which she pretended to hide, and at the end she threw down the *fichu*."[21] A curious feature of this dance is its aura of taboo: the musicians and other necessary members of the dancer's entourage are themselves veiled or blindfolded during the performance; Flaubert and his companions, alone, are permitted to watch: "That was the Bee. She danced it very briefly, and said she does not like to dance that dance."

As Joseph Boone points out, Said ignores the homosexual and homosocial aspects of Flaubert's account, and especially the salacious, erotically charged letters to his friend Louis Bouilhet, who features in a number of thinly veiled sexual reveries, and for whom the descriptions of the female courtesans and male bardashes seem explicitly intended. Boys, as well as girls, excited Flaubert's imagination in Egypt; he claims to have buggered a boy in a male brothel, on the custom-of-the-country principle, and intends to learn how to do it better—or so, at least, he writes to Bouilhet. Said is willing to note that Flaubert learned from his reading of W. E. Lane about both male and female dancers, but for Said, as for Flaubert, the Otherness that produces unbounded desire is a woman. Boone's critique thus in effect proposes to substitute a dancing boy for the dancing girl, as an equally appropriate, and more destabilizing, reading of the Orientalist impulse in Western culture.

Renouncing the femininity of Salome is a task not only for gender theory, but for a new cultural criticism, since it challenges the construction of a feminized Orient subservient to the heterosexual masculinity

of the Western observer. But as politically necessary as this substitution may be, it is not sufficient, in reading the riddle of Salome and her veils.

For Boone's salutary substitution, therefore, I want to suggest another—the substitution not of a regendered dancer but of a transvestite dance. I want to argue that on the level of the Imaginary, the dancer is neither male nor female, but rather, transvestic—that the essence of the dance itself, its taboo border-crossing, is not only sensuality, but gender undecidability, and not only gender undecidability, but the paradox of gender identification—the disruptive element that intervenes, transvestism as a space of possibility structuring and confounding culture. *That* is the taboo against which Occidental eyes are veiled. The cultural Imaginary of the Salome story is the veiled phallus and the masquerade. This is the latent dream thought behind the manifest content of Salome.

Subsequent retellings of Salome have come closer and closer to this unveiling; the veils drawn aside have been national as well as cultural, so that Oscar Wilde, an Irishman writing in French, can see through the necessary fictions of Flaubert and even Huysmans, as Ken Russell's American film, a triumph of postmodern trash cinema, sees through, as it restages, Wilde. In order to make this argument, it will be necessary to review, briefly, some of the details of the Salome tradition, and then look at some evidence for peeking behind the veil.

Wilde begins, characteristically, by playing with the possibility of regendering the gaze. In his *Salome* the obsessive desire shared by Herod and the young Syrian Captain to look at Salome ("You look at her too much," each is told, over and over) is ultimately less compelling, and less compulsive, than Salome's own limitless desire to gaze upon Iokanaan—and to have him return the gaze. ("Wherefore dost thou not look at me, Iokanaan? Thine eyes that were so terrible, so full of rage and scorn, are shut now. Wherefore are they shut? Open thine eyes!"[22]) The Medusa moment is doubled and literalized; not only is the gazing Herod (and before him the young Captain) destroyed, but so too is Salome. As she kisses the severed head, Herod gives the order for her to be killed. Aubrey Beardsley's famous illustration, aptly titled "The Climax," captures the regendering of the Medusa story and its conflation with the story of Narcissus.

Wilde seems, in fact, to have been at some pains to experiment with

reversing the gender roles here. At an early stage of composition, he considered calling his play *The Decapitation of Salome,* and extending the plot to describe Salome's subsequent wanderings through deserts of sand and snow, and her spectacular accidental decapitation when she falls into a river of jagged ice.[23] In this fantasy, too, she becomes by reversal a female version of John the Baptist, ironically bathed in a river, dying a Christian and a symbolic castrate. Salome's extended praise of Iokanaan's body, hair, and mouth follow the incantatory rhetoric of the Song of Songs—"but," notes Richard Ellman, "The Song of Songs describes a woman's beauty, not a man's."[24] This is part of what makes Iokanaan's position intolerable to him; he is, in effect, feminized by the gaze of Salome.

Now, what if we were to take Wilde's gender hypothesis one step further, and ask what would happen if the object of the gaze were, not a woman or a man, but a transvestite? This is—I want to claim—in fact the substitution that Wilde's *Salome* enacts, a substitution radicalized and made visible in Ken Russell's 1988 film, *Salome's Last Dance.*[25] And this substitution is not only a rewriting of the Salome story but a rereading of it that makes all the sense in the world—makes sense, for example, of the cultural amnesia that omits to mention the dancer's name, or the name of her fabled dance. Let us see how that might happen.

Ellmann's biography of Wilde contains an amusing and disconcerting photograph of Wilde himself in the costume of Salome, a photograph I have already described above. The moment depicted is that which will lead to "The Climax": Wilde-Salome kneels, his/her bejeweled hands and arms outstretched, and gestures toward the head on the charger. The head itself is turned away, so that only its hair can be seen; it looks very like a wig. Thus: Wilde the author, Wilde the libertine, Wilde the homosexual, as Salome. The transvestite Wilde is yet another version of the "to seem" that replaces the "to have" in Lacan's trajectory of desire. Reaching toward the wig on the platter, he focuses attention on the materials of transvestite masquerade—on drag as, and in, theatrical representation.

In Russell's film, this substitution is brought to consciousness in the moment when the dancing Salome drops her final veil and appears naked, not as a woman *or* as a man but as two figures dancing side by side, one male and one female. This double image reduces to a single

image of the boy, his whirling penis the center of the camera's (Herod's) astonished fascination—and then, the dance over, we see instead a naked girl, the Salome we thought we were watching all along. It is important to stress that this is *not* a hermaphrodite, despite the allure of Beardsley's illustrations. It is a stereo-optical intuition of transvestism (was it as boy? was it a girl?) apparently satisfied by the sight of the unveiled penis, then covered over again as the girl, her pubic area clearly visible, is wrapped in a robe and congratulated on her performance.

Let us now take note of Mallarmé's dictum, that the Dancer "delivers up to you through the ultimate veil that always remains, the nudity of your concepts and silently begins to write your vision in the manner of a Sign, which she is." And let us consider, in conjunction with it, Lacan's observation that "the phallus is a signifier, a signifier whose function, in the transubjective economy of the analysis, lifts the veil perhaps from the function it performed in the mysteries,"[26] and, even more centrally, the phrase of his that seems, again and again, to have such pertinence to the transvestite masquerade: "[the phallus] can play its role only when veiled."[27] In other words, because human sexuality is constructed through repression, the signifier of desire cannot be represented directly, but only under a veil. Taken together, these somewhat abstract formulations about the dancer, the dance, and the veiled phallus, tell the story of the power of Salome—and the reason why the removal of the last veil is the sign of her death. For when the veil is lifted, what is revealed is the transvestite—the deconstruction of the binary, the riddle of culture.

What Oscar Wilde added to the long list of Symbolist Salomes was the realization that Salome was a figure for transvestism in its power to destabilize and define. What Russell added to Wilde was the literalization of the unveiled phallus—an interpretation of Wilde, not a rewriting of him, as Wilde read what was already inscribed in Salome, under the veil. And a key player in helping Wilde to reshape the role was Sarah Bernhardt.

Wilde, having written his play in French—an homage to the French preoccupation with the Salome story, to Flaubert as well as to Mallarmé, Moreau, and Huysmans—decided that the part of Salome should be played by Sarah Bernhardt. Wilde greatly admired Bernhardt. When she arrived in London in May 1879 he cast an armful of

lilies beneath her feet as a carpet, and conceived a strong desire for her to act in one of his plays. Bernhardt had already become famous for her cross-dressed roles, of which she would play at least twenty-five in the course of her long career: Zacharie in Racine's *Athalie* and Zanetto, the strolling boy troubadour in Coppée's *Le Passant* in 1869 were among her early triumphs in breeches parts—later she would play Hamlet, in 1899, and Napoleon's doomed son, the Duc de Reichstadt, in a celebrated production of Rostand's *L'Aiglon* in 1900.

When, in 1892, Wilde replied to Bernhardt's request to write a play for her by saying, "I have already done so," he meant *Salome,* and she eagerly agreed to play the title role. The intended London production foundered on the licenser's ruling, but Wilde continued to hope that Bernhardt would stage his play.[28] Wilde, in other words, visualized his Salome as a woman who could play the part of a boy.

In Russell's film, Bernhardt plays a brief but crucial role as an absent presence; her relationship to *Salome* is tracked down and camped up. For at the end of the play-within-the-play Wilde, praising Lady Alice's performance as Herodias, remarks that no actress could have done better—except Sarah Bernhardt, who has something Lady Alice lacks. What's that?, Lady Alice asks, with hauteur. Why—a wooden leg, he replies.

In fact, Bernhardt's leg was not amputated until 1915, twenty-three years after Wilde's initial suggestion that she should play the title part in his play, and the same length of time after Wilde's association with Alfred Taylor, the purported "historical" occasion of the film. Why, then, does *Salome's Last Dance* go out of its way to include an apparently anachronistic reference to Bernhardt's wooden leg?

Perhaps merely to give a sense of local color to this fantasy event; perhaps to underscore Wilde's misogyny; but perhaps, also, because the mention of Bernhardt's wooden leg here presents another detachable phallus, another sign of lack and its substitution in a phallic woman who happened to play, in the decades that she dominated the stage and the theatrical Imaginary, the part of boys and men. That wooden legs played such a part in theatrical representation has been true at least since Marlowe's *Doctor Faustus.* But that the wooden leg should be a *woman's*—should be *Salome's*—reinforces the sense in which Salome herself is a transvestic construction. In other words, the wooden leg, though added after the fact as a sign of Bernhardt/Salome's amputa-

tion/castration, is part and parcel of the story here. And how does one dance with a wooden leg?

In the early, hopeful days when it looked as if Bernhardt could produce the play in London, before the intervention of the licenser of plays (the castrator of culture), the Marquess of Queensberry (the castrator as heavy father), and Mr. Justice Clark (the castrator of law), the designer Graham Robertson asked the actress whether she wanted a stand-in for the dance. Bernhardt replied equably, "I'm going to dance myself."

"How will you do the dance of the seven veils?" he asked, and she answered, smiling enigmatically, "Never you mind."[29]

So, once more, as always, the dance remains undescribable, undescribed—and, in the event, unperformed. Yet it may be that Bernhardt's refusal to involve herself in Wilde's misfortunes by purchasing the rights to *Salome* constitute an emblematic performance of the *Salome* part *par excellence:* indifferent, cruel, thoughtless. "Never you mind." This is the Dance of the Seven Veils as imagined by postmodernism, its ultimate performance, "the ultimate veil that always remains."

Let us now consider another postmodern drag Salome that addresses the issue of transvestism and the veil.

In *Pumping Iron II: The Women* (1985), a contest for female body builders, the entire competition is in effect one big Salome dance, as each woman performs a "free pose" routine, flexing her abs and delts for the judges to the tune of songs like "I'm Dangerous." But as aficionados (and aficionadas) of this film will know, a symptomatic narrative cross-cuts the docu-drama of the competition; contestants and judges are racked by dissension about the meaning of the word "femininity": can it be used to characterize a woman with musculature so developed that she looks like a man? Although the word "lesbian" is never spoken, the subtext is perfectly clear. What threat do well-muscled women pose to the fantasy idea of "woman"? The controversy centers on Bev Francis, a former power lifter from Australia, whose appearance creates consternation in onlookers—and in the other contestants. Francis, the film's "heroine" and figure of ambivalent pathos, slims down to enter the contest and is immediately the cause of controversy, but some contestants—and one female judge—are virulent in their dislike of her body image. It will, says the judge, ruin the appeal of a growing sport: "Bev Francis doesn't look like a woman."[30] Bev

herself, innocent of the heavy eye-makeup and teased hair of her American counterparts, worries anxiously after her "free pose": "Did my feminine quality come through? Are they going to say I'm too masculine?" In effect, they do; of the eight finalists, she comes in last.

But as the judges withdraw to consult about the rules (and the possible "new concept" of a woman's body), some entertainment is provided to keep the audience amused. An official spokesman for the contest describes this intervention, in unwittingly Lacanian terms, as "an exhibition to cover the gap." And the "exhibition" is, perhaps inevitably, a dance, performed by a figure swathed in veils.

The dancer's head and body are alike masked, so that it is at first impossible to determine its gender. But step by step the veils are discarded, disclosing at last the figure of Salome: a grinning *male* body builder, who pauses in his dance long enough to strip away a loincloth, revealing a skimpy G-string beneath. And the crowd roars. This dancer, who intervenes to "cover the gap" of judgment at a contest called— not entirely irrelevantly, in view of the Herodian context—"Caesar's World Cup for Women," literalizes the fantasy and fear that have been expressed throughout. Does she or doesn't she? Is she or isn't she? The game of phallic keepaway *is* the Salome dance. Here is an uncanny repetition of the scenario of Hasan el-Belbeissi, the male dancer who performed for Flaubert. The nameless male dancer of *Pumping Iron II*, so demonstrably and apparently unanxiously on display, doubles and translates the obsessive, unspoken question about Bev Francis and her sport that underlies so much of the film. "That *can't* be a woman." The cultural Imaginary of the Salome story is always the veiled phallus—and the threat (and promise) of its unveiling.

What is unveiled here—and I want to stress this—is not a man or a woman, not masculinity or femininity, but the specter and spectacle of transvestism: transvestism as that which constitutes culture.

Salomé's Salome

"Freud was also interested in another type of woman, of a more intellectual and perhaps masculine cast. Such women several times played a part in his life, accessory to his men friends though of a finer caliber, but they had no erotic attraction for him . . . Freud had a special admiration

for Lou Andreas-Salomé's distinguished personality and ethical ideal,
which he felt far transcended his own."
 —Ernest Jones, *The Life and Works of Sigmund Freud* 2:377.

It is almost irresistible to draw some connection between the psychoanalyst Lou Andreas-Salomé and her biblical namesake.

What are the limits of the power of signification? How does "Salome" as signifier encode a whole story below the line, below the surface: a story of dance, of the Orient, of enigma and narcissistic self-sufficiency, of castration and fetishism? Let us see.

In her childhood in Russia Louise von Salomé was given red-and-gold morocco slippers and was carried about by servants; "she would put on dancing shoes and go sliding over the parquet floors of their huge hall, liking the solitude as well as the movement."[31] Solitude and movement together continued to characterize her throughout her life, as did an enigmatic sexual appeal. Her marriage to the Iranologist Friedrich Carl Andreas was successful, although apparently it was never consummated. Ernest Jones—perhaps protesting too much?—counted her among the women of "a more intellectual and perhaps more masculine cast," in Freud's life, and Freud himself, acknowledging that she had been a "Muse" to the weaker Rilke, contended that "those who were closer to her had the strongest impression . . . that all feminine frailties . . . were foreign to her."[32] "Frau Lou" as Salome? As the transvestite Salome?

Admired not only by Freud but also by Nietzsche, who proposed marriage to her and was refused, by Rilke, who was for many years her lover, and by the philosopher Paul Rée, Lou Salomé married an Orientalist and wrote—among many other things—essays on Islam. "Spectacular and seductive," with "a high forehead, generous mouth, strong features, and voluptuous figure," according to Peter Gay (who clearly both sees and tries to resist her appeal), she met Freud, who would later describe her as "a female of dangerous intelligence," at the Weimar Congress of psychoanalysts when she was already fifty years old. "Her appetite for men, especially brilliant men, was unabated," notes Gay, who characterizes her friendship with Freud as a mutual courtship ("Frau Lou had no monopoly on deploying the arts of seduction,"[33] that became also a relationship of intellectual respect.

When she became a practicing analyst Lou Andreas-Salomé's own

work centered on narcissism, a subject on which she became a recognized authority, giving a much more positive valuation to self-love than did Freud, and anticipating some of the ideas of Kohut. In the course of her long correspondence with him she writes to Freud not only about narcissism but also about fetishism and castration anxiety, referring in particular to Rilke's confessions about "the penis as . . . 'the big one,' the extra-big, uncannily superior and uncontrollable one, haunting dreams and feverish nightmares"[34]; these led to the poet's "pleasure in masks and dressing up, as if he were protecting himself through disguises from something which nevertheless is himself and which on the other hand he would like to be rid of." Rilke's fear of the "too big" had in fact attached itself to Andreas-Salomé, whom she also associated with stone; the imagery of the "mother figure with a penis,"[35] which struck her in Freud's essay on "Fetishism," is clearly established in Rilke's confession to her: "I hated you as something *too big*."[36] The intersection of the myths of Medusa and Narcissus, which came together in the figure of the dancing Salome, come together again in Rilke's fantasy of Lou Andreas.

As for Freud (a Jew, a classicist, a fetishizer of antiquities), he referred to her in his letters as "Frau Andreas," and later as "Lou," never with the patronymic "Salomé" inherited from her Russian father—avoiding, we may say, or repressing, or disavowing the image of the dancer who held a king in thrall. Yet clearly Lou Salomé was for him, and apparently from the beginning, the object of specularity, as well as speculation, as a final piece of documentary evidence will suggest. Everyone who tells the story of Freud and "Frau Lou" takes note of his jealousy or pique when, briefly, she showed interest in the ideas of his former disciple Alfred Adler. Adler had split with Freud in part over the question of the fundamentally aggressive nature of human behavior—what Adler called the "masculine protest" over innate femininity in the (male) subject. Adler substituted aggression for sexuality as the foundational human activity, the male wish to conquer a female masquerading, in his view, as sexual desire. It is therefore particularly striking that Freud registered Andreas-Salomé's absence at one of his Saturday lectures, and associated that absence with her flirtation with Adler's ideas. Here is the letter he wrote to her, taking note of what was to be a temporary defection:

I missed you in the lecture yesterday and I am glad to hear that your visit to the camp of masculine protest played no part in your absence. I have adopted the bad habit of always directing my lecture to a definite member of the audience, and yesterday I fixed my gaze as if spellbound at the place which had been kept for you.[37]

The ghostly absent presence of "Frau Lou," like the figure of Salome herself, is here invoked as the veiled phallus, the phallus under erasure, *not* masculine protest after all. For Freud, as in a different way for Rilke and for Nietzsche, Lou Andreas *was* Salome, compact of contradiction and category crisis: the seductive "masculine" woman, the female psychiatrist, the Oriental European, who, without herself cross-dressing, theorized the power of castration—and the power of transvestism.

Man and Oman

I want to conclude this brief articulation of an abiding cultural fantasy and its effects by taking note of at least one Middle Eastern society in which cross-dressing has played a crucial defining role. As will be clear shortly, my interest in the Omani *xanith* is not so much in determining the precise social function this personage performs for his own culture as in the ways the *xanith* has recently come to signify something particular in, and for, a discourse of "third gender" roles in the United States and in Britain.

The association of the Middle East with transvestism and sexual deviance, and particularly with male homosexuality, reached what might be thought of as a theoretically inevitable stage with the discovery by an anthropologist, in 1977, of an Arabic culture that seemed to institutionalize the transsexual male as a third gender role. Writing in the British anthropological journal *Man*, Unni Wikan described the *xanith* of coastal Oman, effeminate males who wore pastel-colored *dishdashas*, walked with swaying gait and "reeked of perfume," who functioned as house servants and/or homosexual prostitutes, and who associated on most formal and informal occasions not with the men in this rigidly segregated Muslim society, but with the women. At a

wedding Wikan observed *xanith* singing with the women, eating with them, even entering the bride's seclusion chamber and peeping behind her veil.

Wikan identified these *xanith* as "transsexuals," a term she defined as "a socially acknowledged role pattern whereby a person acts and is classified as if he/she were a person of the opposite sex for a number of crucial purposes." (This definition, which she attributed to Drs. Harry Benjamin and Robert Stoller, was later to be one of many points on which she was challenged).[38] The transsexuals of this Omani society—which she located in and around the small coastal town of Sohar, "reputed home of Sinbad the Sailor"—occupied, said Wikan, an intermediate role between men and women, a third position that was clearly demarcated by their dress.

> The transsexual . . . is not allowed to wear the mask [which covers forehead, cheeks, nose, and lips of Omani women from about the age of 13], or other female clothing. His clothes are intermediate between male and female; he wears the ankle-length tunic of the male, but with the tight waist of the female dress. Male clothing is white, females wear patterned cloth in bright colours, and transsexuals wear unpatterned coloured clothes. Men cut their hair short, women wear theirs long, the transsexuals medium long. Men comb their hair backward away from the face, women comb theirs diagonally forward from a central parting, transsexuals comb theirs forward from a sideparting, and they oil it heavily in the style of women. Both men and women cover their head, transsexuals go bareheaded. Perfume is used by both sexes, especially at festive occasions and during intercourse. The transsexual is generally heavily perfumed, and uses much make-up to draw attention to himself. This is also achieved by his affected swaying gait, emphasized by the close-fitting garments. His sweet falsetto voice and facial expressions and movements also closely mimic those of women.[39]

The transsexuals in Omani society, unlike women, according to Wikan, are deemed capable of representing themselves in a legal capacity; juridically, they are men, as they are grammatically, being referred to in the masculine gender. They are punished if they attempt to wear women's clothes. *Xanith*, biologically male, serve as passive homosexual prostitutes. If they wish to and can afford to, however, they may marry, and if they succeed in "perform[ing] intercourse in the male

role,"[40] and giving the traditional proof of defloration of the bride, they cease to be *xanith* and become men.

Thus Wikan suggests that it is the sexual act, and not the sexual organs, that defines gender in the society. Should he wish to, a *xanith* who has married may return to his former status, as some older *xanith*, once widowed, sometimes do; this change he signals by a public action (like singing at a wedding) that declares him to be no longer a man. The *xanith* can continue throughout his life to change from the role of "woman" to that of "man." Wikan explains the social necessity of this third gender role by the high standard of purity imposed upon Omani women; prostitutes are necessary, though held in low repute. *Xanith* are often "sexual deviants," who are attracted to their own sex; this the society accepts, though it does not approve. The Omani system thus protects women, while severely restricting their freedoms, and accommodates sexual variation as well as male sexual appetite by establishing a triad of gender roles, woman, man, and transsexual. About one in fifty males in Sohar become *xanith*.

The appearance of Wikan's article in the pages of *Man*—a journal whose complacent nineteenth-century title lent an unacknowledged irony to the succeeding exchanges—led to immediate and heated debate. The situation of the *xanith*, it was suggested by one scholar, was more likely the result of economic than of innate gender characteristics; a "man" is one who has the wherewithal to buy "himself" a bride— something, for example, that "dominant lesbian women" in a similar society of Muslims in Mombasa, Kenya, had perceived, choosing to have dependents rather than to be one. Poverty, not the demands of the male role, might be the cause of the *xanith's* lifestyle.[41] Another correspondent accused Wikan of being "doggedly ethnocentric," and ignoring comparative materials from other cultures in order to make a claim for singularity in the case of the *xanith*. Citing articles on transsexuals in Aden, Australia, and Polynesia, as well as in the streets of Naples and Sydney, he urged anthropologists to come out of the closet and study the scene around them in the major cities of the West.[42]

Wikan retorted sharply, again in *Man*, flinging the charge of ethnocentrism back at her first critic; the argument that marriage creates an inequality in the status of women vis-à-vis men is "nothing less than straightforward and fashionable ethnocentricity," she declared. Indeed this epithet, which is clearly the worst possible insult to an anthropolo-

gist, surfaced yet again in Wikan's stinging reply to a *second* letter from the same critic ("less readiness to reshape . . . reality with ethnocentric—or Mombasa—concepts would protect her from pursuing so many odd and fruitless tangents").[43] Citing the British explorer Richard Burton on the subject of pederasty among the Arabs and faulting Wikan for "assuming that in a sex act between men one partner is always a substitute woman," Gill Shepherd of the London School of Economics again contended that Wikan was overemphasizing gender and ignoring economic and class factors.

The controversy continued to occupy *Man* and its readers. A further pair of correspondents queried Wikan's use of the term "Oman"— which covers a wide variety of communities, all different from one another—suggested that (presumably like Margaret Mead) she "may possibly have been misled by her female informants," and challenged the notion of "intermediate gender" in particular and the role analysis mode of theorization in general.[44] And another writer challenged Wikan's use of the term "transsexual," pointing out that her definition (given above) differed sharply from Stoller's description of transsexuals as those who "contend from earliest childhood that they are really members of the opposite sex." "Anthropologists," the writer asserted, "would perhaps be better off just using ethnic labels in the analysis of cross-gender and sexual behaviour in other societies. Sufficient cross-cultural data are not yet available to make sound judgements as to how well Western *clinical* categories fit these behaviours in non-Western societies."[45]

This, in point of fact, seems to be not only a key problem in Wikan's argument but also a key factor raising the temperature (and the stakes) in the exchange that it provoked. How possible is it to take a term like "transsexual," coined in 1949 to describe the condition of certain European and Anglo-American men, and translate it back into a culture which had been closed to the outside world (by Wikan's account) until 1971? What are the *ideological* and *political* implications of this cross-cultural labeling, and what if anything does it have to do with the constructed role of the Middle East itself as an "intermediate" zone, a place where pederasty, homosexuality, and transsexualism are all perceived (by Western observers) as viable options? If a Shangri-La for transsexualism as a "natural" development, a "third gender role" crucial to the social economy, were to be discovered *anywhere*, we

should not perhaps be surprised to find that it is located in Oman, in the "reputed home of Sinbad the Sailor."

Nor should we be surprised that, whatever the methodological shortcomings of Wikan's research, or the unexamined implications discerned in it by feminists, Marxists, or comparative anthropologists, her argument for the *xanith* should be welcomed, uncritically, by another interested group; the editors, and presumably the readers, of *TV-TS Tapestry: The Journal for Persons Interested in Crossdressing and Transsexualism*. An article by "Nancy A." entitled "Other Old Time Religions," cites Wikan's research extensively and straightforwardly, describing the dress and customs of the *xanith* in Omani society, and noting as well other transvestite or transsexual societies mentioned by Wikan or her various correspondents: the *berdache* of the Plains Indians, virtually the locus classicus of transsexualism in anthropology, and inevitably mentioned in survey studies of cross-dressing[46]; the *mahu* of Tahiti, who serves as a symbolic marker in his village, against which men can define their own role ("Since I am not the '*mahu*,' I must be a man," as Nancy A. puts it, though her source in the pages of *Man* is less liberally inclined; *his* imagined Tahitian villager says to himself, "this is what I am not and what I must not become"[47]).

At one point, after noting that *xanith* who wear women's clothes are imprisoned and flogged, the author comments in a somewhat wistful parenthesis "(I guess it's not so great after all)"—a reminder that "Nancy A." herself is a male-to-female cross-dresser. The final paragraph makes it clear that the *xanith* and the *mahu* are to *Tapestry's* readers nothing less than role models, examples of societies in which the transsexual has a crucial defining place. "I'm not sure," she concludes, "if these examples convince you to fly to Tahiti or Oman . . . but at least you can see other societies' responses to a common phenomenon. Although we can't be as open as we would like, we can get out and help others understand and be more accepting. We have no clearly defined role, set rigidly in the society we live in, as do the other we have mentioned, so we have to make our own way."

Nancy A.'s article manifestly illustrates many of the dangers warned against by Unni Wikan's critics. Obviously a lay commentary and an unsophisticated one at that, completely unscholarly in style and method, it generalizes with unwarranted broadness, and collapses dis-

tinctions that the warring anthropologists on the battlefields of *Man* are at great, and important, pains to draw. The ultimate epithet, "ethnocentric," could again be deployed against it, if so big a club is needed to swat so small a fly. Yet the very ethnocentricity of the piece is its political strength. Nancy A. espouses what might be described as an ethnocentric pluralism. The *xanith*, the *berdache* and the *manu* are her brothers—or her sisters. Her aims are frankly political and oppositional, her subject position as social marginal is her license to generalize, and indeed to omit what does not suit her purposes. For example, she takes the title of Wikan's article, "Man Becomes Woman: Transsexualism in Oman as a Key to Gender Roles," and masterfully abbreviates it, in the manner of the *National Enquirer*, as "Man Becomes Woman," so that she can say, without overt irony, that Unni Wikan notes such-and-such "in her article, 'Man Becomes Woman' in the anthropological journal *Man*." This is a tour-de-force of titles and gender roles, and if *Man* does not become *Woman* as a result of such efforts, perhaps it ought to. Certainly the kind of -centrism indicated by *Man*'s nineteenth-century title is at least a little decentered in the course of these exertions, and feminists who cavil about welcoming male-to-female transsexuals in their midst might take note of the effectiveness of an interested critique from a position so culturally disadvantaged ("We can't be as open as we would like") that it mandates outreach as a condition for existence ("we can get out and help others understand and be more accepting"; "we have to make our own way").

The strictly veiled, strictly masked, strictly segregated women of the Sohari region of Oman, Wikan reasoned, were the precondition for the development of the *xanith* role. Men needed sex, women needed companionship, both needed servants; the *xanith* needed money, or sex, or acceptance, or all of these. The triadic structure she suggested, and that came under such sharp attack in part because it did posit a social logic, a story of positions and positionality, is a cultural reading of a social phenomenon, a reading clearly influenced, whether before or after the fact, by Wikan's discovery of a clinical literature on transsexualism. This move did not fully satisfy either anthropologists or clinicians. But it provided a necessary template for transsexuals themselves—*some* transsexuals and transvestites, U.S. transsexuals and transvestites, not the *xanith*—to analyze and interpret the possibilities and dignities of their own social role.

The Chic of Araby

This is another side to Orientalism; more than one kind of Western subject looks East, and sees himself/herself already inscribed there. What, finally, does the controversy around *Man* and Oman have to do with "the chic of Araby"? The *xanith* provided an uncanny "role model" for some observers specifically concerned with gender dysphoria and gender roles, and offered yet one more extraordinary example of the complex ways in which some Westerners have looked East for role models and for deliberate cultural masquerade—for living metaphors that define, articulate, or underscore the contradictions and fantasies with which they live.

Notes

1. Dr. Georges Burou. Morris's omission or suppression of "Dr. B—'s" surname, whether motivated by discretion or stylistic verve, makes the whole episode into a novelistic adventure with something of an eighteenth-century flavor.
This essay is part of a much more extensive discussion of "The Chic of Araby" in my book on transvestism and culture, *Vested Interests: Cross-Dressing and Cultural Anxiety* (New York: Routledge, 1991).

2. Jan Morris, *Conundrum* (New York: Henry Holt and Company, 1974), 136.

3. Renée Richards, with John Ames, *Second Serve: The Renée Richards Story* (New York: Stein and Day, 1983): 246.

4. Morris, 113.

5. Ibid., 172.

6. Elizabeth Wilson, *Adorned in Dreams: Fashion and Modernity* (Berkeley: University of California Press, 1985), 162.

7. Morris, 156.

8. Morris, 159.

9. Ludmilla Jordanova, *Sexual Visions: Images of Gender in Science and Medicine between the Eighteenth and Twentieth Centuries* (Madison: University of Wisconsin Press, 1989), 90.

10. Peter Fuchs, *The Land of Veiled Men.* trans. Bice Fawcett (New York: Citadel Press, 1956), 49.

11. Jacques Lacan, "The Signification of the Phallus." in *Ecrits: A Selection*, trans. Alan Sheridan (New York: W. W. Norton, 1977), 288.

12. Heinz Kohut, *The Analysis of the Self* (Madison, CT: International Universities Press, 1971; 1987), 210–211.

13. For example, René Girard, "Scandal and the Dance: Salome in the Gospel of Mark," *New Literary History* 15. no. 2 (Winter, 1984), 311–24, and in the same issue, Françoise Meltzer, "A Response to René Girard's Reading of Salome"; Linda Seidel, "Salome and the Canons," *Women's Studies* 2 (1984), 29–66; Françoise Meltzer, *Salome and the Dance of Writing: Portraits of Mimesis in Literature* (Chicago: University of Chicago Press, 1987), 13–46.

14. Huysmans' Des Esseintes finds in Salome "the symbolic incarnation of undying

Lust, the Goddess of Immortal Hysteria, . . . the monstrous Beast, indifferent, irresponsible, insensible." Joris-Karl Huysmans, *A Rebours*. Trans. as *Against Nature* by Robert Baldick (Baltimore: Penguin, 1959), 66.

15. Françoise Meltzer, *Salome and the Dance of Writing: Portraits of Mimesis in Literature* (Chicago: University of Chicago Press, 1987), 46.

16. In a passage that has been allusively linked to Salome, describing the power of Dance upon the spectator, Mallarmé makes the connection between femininity and textuality explicit, while retaining the emphasis upon the poet as gazing subject and the dancer as "illiterate" (*illetrée*), "unconscious" (*inconsciente*) object of the gaze, who becomes the catalyst for the male poet's creativity:

> par un commerce dont parait son sourire verser le secret, sans tarder elle te livre à travers le voile dernier qui toujours reste, la nudité de tes concepts et silencieusement écrira ta vision à la façon d'un Signe, qu'elle est.

> [through a commerce whose secret her smile appears to pour out, without delay she delivers up to you through the ultimate veil that always remains, the nudity of your concepts and silently begins to write your vision in the manner of a Sign, which she is.]

Stephane Mallarmé, "Symphonie litteraire," in *Oeuvres complètes*. (Paris: Pléiade, 1946), p. 307. trans. Barbara Johnson, in her essay, "Les Fleurs du Mal Armé," *A World of Difference* (Baltimore: Johns Hopkins University Press, 1987, 127.

17. Said, *Orientalism* (New York: Vintage Books, 1978), 187.

18. Joseph A. Boone, "Mappings of Male Desire in Durrell's *Alexandria Quartet*." *South Atlantic Quarterly* 88: 1 (Winter, 1989), 81.

19. *Flaubert in Egypt: A Sensibility on Tour*. Ed. and trans. Francis Steegmuller. (London: Bodley Head, 1972), 39.

20. Flaubert, 84.

21. Flaubert, 117.

22. Oscar Wilde, *Salome, A Tragedy in One Act*. Trans. Alfred Douglas. (New York: Dover Publications, 1967), 64.

23. Richard Ellmann, *Oscar Wilde*. (New York: Alfred A. Knopf, 1988).

24. Ellmann, 344.

25. Russell's film is clearly indebted to the earlier Alla Nazimova silent film version of Wilde's play, a clear case of camp *avant la lettre*.

26. Lacan, 287.

27. Lacan, 288.

28. Cornelia Otis Skinner, *Madame Sarah* (New York: Paragon House, 1966, pp. 63,123–24, 260–70. Ellmann, 371. After his arrest in 1895 Wilde sent a friend to ask her to assist him by paying 400 pounds for the rights to *Salome*, but although she expressed sympathy, she delayed and did nothing. Ellmann, 458; Skinner, 123–24.

29. [Walford] Graham Robertson, *Time Was.* (1931), 125–27. Ellmann, 372.

30. The "typical response" to Francis' body, according to *Newsweek*, was "that *can't* be a woman." Charles Leerhsen and Pamela Abramson, "The new Sex Appeal." *Newsweek*, 6 May 1985, 82. See also Laurie Schulze, "On the Muscle," in *Fabrications: Costume and the Female Body*. New York: Routledge, 1990, 59–78.

31. Angela Livingstone, *Salomé, Her Life and Work* (Mt. Kisko, New York: Moyer Bell, 1984), 18.

32. Sigmund Freud, "Lou Andreas-Salomé" (1937), trans. James Strachey. *SE* 23:297.

The Chic of Araby

33. Peter Gay, *Freud: A Life for Our Time* (New York: W. W. Norton, 1988; Doubleday Anchor, 1989), 193.

34. Letter to Freud, 19 October 1917, in Ernst Pfeiffer, ed., *Sigmund Freud and Lou Andreas-Salomé, Letters*, trans. William and Elaine Robson-Scott. New York: W. W. Norton, 1966, 66–67.

35. Letter to Freud, November 6, 1927. In Pfeiffer, 168.

36. Letter from Rilke to Lou Andreas-Salomé, 1898, quoted in Angela Livingstone, *Salomé, Her Life and Work*. Mt. Kisco, NY: Moyer Bell, 1984, 126.

37. Letter from Freud to Lou Andreas-Salomé, November 10, 1912. Pfeiffer, *Letters*, 11.

38. Harry Benjamin, *The Transsexual Phenomenon*. (New York: Julian Press, 1966); Robert J. Stoller, *Sex and Gender*, Vol. I (New York: Science House, 1968). Vol. II, *The Transsexual Experiment* (London: Hogarth Press, 1975). See also the essays by Judith Shapiro and Sandy Stone in this volume. For a more extended discussion of transsexualism, see Marjorie Garber, "Spare Parts: The Surgical Construction of Gender," *differences* 1.3.(1989), p. 137–159, and *Vested Interests: Cross-Dressing and Cultural Anxiety* (New York: Routledge, 1991).

39. Unni Wikan, "Man Becomes Woman: Transsexualism in Oman as a Key to Gender Roles." *Man* NS 12 (1977), p. 307. Reprinted in a somewhat expanded form as "the *Xanith*: a Third Gender Role?" in Unni Wikan, *Behind the Veil in Arabia: Women in Oman*. Baltimore and London: Johns Hopkins University Press, 1982, 168–186. For another discussion of Wikan's work on the *xanith*, see Judith Shapiro's essay in this volume.

40. Wikan, 308.

41. Gill Shepherd, "Transsexualism in Oman?" (letter). *Man* NS 13 (1978), 133–4.

42. Robert Brain, *Man* NS 13 (1978), 322–23.

43. Shepherd, The Oman *xanith*." *Man* NS (1978), 663–71; Wikan, 667–71.

44. G. Feurstein and S. al-Marzooq, *Man* NS 13 (1978), 665–67.

45. J. M. Carrier, "The Omani *xanith* controversy." *Man* NS 15 (1980): 541–2.

46. For example, Peter Ackroyd, *Dressing Up*, 37. Ackroyd classifies the *berdache* with Tahitian, Brazilian, Aztec and Inca tribal transvestites as members of an "honorary third sex" in a section of his book called "Transvestism Accepted." Nancy A., "Other Old Time Religions," *The TV-TS Tapestry Journal* 40: 70–72.

47. The example of the *mahu*, from Robert I. Levy, "The Community function of Tahitian Male Transvestism: a Hypothesis." *Anthropological Quarterly*. 44 (1971), 12–21, is cited in Brain's letter to *Man*.

10

Transsexualism:
Reflections on the Persistence of Gender and
the Mutability of Sex

Judith Shapiro

There is a story about two small children in a museum standing in front of a painting of Adam and Eve. One child asks the other, "Which is the man and which is the lady?" The other child answers, "I can't tell—they don't have any clothes on." A story to delight those favoring the social constructionist view of gender. An even better story would be one in which the body itself becomes a set of clothes that can be put on.

All societies differentiate among their members on the basis of what we can identify as "gender." All gender systems rely, albeit in differing ways, on bodily sex differences between females and males. How can we understand the grounding of gender in sex as at once a necessity and an illusion?

Powerful cultural mechanisms operate to ensure that boys will be boys and girls will be girls. Such mechanisms appear to include turning some of the girls into boys and some of the boys into girls.

The purpose of this paper is to take transsexualism as a point of departure for examining the paradoxical relationship between sex and gender. In its suspension of the usual anatomical recruitment rule to gender category membership, transsexualism raises questions about what it means to consider sex as the "basis" for systems of gender difference. At the same time, the ability of traditional gender systems to absorb, or even require, such forms of gender-crossing as transsexu-

alism leads us to a more sophisticated appreciation of the power of gender as a principle of social and cultural order. While transsexualism reveals that a society's gender system is a trick done with mirrors, those mirrors are the walls of our species' very real and only home.

Defining Transsexualism

The term "transsexual," as understood in its Euro-American context, is used in the following related senses: most broadly, to designate those who feel that their true gender is at variance with their biological sex; more specifically, to designate those who are attempting to "pass" as members of the opposite sex; and, most specifically, to designate those who have either had sex change surgery or are undergoing medical treatment with a view toward changing their sex anatomically.[1]

Male to female transformation appears to be far more frequent than the reverse.[2] There is also a general tendency in the literature for male to female transsexualism to function as an unmarked form, that is, for it to stand for the phenomenon in general.[3] Studies of transsexualism are overwhelmingly focused on men who have become women—an interesting twist on androcentric bias in research.

Transsexualism first captured the popular imagination both nationally and internationally with Christine Jorgensen's much publicized "sex-change operation" in Denmark in 1952. Her subsequent career can be seen as a prototype of the transsexual as celebrity, subsequent examples being Jan Morris (formerly James Morris, correspondent to the London *Times* and journalist who covered the first expedition to Mount Everest in 1953), and Renée Richards (tennis star and successful ophthalmologist, born Richard Raskind, the son of two Jewish doctors from New York). All three have written widely-read autobiographies (Jorgensen 1967, Morris 1974, Richards 1983), which are valuable sources of ethnographic information on the place of gender in the construction of personal identity.

In the course of the 1960s, transsexualism became a focus of medical/psychiatric attention and the contested ground of competing therapies, from the psychoanalytic to the behaviorist to the surgical. Up until the mid-60s, the American medical establishment had taken a generally negative view of sex change surgery; with a few exceptions,

those seeking operations generally had to go abroad to obtain it—the Mecca being Casablanca and the clinic of Dr. Georges Burou.[4] Through the efforts of a small number of physician advocates like the endocrinologist Harry Benjamin,[5] who is credited with propagating the use of "transsexualism" as a diagnostic category and who urged greater understanding and tolerance of the transsexual condition, gender clinics were established at some major American hospitals and sex change surgery became one of the forms of available therapy.

The turn to sex change surgery followed upon the apparent ineffectiveness of all forms of psychological therapy in dealing with transsexualism.[6] As two sociologists writing about transsexualism in 1978 noted, "[g]enitals have turned out to be easier to change than gender identity . . . [w]hat we have witnessed in the last 10 years is the triumph of the surgeons over the psychotherapists in the race to restore gender to an unambiguous reality" (Kessler and McKenna 1978: 120).

Prominent early contributors to the biomedical and psychological literature on transsexualism include, along with Benjamin, John Money, Robert Stoller, and Richard Green.[7] These researchers and clinicians, who accomplished a transfer in the frame of reference for transsexualism from the moral to the medical, generally viewed themselves as part of a movement to foster more enlightened, liberal and scientific attitudes toward sexuality. At the same time, their work reflects a highly traditional attitude toward gender, an issue that will be explored more fully below.

In the medical literature, the transsexual condition has commonly been designated by the term "gender dysphoria syndrome."[8] In fact, transsexuals usually claim to have a quite definite sense of their gender; it is their physical sex that is experienced as the problem.[9] The term "sexual dysphoria" was thus at one point suggested as being more appropriate (Prince 1973). And yet, the concept of biological "sex" is not without its own problems; the more we learn about it, the more complicated things become, since we might be talking about chromosomal (or genetic) sex, anatomical (or morphological) sex, genital (or gonadal) sex, germinal sex, and hormonal sex.[10] Perhaps the most satisfactory formulation is that transsexuals are people who experience a conflict between their gender assignment, made at birth on the basis of anatomical appearance, and their sense of gender identity.[11]

This, however, opens up the question of what is meant by "gender

identity." According to the literature of developmental psychology, a core gender identity is something that is established early and is relatively impervious to change. It designates the experience of belonging clearly and unambiguously to one—and only one—of the two categories, male and female.[12] Given such a notion of gender identity, transsexualism can be diagnosed as a form of crossed wiring. Whatever the reason for it, even if we cannot ultimately specify what causes it,[13] individuals can simply be recategorized, which has the considerable advantage of leaving the two-category system intact. The problem with this approach, as we shall see below, is that one cannot take at face value transsexuals' own accounts of a fixed and unchanging (albeit sex-crossed) gender identity, given the immense pressure on them to produce the kinds of life histories that will get them what they want from the medico-psychiatric establishment. To take the problem one step further, the project of autobiographical reconstruction in which transsexuals are engaged, although more focused and motivated from the one that all of us pursue, is not entirely different in kind. We must all repress information that creates problems for culturally canonical narratives of identity and the self, and consistency in gender attribution is very much a part of this.

Transsexualism as a diagnostic category is defined in relation to such other categories as transvestism and homosexuality. Transsexualism is generally distinguished from transvestism understood as cross-dressing that does not call into question a person's basic sense of gender identity. In cases in which cross-dressing becomes increasingly central to a person's life and comes to reflect a desire to assume the opposite gender role, transvestism and transsexualism can be seen as developmental stages in a gender-crossing career.[14] In recent years, the term "transgenderist" has come to be used to designate a career of gender-crossing, which may or may not be directed toward an ultimate physical sex change.

The way in which transsexualism is seen as being related, or not related, to homosexuality is a particularly interesting question, since it leads into general issues concerning the relationship between gender and sexual orientation, and how each enters into the construction of personal and social identity. The literature indicates that most transsexuals consider themselves to be heterosexual. A male to female transsexual who feels herself to be a woman wants to be able to have sex with a man as a woman, not as a male homosexual.[15] There are

also homosexual transsexuals—for example, male to female lesbian feminist transsexuals, who caused a great deal of havoc in the separatist wing of the women's movement in the late 70s.

When I have shared my work and thoughts on transsexualism with colleagues, either at seminars or in informal conversations, I have frequently encountered the argument that transsexualism is a form of disguised homosexuality. Psychiatrists and psychologists are particularly apt to make the argument that men who believe themselves to be women are seeking an appropriate way to have other men as objects of desire while avoiding the stigma of homosexuality. It is hard to know whether such arguments reflect the homophobia of the person presenting them or a response to the level of homophobia found in society. In either event, they seem to indicate a certain obliviousness to the difficulties of life as a transsexual.

Some gays and lesbians view transsexuals as homosexuals who have found a particularly desperate and insidious way of staying in the closet. Transsexuals, for their part, often express negative attitudes toward homosexuals.[16] While it might be argued that transsexuals' hostility toward homosexuality is a form of denial, the same argument can be made (and often is made) about nontranssexual heterosexuals. Although denial of homosexuality may play a role in the transsexualism of particular individuals, the general argument that transsexualism is an epiphenomenon of homosexuality is neither convincing nor logically parsimonious. In the context of the analysis of transsexualism developed here, it can be understood as reflecting a fundamentalist approach to the relationship between sex and gender, that is, an inability to see an anatomical male as anything other than a man and an anatomical female as anything other than a woman.

Transsexualism and the Conservation of Gender

Transsexualism has attracted a considerable amount of attention from sociologists, in particular those of the ethnomethodological persuasion, who have seen it as a privileged vantage point from which to observe the social construction of reality—in this case, gender reality. Transsexuals shed a self-reflective light on what we are all engaged in as we perform our gender roles. Because transsexuals have to work at

establishing their credentials as men or women in a relatively self-conscious way, whereas the rest of us are under the illusion that we are just doing what comes naturally, they bring to the surface many of the tacit understandings that guide the creation and maintenance of gender differences in ongoing social life. Sociological studies of transsexualism thus belong not only to the literature on deviance, as one might expect, but are at the core of the sociological study of gender.

One of the major findings of the sociological literature on transsexualism is the degree of conservatism in transsexuals' views about masculinity and femininity. While transsexuals may be deviants in terms of cultural norms about how one arrives at being a man or a woman, they are, for the most part, highly conformist about what to do once you get there. The following summary characterization is representative of those commonly found in the literature:

> . . . many transsexuals said they viewed themselves as passive, nurturing, emotional, intuitive, and the like. Very often, many expressed a preference for female dress and make-up. Others saw their feminine identification in terms of feminine occupations: housework, secretarial, and stewardess work. Some expressed feminine identification in terms of marriage and motherhood—wanting to "meet the right man," "have him take care of me," "adopt kids," and "bring them up." One expressed very definite views on child-rearing that were quite ironic in this context: "I would definitely teach my kids that boys should be boys and girls should be girls". (Raymond 1979: 78)[17]

Many transsexuals are, in fact, "more royalist than the king" in matters of gender. The sociologist Thomas Kando, who worked with a group of transsexuals who had undergone sex change surgery at the University of Minnesota in 1968–1969, reported test and questionnaire results showing that transsexuals were more conservative about sex role norms than both men and women (or, to be precise, than non-transsexual men and women), women being the least conservative. Male to female transsexuals tested higher in femininity than women. Most of the transsexuals in Kando's sample held stereotypical women's jobs and seemed, on the average, to be "better adjusted" to the female role than women were. As Kando noted, "[transsexuals] are, in many of their everyday activities, attitudes, habits, and emphases what our culture expects women to be, only more so" (Kando 1973: 22–27).[18]

The gender conservatism of transsexuals is encouraged and reinforced by the medical establishment on which they are dependent for therapy. The conservatism of the doctors is in turn reinforced by their need to feel justified in undertaking as momentous a procedure as sex change surgery. In order to be convinced that such surgery is more likely to help than to harm, they feel the need to engage in close preoperative monitoring of the candidate's behavior, attitudes, and feelings. This is particularly important, since some of those who present themselves as candidates for surgery would not be appropriately diagnosed as transsexuals.[19] The gender identity clinics operated in conjunction with programs of sex change surgery provide the context of determining whether such surgery is indeed the most appropriate form of therapy for a particular individual, and also provide therapists and surgeons with an opportunity to judge how successful an applicant for surgery is likely to be at playing the desired gender role.

Given the preponderance of male to female transsexuals, it is interesting to keep in mind that the professional community in which this transformation is effected is largely male. It has been male surgeons' and psychiatrists' expectations about femininity that have had to be satisfied if a sex change operation is to be performed. There are reports in the literature of doctors using their own responses to a patient— that is, whether or not the doctor is attracted to the patient—to gauge the suitability of sex change surgery (Kessler and McKenna 1978: 118). Physical attractiveness seems to have provided the major basis for an optimistic prognosis in male to female sex change.

But looks aren't everything. Members of the medical establishment have also felt the need to socialize male to female transsexuals into their future roles in a gender-stratified economy. In the following excerpt from an "advice" column, published in the December 1963 issue of *Sexology Magazine*, Harry Benjamin, who had been outlining all the obstacles that lie before those seeking sex change surgery, from the physical rigors of the operation and related medical procedures themselves to the difficulties of learning to behave like a woman in matters of dress, make-up, body movement, speech style, etc., moved on to the bottom line:

> Finally, but highly important, how do you know you can make a living as a woman? Have you ever worked as a woman before? I assume that

so far, you have only held a man's job and have drawn a man's salary. Now you have to learn something entirely new. Could you do that? Could you get along with smaller earnings? (Benjamin 1966: 109).[20]

Thus, while transsexualism may strike most people as being far out, it is clearly at the same time fairly far in. Thomas Kando put it as follows:

> Unlike various liberated groups, transsexuals are reactionary, moving back toward the core-culture rather than away from it. They are the Uncle Toms of the sexual revolution. With these individuals, the dialectic of social change comes full circle and the position of greatest deviance becomes that of the greatest conformity. (Kando 1973: 145)

Those who have been involved in the political struggle to transform the gender system and do away with its hierarchies have been particularly distrustful of transsexuals. Dwight Billings and Thomas Urban, in their socialist critique of transsexualism, noted the way in which "the medical profession has indirectly tamed and transformed a potential wildcat strike at the gender factory" (Billings and Urban 1982: 278). Janice Raymond, the author of a radical feminist critique of transsexualism that will be discussed further below, diagnosed transsexuals as gender revolutionaries manqué, carriers of a potentially subversive message who instead serve the interests of the patriarchal establishment (Raymond 1979: 36, 124). She viewed female to male transsexuals, who in her opinion should rightly have become lesbian feminists, as "castrated women," who have cut themselves off from their authentic source of female power. She compared them to the so-called "token woman" who becomes acceptable to the male establishment by aping men (Raymond 1979: xxiv). Raymond contemplated transsexualism with all the frustration and disgust of a missionary watching prime converts backslide into paganism and witchcraft.

Passing

The efforts of transsexuals to achieve normal gender status involve them in what is generally referred to as "passing." Since the term "passing" carries the connotation of being accepted for something one

is not, it is important to consider the complexities that arise when this term is applied to what transsexuals are doing.

First of all, transsexuals commonly believe that it is when they are trying to play the role of their anatomical sex, as opposed to their subjectively experienced gender, that they are trying to pass as something they are not. The way they frequently put this is to say that they feel they are "masquerading" as a man or a woman.[21]

At the same time, transsexuals must work hard at passing in their new gender status, however more authentic they may themselves believe it to be. They have, after all, come to that status in a way that is less than culturally legitimate. They may also continue to have gender-inappropriate physical attributes, as well as behavioral habits acquired from years spent in the opposite gender role. Some transsexuals are, of course, more successful at passing than others, much of this depending on secondary sexual characteristics. Physical repairs are possible in certain areas: corrective surgery to reduce the size of an "Adam's Apple," electrolysis to remove facial and body hair.[22] Voice pitch cannot be changed, but transsexuals often seek speech therapy to help them achieve habits in conformity with their new gender.

The obstacles to successful passing provide an important context for the gender conservatism of transsexuals, discussed above. The strategies transsexuals use for passing in everyday life involve outward physical appearance, the more private body (which must be revealed in some contexts, for example, doctors' offices or communal dressing rooms), general conversation in a variety of social settings, and the construction of a suitable retrospective biography.[23] One aspect of biographical revision that transsexuals engage in, both for social purposes and for reasons of personal identity, is a recategorization of kinship ties they carry with them from the period before their sex change, particularly those associated with marriage. Jan Morris, for example, recategorized herself as a sister-in-law to her wife and an aunt to the children she fathered (Morris 1974: 122). A male to female transsexual in Thomas Kando's study reported the following conversation with a daughter:

" . . . as far as Paula [the daughter] is concerned, what brought it to a head is, I was praying for a way to advise her, and then she called me one time and asked me 'Are we going to get together, because remember,

15th is Father's Day.' And I said, 'Paula, of course I love you very much, but I do have to tell you that I can no longer accept Father's Day gifts. If you wish to continue relations with me I could be your special Aunt Vanessa or something like that, but please don't remind me of that situation and certainly don't bring me any male clothing under any circumstances." (Kando 1973: 71)

The way in which transsexuals go about establishing their gender in social interactions reminds us that the basis on which we are assigned a gender in the first place (that is, anatomical sex) is not what creates the reality of gender in ongoing social life. Moreover, the strategies used by transsexuals to establish their gender socially are the same when they are playing the role associated with their original anatomical sex and when they are playing the role associated with their new achieved sex (Kessler and McKenna 1978: 127). In neither case is this accomplished by flashing. Transsexuals make explicit for us the usually tacit processes of gender attribution. As Harold Garfinkel put it, the transsexual reveals the extent to which the normally sexed person is a "contingent practical accomplishment" (Garfinkel 1967: 181).[24] In other words, they make us realize that we are all passing.

While establishing your gender credentials is a more demanding and riskier project if you are a transsexual, gender is not what could be called a sinecure for any of us. Fortunately, we receive a great deal of help from those around us who order their perceptions and interpretations according to the expectation that people should fall into one of two gender categories and remain there. The literature on transsexualism gives repeated examples of how slips and infelicities pass unnoticed as people discount incongruous information (see, for example, Kessler and McKenna 1978: 137–138).[25]

In this project of passing and being helped to pass, transsexuals sustain what the ethnomethodologist Harold Garfinkel called the "natural attitude" with respect to gender, which is made up of the assumptions that there are only two genders, that one's gender is invariant and permanent, that genitals are essential signs of gender, that there are no exceptions, that gender dichotomy and gender membership are "natural" (Garfinkel 1967: 122–128). At the same time, transsexuals reveal to the more detached and skeptical observer the ways in which such a natural attitude is socially and culturally achieved.

If transsexuals are commonly successful in passing as members of

their gender of choice, the question arises as to how they are viewed when their particular circumstances become known. Are transsexuals accepted by nontranssexuals as "women" and as "men"?

Available research indicates that their status is problematic. The claims transsexuals make for the authenticity of their gender status are not convincing to most nontranssexuals. Transsexuals themselves are, in fact, ambivalent about the issue, sometimes saying they are "real" men and women and sometimes not. (See, for example, Kando 1973: 28–30.) Questions about the gender authenticity of transsexuals provide an occasion for culturally revealing negotiation around the definition of gender, transsexuals and non-transsexuals each gravitating toward definitions that work best to validate, or privilege, their own membership.

One transsexual who has argued forcefully and publicly for her status as a woman is Renée Richards, whose particular motivation came from her desire to pursue her career in tennis. Appealing to biology selectively, but in accordance with cultural definitions of gender, she considered that her female genitals settled the matter beyond question. That being the case, she felt that the chromosome tests administered by the various major tennis associations were an inappropriate and unfair barrier to her acceptance for women's tournament play. In fact, she asserted that of all players in women's tennis, her sex was least in question given all the publicity about it (Richards 1983: 320–321, 343). Clearly, the domain of physical sex differences leaves room for maneuver in finding a biological charter for gender. We can probably expect an increasing tendency to think of "real" biological sex in terms of chromosomes, although chromosomes clearly do not serve as the basis for determining sex, and hence gender, in ordinary practice.[26]

A particularly interesting case of negotiating the gender status of transsexuals came out of one segment of the feminist community in the late 1970s. In a book entitled *The Transsexual Empire*, Janice Raymond presented a critique of transsexualism motivated primarily by a felt need to exclude male to female transsexuals from the category of women, and, more specifically, to address the vexing issue of male to female lesbian feminist transsexuals. Her approach was to draw a picture of these transsexuals as men in ultimate drag, intruding on a world in which women have chosen to dedicate themselves socially

and sexually to one another—a scenario reminiscent of *The Invasion of the Body Snatchers*.[27]

In denying womanhood to transsexuals, Raymond insisted on the physical limits of what can be accomplished through sex change operations and emphasized that male to female transsexuals can't, after all, have babies and don't have two X chromosomes (Raymond 1979: 10, 188). In the following representative passage from her argument, we see a once-a-man-always-a-man line of reasoning that slides between a definition of womanhood based on historical/biographical experience and one defined biologically in terms of sex:

> We know that we are women who are born with female chromosomes and anatomy, and that whether or not we were socialized to be so-called normal women, patriarchy has treated us and will treat us like women. Transsexuals have not had this same history. (Raymond 1979: 114)

To this argument, which apparently relies on the notion that chromosomes are destiny, is added an etherealized essentialism in which the defining attributes of womanhood that attract the male to female transsexual transcend the physical plane:

> [T]he creative power that is associated with female biology is not envied primarily because it is able to give birth physically but because it is multidimensional, bearing culture, harmony, and true inventiveness. (Raymond 1979: 107)

If this had been intended simply as an ethnographic description of transsexual motivation, it would have captured well the desires and wishes expressed by many transsexuals. It is more accurately seen, however, as being itself ethnographic data on the feminine mystique that has characterized much feminist writing over the past couple of decades, in which there has been a somewhat unprincipled marriage of convenience between a social constructionist view of gender and an essentialist view of womanhood.

If asking what gender transsexuals "really" belong to begs a number of fundamental questions, an alternative that seems to capture their distinctive place in a particular cultural scheme of things is to think of them as "naturalized" women and men. Such a formulation can evoke

multiple meanings of "naturalization": (1) a status acquired in the way foreigners acquire citizenship,[28] (2) a change in gender that entails a change in the body, which we associate with the domain of nature, and (3) a recognition of the transsexuals' own experience of sex change as validating what they believe to be their true nature.

Transsexual Embodiment

In order to achieve the sense of a unified gender that forms an essential part of the more general sense of a unified self, the transsexual must acquire an appropriate body. Jan Morris, for example, who flirted with mystic visions of transcending the body altogether,[29] expressed what was ultimately her dominant desire to be properly embodied with a particularly fierce vividness:

> . . . if I were trapped in that cage again [a man's body] nothing would keep me from my goal, however fearful its prospect, however hopeless the odds. I would search the earth for surgeons, I would bribe barbers or abortionists, I would take knife and do it myself, without fear, without qualms, without a second thought. (Morris 1974: 169)

To those who might be tempted to diagnose the transsexual's focus on the genitals as obsessive or fetishistic (see, for example, Raymond 1979: 122), the response is that transsexuals are, in fact, simply conforming to their culture's criteria for gender assignment. Transsexuals' fixation on having the right genitals is clearly less pathological than if they were to insist that they were women with penises or men with vaginas (Kessler and McKenna 1978: 123).

Transsexuals can make use of the mind/body dualism when arguing for the primacy of their gender identity over their original anatomical sex, while at the same time insisting on the need to acquire the right kind of body. Consider, for example, the following arguments by a female to male transsexual:

> "Your body is just something that holds you together; it's part of you; it's an important part—but your mind is strong; it is your will; your mind is everything. I mean as far as everything you want to be. If you had the body, the hands to play baseball, and it just wasn't in your mind,

and it wasn't what you enjoyed, you might go and be a doctor. When all this was going on, I thought of God: Am I doing wrong? God created me as a girl, so maybe I should be. But I couldn't be, and which is more important, your mind or your body? God created my mind too . . . " (cited in Stoller 1968: 200)

This same person considered it self-evident that her sexual organs should be changed from female to male. Similarly, Jan Morris, whose desperation for physical sex change surgery has just been seen, at the same time identified gender with the soul and insisted upon the incorporeal nature of her quest:

To me gender is not physical at all, but is altogether insubstantial. It is the soul perhaps . . . It is the essentialness of oneself, the psyche, the fragment of unity. (Morris 1974: 25)

. . . that my conundrum might simply be a matter of penis or vagina, testicle or womb, seems to me still a contradiction in terms, for it concerned not my apparatus, but my *self*. (Morris 1974: 22; italics in original)

The bodily outcome of sex change surgery is itself somewhat make-shift. As Dr. Georges Burou put it: " 'I don't change men into women. I transform male genitals into genitals that have a female aspect. All the rest is in the patient's mind' " (cited in Raymond 1979: 10). In a famous case study analyzed by the sociologist Harold Garfinkel in *Studies in Ethnomethodology*, his informant, Agnes, admitted that her artificial vagina was inferior to one provided by nature. Her feeling about this reflected not only considerations of physical practicality, but also what we might call cultural metaphysics. At the same time, though, it was a vagina to which she felt legitimately and morally entitled, given that she was "really" a woman. Agnes spoke of her penis and testicles as if they were some unfortunate, pathological growth, a kind of tumor; getting rid of them was like removing a wart (Garfinkel 1967: 126–127, 181–182).

The relationship of the transsexed body to the "naturally" sexed body calls attention to notions of nature as being associated, on the one hand, with "reality" and, on the other, as something to be manipulated and controlled by science. In this sense, transsexualism is located

Body Guards

at the intersection of bio-material fundamentalism and voluntaristic transcendence. Sex change surgery, for its part, belongs to the domain of heroic medicine,[30] destined, however, to be left behind as science marches on. The prospects of such things as recombinant DNA technology already permit us to look ahead to a time when these operations would be viewed as a crude and primitive approach to transforming our natural endowments. The futuristic possibilities of transsexualism are invoked in the following passage by a defensive male to female transsexual seeking to assert her superiority over what are here called "Gennys," or genetic females:

> Free from the chains of menstruation and child-bearing, transsexual women are obviously far superior to Gennys in many ways . . . Genetic women are becoming quite obsolete, which is obvious, and the future belongs to transsexual women. We know this, and perhaps some of you suspect it. All you will have left is your "ability" to bear children, and in a world which will groan to feed 6 billion by the year 2000, that's a negative asset. (cited in Raymond 1979: xvii)

If, on the other hand, we step back from the entire enterprise of physical sex change, as many critics of the transsexual phenomenon have done, we might see the most technologically sophisticated strategy imaginable as a crude and primitive approach to issues of personal and social identity. Though the analogy cannot be pushed too far, addressing gender issues through sex change surgery is a bit like turning to dermatologists to solve the race problem.

Transsexualism in Cross-cultural Perspective

It is instructive to compare Euro-American transsexualism with forms of institutionalized gender crossing found in other societies. I have selected three such examples from very different cultural settings. Their juxtaposition to one another and to Euro-American transsexualism throws into relief certain culturally distinctive characteristics of the gender systems of which each is a part; at the same time, they all illustrate the same basic paradox—or, to use Morris' term, conundrum—at the heart of the relationship between sex and gender.

Gender and the Mutability of Sex

The *Berdache* in North America

The best-known case of institutionalized gender crossing in the ethnographic literature is the so-called *berdache* found in a number of societies indigenous to North America. The term itself, which seems to come ultimately from Persian via Arabic, Italian, and French (Forgey 1975: 2) and not from any Native American language, has come to be used in the North Americanist literature as a general designation for individuals who take on gender roles in opposition to their anatomical sex by adopting the dress and performing the activities of members of the other group.[31] As in the case of Euro-American transsexualism, gender crossing in North American Indian societies is most commonly male to female; cases of girls or women who take on male behavior, dress, or activities are relatively rare.[32] The significance of such asymmetries in gender crossing will be discussed below.

Information on the *berdache* is uneven in quality and quite sparse in the case of some groups. It is also difficult to gauge how the colonial situation affected both the practices themselves and the quality of the information that outsiders were able to obtain about them. There seems to have been a great deal of variation in patterns of gender crossing from one society to another, and sometimes within a society as well. In some cases, the parents decided that a child of one sex would serve as a substitute for a child of the other. More commonly, children were allowed to take on attributes of the gender opposite to their anatomical sex if their general inclinations and preferred activities pointed in that direction. Some *berdache* were reported to have sexual relations with persons of the same sex; others seem not to have done so. As we can see from the discussion of transsexualism, it is not clear what it would mean to designate the *berdache*'s same-sex sexual activity as "homosexual," particularly in the absence of fuller data from each society in question.

The defining feature of the *berdache* status seems generally to have been adopting the dress and assuming the day-to-day activities of the opposite sex. In a comparative analysis of the *berdache*, the anthropologist Harriet Whitehead has argued that the institution is to be understood in the context of certain distinguishing features of North American Indian cultures, notably, an ethic of individual destiny that could make itself known in a variety of ways and was often the outcome of

a visionary encounter with a supernatural being. Whitehead also argued that the institution of the *berdache* reflects a social system in which the division of labor is at the forefront of gender definition (Whitehead 1981: 99–103).

We do not know enough about North American Indian concepts of gender to understand how the gender of the *berdache* was construed in the various societies in which the institution was found. Should we be thinking about the *berdache* in terms of a basic two-gender system with the possibility of individuals transferring from one to the other? Or is it more appropriate to think of the *berdache* as constituting a distinct third gender, a special status with cultural functions and meanings of its own?[33] How might different societies have varied in this regard? Was the *berdache* in some societies believed to have actually "become" a member of the opposite gender? If so, what does this say about how such societies might differ from our own in terms of the distinctive criteria of gender? Might a change in activities and demeanor suffice for legitimate gender transformation?[34] While we may not be able to answer these questions satisfactorily, an encounter with the North American berdache at least provokes us to ask them.

The *Xanith* in Oman

In Oman, where men and women lead lives that are highly segregated from one another, there is a form of gender crossing in which men who adopt a distinctive form of dress and comportment can move in the world of women.[35] They may, for example, socialize freely with women who are not their relatives and may see unrelated women unveiled. The *xanith* engages in various forms of women's work, including cooking and paid domestic service. At the same time, *xanith* retain many jural privileges of male status. They may move about publicly in a way that women cannot. Their dress is not exactly the same as that of women, but is distinctive and can be seen as something in between male and female garb. While accepted as women for many purposes, they do not "pass."

The Omani status of *xanith* is coterminous with that of the male homosexual prostitute. The anthropologist who has provided the ethnographic information on this cultural practice, Unni Wikan, has ar-

gued that the *xanith* provides a means for Omani men to engage in premarital and extramarital sex without compromising the virtue of Omani women and the rights of the men who have responsibility over them.[36] Insofar as the *xanith*'s partner retains the active role in the sexual act, the partner's own masculine gender status is not in question. According to Wikan, the differential gender categorization of *xanith* and "men" indicates that the sex act takes priority over the sexual organs for purposes of establishing gender status.

Individuals may move in and out of the *xanith* status, and once a man has given it up by marrying and proving his sexual potency with his bride, he is fully accepted as a man. This presents a contrast with Euro-American transsexualism, in which the cultural current moves individuals toward an experience of essential and unchanging gender that is an intrinsic part of an essential and chronologically continuous self.

The two cases also offer interesting contrasts with respect to the relationship between sexual orientation and gender identity. Debate around the relationship between transsexualism and homosexuality in the Euro-American case reflects, on the one hand, their possible separability and, on the other, the way in which gender status is validated or challenged by considerations of sexual orientation; it also reflects the way in which both gender and sexual orientation are essentially defining of personhood and identity. Omani transgenderism involves a closer link between sexual orientation and gender status while at the same reflecting the possibilities for change in these aspects of social identity over the course of a person's—or, rather, a male person's—life.

Woman-Woman Marriage in Africa

In a number of societies in Africa, it has traditionally been possible for a woman to take another woman as a wife, and to acquire rights both to the domestic services of the wife and to any offspring she produces. This practice of 'woman-woman marriage,' as it has come to be called, while showing certain variations from one culture to another, at the same time reveals some basic similarities about the African societies in which it is found.[37] In general, woman-woman

marriage operates within a system in which marriages are established through exchanges of wealth; in which they are relationships not so much between individuals as between kin groups; in which a major concern is the perpetuation of kin groups defined through descent; and in which paternity is achieved through payment of bridewealth rather than through sexual activity. The relationship between the female husband and her wife is not a sexual one. The wife has a lover or lovers, sometimes selected by the female husband and sometimes of the wife's own choosing.

Women who become husbands and fathers may do so by standing in for men of their lineage, for example, when there is no male to serve as an appropriate heir. In these cases, it seems that descent group membership is a sufficiently important aspect of social identity to override differences of role usually associated with gender. Insofar as marriages are established through exchanges of wealth, women can acquire wives if they have access to property over which they can exercise control. In societies in which women occupy positions of political leadership, they can take wives in order to form alliances with other kin groups in much the same way as men do. In some ethnographic reports, the role of female husband and father is said to be limited to barren women who have no children of their own through marriage to a male husband. In other cases, women combine their roles as wife and mother in one marriage with their roles as husband and father in another.

The question raised by woman-woman marriage for our present purposes is how the assumption of husbandhood and fatherhood affects a woman's gender status. When women become husbands and fathers, are they engaged in what would appropriately be termed gender crossing? The answer seems to be no in some cases and yes in others.

Among the Lovedu of South Africa, for example, the role of husband and father seems open to women as women. Lovedu women who acquire wives generally do so because they are entitled to a daughter-in-law from their brother's household and may themselves have no son, or no willing son, to serve as the husband. The woman may thus take her brother's daughter to be her own wife instead; in this case, the female husband is seen as being like a mother-in-law. Woman-woman marriage in Lovedu society is also linked to the ability of

women to occupy various important political offices and to control the wealth they earn after they marry. The queen who traditionally ruled Lovedu society customarily received wives given to solicit political favors; some of these wives were, in turn, given away in marriage by the queen in her own strategies of alliance formation (Krige 1974: 15–22).

Among the Nandi of Western Kenya, on the other hand, a woman who becomes a husband and father is reclassified as a man. The Nandi female husband is commonly a woman of relatively advanced years who has failed to produce a male heir. The need for such an heir is tied to a "house property complex," in which each of a man's co-wives is endowed with a share of her husband's property, which will be passed on to her son or sons to manage (Oboler 1980: 69, 73). A Nandi woman may acquire a wife to produce the needed heir, while she herself takes on the interim management of her house's share of her husband's estate. When a Nandi woman takes a wife, she must cease engaging in sexual relations with her husband, since this would both compromise her reclassification as a man and, should she conceive by some chance, raise problems of succession and inheritance. Female husbands are supposed to give up women's work. The ethnographer who has described woman-woman marriage among the Nandi, Regina Oboler, noted that in the past they were expected to adopt male dress and adornment, although this was no longer the case during the period of her fieldwork (Oboler 1980: 74, 85).

According to Oboler, the Nandi reclassify the female husband as a man because she is assuming economic and managerial responsibilities that Nandi see as the exclusive preserve of men:

> It is an ideological assertion which masks the fact that the female husband is an anomaly: she is a woman who of necessity behaves as no woman in her culture should. Her situation forces her to assume male behavior in certain areas that are crucial to the cultural definition of the differences between the sexes. These areas have to do with the management and transmission of the family estate. (Oboler 1980: 83)

The role played by the Nandi female husband is not something simply open to both women and men, nor is it apparently sufficient for the Nandi to think of the female husband as a woman taking on a man's

responsibilities. Instead, the Nandi prefer to say that the female husband "is" a man.

In fact, it would seem more accurate to say that the female husband is a man in some contexts, but not in others. It is when matters of property and heirship are at issue that Nandi are most insistent about the female husband being a man (Oboler 1980: 70). Although the ideology of the female-husband-as-man takes on a life of its own, leading the Nandi to assert that female husbands behave as men in all areas of social life, this is not actually the case. In many contexts, the female husband continues to behave more as a woman than as a man. Behaviors designated by Nandi as "masculine" in the case of female husbands are often not, in fact, gender-specific; others are characteristic of older women in general. It is also the case that the female husband whose own husband is still living continues in the role of wife to him, and mother to any children of the marriage. Thus, while the Nandi may generally characterize the female husband as a man, her manhood seems to be focused around the more specific project of maintaining the link between gender, control over property, and inheritance.

What all of these forms of gender crossing have in common, their considerable differences notwithstanding, is that they call into question systems of gender differentiation and at the same time support them. They pose an implicit, or in the Euro-American case explicit, challenge to the usual basis for sorting individuals into gender categories while operating to maintain culturally traditional distinctions between women and men.

We can see how this works more clearly if we consider the following two issues: 1) the significance of asymmetries in the directionality of culturally patterned forms of gender change, and 2) the paradoxical relationship between gender and sex.

Asymmetries of Gender Crossing

The cases of gender crossing presented here show various kinds of asymmetries. Two cases are unidirectional: the Omani *xanith* has no female to male counterpart; woman-woman marriage in African society has no comparable male-male form. The two others, Euro-American transsexualism and the North American *berdache,* are

bidirectional, but show a skewed distribution with a greater frequency of male to female transformation. The reasons for these asymmetries are, in part, specific to the meanings and functions of gender in the respective societies at issue. However, they are also understandable in terms of gender hierarchy itself and the social dominance of men.

In order to see this, let us consider how asymmetry in Euro-American transsexualism can be understood. Among the factors cited in the literature are: the greater difficulty and cost of female to male sex change surgery, and its less satisfactory results; the greater propensity of men for the kind of experimentation, risk, and initiative involved in sex change surgery; the apparently greater propensity of males for sexual deviance in general; the dominant role of the mother in the rearing of children of both sexes; the relationship of transsexualism to other cultural institutions in which envious men are trying to appropriate the powers of women (for example, the dominance of men in the field of obstetrics and gynecology)—in this case, taking the ultimate step of becoming women themselves.[38]

Some authorities on transsexualism have remarked upon the apparently paradoxical relationship between the high ratio of male to female transsexuals and the results of survey research showing that it is more common for girls to say they want to be boys than the reverse, more common for adult women than for adult men to say they would rather have been born the opposite sex (see, for example, Benjamin 1966: 147; Pauly 1969: 60). This, taken together with society's greater permissiveness toward girls acting like boys than toward boys acting like girls, has been seen as a puzzle to be solved—often by recourse to biological or psychiatric speculation. A possible Freudian twist on all of this, given a view of women as castrated beings longing for possession of the penis, is that all women are transsexuals,[39] which either makes one wonder why more of them do not seek sex change surgery or makes one appreciate their success in finding symbolic substitutes.

The key to understanding the skewed Euro-American pattern of gender crossing would seem to lie in an understanding of the asymmetrical, hierarchical nature of our gender categories, and the extent to which masculinity is the unmarked category and femininity the marked category. That is, our notions of what a man should be

like are linked to our notions of what a person, in general, should be like. This is an important factor in the differential tolerance for cross-gender behavior in women and in men. Women wanting to be like men can be seen as engaging in an understandable project of upward mobility. Insofar as becoming more like a man is becoming more like a person, the implications for gender reclassification are less radical than movement away from the unmarked, generic human standard.[40] When we encounter cases of female to male gender reclassification, as in some versions of African woman-woman marriage, these are perhaps best looked at in terms of social promotion to a superior status. In fact, the Nandi speak of it in just these terms (Oboler 1980: 74, 86).[41] By the same token, the absence of female to male gender crossing in a society like Oman reflects a lack of comparable opportunities for the upward mobility of women into the status of men.

Male to female transgenderists, for their part, would seem to be engaged in a willful act of downward mobility. When Renée Richards told a friend about her plans for a sex change operation, the friend said, "Anyone who voluntarily wants to become a forty-year-old woman, I take my hat off to" (Richards 1983: 308). Jan Morris was quite sensitive to the privileges she was losing in giving up her manhood. She remarked upon the shock of suddenly being condescended to and being assumed to be incompetent in a variety of areas: "[A]ddressed every day of my life as an inferior, involuntarily, month by month I accepted the condition" (Morris 1974: 149). At the same time, both Richards and Morris clearly felt that the compensations of womanhood more than made up for the drawbacks.

In the context of these considerations, we might see cultural discomfort with male to female transsexualism in Euro-American society as reflecting the fact that those who intentionally move down in the system are more threatening to its values than those seeking to move up. The latter may constitute a threat to the group concerned with maintaining its privileges, but the former constitute a threat to the principles on which the hierarchy itself is based. The greater cultural tolerance for male to female gender crossing in native North American societies may, in this light, be interpreted as an index of a less stratified relationship between men and women.

Gender and the Mutability of Sex

The Paradox of Sex and Gender

The terms "sex" and "gender" are generally used to distinguish a set of biological differences from a system of social, cultural, and psychological ones. The culturally structured system of differences we designate by the term "gender" bears some relationship to the biological difference between women and men, but is not reducible to it. In other words, the relationship between sex and gender is at once a motivated and an arbitrary one. It is motivated insofar as there must be reasons for the cross-culturally universal use of sex as a principle in systems of social differentiation; it is arbitrary, or conventional, insofar as gender differences are not directly derivative of natural, biological facts, but rather vary from one culture to another in the way in which they order experience and action. In any society, the meaning of gender is constituted in the context of a variety of domains—political, economic, etc.—that extend beyond what we think of as gender per se, and certainly beyond what we understand by the term "sex" in its various senses.[42] Gender is a classic example of what the sociologist Marcel Mauss called a "total social fact":

> In these *total* social phenomena, as we propose to call them, all kinds of institutions find simultaneous expression: religious, legal, moral, and economic. In addition, the phenomena have their aesthetic aspect . . . (Mauss [1925] 1954: 2)

We recognize "gender" as a cross-culturally distinct category of social difference by virtue of some relationship that it has to physical sex differences. When we inquire into what motivates the relationship between sex and gender, however, confusions may arise as to what kinds of connections we are talking about, given the multiple meanings of the term "sex." Is "sex" being used to designate general morphological differences between males and females? Is it being used to focus on reproductive capacities and roles more specifically? Is erotic activity what we have in mind? Are we using the term in a shifting sense, sometimes talking about all of the above and sometimes only some of it? The other major question is, of course, the extent to which our own

culturally specific folk beliefs about biology saturate our view of gender and provide us with the illusory truths we hold to be self-evident.[43]

Just as the comparative study of gender differences shows how little of the specific content of such differences can be predicted by sex in any sense of the term, so the study of gender crossing shows us the robustness of gender systems in their transcendence of the usual rule of recruitment by sex. While sex differences may serve to "ground" a society's system of gender differences, the ground seems in some ways to be less firm than what it is supporting.[44]

Euro-American transsexualism presents us with the particular paradox of ascribed gender and achieved sex. While some may think of transsexuals as individuals exercising the right to "choose" their gender identity, freeing themselves from what is for most people a physically-determined fate, this identity is usually experienced by transsexuals themselves as something that is in no way subject to their own will. For transsexuals, gender is destiny and anatomy is achieved.[45]

This reversal of the Euro-American folk ontology of sex and gender was experienced by Jan Morris in terms she took from C.S. Lewis:

> Gender is a reality, and a more fundamental reality than sex. Sex is, in fact, merely the adaptation to organic life of a fundamental polarity which divides all created beings. Female sex is simply one of the things that have feminine gender; there are many others, and Masculine and Feminine meet us on planes of reality where male and female would be simply meaningless. (cited in Morris 1974: 25)

In sum, what we seem to see in systems of institutionalized gender-crossing is the maintenance of a society's gender system through the detachment of gender from the very principle that provides its apparent foundation.

Notes

1. An earlier draft of this paper was written during a sabbatical semester at the Stanford Center for Advanced Study in the Behavioral Sciences, in the spring of 1989. I am using the term "sex change surgery" in this paper, although much of the current literature favors the term "sex reassignment surgery", or even "gender reassignment surgery." Each of these labels carries its own conceptual and analytical presuppositions,

and none is completely satisfactory. My own choice is intended to be as neutral as possible; the theoretical orientation I am taking to transsexualism will emerge in the course of the discussion, as will my uses of the terms "sex" and "gender."

2. The population reported on in one important early study showed a ratio of 8:1 (Benjamin 1966: 147). The overall ratios presented in subsequent literature are lower, but still have tended to run 4:1 or 3:1 (Raymond 1979: 24). It should be noted that researchers frequently remark upon the difficulty of getting good statistical data on transsexualism and sex change surgery.

3. The following passage is an example: "Initially, many psychiatrists assumed that individuals seeking [sex change] surgery were psychotic, and they opposed the procedure in principle . . . However, as experience with patients seeking sex change accumulated, it became clear that there was a group of men characterized by extreme, lifelong feminine orientation and absence of a sense of maleness for whom sex change was followed by greatly improved emotional and social adjustment." (Newman and Stoller 1974: 437; note the elision from "individuals" to "men").

4. Dr. Burou's clinic is described by Jan Morris, who went there for her own surgery (Morris 1974: 135–144). Renée Richards also traveled there, but twice developed cold feet at the clinic door (Richards 1983: 246–247, 252). Garber's essay in Chapter 9 of this volume, which takes an "Orientalist" perspective on transsexualism, opens with observations on how Casablanca was viewed by Jan Morris. An engagingly bizarre fictionalized account of Burou's clinic can be found in a novel by the Brazilian author Moacyr Scliar in which the protagonists, born as centaurs, go to Morocco to have operations to turn themselves into "normal" human beings (Scliar 1980).

5. See Benjamin 1966, for his most comprehensive discussion of transsexualism. Jan Morris and Renée Richards both describe the hormone treatment they received from Benjamin (Morris 1974: 48–9, 105; Richards 1983: 161ff.).

6. Renée Richards describes her two unsuccessful experiences with psychoanalysis, which together lasted over nine years (Richards 1983: 99ff., 120 ff.) She gives a particularly uncomplimentary and bitter portrait of her second analyst, a prominent member of the New York psychoanalytic community (see, e.g., 161, 362–3).

7. Major influential works include Stoller 1968, 1974; Green and Money 1969.

8. The adoption of this term as an instance of the "politics of renaming" has been discussed by Dwight Billings and Thomas Urban as a part of their critique of transsexualism as a symptom of the alienation and commodification of sex and gender in capitalist society (Billings and Urban 1982).

9. See, for example, Jan Morris: "It became fashionable later to talk of my condition as 'gender confusion,' but I think it a philistine misnomer: I have had no doubt about my gender since that moment of self-realization [which Morris claims came at the age of three or four]" (Morris 1974: 25).

10. For one discussion of these various dimensions of sex, see Benjamin 1966, 5–9.

11. This is the formulation adopted by Suzanne Kessler and Wendy McKenna in their sociological study of transsexualism (Kessler and McKenna 1978: 13).

12. Billings and Urban (1982) discuss the way in which concepts of core gender identity and its imperviousness to change have figured in the analysis and treatment of transsexualism.

13. Attempts by psychologists, psychiatrists and other medical researchers to identify the causes of transsexualism include some that look to biological or constitutional factors and others that emphasize early socialization and the constellation of family relations, with a developing consensus that both nature and nurture are probably at issue. In

other words, it is not known why some people become transsexuals and others don't. Renée Richards, herself a doctor and well aware of the various debates in the medical literature, began her autobiography by raising the question of causes, noting that even if it should ultimately be discovered that transsexualism is biochemically determined, her own family experience offered an embarrassingly stereotyped picture of how transsexualism can be explained by an abnormal and gender-confused family situation (Richards 1983: 2). For the major clinical attempt to find causes for transsexualism in family dynamics, and in the mother-son relationship most particularly, see Stoller 1968. Medico-psychiatric debate about the causes of transsexualism has obvious similarities with debate about the causes of homosexuality; the two have intersected at various points.

14. For a developmental approach to transvestism and transsexualism, see Docter 1988.

15. See, for example, Renée Richards' accounts of the encounters she had with male homosexuals while she was still a man, in which the parties were clearly at cross purposes (Richard 1983: 77, 294–6).

16. For examples of negative attitudes toward homosexuality among transsexuals, see Jan Morris' autobiography (Morris 1974: 24, 62, 169) and the case studies reported in Kando 1973. Robert Stoller devotes a chapter of *Sex and Gender* (Vol. I) to a discussion of the transsexual's denial of homosexuality (Stoller 1968: 141–153). He also provides data from a female to male transsexual who became disgusted with a female lover she had during adolescence while she was still anatomically female; the other girl's interest in her genitals was experienced as unwelcome lesbianism (202–203).

17. Renée Richards expressed her relief that her own transsexualism did not in any way affect her son's clear masculine identity (Richards 1983: 370) It is important to keep in mind that the motivation for such sentiments is not simply gender conservatism, but also the desire to spare one's children the kind of suffering one has experienced oneself.

18. In the years since studies such as this one were carried out, more has come to be known about diversity among transsexuals. Patterns of transsexualism have also been affected by the kinds of social changes that have affected the lives of women and men generally. Stone's paper in this volume contributes to an understanding of such change, as well as providing the kind of insider perspectives that did not make their way into most of the scientific and scholarly literature. Stone makes the argument that transsexuals should come out of the closet and cease disappearing into the two-gender system.

19. See, for example, Newman and Stoller 1974 for case studies in which sex change surgery would have been a grave mistake; these include a fetishistic cross-dresser who combined the desire to wear women's clothes with an underlying attachment to his masculinity; a male homosexual who thought he could hold on to his bisexual lover if he became a "real woman"; and a schizophrenic who came seeking sex change surgery after having had a revelation that Jesus Christ was really a woman and that he himself was a reincarnation of Mary Magdalen.

20. Of the 51 transsexuals in Benjamin's study, the only 2 who were reported as having failed to adjust to their new, postoperative situation were male to female transsexuals who experienced a dislocating downward mobility in income and occupational status (Benjamin 1966: 122–124). The major problem that Renée Richards encountered in trying to obtain sex change surgery in the United States was that the doctors she consulted, Harry Benjamin among them, were fearful of destroying Richard Raskind's medical career (Richards 1983: 165, 178–179, 210).

21. See, for example, Benjamin 1966: 202, 242; Stoller 1968: 202; Kessler and McKenna 1978: 126–7. Jan Morris described the experience of being in the 9th Queens Royal Lancers as akin to that of an anthropologist moving among an exotic tribe while being taken for a native (Morris 1974: 31–32).

22. For descriptions of the experience of undergoing both electrolysis and corrective surgery to the "Adam's Apple," see Richards 1983: 176–178 and 211–213.

23. These various dimensions of passing are discussed by Kessler and McKenna (1978: 127–135).

24. See also Kessler and McKenna 1978: 16–17, for a discussion of this point.

25. In this connection, we might think of the famous case dramatized in the play "M. Butterfly," in which a French diplomat carried on an affair for twenty years with a Chinese opera star who turned out not only to be a spy, but also to be a man, having deceived the diplomat on this point for the entire period of their relationship. Dorinne Kondo has provided an elegant analysis of the case and of the play by David Henry Hwang (Kondo 1990). She discusses how the opera star's ability to pass as a woman rested on his lover's propensity to interpret his behavior in terms of stereotypes involving both gender and race: the fact that the diplomat was never able to see the opera star unclothed, even in their most intimate moments, was interpreted as a sign of the "shame" and "modesty" appropriate to Asian women.

26. Stoller described an attempt on the part of a group of researchers in the late 1950s to arrive at a mathematical formula for determining gender by weighing the various components of somatic and psychological sex (Stoller 1968: 232).

27. An analysis of transsexualism shaped in response and opposition to Raymond's is presented in Stone's paper in this volume. There has, in fact, been division of opinion in the feminist community about male to female transsexuals, with some feminists adopting the liberal position that women, as a disadvantaged minority, should not be discriminating against transsexuals. Renée Richards appealed to such sentiments when she made a point of noting the support she had received over the years from members of minority groups (Richards 1983: 317, 324–325).

28. When I presented an earlier version of this paper at the University of California at Santa Cruz in 1989, one feminist member of the audience responded to this formulation by suggesting that male to female transsexuals be seen as "defectors" from the male status (that is, as people seeking asylum from an oppressive regime). She opposed those, who, like Raymond, reject male to female transsexuals as "women," maintaining instead that the feminist goal should be for all men to become women—without, of course, having to go through sex change surgery.

29. Such a vision of disembodiment was expressed in the context of a mysterious encounter Morris had with a holy man in the course of one of his solitary rambles during the Everest expedition (Morris 1974: 87–88).

30. Billings and Urban call attention to the fact that doctors view sex change surgery as a technical tour de force (1982: 269).

31. Forgey 1975, Whitehead 1981, Kessler and McKenna 1978 (21–41), and Williams 1986 provide comparative overviews and theoretical discussions of the *berdache* in Native American societies. A case study of two *berdache*, one Zuni and one Navajo, is presented in Roscoe 1988. For a critique of the historical anachronism of some analyses of the *berdache*, particularly those that come from a contemporary Euro-American gay male perspective, see Gutierrez 1989. The North American *berdache* has often been compared with similar patterns of institutionalized gender crossing among Siberian tribal peoples.

32. One such case of female to male gender crossing in Native North American is that of the "manly-hearted woman" among the Piegan (Lewis 1941).

33. Will Roscoe, who has provided case studies of Zuni and Navajo *berdache*, argues that they are to be seen as occupying a special and intermediate status between women and men, which draws its power from the very combination of gender attributes (Roscoe 1988). An example of such a status in an area other than North America is the *waneng aiyem ser* ("sacred woman") among the Bimin-Kuskusman of Papua New Guinea, as described by Fitz John Porter Poole (1981). This role of ritual leadership, which is filled by a post-menopausal woman who is no longer married or sexually active, is intentionally ambiguous with respect to gender and is intended to evoke primordial, hermaphroditic ancestors (Poole 1981: 117).

34. These points are discussed in Kessler and McKenna 1978: 21–24, 38.

35. The material on the Omani *xanith* presented here comes from Wikan 1977. Wikan's essay provoked some criticism and interchange in the pages of the journal *Man* (sic), where it was published; the kinds of points that were raised there are taken into account in this presentation of Wikan's description and analysis. Garber's essay in this volume also includes a consideration of Omani gender-crossing and the debate around Wikan's work.

36. While there are in fact women prostitutes in Oman, it is interesting to note that the term for them is a modified form of the term *xanith* (Wikan 1977: 311, 319).

37. General and comparative discussions of woman-woman marriage can be found in Krige 1974 and O'Brien 1977. Krige's study is of particular value, since it combines a general discussion with case studies from several different societies and a detailed analysis of woman-woman marriage among the Lovedu, where Krige did fieldwork. Another excellent case study is Oboler's discussion of the female husband among the Nandi, in which particular attention is given to the gender status of the female husband (Oboler 1980). Krige offers information on how social change has affected the institution of woman-woman marriage. I use the notorious ethnographic present here, given the generality of the patterns I am addressing and their persistence over time. I should note, however, that the usage is problematic and that changes have no doubt occurred in the time since the research drawn upon here was carried out.

38. For examples of these various explanations, see Raymond 1979: 26; Pauly 1969: 60; Stoller 1968: 263–264. Raymond, who sees transsexualism as the usurpation by men of women's bodies, also sees the male surgeon in a sex change operation as usurping the reproductive powers of women; she claims that "[t]ranssexualism can be viewed as one more androcentric interventionist procedure. Along with male-controlled cloning, test-tube fertilization, and sex selection technology, it tends to wrest from women those powers inherent to female biology" (Raymond 1979: 29). It is interesting to note here the distance traveled from the work of such feminists as Shulamith Firestone who were looking to medical technology to free women from servitude to their role in biological reproduction (Firestone 1970: 191–202).

39. Robert Stoller pointed out that Freud's view of femininity made all women transsexuals (Stoller 1968: 58–59).

40. We can see this kind of asymmetry in political revolutions that have sexual equality as one of their goals; the attempt to achieve such equality is generally a matter of trying to turn women into the social equivalents of men. A particularly clear example was the kibbutz movement in Israel, with its focus on "the problem of the woman." (There was never any comparable consideration of "the problem of the man.") Women had to be given the opportunity to work in agricultural production, in developing

industries, and in the army. There was, however, no comparable effort to get men into the kitchens and laundries (Talmon 1974; Tiger and Shepher 1975; Shapiro 1976).

41. Female to male gender crossing as a form of upward mobility is also discussed in Castelli's article in this volume.

42. The way in which gender intersects with other axes of social inequality—including how it articulates with race and class differences, how it operates in societies with caste systems—has become a major focus of work on gender in recent years. Attention has also increasingly been given to the way in which gender oppositions structure and are structured by a variety of cultural symbolic domains, some familiar Euro-American examples being nature and culture, reason and emotion, domestic and public, individualism and social responsibility (see Shapiro 1988). Sex/gender difference provides a particularly powerful model for generating binary oppositions.

43. For a general discussion of this issue, see Yanagisako and Collier 1987. For a more ethnographically focused analysis of how the cultural preoccupations of Western anthropologists in matters of sex, procreation, and gender have skewed their understanding both of their own culture and others, see Delaney 1986. The attempt to liberate the study of gender from the thrall of our own bio-ideology has led some anthropologists to argue that the concept of gender should be unhooked from sex altogether (Yanagisako and Collier 1987). Elsewhere (Shapiro ms. 1989), I have argued that this is an impossible project; without reference to biological sex, the concept of gender dissolves altogether. Moreover, what has motivated the study of gender is an inquiry into the relationship between sex and culture, which, after all, includes an exploration of the limits of that relationship.

44. Jones and Stallybrass, in chapter 4 in this volume, also explore the illusory nature of the "grounding" of gender differences in a foundational definition of male and female.

45. Stoller has emphasized the extent to which the transsexual's sense of gender identity is beyond his or her control (Stoller 1968: 260, 268–269, 271). See Garfinkel 1967: 133–137 for a more theoretically elaborate discussion of the concepts of ascription and achievement as they apply to the transsexual experience.

Bibliography

Benjamin, Harry. *The Transsexual Phenomenon.* New York: Julian Press, 1966.

Billings, Dwight B. and Thomas Urban. "The Socio-Medical Construction of Transsexualism: An Interpretation and Critique" *Social Problems* 29 (3), 266–282, 1982.

Delaney, Carol. "The Meaning of Paternity and the Virgin Birth Debate." *Man* 21(3): 494–513, 1986.

Docter, Richard F. *Transvestites and Transsexuals: Toward a Theory of Cross-Gender Behavior.* New York: Plenum, 1988.

Firestone, Shulamith. *The Dialectic of Sex: The Case for Feminist Revolution.* New York: Bantham Books, 1970.

Forgey, Donald G. "The Institution of Berdache Among the North American Plains Indians." *The Journal of Sex Research* 11(1): 1–15, 1975.

Garfinkel, Harold. *Studies in Ethnomethodology.* Englewood Cliffs, New Jersey: Prentice-Hall, 1967.

Green, Richard and John Money (eds.). *Transsexualism and Sex Reassignment.* Baltimore: The John Hopkins University Press, 1969.

Gutierrez, Ramon. "Must We Deracinate Indians to Find Gay Roots?" *Out/Look* 1(4): 61–67, 1989.

Jorgensen, Christine. *Christine Jorgensen: A Personal Biography*. Introduction by Harry Benjamin, M.D. New York: Paul S. Eriksson, Inc., 1967.

Kando, Thomas. *Sex Change: The Achievement of Gender Identity Among Feminized Transsexuals*. Springfield, Illinois: Charles C. Thomas Publisher, 1973.

Kessler, Suzanne J., and Wendy McKenna. *Gender: An Ethnomethodological Approach*. New York: John Wiley & Sons, 1978.

Kondo, Dorinne. "M. Butterfly: Orientalism, Gender, and a Critique of Essentialized Identity," *Cultural Critique* 16, Fall 1990: 5–29.

Krige, Eileen Jensen. "Woman-Marriage, With Special Reference to the Lovedu—Its Significance for the Definition of Marriage." *Africa* 44: 11–37, 1974.

Lewis, O. "Manly-Hearted Women among the North Piegan," *American Anthropologist*, 43: 173–187, 1941.

Mauss, Marcel. *The Gift: Forms and Functions of Exchange in Archaic Societies*. Translated by Ian Cunnison. Illinois: The Free Press, (1925) 1954.

Morris, Jan. *Conundrum*. New York: Harcourt, Brace, Jovanovich, 1974.

Newman, Lawrence E., and Robert J. Stoller. "Nontranssexual Men Who Seek Sex Reassignment." *American Journal of Psychiatry* 131(4): 437–41, 1974.

Oboler, Regina Smith. "Is the Female Husband a Man? Woman/Woman Marriage Among the Nandi of Kenya." *Ethnology* 19(1): 69–88, 1980.

O'Brien, Denise. "Female Husbands in Southern Bantu Societies." In Alice Schlegel ed., *Sexual Stratification: A Cross-Cultural View*, 109–26, New York, 1977.

Pauly, Ira B. "Adult Manifestations of Female Transsexualism." In John Money, and Richard Green, eds., *Transsexualism and Sex Reassignment*, 59–87, Baltimore: John Hopkins University Press, 1969.

Prince, V. "Sex vs. Gender." In D. Laub, and D. Gandy, eds., *Proceedings of the Second Interdisciplinary Symposium on Gender Dysphoria Syndrome*, Stanford: Stanford University Medical Center, 1973.

Raymond, Janice. G. *The Transsexual Empire: The Making of the She-Male*. Boston: Beacon Press, 1979.

Richards, Renée, and John Ames. *Second Serve: The Renée Richards Story*. New York: Stein and Day, 1983.

Roscoe, Will. "We'Wha and Klah: The American Indian Berdache as Artist and Priest." *American Indian Quarterly*, 12(2), Spring 1988: 127–50.

Scliar, Moacyr. *O Centauro no Jardim*. Rio de Janeiro: Editora Nova Fronteira, 1980.

Shapiro, Judith. "Determinants of Sex Role Differentiation: The Kibbutz Case." *Reviews in Anthropology* 3(6): 682–692, 1976.

——— "Gender Totemism." In Richard R. Randolph, David M. Schneider, and May N. Diaz, eds., *Dialectics and Gender: Anthropological Approaches*. 1–19, Boulder: Westview Press, 1988.

——— "The Concept of Gender." ms., 1989.

Stoller, Robert. *Sex and Gender*, Vol I. New York: Science House, 1968; Vol II (*The Transsexual Experiment*). London: Hogarth Press, 1975.

Talmon, Yonina. *Family and Community in the Kibbutz*. Cambridge: Harvard University Press, 1972.

Tiger, Lionel and Joseph Shepher. *Women in the Kibbutz*. New York: Harcourt, Brace, Jovanovich, 1975.

Whitehead, Harriet. "The Bow and the Burden Strap: A New Look at Institutionalized

Homosexuality in Native North America." In Sherry B. Ortner and Harriet Whitehead, eds., *Sexual Meanings: The Cultural Construction of Gender and Sexuality*, 80–115. Cambridge: Cambridge University Press, 1981.

Wikan, Unni. "Man Becomes Woman: Transsexualism in Oman as a Key to Gender Roles." *Man* 12: 304–319, 1977.

Williams, W. *The Spirit and the Flesh: Sexual Diversity in American Indian Culture*. Boston: Beacon Press, 1986.

Yanagisako, Sylvia Junko, and Jane Fishburne Collier. "Toward a Unified Analysis of Gender and Kinship." In Jane Fishburne Collier, and Syliva Junko Yanagisako, eds., *Gender and Kinship*. Stanford: Stanford University Press, 1987.

I I

The *Empire* Strikes Back:
A Posttranssexual Manifesto

Sandy Stone

Frogs into Princesses

The verdant hills of Casablanca look down on homes and shops jammed chockablock against narrow, twisted streets filled with the odors of spices and dung. Casablanca is a very old city, passed over by Lawrence Durrell perhaps only by a geographical accident as the winepress of love. In the more modern quarter, located on a broad, sunny boulevard, is a building otherwise unremarkable except for a small brass nameplate that identifies it as the clinic of Dr. Georges Burou. It is predominantly devoted to obstetrics and gynecology, but for many years has maintained another reputation quite unknown to the stream of Moroccan women who pass through its rooms.

Dr. Burou is being visited by journalist James Morris. Morris fidgets in an anteroom reading *Elle* and *Paris-Match* with something less than full attention, because he is on an errand of immense personal import. At last the receptionist calls for him, and he is shown to the inner sanctum. He relates:

> I was led along corridors and up staircases into the inner premises of the clinic. The atmosphere thickened as we proceeded. The rooms became more heavily curtained, more velvety, more voluptuous. Portrait busts appeared, I think, and there was a hint of heavy perfume. Presently I saw, advancing upon me through the dim alcoves of this retreat, which

distinctly suggested to me the allure of a harem, a figure no less recogniz-
ably odalesque. It was Madame Burou. She was dressed in a long white
robe, tasseled I think around the waist, which subtly managed to combine
the luxuriance of a caftan with the hygiene of a nurse's uniform, and she
was blonde herself, and carefully mysterious. . . . Powers beyond my
control had brought me to Room 5 at the clinic in Casablanca, and I
could not have run away then even if I had wanted to. . . . I went to say
good-bye to myself in the mirror. We would never meet again, and I
wanted to give that other self a long last look in the eye, and a wink for
luck. As I did so a street vendor outside played a delicate arpeggio upon
his flute, a very gentle merry sound which he repeated, over and over
again, in sweet diminuendo down the street. Flights of angels, I said to
myself, and so staggered . . . to my bed, and oblivion.[1]

Exit James Morris, enter Jan Morris, through the intervention of late
twentieth–century medical practices in this wonderfully "oriental,"
almost religious narrative of transformation. The passage is from *Co-
nundrum*, the story of Morris' "sex change" and the consequences for
her life. Besides the wink for luck, there is another obligatory ceremony
known to male-to-female transsexuals which is called "wringing the
turkey's neck," although it is not recorded whether Morris performed
it as well. I will return to this rite of passage later in more detail.

Making History

Imagine now a swift segue from the moiling alleyways of Casablanca
to the rolling green hills of Palo Alto. The Stanford Gender Dysphoria
Program occupies a small room near the campus in a quiet residential
section of this affluent community. The Program, which is a counter-
part to Georges Burou's clinic in Morocco, has been for many years
the academic focus of Western studies of gender dysphoria syndrome,
also known as transsexualism. Here are determined etiology, diagnos-
tic criteria, and treatment.

The Program was begun in 1968, and its staff of surgeons and
psychologists first set out to collect as much history on the subject of
transsexualism as was available. Let me pause to provide a very brief
capsule of their results. A transsexual is a person who identifies his or
her gender identity with that of the "opposite" gender. Sex and gender
are quite separate issues, but transsexuals commonly blur the distinc-

tion by confusing the performative character of gender with the physi-cal "fact" of sex, referring to their perceptions of their situation as being in the "wrong body." Although the term transsexual is of recent origin, the phenomenon is not. The earliest mention of something which we can recognize *ex post facto* as transsexualism, in light of current diagnostic criteria, was of the Assyrian king Sardanapalus, who was reported to have dressed in women's clothing and spun with his wives.[2] Later instances of something very like transsexualism were reported by Philo of Judea, during the Roman Empire. In the eighteenth century the Chevalier d'Eon, who lived for thirty-nine years in the female role, was a rival of Madame Pompadour for the attention of Louis XV. The first colonial governor of New York, Lord Cornbury, came from England fully attired as a woman and remained so during his time in office.[3]

Transsexualism was not accorded the status of an "official disorder" until 1980, when it was first listed in the *American Psychiatric Associa-tion Diagnostic and Statistical Manual*. As Marie Mehl points out, this is something of a Pyrrhic victory.[4]

Prior to 1980, much work had already been done in an attempt to define criteria for differential diagnosis. An example from the 1970s is this one, from work carried out by Leslie Lothstein and reported in Walters and Ross's *Transsexualism and Sex Reassignment*[5]:

> Lothstein, in his study of ten ageing transsexuals [average age fifty-two], found that psychological testing helped to determine the extent of the patients' pathology [*sic*] . . . [he] concluded that [transsexuals as a class] were depressed, isolated, withdrawn, schizoid individuals with profound dependency conflicts. Furthermore, they were immature, narcissistic, egocentric and potentially explosive, while their attempts to obtain [pro-fessional assistance] were demanding, manipulative, controlling, coer-cive, and paranoid.[6]

Here's another:

> In a study of 56 transsexuals the results on the schizophrenia and depres-sion scales were outside the upper limit of the normal range. The authors see these profiles as reflecting the confused and bizarre life styles of the subjects.[7]

These were clinical studies, which represented a very limited class of subjects. However, the studies were considered sufficiently representative for them to be reprinted without comment in collections such as that of Walters and Ross. Further on in each paper, though, we find that each investigator invalidates his results in a brief disclaimer which is reminiscent of the fine print in a cigarette ad: In the first, by adding "It must be admitted that Lothstein's subjects could hardly be called a typical sample as nine of the ten studied had serious physical health problems" (this was a study conducted in a health clinic, not a gender clinic), and in the second, with the afterthought that "82 per cent of [the subjects] were prostitutes and atypical of transsexuals in other parts of the world."[8] Such results might have been considered marginal, hedged about as they were with markers of questionable method or excessively limited samples. Yet they came to represent transsexuals in medicolegal/psychological literature, disclaimers and all, almost to the present day.

During the same period, feminist theoreticians were developing their own analyses. The issue quickly became, and remains, volatile and divisive. Let me quote an example.

> Rape . . . is a masculinist violation of bodily integrity. All transsexuals rape women's bodies by reducing the female form to an artifact, appropriating this body for themselves. . . . Rape, although it is usually done by force, can also be accomplished by deception.

This quote is from Janice Raymond's 1979 book *The Transsexual Empire: The Making of The She-Male*, which occasioned the title of this paper. I read Raymond to be claiming that transsexuals are constructs of an evil phallocratic empire and were designed to invade women's spaces and appropriate women's power. Though *Empire* represented a specific moment in feminist analysis and prefigured the appropriation of liberal political language by a radical right, here in 1991, on the twelfth anniversary of its publication, it is still the definitive statement on transsexualism by a genetic female academic.[9] To clarify my stakes in this discourse let me quote another passage from *Empire*:

> Masculine behavior is notably obtrusive. It is significant that transsexually constructed lesbian-feminists have inserted themselves into the posi-

tions of importance and/or performance in the feminist community. Sandy Stone, the transsexual engineer with Olivia Records, an 'all-women' recording company, illustrates this well. Stone is not only crucial to the Olivia enterprise but plays a very dominant role there. The ... visibility he achieved in the aftermath of the Olivia controversy ... only serves to enhance his previously dominant role and to divide women, as men frequently do, when they make their presence necessary and vital to women. As one woman wrote: "I feel raped when Olivia passes off Sandy ... as a real woman. After all his male privilege, is he going to cash in on lesbian feminist culture too?"

This paper, "The *Empire* Strikes Back," is about morality tales and origin myths, about telling the "truth" of gender. Its informing principle is that "technical arts are always imagined to be subordinated by the ruling artistic idea, itself rooted authoritatively in nature's own life."[10] It is about the image and the real mutually defining each other through the inscriptions and reading practices of late capitalism. It is about postmodernism, postfeminism, and (dare I say it) posttranssexualism. Throughout, the paper owes a large debt to Donna Haraway.

"All of reality in late capitalist culture lusts to become an image for its own security"[11]

Let's turn to accounts by the transsexuals themselves. During this period virtually all of the published accounts were written by male-to-females. I want to briefly consider four autobiographical accounts of male-to-female transsexuals, to see what we can learn about what they think they are doing. (I will consider female-to-male transsexuals in another paper.)

The earliest partially autobiographical account in existence is that of Lili Elbe in Niels Hoyer's book *Man Into Woman* [1933].[12] The first fully autobiographical book was the paperback *I Changed My Sex!* (not exactly a quiet, contemplative title), written by the striptease artist Hedy Jo Star in the mid-1950s.[13] Christine Jorgensen, who underwent surgery in the early 1950s and is arguably the best known of the recent transsexuals, did not publish her autobiography until 1967; instead, Star's book rode the wave of publicity surrounding Jorgensen's surgery. In 1974 *Conundrum* was published, written by the popular English

journalist Jan Morris. In 1977 there was *Canary*, by musician and performer Canary Conn.[14] In addition, many transsexuals keep something they call by the argot term "O.T.F.": The Obligatory Transsexual File. This usually contains newspaper articles and bits of forbidden diary entries about "inappropriate" gender behavior. Transsexuals also collect autobiographical literature. According to the Stanford gender dysphoria program, the medical clinics do not, because they consider autobiographical accounts thoroughly unreliable. Because of this, and since a fair percentage of the literature is invisible to many library systems, these personal collections are the only source for some of this information. I am fortunate to have a few of them at my disposal.

What sort of subject is constituted in these texts? Hoyer (representing Jacobson representing Elbe, who is representing Wegener who is representing Sparre),[15] writes:

> A single glance of this man had deprived her of all her strength. She felt as if her whole personality had been crushed by him. With a single glance he had extinguished it. Something in her rebelled. She felt like a schoolgirl who had received short shrift from an idolized teacher. She was conscious of a peculiar weakness in all her members . . . it was the first time her woman's heart had trembled before her lord and master, before the man who had constituted himself her protector, and she understood why she then submitted so utterly to him and his will.[16]

We can put to this fragment all of the usual questions: Not by whom but *for* whom was Lili Elbe constructed? Under whose gaze did her text fall? And consequently what stories appear and disappear in this kind of seduction? It may come as no surprise that all of the accounts I will relate here are similar in their description of "woman" as male fetish, as replicating a socially enforced role, or as constituted by performative gender. Lili Elbe faints at the sight of blood.[17] Jan Morris, a world-class journalist who has been around the block a few times, still describes her sense of herself in relation to makeup and dress, of being on display, and is pleased when men open doors for her:

> I feel small, and neat. I am not small in fact, and not terribly neat either, but femininity conspires to make me feel so. My blouse and skirt are light, bright, crisp. My shoes make my feet look more delicate than they are, besides giving me . . . a suggestion of vulnerability that I rather like.

My red and white bangles give me a racy feel, my bag matches my shoes and makes me feel well organized . . . When I walk out into the street I feel consciously ready for the world's appraisal, in a way that I never felt as a man.[18]

Hedy Jo Star, who was a professional stripper, says in *I Changed My Sex!*: "I wanted the sensual feel of lingerie against my skin, I wanted to brighten my face with cosmetics. I wanted a strong man to protect me." Here in 1991 I have also encountered a few men who are brave enough to echo this sentiment for themselves, but in 1955 it was a proprietary feminine position.

Besides the obvious complicity of these accounts in a Western white male definition of performative gender, the authors also reinforce a binary, oppositional mode of gender identification. They go from being unambiguous men, albeit unhappy men, to unambiguous women. There is no territory between.[19] Further, each constructs a specific narrative moment when their personal sexual identification changes from male to female. This moment is the moment of neocolporraphy— that is, of gender reassignment or "sex change surgery."[20] Jan Morris, on the night preceding surgery, wrote: "I went to say good-bye to myself in the mirror. We would never meet again, and I wanted to give that other self a last wink for luck . . . "[21]

Canary Conn writes: "I'm not a *muchacho* . . . I'm a *muchacha* now . . . a girl [*sic*]."[22]

Hedy Jo Star writes: "In the instant that I awoke from the anaesthetic, I realized that I had finally become a woman."[23]

Even Lili Elbe, whose text is second-hand, used the same terms: "Suddenly it occurred to him that he, Andreas Sparre, was probably undressing for the last time." Immediately on awakening from first-stage surgery [castration in Hoyer's account], Sparre writes a note. "He gazed at the card and failed to recognize the writing. It was a woman's script." Inger carries the note to the doctor: "What do you think of this, Doctor. No man could have written it?" "No," said the astonished doctor; "no, you are quite right . . . " —an exchange which requires the reader to forget that orthography is an acquired skill. The same thing happens with Elbe's voice: "the strange thing was that your voice had completely changed . . . You have a splendid soprano voice! Simply astounding."[24] Perhaps as astounding now as then but for

different reasons, since in light of present knowledge of the effects [and more to the point, the non-effects] of castration and hormones none of this could have happened. Neither has any effect on voice timbre. Hence, incidentally, the jaundiced eyes with which the clinics regard historical accounts.

If Hoyer mixes reality with fantasy and caricatures his subjects besides ("Simply astounding!"), what lessons are there in *Man Into Woman?* Partly what emerges from the book is how Hoyer deploys the strategy of building barriers within a single subject, strategies that are still in gainful employment today. Lili displaces the irruptive masculine self, still dangerously present within her, onto the God-figure of her surgeon/therapist Werner Kreutz, whom she calls The Professor, or The Miracle Man. The Professor is He Who molds and Lili that which is molded:

> what the Professor is now doing with Lili is nothing less than an emotional moulding, which is preceding the physical moulding into a woman. Hitherto Lili has been like clay which others had prepared and to which the Professor has given form and life . . . by a single glance the Professor awoke her heart to life, a life with all the instincts of woman.[25]

The female is immanent, the female is bone-deep, the female is instinct. With Lili's eager complicity, The Professor drives a massive wedge between the masculine and the feminine within her. In this passage, reminiscent of the "oriental" quality of Morris's narrative, the male must be annihilated or at least denied, but the female is that which exists to be *continually* annihilated:

> It seemed to her as if she no longer had any responsibility for herself, for her fate. For Werner Kreutz had relieved her of it all. Nor had she any longer a will of her own . . . there could be no past for her. Everything in the past belonged to a person who . . . was dead. Now there was only a perfectly humble woman, who was ready to obey, who was happy to submit herself to the will of another . . . her master, her creator, her Professor. Between [Andreas] and her stood Werner Kreutz. She felt secure and salvaged.[26]

Hoyer has the same problems with purity and denial of mixture that recur in many transsexual autobiographical narratives. The characters

in his narrative exist in an historical period of enormous sexual repression. How is one to maintain the divide between the "male" self, whose proper object of desire is Woman, and the "female" self, whose proper object of desire is Man?

> "As a man you have always seemed to me unquestionably healthy. I have, indeed, seen with my own eyes that you attract women, and that is the clearest proof that you are a genuine fellow." He paused, and then placed his hand on Andreas' shoulder. "You won't take it amiss if I ask you a frank question? . . . Have you at any time been interested in your own kind? You know what I mean."
> Andreas shook his head calmly. "My word on it, Niels; never in my life. And I can add that those kind of creatures have never shown any interest in me."
> "Good, Andreas! That's just what I thought."[27]

Hoyer must separate the subjectivity of "Andreas," who has never felt anything for men, and "Lili," who, in the course of the narrative, wants to marry one. This salvaging procedure makes the world safe for "Lili" by erecting and maintaining an impenetrable barrier between her and "Andreas," reinforced again and again in such ways as two different handwriting styles and two different voices. The force of an imperative—a natural state toward which all things tend—to deny the potentialities of mixture, acts to preserve "pure" gender identity: at the dawn of the Nazi-led love affair with purity, no "creatures" tempt Andreas into transgressing boundaries with his "own kind."

> "I will honestly and plainly confess to you, Niels, that I have always been attracted to women. And to-day as much as ever. A most banal confession!"[28]

—banal only so long as the person inside Andreas's body who voices it is Andreas, rather than Lili. There is a lot of work being done in this passage, a microcosm of the work it takes to maintain the same polar personae in society in the large. Further, each of these writers constructs his or her account as a narrative of redemption. There is a strong element of drama, of the sense of struggle against huge odds, of overcoming perilous obstacles, and of mounting awe and mystery at the

breathtaking approach and final apotheosis of the Forbidden Transformation. Oboy.

> The first operation ... has been successful beyond all expectations. Andreas has ceased to exist, they said. His germ glands—oh, mystic words—have been removed.[29]

Oh, mystic words. The *mysterium tremendum* of deep identity hovers about a physical locus; the entire complex of male engenderment, the mysterious power of the Man-God, inhabits the "germ glands" in the way that the soul was thought to inhabit the pineal. Maleness is in the you-know-whats. For that matter, so is the ontology of the subject. Therefore Hoyer can demonstrate in the coarsest way that femaleness is lack:

> The operation which has been performed here [that is, castration] enables me to enter the clinic for women [exclusively for women].[30]

On the other hand, either Niels or Lili can be constituted by an act of *insinuation*, what the New Testament calls *endeuein*, or the putting on of the god, inserting the physical body within a shell of cultural signification:

> Andreas Sparre ... was probably undressing for the last time ... For a lifetime these coverings of coat and waistcoat and trousers had enclosed him.[31]
> It is now Lili who is writing to you. I am sitting up in my bed in a silk nightdress with lace trimming, curled, powdered, with bangles, necklace, and rings ... [32]

All these authors replicate the stereotypical male account of the constitution of woman: Dress, makeup, and delicate fainting at the sight of blood. Each of these adventurers passes directly from one pole of sexual experience to the other. If there is any intervening space in the continuum of sexuality, it is invisible. And nobody *ever* mentions wringing the turkey's neck.

No wonder feminist theorists have been suspicious. Hell, *I'm* suspicious.

How do these accounts converse with the medical/psychological

texts? In a time in which more interactions occur through texts, computer conferences, and electronic media than by personal contact, and consequently when individual subjectivity can be constituted through inscription more often than through personal association, there are still moments of embodied "natural truth" that cannot be avoided. In the time period of most of these books, the most critical of these moments was the intake interview at the gender dysphoria clinic when the doctors, who were all males, decided whether the person was eligible for gender reassignment surgery. The origin of the gender dysphoria clinics is a microcosmic look at the construction of criteria for gender. The foundational idea for the gender dysphoria clinics was first, to study an interesting and potentially fundable human aberration; second, to provide help, as they understood the term, for a "correctable problem."

Some of the early nonacademic gender dysphoria clinics performed *surgery on demand*, which is to say regardless of any judgment on the part of the clinic staff regarding what came to be called appropriateness to the gender of choice. When the first academic gender dysphoria clinics were started on an experimental basis in the 1960s, the medical staff would not perform surgery on demand, because of the professional risks involved in performing experimental surgery on "sociopaths." At this time there were no official diagnostic criteria; "transsexuals" were, *ipso facto*, whoever signed up for assistance. Professionally this was a dicey situation. It was necessary to construct the category "transsexual" along customary and traditional lines, to construct plausible criteria for acceptance into a clinic. Professionally speaking, a test or a differential diagnosis was needed for transsexualism that did not depend on anything as simple and subjective as feeling that one was in the wrong body. The test needed to be objective, clinically appropriate, and repeatable. But even after considerable research, no simple and unambiguous test for gender dysphoria syndrome could be developed.[33]

The Stanford clinic was in the business of helping people, among its other agendas, as its members understood the term. Therefore the final decisions of eligibility for gender reassignment were made by the staff on the basis of an individual *sense* of the "appropriateness of the individual to their gender of choice." The clinic took on the additional role of "grooming clinic" or "charm school" because, according to the

judgment of the staff, the men who presented as wanting to be women did not always "behave like" women. Stanford recognized that gender roles could be learned (to an extent). Their involvement with the grooming clinics was an effort to produce not simply anatomically legible females, but *women* . . . i.e., *gendered* females. As Norman Fisk remarked, "I now admit very candidly that . . . in the early phases we were avowedly seeking candidates who would have the best chance for success."[34] In practice this meant that the candidates for surgery were evaluated on the basis of their *performance* in the gender of choice. The criteria constituted a fully acculturated, consensual definition of gender, and *at the site of their enactment we can locate an actual instance of the apparatus of production of gender.*

This raises several sticky questions, the chief two being: Who is telling the story for whom, and how do the storytellers differentiate between the story they tell and the story they hear?

One answer is that they differentiate with great difficulty. The criteria which the researchers developed and then applied were defined recursively through a series of interactions with the candidates. The scenario worked this way: Initially, the only textbook on the subject of transsexualism was Harry Benjamin's definitive work *The Transsexual Phenomenon* [1966].[35] [Note that Benjamin's book actually postdates *I Changed My Sex!* by about ten years.] When the first clinics were constituted, Benjamin's book was the researchers' standard reference. And when the first transsexuals were evaluated for their suitability for surgery, their behavior matched up gratifyingly with Benjamin's criteria. The researchers produced papers which reported on this, and which were used as bases for funding.

It took a surprisingly long time—several years—for the researchers to realize that the reason the candidates' behavioral profiles matched Benjamin's so well was that the candidates, too, had read Benjamin's book, which was passed from hand to hand within the transsexual community, and they were only too happy to provide the behavior that led to acceptance for surgery.[36] This sort of careful repositioning created interesting problems. Among them was the determination of the permissible range of expressions of physical sexuality. This was a large gray area in the candidates' self-presentations, because Benjamin's subjects did not talk about any erotic sense of their own bodies. Consequently nobody else who came to the clinics did either. By textual

authority, physical men who lived as women and who identified themselves as transsexuals, as opposed to male transvestites for whom erotic penile sensation was permissible, could not experience penile pleasure. Into the 1980s there was not a single preoperative male-to-female transsexual for whom data was available who experienced genital sexual pleasure while living in the "gender of choice."[37] The prohibition continued postoperatively in interestingly transmuted form, and remained so absolute that no postoperative transsexual would admit to experiencing sexual pleasure through masturbation either. Full membership in the assigned gender was conferred by orgasm, real or faked, accomplished through heterosexual penetration.[38] "Wringing the turkey's neck," the ritual of penile masturbation just before surgery, was the most secret of secret traditions. To acknowledge so natural a desire would be to risk "crash landing"; that is, "role inappropriateness" leading to disqualification.[39]

It was necessary to retrench. The two groups, on one hand the researchers and on the other the transsexuals, were pursuing separate ends. The researchers wanted to know what this thing they called gender dysphoria syndrome was. They wanted a taxonomy of symptoms, criteria for differential diagnosis, procedures for evaluation, reliable courses of treatment, and thorough follow–up. The transsexuals wanted surgery. They had very clear agendas regarding their relation to the researchers, and considered the doctors' evaluation criteria merely another obstacle in their path—something to be overcome. In this they unambiguously expressed Benjamin's original criterion in its simplest form: The sense of being in the "wrong" body.[40] This seems a recipe for an uneasy adversarial relationship, and it was. It continues to be, although with the passage of time there has been considerable dialogue between the two camps. Partly this has been made possible by the realization among the medical and psychological community that the expected criteria for differential diagnosis did not emerge. Consider this excerpt from a paper by Marie Mehl, written in 1986:

There is no mental nor psychological test which successfully differentiates the transsexual from the so-called normal population. There is no more psychopathology in the transsexual population than in the population at large, although societal response to the transsexual does pose some insurmountable problems. The psychodynamic histories of

transsexuals do not yield any consistent differentiation characteristics from the rest of the population.[41]

These two accounts, Mehl's statement and that of Lothstein, in which he found transsexuals to be depressed, schizoid, manipulative, controlling, and paranoid, coexist within a span of less than ten years. With the achievement of a diagnostic category in 1980—one which, after years of research, did not involve much more than the original sense of "being in the wrong body"—and consequent acceptance by the body police, i.e., the medical establishment, clinically "good" histories now exist of transsexuals in areas as widely dispersed as Australia, Sweden, Czechoslovakia, Vietnam, Singapore, China, Malaysia, India, Uganda, Sudan, Tahiti, Chile, Borneo, Madagascar, and the Aleutians.[42] (This is not a complete list.) It is a considerable stretch to fit them all into some plausible theory. Were there undiscovered or untried diagnostic techniques that would have differentiated transsexuals from the "normal" population? Were the criteria wrong, limited, or short-sighted? Did the realization that criteria were not emerging just naturally appear as a result of "scientific progress," or were there other forces at work?

Such a banquet of data creates its own problems. Concomitant with the dubious achievement of a diagnostic category is the inevitable blurring of boundaries as a vast heteroglossic account of difference, heretofore invisible to the "legitimate" professions, suddenly achieves canonization and simultaneously becomes homogenized to satisfy the constraints of the category. Suddenly the old morality tale of the truth of gender, told by a kindly white patriarch in New York in 1966, becomes pancultural in the 1980s. Emergent polyvocalities of lived experience, never represented in the discourse but present at least in potential, disappear; the *berdache* and the stripper, the tweedy housewife and the *mujerado*, the *mah'u* and the rock star, are still the same story after all, if we only try hard enough.

Whose story is this, anyway?

I wish to point out the broad similarities which this peculiar juxtaposition suggests to aspects of colonial discourse with which we may be

familiar: The initial fascination with the exotic, extending to professional investigators; denial of subjectivity and lack of access to the dominant discourse; followed by a species of rehabilitation.

Raising these issues has complicated life in the clinics.

"Making" history, whether autobiographic, academic, or clinical, is partly a struggle to ground an account in some natural inevitability. Bodies are screens on which we see projected the momentary settlements that emerge from ongoing struggles over beliefs and practices within the academic and medical communities. These struggles play themselves out in arenas far removed from the body. Each is an attempt to gain a high ground which is profoundly moral in character, to make an authoritative and final explanation for the way things are and consequently for the way they must continue to be. In other words, each of these accounts is culture speaking with the voice of an individual. The people who have no voice in this theorizing are the transsexuals themselves. As with males theorizing about women from the beginning of time, theorists of gender have seen transsexuals as possessing something less than agency. As with "genetic" "women," transsexuals are infantilized, considered too illogical or irresponsible to achieve true subjectivity, or clinically erased by diagnostic criteria; or else, as constructed by some radical feminist theorists, as robots of an insidious and menacing patriarchy, an alien army designed and constructed to infiltrate, pervert and destroy "true" women. In this construction as well, the transsexuals have been resolutely complicit by failing to develop an effective counterdiscourse.

Here on the gender borders at the close of the twentieth century, with the faltering of phallocratic hegemony and the bumptious appearance of heteroglossic origin accounts, we find the epistemologies of white male medical practice, the rage of radical feminist theories and the chaos of lived gendered experience meeting on the battlefield of the transsexual body: a hotly contested site of cultural inscription, a meaning machine for the production of ideal type. Representation at its most magical, the transsexual body is perfected memory, inscribed with the "true" story of Adam and Eve as the ontological account of irreducible difference, an essential biography which is part of nature. A story which culture tells itself, the transsexual body is a tactile politics of reproduction constituted through textual violence. The clinic is a technology of inscription.

Given this circumstance in which a minority discourse comes to ground in the physical, a counterdiscourse is critical. But it is difficult to generate a counterdiscourse if one is programmed to disappear. The highest purpose of the transsexual is to erase him/herself, to fade into the "normal" population as soon as possible. Part of this process is known as *constructing a plausible history*—learning to lie effectively about one's past. What is gained is acceptability in society. What is lost is the ability to authentically represent the complexities and ambiguities of lived experience, and thereby is lost that aspect of "nature" which Donna Haraway theorizes as Coyote—the Native American spirit animal who represents the power of continual transformation which is the heart of engaged life. Instead, authentic experience is replaced by a particular kind of story, one that supports the old constructed positions. This is expensive, and profoundly disempowering. Whether desiring to do so or not, transsexuals do not grow up in the same ways as "GGs," or genetic "naturals."[43] Transsexuals do not possess the same history as genetic "naturals," and do not share common oppression prior to gender reassignment. I am not suggesting a shared discourse. I am suggesting that in the transsexual's erased history we can find a story disruptive to the accepted discourses of gender, which originates from within the gender minority itself and which can make common cause with other oppositional discourses. But the transsexual currently occupies a position which is nowhere, which is outside the binary oppositions of gendered discourse. For a transsexual, *as a transsexual*, to generate a true, effective and representational counterdiscourse is to speak from outside the boundaries of gender, beyond the constructed oppositional nodes which have been predefined as the only positions from which discourse is possible. How, then, can the transsexual speak? If the transsexual were to speak, what would s/he say?

A Posttranssexual Manifesto

To attempt to occupy a place as speaking subject within the traditional gender frame is to become complicit in the discourse which one wishes to deconstruct. Rather, we can seize upon the textual violence inscribed in the transsexual body and turn it into a reconstructive force.

Let me suggest a more familiar example. Judith Butler points out that the lesbian categories of "butch" and "femme" are not simple assimilations of lesbianism back into terms of heterosexuality. Rather, Butler introduces the concept of *cultural intelligibility*, and suggests that the contextualized and resignified "masculinity" of the butch, seen against a culturally intelligible "female" body, invokes a dissonance that both generates a sexual tension and constitutes the object of desire. She points out that this way of thinking about gendered objects of desire admits of much greater complexity than the example suggests. The lesbian butch or femme both recall the heterosexual scene but simultaneously displace it. The idea that butch and femme are "replicas" or "copies" of heterosexual exchange underestimates the erotic power of their internal dissonance.[44] In the case of the transsexual, the varieties of performative gender, seen against a culturally intelligible gendered body *which is itself a medically constituted textual violence*, generate new and unpredictable dissonances which implicate entire spectra of desire. In the transsexual as text we may find the potential to map the refigured body onto conventional gender discourse and thereby disrupt it, to take advantage of the dissonances created by such a juxtaposition to fragment and reconstitute the elements of gender in new and unexpected geometries. I suggest we start by taking Raymond's accusation that "transsexuals divide women" beyond itself, and turn it into a productive force to multiplicatively divide the old binary discourses of gender—as well as Raymond's own monistic discourse. To foreground the practices of inscription and reading which are part of this deliberate invocation of dissonance, I suggest constituting transsexuals not as a class or problematic "third gender," but rather as a *genre*—a set of embodied texts whose potential for *productive* disruption of structured sexualities and spectra of desire has yet to be explored.

In order to effect this, the genre of visible transsexuals must grow by recruiting members from the class of invisible ones, from those who have disappeared into their "plausible histories." The most critical thing a transsexual can do, the thing that *constitutes* success, is to "pass."[45] Passing means to live successfully in the gender of choice, to be accepted as a "natural" member of that gender. Passing means the denial of mixture. One and the same with passing is effacement of the prior gender role, or the construction of a plausible history. Consider-

ing that most transsexuals choose reassignment in their third or fourth decade, this means erasing a considerable portion of their personal experience. It is my contention that this process, in which both the transsexual and the medicolegal/psychological establishment are complicit, forecloses the possibility of a life grounded in the *intertextual* possibilities of the transsexual body.

To negotiate the troubling and productive multiple permeabilities of boundary and subject position that intertextuality implies, we must begin to rearticulate the foundational language by which both sexuality and transsexuality are described. For example, neither the investigators nor the transsexuals have taken the step of problematizing "wrong body" as an adequate descriptive category. In fact "wrong body" has come, virtually by default, to *define* the syndrome.[46] It is quite understandable, I think, that a phrase whose lexicality suggests the phallocentric, binary character of gender differentiation should be examined with deepest suspicion. So long as we, whether academics, clinicians, or transsexuals, ontologize both sexuality and transsexuality in this way, we have foreclosed the possibility of analyzing desire and motivational complexity in a manner which adequately describes the multiple contradictions of individual lived experience. We need a deeper analytical language for transsexual theory, one which allows for the sorts of ambiguities and polyvocalities which have already so productively informed and enriched feminist theory.

In this volume, Judith Shapiro points out that "To those . . . who might be inclined to diagnose the transsexual's focus on the genitals as obsessive or fetishistic, the response is that they are, in fact, simply conforming to *their culture's* criteria for gender assignment" [emphasis mine]. This statement points to deeper workings, to hidden discourses and experiential pluralities within the transsexual monolith. They are not yet clinically or academically visible, and with good reason. For example, in pursuit of differential diagnosis a question sometimes asked of a prospective transsexual is "Suppose that you could be a man [or woman] in every way except for your genitals; would you be content?" There are several possible answers, but only one is clinically correct.[47] Small wonder, then, that so much of these discourses revolves around the phrase "wrong body." Under the binary phallocratic founding myth by which Western bodies and subjects are authorized, only one body per gendered subject is "right." All other bodies are wrong.

As clinicians and transsexuals continue to face off across the diagnostic battlefield which this scenario suggests, the transsexuals for whom gender identity is something different from *and perhaps irrelevant to* physical genitalia are occulted by those for whom the power of the medical/psychological establishments, and their ability to act as gatekeepers for cultural norms, is the final authority for what counts as a culturally intelligible body. This is a treacherous area, and were the silenced groups to achieve voice we might well find, as feminist theorists have claimed, that the identities of individual, embodied subjects were far less implicated in physical norms, and far more diversely spread across a rich and complex structuration of identity and desire, than it is now possible to express. And yet in even the best of the current debates, the standard mode is one of relentless totalization. The most egregious example in this paper, Raymond's stunning "All transsexuals rape women's bodies" (what if she had said, e.g., "all blacks rape women's bodies"), is no less totalizing than Kates's "transsexuals . . . take on an exaggerated and sterotypical female role," or Bolin's "transsexuals try to forget their male history." There are no subjects in these discourses, only homogenized, totalized objects—fractally replicating earlier histories of minority discourses in the large. So when I speak the forgotten word, it will perhaps wake memories of other debates. The word is *some.*

Transsexuals who pass seem able to ignore the fact that by creating totalized, monistic identities, forgoing physical and subjective intertextuality, they have foreclosed the possibility of authentic relationships. Under the principle of passing, denying the destabilizing power of being "read," relationships begin as lies—and passing, of course, is not an activity restricted to transsexuals. This is familiar to the person of color whose skin is light enough to pass as white, or to the closet gay or lesbian . . . or to anyone who has chosen invisibility as an imperfect solution to personal dissonance. In essence I am rearticulating one of the arguments for solidarity which has been developed by gays, lesbians and people of color. The comparison extends further. To deconstruct the necessity for passing implies that transsexuals must take responsibility for *all* of their history, to begin to rearticulate their lives not as a series of erasures in the service of a species of feminism conceived from within a traditional frame, but as a political action begun by reappropriating difference and reclaiming the power of the refigured

and reinscribed body. The disruptions of the old patterns of desire that the multiple dissonances of the transsexual body imply produce not an irreducible alterity but a myriad of alterities, whose unanticipated juxtapositions hold what Donna Haraway has called the promises of monsters—physicalities of constantly shifting figure and ground that exceed the frame of any possible representation.[48]

The essence of transsexualism is the act of passing. A transsexual who passes is obeying the Derridean imperative: "Genres are not to be mixed. I will not mix genres."[49] I could not ask a transsexual for anything more inconceivable than to forgo passing, to be consciously "read," to read oneself aloud—and by this troubling and productive reading, to begin to *write oneself* into the discourses by which one has been written—in effect, then, to become a (look out—dare I say it again?) posttranssexual.[50] Still, transsexuals know that silence can be an extremely high price to pay for acceptance. I want to speak directly to the brothers, sisters and others who may read/"read" this and say: I ask all of us to use the strength which brought us through the effort of restructuring identity, and which has also helped us to live in silence and denial, for a re-visioning of our lives. I know you feel that most of the work is behind you and that the price of invisibility is not great. But, although *individual* change is the foundation of all things, it is not the end of all things. Perhaps it's time to begin laying the groundwork for the next transformation.

Notes

Thanks to Gloria Anzaldúa, Laura Chernaik, Ramona Fernandez, Thyrza Goodeve, and John Hartigan for their valuable comments on earlier drafts of this paper, Judy Van Maasdam and Donald Laub of the Stanford Gender Dysphoria Program for their uneasy help, Wendy Chapkis; Nathalie Magan; the Olivia Records Collective, for whose caring in difficult times I am deeply grateful; Janice Raymond, for playing Luke Skywalker to my Darth Vader; Graham Nash and David Crosby; and to Christy Staats and Brenda Warren for their steadfastness. In particular, I thank Donna Haraway, whose insight and encouragement continue to inform and illuminate this work.

1. Jan Morris, *Conundrum*, (New York: Harcourt Brace Jovanovich, 1974) 155.

2. In William A.W. Walters, and Michael W. Ross, *Transsexualism and Sex Reassignment*, (Oxford: Oxford University Press, 1986).

3. This capsule history is related in the introduction to Richard Docter's *Transvestites and Transsexuals: Toward a Theory of Cross-Gender Behavior*, New York: Plenum

Press, 1988. It is also treated by Judith Shapiro, "Transsexualism: Reflections on the Persistence of Gender and the Mutability of Sex", in this volume, as well as by Janice Irvine in *Disorders of Desire: Sex and Gender in Modern American Sexology* (Philadelphia: Temple University Press, 1990). In chapter seven of this volume, Gary Kates argues that the Chevalier d'Eon was not a transsexual because he did not demonstrate the transsexual syndrome as Kates understands it; i.e., "intense discomfort with masculine clothes and activities, as is normal in male-to-female transsexuals." Kates's idea of the syndrome comes from standard texts. Later in this paper I discuss the mythic quality of much of this information.

4. In Mehl's introduction to Betty Steiner, ed., *Gender Dysphoria Syndrome: Development, Research, Management* (New York: Plenum Press, 1985).

5. Walters and Ross, op.cit.

6. From Don Burnard and Michael W. Ross, "Psychosocial Aspects and Psychological Theory: What Can Psychological Testing Reveal?" in Walters and Ross [58,2].

7. Walters and Ross, [58,3].

8. Walters and Ross, [58,3].

9. There is some hope to be taken that Judith Shapiro's work will supercede Raymond's as such a definitive statement. Shapiro's accounts seem excellently balanced, and she is aware that there are more accounts from transsexual scholars that have not yet entered the discourse.

10. This wonderful phrase is from Donna Haraway's "Teddy Bear Patriarchy: Taxidermy in the Garden Of Eden, New York City, 1908–1936," in *Social Text* 11, 11:20.

11. Haraway, op.cit. The anecdotal character of this section is supported by field notes which have not yet been organized and coded. A thoroughly definitive and perhaps ethnographic version of this paper, with appropriate citations of both professionals and their subjects, awaits research time and funding.

12. The British sexologist, Norman Haine, wrote the introduction, thus making Hoyer's book a semi-medical contribution.

13. Hedy Jo Star, (Carl Rollins Hammonds), 1955. *I Changed My Sex! [From an O.T.F.].* Star's book has disappeared from history, and I have been unable to find reference to it in any library catalog. Having held a copy in my hand, I am sorry I didn't hold tighter.

14. There was at least one other book published during this period, Renée Richards's "Second Serve," which is not treated here.

15. Niels Hoyer was a pseudonym for Ernst Ludwig Harthern Jacobson; Lili Elbe was the female name chosen by the artist Einar Wegener, whose given name was Andreas Sparre. This lexical profusion has rich implications for studies of self and its constructions, in literature and also in such emergent social settings as computer conferences, where several personalities grounded in a single body are as much the rule as the exception.

16. Hoyer [163].

17. Hoyer [147].

18. Morris [174].

19. In *Conundrum*, Morris does describe a period in her journey from masculine to feminine (from a few years before surgery to immediately afterward) during which her gender was perceived, by herself and others, as ambiguous. She is quite unambiguous, though, about the moment of transition from *male* to *female*.

20. Gender reassignment is the correct disciplinary term. In current medical discourse, sex is taken as a natural physical fact and cannot be changed.

21. Morris [115]. I was reminded of this account on the eve of my own surgery. Gee, I thought on that occasion, it would be interesting to magically become another person in that binary and final way. So I tried it myself—going to the mirror and saying goodbye to the person I saw there—and unfortunately it didn't work. A few days later, when I could next get to the mirror, the person looking back at me was still me. I still don't understand what I did wrong.

22. Canary Conn, *Canary: The Story of a Transsexual* (New York: Bantam, 1977), 271. Conn had her surgery at the clinic of Jesus Maria Barbosa in Tijuana. In this excerpt she is speaking to a Mexican nurse; hence the Spanish terms.

23. Star, op.cit.

24. I admit to being every bit as astounded as the good Doctor, since except for Hoyer's account there are no other records of change in vocal pitch or timbre following administration of hormones or gender reassignment surgery. If transsexuals do succeed in altering their vocal characteristics, they do it gradually and with great difficulty. But there are more than sufficient problems with Lili Elbe's "true story," not the least of which is the scene in which Elbe finally "becomes a woman" by virtue of her physician's *implanting into her abdominal cavity a set of human ovaries.* The attention given by the media in the past decade to heart transplants and diseases of the immune system have made the lay public more aware of the workings of the human immune response, but even in 1936 Hoyer's account would have been recognized by the medical community as questionable. Tissue rejection and the dream of mitigating it were the subjects of speculation in fiction and science fiction as late as the 1940s; e.g., the miracle drug "collodiansy" in H. Beam Piper's *One Leg Too Many* (1949).

25. Hoyer [165].

26. Hoyer [170]. For an extended discussion of texts that transmute submission into personal fulfillment cf. Sandy Stone, forthcoming, "Sweet Surrender: Gender, Spirtuality, and the Ecstasy of Subjection; Pseudo-transsexual Fiction in the 1970s."

27. Hoyer [53].

28. Ibid.

29. Hoyer [134].

30. Hoyer [139]. Lili Elbe's sex change took place in 1930. In the United States today, the juridical view of successful male-to-female sex change is still based upon lack; e.g., a man is a woman when "the male generative organs have been totally and irrevocably destroyed." (From a clinic letter authorizing a name change on a passport, 1980).

31. Hoyer [125].

32. Hoyer [139]. I call attention in both preceding passages to the Koine Greek verb ἐνδύειν, referring to the moment of baptism, when the one being baptized enters into and is entered by the Word; *endeuein* may be translated as "to enter into" but also "to put on, to insinuate oneself into, like a glove"; viz. "He [*sic*] who is baptized into Christ shall have put on Christ." In this intense homoerotic vein in which both genders are present but collapsed in the sacrifi[c]ed body cf. such examples as Fray Bernardino de Sahagun's description of rituals during which the officiating priest puts on the flayed skin of a young woman (in Frazer [589–91]).

33. The evolution and management of this problem deserves a paper in itself. It is discussed in capsule form in Donald R. Laub and Patrick Gandy, eds., *Proceedings of the Second Interdisciplinary Symposium on Gender Dysphoria Syndrome* (Stanford: Division of Reconstructive and Rehabilitation Surgery, Stanford Medical Center, 1973) and in Janice M. Irvine, *Disorders Of Desire: Sex and Gender in Modern American Sexology,* (Philadelphia: Temple University Press, 1990).

34. In Laub and Gandy [7]. Fisk's full remarks provide an excellent description of the aims and procedures of the Stanford group during the early years, and the tensions of conflicting agendas and various attempts at resolution are implicit in his account. For additional accounts cf. both Irvine and Shapiro, op.cit.

35. Harry Benjamin, *The Transsexual Phenomenon* (New York: Julian Press, 1966). The paper which was the foundation for the book was published as "Transsexualism and Transvestism as Psycho-somatic and Somato-Psychic Syndromes" in the *American Journal of Psychotherapy* [8:219–30 (1954)]. A much earlier paper by D.O. Cauldwell, "Psychopathia transexualis", in *Sexology* 16:274–80 (1949), does not appear to have had the same effect within the field, although John Money still pays homage to it by retaining Cauldwell's single-s spelling of the term. In early documents by other workers one may sometimes trace the influence of Cauldwell or Benjamin by how the word is spelled.

36. Laub and Gandy [8, 9 *passim*].

37. The problem here is with the ontology of the term "genital," in particular with regard to its definition for such activities as pre- and postoperative masturbation. Engenderment ontologizes the erotic economy of body surface; as Judith Butler and others (e.g., Foucault) point out, engenderment polices which parts of the body have their erotic components switched off or on. Conflicts arise when the *same* parts become multivalent; e.g., when portions of the (physical male) urethra are used to construct portions of the (gendered female in the physical male) neoclitoris. I suggest that we use this vertiginous idea as an example of ways in which we can refigure multivalence as intervention into the constitution of binary gendered subject positions; in a binary erotic economy, "Who" experiences erotic sensation associated with these areas? (In chapter ten in this volume Judith Shapiro raises a similar point in her essay "Transsexualism: Reflections on the Persistence of Gender and the Mutability of Sex." I have chosen a site geographically quite close to the one she describes, but hopefully more ambiguous, and therefore more dissonant in these discourses in which dissonance can be a powerful and productive intervention.)

38. This act in the borderlands of subject position suggests a category missing from Marjorie Garber's excellent paper "Spare Parts: The Surgical Construction of Gender," in *differences* 1:137–59 (1990); it is an intervention into the dissymmetry between "making a man" and "making a woman" that Garber describes. To a certain extent it figures a collapse of those categories within the transsexual imaginary, although it seems reasonable to conclude that this version of the coming-of-age story is still largely male— the male doctors and patients telling each other the stories of what Nature means for both Man and Woman. Generally female (female-to-male) patients tell the same stories from the other side.

39. The terms "wringing the turkey's neck" (male masturbation), "crash landing" (rejection by a clinical program), and "gaff" (an undergarment used to conceal male genitalia in preoperative m/f transsexuals), vary slightly in different geographical areas but are common enough to be recognized across sites.

40. Based upon Norman Fisk's remarks in Laub and Gandy [7], as well as my own notes. Part of the difficulty, as I discuss in this paper, is that the investigators (not to mention the transsexuals) have failed to problematize the phrase "wrong body" as an adequate descriptive category.

41. In Walters and Ross, *op.cit.*

42. I use the word "clinical" here and elsewhere while remaining mindful of the "Pyrrhic victory" of which Marie Mehl spoke. Now that transsexualism has the uneasy

A Posttranssexual Manifesto

legitimacy of a diagnostic category in the DSM, how do we begin the process of getting it *out* of the book?

43. The actual meaning of "GG," a m/f transsexual slang term, is "genuine girl," (*sic*) also called "genny."

44. Judith Butler, *Gender Trouble* (New York: Routledge, 1990).

45. The opposite of passing, being *read*, provocatively invokes the inscription practices to which I have referred.

46. I am suggesting a starting point, but it is necessary to go much further. We will have to question not only how *body* is defined in these discourses, but to more critically examine who gets to say *what "body" means.*

47. In case the reader is unsure, let me supply the clinically correct answer: "No."

48. For an elaboration of this concept cf. Donna Haraway, "The Promises Of Monsters: A Regenerative Politics for Inappropriate/d Others," in Paula Treichler, Cary Nelson, and Larry Grossberg, eds. *Cultural Studies* (New York: Routledge, 1991).

49. Jacques Derrida, "La Loi Du Genre/The Law Of Genre," trans. Avital Ronell in *Glyph* 7(1980):176 (French); 202 (English).

50. I also call attention to Gloria Anzaldúa's theory of the mestiza, an illegible subject living in the borderlands between cultures, capable of partial speech in each but always only partially intelligible to each. Working against the grain of this position, Anzaldúa's "new mestiza" attempts to overcome illegibility partly by seizing control of speech and inscription and writing herself into cultural discourse. The stunning "Borderlands" is a case in point; cf. Gloria Anzaldúa, *Borderlands/La Frontera: The New Mestiza* (San Francisco: Spinsters/Aunt Lute, 1987).

Bibliography

Anzaldúa, Gloria, 1987. *Borderlands/La Frontera: The New Mestiza*. San Francisco: Spinsters/Aunt Lute.

Benjamin, Harry, 1966. *The Transsexual Phenomenon*. New York: Julian Press.

Conn, Canary, 1977. *Canary: The Story of a Transsexual*. New York: Bantam.

Derrida, Jacques, 1980. *La Loi Du Genre/The Law Of Genre* [trans. Avital Ronell]. In *Glyph* 7:176 [French]; 202 [English].

Docter, Richard F., 1988. *Transvestites and Transsexuals: Toward a Theory of Cross-Gender Behavior*. New York: Plenum Press.

Elbe, Lili, 1933. *Man Into Woman: An Authentic Record of a Change of Sex. The true story of the miraculous transformation of the Danish painter, Einar Wegener* [Andreas Sparre], edited by Niels Hoyer [pseud. for Ernst Ludwig Harthern Jacobsen], Translated from the German by H.J. Stenning, introduction by Norman Haire. New York: E.P. Dutton & Co., Inc.

Faith, Karlene, forthcoming. *If it weren't for the music: a history of Olivia Records* [mss].

Foucault, Michel, 1980. *Herculine Barbin: Being the Recently Discovered Memoirs of a Nineteenth-Century Hermaphrodite*. New York: Pantheon.

Frazer, Sir James George, 1911. *The Golden Bough, a Study in Magic and Religion*. London: Macmillan.

Gatens, Moira, 1988. "A Critique of the Sex-Gender Distinction." In Allen, J. and P. Patton [eds.]: *Interventions After Marx*.

Grahn, Judy, 1984. *Another Mother Tongue: Gay Words, Gay Worlds.* Boston: Beacon Press.

Green, Richard, and John Money [eds.], 1969. *Transsexualism and Sex Reassignment.* Baltimore: Johns Hopkins Press.

Grosz, Elizabeth, 1988. "Freaks:" A paper delivered at the University of California, Santa Cruz Conference on Women and Philosophy, 1988.

Haraway, Donna J., 1985. "Teddy Bear Patriarchy: Taxidermy in the Garden of Eden, New York City, 1908–1936." In *Social Text* 11:20, Winter 1984–85.

Haraway, Donna, 1985. "A Manifesto For Cyborgs: Science, Technology and Socialist Feminism in the 1980s," *Socialist Review*, 80:65–107.

Haraway, Donna, 1990. "The Promises Of Monsters: A Regenerative Politics for Inappropriated Others." Forthcoming in Treichler, Paula, Cary Nelson, and Larry Grossberg [eds.]: *Cultural Studies* (New York: Routledge, 1991).

Hoyer, Niels, 1933. *Man Into Woman.* [See Elbe, Lili.].

Laub, Donald R. and Patrick Gandy [eds.], 1973: Proceedings of the Second Interdisciplinary Symposium on Gender Dysphoria Syndrome. Stanford: Division of Reconstructive and Rehabilitation Surgery, Stanford Medical Center.

Lothstein, Leslie Martin, 1983. *Female-to-Male Transsexualism: Historical, Clinical and Theoretical Issues.* Boston: Routledge and Kegan Paul.

Morris, Jan, 1974. *Conundrum.* New York: Harcourt Brace Jovanovich.

Nettick, Geri and Beth Elliot [forthcoming]. "The Transsexual Vampire." In *Lonely and a Long Way from Home: The Life and Strange Adventures of a Lesbian Transsexual* [mss].

Raymond, Janice, 1979. *The Transsexual Empire: The Making of the She-Male.* Boston: Beacon.

Riddell, Carol, 1980. Divided Sisterhood: A Critical Review of Janice Raymond's *The Transsexual Empire*. Liverpool: News From Nowhere.

Spivak, Gayatri Chakravorty, 1988. *In Other Worlds: Essays in Cultural Politics.* New York: Routledge.

Star, Hedy Jo [Carl Rollins Hammonds], 1955. *I Changed My Sex!* [Publisher unknown.]

Steiner, Betty [ed.], 1985. *Gender Dysphoria Syndrome: Development, Research, Management.* New York: Plenum Press.

Stoller, Robert J., 1985. *Presentations of Gender.* New Haven: Yale University Press.

Stone, Sandy [forthcoming]. *In The Belly Of The Goddess: "Women's Music," Feminist Collectives, and the Cultural Arc of Lesbian Separatism, 1972–1979.*

Walters, William A.W., and Michael W. Ross, 1986. *Transsexualism and Sex Reassignment.* Oxford: Oxford University Press.

I 2

The Ambiguities of "Lesbian" Viewing Pleasure: The (Dis)articulations of *Black Widow*

Valerie Traub

To ask, "What is a 'lesbian'?" is generally to elicit a direct, descriptive response: "A lesbian is such and such." But the very simplicity of this question is, in fact, disarming, for part of the theoretical and existential problem of defining the "lesbian" is the variability and fluidity of the category to which "she" belongs. To answer the question is to *fix* that which is fundamentally unstable, to immobilize what is in fact a shifting field of only temporarily meaningful significations. Whatever a "lesbian" "is" is constantly negotiated—a matter of conflicting and contradictory investments and agendas, desires and wills. Although "love" and "desire" for other women is a historical constant within a consistent minority of the population, how that love and desire are experienced and expressed—individually and culturally— are historically changing phenomena. The terms by which "lesbian" is interpreted, and thus given cultural meaning and presence, alter in relation to the shifting fortunes of gender ideologies and conflicts, erotic techniques and disciplines, movement politics, fashion and consumer trends, media representations, and paradigms of mental illness and physical disease—to name just a very few.

And yet, despite this historical variability in what a "lesbian" "is," a particular construction of the "lesbian" has achieved the reified, if unconscious, status of the "real." To put this in historical perspective: At the turn of the century, the ascending theoretical paradigm regarding both the female and male "homosexual" was that of psychoanalysis,

which, as Jeffrey Weeks and Michel Foucault have argued, marked both a new mode of categorization and discipline, and a historical point of departure for a newly "identified" segment of the population.[1] Yet, despite the subsequent delegitimization of the psychoanalytic paradigm by the feminist and gay liberation movements in the 1960s and 70s, the terms of psychoanalysis have continued to define, pervasively if unintentionally, what a "lesbian" "is"—not only within the rarified atmosphere of academic or medical discourses, but within popular culture and, more insidiously, within the "lesbian" subcultures within which I live. In novels and films, mainstream and alternative—and more importantly, in our reactions to them—"lesbian" continues to be thought through and within a psychoanalytic nexus of signification. "Lesbians" are both outside of and implicated within this nexus, as we are simultaneously marginalized *by* it and unwitting reproducers *of* it.

To unpack the workings of this paradigm, let us begin with Freud's notorious remark about the impossibility of female desire:

> There is only one libido, which serves both the masculine and the feminine sexual functions. To it itself we cannot assign any sex; if, following the conventional equation of activity and masculinity, we are inclined to describe it as masculine, we must not forget that it also covers trends with a passive aim. Nevertheless the juxtaposition "feminine libido" is without any justification.[2]

And let us follow Freud with the observations of the feminist Lacanian, Julia Kristeva:

> Obliteration of the pre-Oedipal stage, identification with the father, and then: "I'm looking, as a man would, for a woman"; or else, "I submit myself, as if I were a man who thought he was a woman, to a woman who thinks she is a man." Such are the double or triple twists of what is commonly called female homosexuality, or lesbianism. . . . Intellectual or artist, she wages a vigilant war against her pre-Oedipal dependence on her mother, which keeps her from discovering her own body as other, different, possessing a vagina.[3]

Despite the historical and political divide between Sigmund Freud and Julia Kristeva—turn of the century Vienna and postmodern France, intransigent patriarchalism and self-reflective feminism—their com-

ments represent a continuous lineage of thought that has become so ubiquitous as to be an ideological commonplace. It is this mode of thinking which demands interrogation if the question of women's desire(s), including "lesbian" desire(s), is to be explored. Not only do Kristeva's remarks, like Freud's, fail to describe my experience of "lesbian" sexuality, but her formulation of "lesbian" desire reproduces Freud's insistence on the necessity of binary categories of gender. Film theorist Laura Mulvey has demonstrated how Freud, in the above passage, shifts the active/masculine equation from a "conventional" metaphorical concept to a naturalizing, biologically-based use.[4] By means of this shift, Freud first metaphorizes the libido as serving both "masculine" and "feminine" sexual functions, but then denies a "feminine" specificity to it, relegating women's active desire to the "unnatural" imposture of "masculinity." Mulvey shows that for Freud, "the feminine cannot be conceptualized as different, but rather only as *opposition* (passivity) in an antinomic sense, or as *similarity* (the phallic phase)." Kristeva's logic remains caught in the same trap: "lesbian" can only be thought of as opposition (to women, to heterosexuality) or similarity ("as a man"). Throughout, Kristeva's rhetorical strategy reproduces Freud's; she invokes "lesbian" only to assert its status as "masculine" imposture: the "difference" existing *within* women's desires is, perversely, male.

The following essay attempts to explore the question of women's desire(s) in terms other than those binary designations offered by Freud and Kristeva, and to refuse, in the words of David Halperin, "to collaborate in the reification of modern sexual categories."[5] My methodology is both informed by and contestatory of psychoanalysis, as I employ psychoanalytic insights to deconstruct normalizing codes and prescriptions. Specifically, I attempt to expose the way binary categories of gender determine in advance our conceptualization not only of gender identity and behavior but erotic positions and practices, and to show how the conflation of gender and erotic desire serves this binary teleology.[6] As I have argued in more detail elsewhere, the very term "sexual difference" conflates two related but different trajectories of subjectivity—gender identification and erotic desire—which, even in the most radical feminist and psychoanalytic theorizing, results in an elision of erotic practice.[7]

I offer the 1987 film *Black Widow*—ostensibly a mainstream, het-

erosexual "woman's film" starring Debra Winger and Theresa Russell—as an example of the way such gendered dualisms simultaneously
make possible and inhibit the representation of "lesbian" desire.[8] By
employing multiple transpositions of identity to produce homoerotic
tension between the two female leads, Black Widow solicits a "lesbian"
gaze at the same time that it invites male heterosexual enjoyment.
"Lesbian" viewing pleasure, however, like male and female heterosexual pleasure, is constructed around a set of overdetermined relations
between gender and sexuality; it does not exist outside of, but in
complex relation to, the "deployment of sexuality" dominating contemporary discourse.[9] "Lesbian" appropriation of the "gaze" comes
only at the price of acquiescence to a system of sexual (gender and
erotic) regularization that reproduces dominant taxonomies of sexual
(gender and erotic) difference.

The terms by which Black Widow elicits "lesbian" desire are precisely those that repress its specificity. Investing in a binary teleology
that upholds a structural heterosexuality at the same time it (con)figures
"lesbian" desire, the film instantiates the following ideological commonplace: if a woman desires a woman, it must be because she 1)
really wants to be a man, or 2) really wants to be the *other* woman.
Seemingly oppositional, the two are actually inversions of one another:
based on an assumption of the "lesbian's" gender dysfunction, the
structure of the opposition preserves the seemingly essential heterosexuality of desire.

Given this ideological constellation, the fact that Black Widow
(directed as it is primarily toward heterosexual entertainment) invites,
even produces, "lesbian" pleasure, seems to me to offer a rarefied
instance of the maintenance of heterosexual hegemony within the particular North American erotic pressures of the 1980s. These pressures include, but are certainly not limited to, male anxiety about erotically assertive women, the refeminization of women in response to male anxiety,
and the newly rematerialized threat of death involved in all erotic liaisons: within the context of AIDS, the *film noir* narrative trope of sexual
danger takes on a more urgent significance. Specific cinematic codes of
gender and eroticism, co-joined with spectator desires for "lesbian" representation (whether for political or erotic reasons), create the conditions for erotically ambiguous but ideologically replete viewings.

Insofar as I attempt both a textual reading of the contradictions and

ambiguities in *Black Widow,* and an audience-directed analysis of "real" "lesbian" responses to the film, my interpretation stands at the crossroads of two trends in feminist film theory: one path follows, in minute detail, the signifying powers of the text; the other begins with the interpretative interventions and appropriations of the film specta-tor.[10] Within both paths, the analysis is complicated by the fact that intentionalities and responses are both conscious and unconscious. If E. Ann Kaplan is correct in her assumption that

> any reading is a result of a delicate, perhaps unconscious, negotiation between the historical positions/ideologies any text is seeking to present, and the frameworks/codes/local ideologies and individual psychoana-lytic constructs that spectators bring to texts,[11]

then any "film event" is a complex and oftentimes contradictory inter-action between conscious and unconscious intentionalities of both text and audience. The "female spectator" or "lesbian viewer" thus is simultaneously a hypothetical point of address to which the film "speaks" and a subject position ascribed to "real" female audience members. Crucial to such an understanding of spectatorship is the awareness that, as much as "lesbians" independently walk into the theater, they are also constructed within the space the film affords them. That this space is precisely a locus of ambiguity—both potential and constraint, affordance and limitation, a space opened for represen-tation and a space denied—suggests that the contradictions *within Black Widow* bear some relation to the status of "lesbian" representa-tion more generally. Ambiguity not only informs this film but consti-tutes the very possibilities of "lesbian" desire within a predominantly heterosexual (and heterosexist) ideology.

* * *

In the classical narrative cinema, to see is to desire.
—Linda Williams, "When the Woman Looks"[12]

[T]he female spectator ... temporarily accepts "masculinization" in memory of her "active" phase. ... the female spectator's phantasy of masculinization [is] at cross-purposes with itself, restless in its transves-tite clothes.
—Laura Mulvey, "Afterthoughts on 'Visual Pleasure and Narrative Cinema' "[13]

Body Guards

Feminist psychoanalytic and film theorists such as E. Ann Kaplan, Luce Irigaray and Laura Mulvey have argued that in phallocentric modes of representation only two positions are possible: the active male subject and the passive female object of the gaze.[14] Mulvey in particular hypothesized that such a phallocentric binarism governs the representation of women in classic Hollywood cinema. Under attack from feminists who challenged her static and totalized description of patriarchal power, as well as her negative view of pleasure itself, Mulvey offered the following amendment to her theory: the position of the female spectator is analogous to that of the female transvestite; adopting a "masculinized" position, the female subject of the gaze is forever at odds with a desire that is never her "own." In seeking to define a more dynamic model of women's agency, Mulvey problematically falls back on the psychoanalytic construct of a masculinized desire.

Other feminist film theorists have focused on those moments *within* filmic texts, in the words of Linda Williams, "when the woman looks." Williams' reading of the horror genre as well as Mary Ann Doane's analysis of "women's films," however, suggest that women characters are punished for adopting the male prerogative of the look; and Carol Clover's reading of slasher films argues that the female gaze works primarily as a "congenial double for the adolescent male" viewer, "a male surrogate in things oedipal, a homoerotic stand in."[15] In short, across genre, the female gaze acts only as an equivocal assumption of power.

Indeed, it could be argued that to the extent film depends on visual stimulation, the genre as a whole enacts the specular economy criticized by Irigaray, in which subject and object are always rigidly demarcated, the logic of castration (depending on the sight of what is *not there*) enforcing the representation of the female body as lack. As a way out of this predominantly visual economy, Irigaray proposes instead a tactile erotics, based on physical and psychological contiguity or "nearness." However, as much as women's eroticism may be infused with tactility, many feminist film theorists do not want to accede the pleasure of the gaze to men alone. Contesting the notion that eroticization of the female body is necessarily phallocentric, they argue that the problem is not in specularity itself, but in the reified status of subject and object in the phallocentric visual economy.

Drawing on the psychoanalytic paradigm of fantasy in which viewing positions are multiple and mobile, such theorists describe the dynamics of identification, and hence, the gaze, as "bisexual," "transactional," or "double."[16] One such theorist, Teresa de Lauretis, implies that a different modality of power might be possible within a homoerotic gaze.[17] In the context of theorizing a gaze unbound by rigid gender polarities, the figure of the "lesbian" is, it seems to me, a privileged site of inquiry. As both subject and object of desire, she embodies the potential desiring modality of all viewing subjects, her body displacing the binary economy enforced by heterosexual ideology. And yet, not quite: insofar as she is still constrained by the structural asymmetries of gender, the "lesbian" *subverts,* but cannot *overturn,* the hegemony of binary codes. More importantly, the terms by which she enacts her subversion may not be of her own making.

The appropriation of *Black Widow* by "lesbian" audiences enacts the dynamic of women looking at a woman looking at another woman; despite whatever masculinist assumptions about female bodies may structure its visuals, *Black Widow* persistently insists that the gaze within the film is female. The protagonist, Alex (Winger), an "androgynous," "asexual" Justice Department investigator, searches for, finds, and eventually conquers her antagonist—a "feminine," "sexy" woman, "Reni" (Russell), who compulsively marries wealthy men in order to kill them. By means of her investigation, Alex's subjectivity is transformed through identification with and desire for the "black widow."

My use of quotation marks around the terms "androgynous" and "feminine," "asexual" and "sexy," signifies my discomfort with these binary designations—for even "androgynous" poses an intermediary position that keeps the oppositional poles intact. Though preferable to "masculine"—which is how many reviewers describe Alex (when they aren't using adjectives like frumpy, clumsy, untidy, bookish and sloppy, drab and dowdily work-obsessed)[18]—"androgyny" hardly describes Alex's character; insofar as it connotes either someone who could "pass" as male or female, or who deliberately seeks to blur gender distinctions (e.g., Annie Lenox, Grace Jones, Boy George, or David Bowie), "androgyny" is a sexual style foreign to Alex. Indeed, the question posed by the figure of Alex—at once powerful in stance and vulnerable in look, a computer "jock" yet conventionally "sexy" in a black evening dress—

is the same question inhering in the figure of the desiring female specta-
tor: how to develop a vocabulary that does not relegate women's
desires to previously constituted poles of femininity = passivity versus
masculinity = activity? In the terms of de Lauretis, Alex represents
"the signified of a sexual difference not reducible to the terms of a
phallic or Oedipal polarity."[19] The strong, effective, attractive, desiring
woman finds no proper name or description in our current gender/
erotic categories. Even the "lesbian" terminology of the "rough-fluff"
maintains the binary schema which Alex's persona defies.

Likewise, Reni, in each of her manifestations—Catharine/Marielle/
Margaret/Reni—is universally acknowledged as a "femme." But, as
much as it may conjure up prescribed images of facial structure and
bodily physique, this term says nothing about her intelligence, strength,
willfulness, courage. She controls every one of her relationships with
men, precisely by allowing them an illusory sense of control. If Reni is
a "femme," then the correlation between "femininity" and passivity
holds no purchase. And if Alex is perceived as "asexual," perhaps this
says more about male expectations of female accessibility than about
her own desires. Indeed, her "asexuality" is defined through the ques-
tionable auspices of her boss, who has been rebuffed in his attempt to
seduce her, and through reviewers who assume that Alex's lack of
interest in *this* man (and this *man*) implies a total disinterest in sexu-
ality.

Structurally, *Black Widow* attempts to revise its genre's investment
in a gendered heterosexuality that positions woman as object to be
sought and either punished or saved. A revision of the *film noir*'s
narrative of the male investigator's pursuit of a "femme fatale," Alex's
role as investigator inverts the cinematic structure of gendered repre-
sentation. And yet, not entirely: for, in retaining a woman (quite
literally, a fatal "femme") as the object of investigation, *Black Widow*
rejects an easy inversion of the *film noir* mode (an inversion that would
keep intact both gender opposition and heterosexuality) and instead
creates the conditions for a homoerotic structuring of pursuit and
desire.[20]

Superficially, the film's main characters represent inversions of the
same problem. Reni, who, in each of her manifestations embodies
the quality of "to-be-looked-at-ness," murders men;[21] conventional in
gender identification, easily objectifiable within mainstream cinematic

codes, she is literally a sexual outlaw, using her charms to lure men into her trap. Conversely, Alex largely ignores men as objects of desire, and defies cinematic objectification during the first half of the film by wearing comfortable, loose clothes; but in her role as Justice Department investigator, she is positioned as the obedient daughter upholding and protecting the Father's laws. To this extent, the women are inverted mirror images which together pose the problem of women and the law: the law of gender, the law of (hetero)sexuality, the law of matrimony, the Law of the Father.

Yet, despite the affirmation of the Law implied by the *film noir* structure, the status of men in the film—and hence, heterosexuality— is problematic. With one exception, the men surrounding Alex—boss, co-workers, cops—are condescending, paternalistic, convinced of their superiority, unable to understand either her pursuit of the murderer (whom they term a phantom) or her refusal of their advances (which they term frigidity). Reni's first three husbands—wealthy, powerful, if a bit gullible—are interchangeable victims; their differences in occupation and personality only serve to highlight Reni's success in transforming her identity to correspond to their fantasies of the desirable woman. Indeed, Reni's verbal responses to these men are so palpably fake, so clichéd, that the message seems to be, echo a man and he'll marry you. The man most fully realized as a character—Reni's Hawaiian fiancé and fourth husband, Paul (Sami Frey)—is interesting not because of his erotic dynamism but because of his lack of it; as many reviewers remarked, this lack seriously undercuts the believability of the two women's alleged sexual competition.[22] Indeed, rather than calling the shots, Paul is first manipulated by Reni into sleeping with Alex (a ploy to make Reni seem even more desirable), and then used by Alex to force Reni into a confession.

What points most insistently to the failure of heterosexuality in the film is the ability of the women to recognize in one another precisely those qualities that the men cannot. Despite her boss' certainty that the murders, if they *are* murders, are not committed by a woman— "the whole MO, a complex series of seductions and murders, that's not something you see a woman do"—Alex takes Reni's capacity for violence seriously; she sees the pattern in the murders because she wills herself into Reni's way of thinking. Likewise, Reni respects Alex; although flattered by Alex's obvious fascination with her, she never

underestimates Alex as an opponent, never dismisses the threat Alex poses. No man distrusts Reni; no man believes Alex. From the perspective of the male gaze within the film, Reni is angelic and Alex neurotic.

* * *

"The black widow—she mates and she kills. Your question is 'Does she love?' It's impossible to answer that—unless you live in her world."
—Reni

According to those reviewers who disliked *Black Widow,* its primary failure was its inadequate contextualizing of Reni's motive for murder.[23] Again and again, the reviewers discuss the film in terms of its *lack:* what it doesn't show, what it doesn't explain. The film does provide a number of possible motives—desire for wealth and power, self-hatred, a confusion of love and death—but it undercuts the totalizing drive to find *one* explanation. Alex's tall tale of her own abused childhood (complete with father beating her with a spatula), offered as a possible parallel to Reni's, is a self-conscious parody: as her facade begins to break down at the excesses of her story, she laughingly exclaims to her boss, "I can't believe you really went for it! Don't you know, no one knows why anyone does anything!"

It just may be that the film's reluctance to provide a compelling motivation for murder is related to a more deeply buried reticence about articulating Reni's erotic desire. As her relationship with Alex takes precedence over the detective story midpoint in the narrative, the question becomes less why Reni kills—she simply does—but whether she is capable of love or desire at all. The *film noir*'s investment in containing female desire by imposing punishment gives way to the prior question of woman's desire per se. Whereas Reni's status as murderer fatally affects her relationships with men, it tends to only minimally affect the eroticism of the film, which is focused, instead, on the women. By the end of the film, the question takes on further specification: what *constitutes* love/desire for a woman "like" her? Despite Reni's assertion that she loved each of her husbands, her strategic withholding of sex from Paul suggests that whatever "authentic" erotic desire she feels for men is submitted to her greater desire to compel them to submit to her will to kill. What is *not* comprehensible within the heterosexual outlines of the plot is why Reni tenderly holds

Alex's handkerchief to her face after searching her room, why she aggressively, even brutally, kisses Alex during her wedding reception, and why, at the end of the film, speaking to Alex across a prison grill, she says, "Of all the relationships I'll look back on in fifty years' time, I'll always remember this one." To the extent that the film *chooses not* to contextualize these actions, Reni remains a mystery.

To know Reni, you have to enter her world. But, what *is* her world? Located precisely at/as the aporia of the film, Reni's erotic subjectivity is the space most vividly *dis*articulated, actively voided of possible "content." A "lesbian" narrative is needed to make the plot comprehensible, but such an option is never offered within the film. Spectator desires for narrative congruity and coherence thus battle with the heterosexist framework that disallows "lesbian" desire as a possible reality. From a "lesbian" perspective, Reni's offer of Paul to Alex is not merely a coercive gesture; in inverting the male homosocial system by which women are exchanged between men, Paul's body becomes a courier, communicating indirectly those desires that Reni and Alex cannot express. What is at stake, then, in the representation of "lesbian" desire in *Black Widow* is the very intelligibility of the narrative; correspondingly, what is at stake in *Black Widow* is the very possibility of "lesbian" representation within a masculinist and heterosexual field.

* * *

> Mirror, mirror, on the wall,
> Who's the fairest of them all?

From the film's first shot, in which "Catharine," her face not only reflected in but split by a mirror, applies makeup to her eyes and then hides them behind dark glasses, the film plays with standard cinematic tropes of sight and identity: eyes, glasses, mirrors, photographs. Concerned not only with what one sees, but who is doing the looking, the film foregrounds "gazing" at the same time it disrupts any stable notion of identity—as if to say, what you see is not necessarily what you get.

In a crucial early scene, Alex engages in an evening of mimetic identification with the representations "Reni" has, at that point, created of herself. Projecting slides of photographs of "Catharine" and "Marielle" onto her living room wall, transposing the different images on top of each other, Alex intends to prove their essential similitude—

315

the different women are, indeed, one and the same. But, the moment of Alex's unification of the object of her search is also the moment that initiates Alex's disunity: superimposing herself on top of the transpositions, walking to her bathroom mirror, comparing her body parts—hand, face, hair—to the images on her wall, Alex calls up her similarity to and difference from the other woman/women. The consensus of reviewers is that Alex thereby confronts her failure to conform to patriarchal standards of "femininity": measuring herself against the image projected by Russell—who is *ipso facto* granted a higher rating in the beauty department than Winger—she finds herself "wanting." As one of the more feminist reviewers writes, in what is her major criticism of the film:

> Alex, in gazing at the "other" woman, is turned back into an awareness of what she herself lacks. Her obsession with Catharine is thus based on her seeing Catharine as alien to herself, but more importantly, it is symptomatic of her devaluation of herself as an "incomplete" woman.[24]

The film does attempt to represent Alex's obsession with Reni as dissatisfaction with her "lack," as jealous (heterosexual) desire to *be* the "other" woman, and it structures the Hawaiian *menage à trois* precisely to foreground Alex's supposed inadequacy: Reni wins, Alex loses Paul. But does Alex even *want* Paul? After their night together, we see Alex gazing into a mirror—but this is no Scarlett O'Hara, her "femininity" at last fulfilled by the force of male passion. Like a similar shot of Reni looking in the mirror after the death of her first husband, Alex's face is utterly inscrutable. Indeed, the clichéd motivation (all she needed was a good fuck) recedes in light of Winger's compelling portrayal of a professional who will not hesitate to use others sexually if her investigation warrants it.

For an audience erotically invested in Winger's powerful persona, unaware that she is lacking in *anything*, the projection scene reads as a refusal of those gender dichotomies that organize erotic desire.[25] A return to Lacan's mirror stage of psychic development, it signals the moment before the Symbolic phallus intervenes to position subjects within an arbitrary system of two genders corresponding to only two desires. The mirror stage is important for two reasons: on the one hand, the mirror reflects back to the infant for the first time an image

of itself as a unified, coherent subject. On the other hand, to the extent that this image is external, inverted, mediated by the mirror and thus alienated, its promise of a unified self is illusory, a lie. The inception of the subject is also the instance of the subject's radical displacement from "itself," prefiguring the "necessary" injunction that the subject embody a normative gender and erotic position. Alex's return to this stage marks a desire for the moment before woman's body is alienated from itself, and from the bodies of other women. Rather than close down the possibilities of female identity and desire, Alex's fascination with Reni re-opens them: activating the sense of "wanting" as verb rather than adjective, as desire rather than merely lack, this scene instantiates the articulation of a desire with no (proper) name.

And yet, the structure of the narrative, like Lacanian psychoanalysis, insists that if Alex wants Reni, she must also want to *be* Reni. From the projection scene on, Alex begins to identify with the object of her gaze: the quality of her obsession (her boss complains, "She's obsessed with killing, and you're obsessed with her") is such that by the end of the film she has borrowed the clothes, hair dresser, and male lover of the woman she pursues. More importantly, Alex has also become a "black widow," desiring, trapping, "mating with," and annihilating her prey.

Visually the film plays with this identification; with increasing regularity after the projection scene, Alex and Reni are alternatingly dressed in blue and red. If one wears blue, the other is in red, as if to emphasize their difference; but insofar as *each* wears both red and blue, difference slides into interchangeability. In fact, from one scene to the next, the women slip into one another: a view of Alex slumped over her bathroom sink is followed by a cut of Reni in a similar posture slumped over her bed; Alex's detective research in the projection scene immediately precedes Reni's research of an anthropological video; Reni's night with Paul succeeds Alex's night with him. Alex, initially coded in binary terms as "masculine" (she really wants to be a man), becomes increasingly "feminized" (she really wants to be the *other* woman). Thus, despite (and because of) the erotic tension between the women, the film reasserts the essential heterosexuality of desire. *Black Widow* manipulates the components of "lesbian" visual pleasure, and thereby constitutes such pleasure, by asserting the isomorphism of gender identification and erotic desire, and their complicity in the filmic gaze itself.

The trap in which Freud, Kristeva, Lacan and Mulvey are caught is the same web *Black Widow* seeks to weave.

From a psychoanalytic perspective, Alex's desire to transform her identity into a mirror image of Reni raises two related issues: narcissism and pre-oedipal conflict. However, rather than comply with the film's rehearsal of psychoanalytic dogma, and rather than assimilate female desire to daughterly ambivalence toward the mother and over-identification with the father, let us expose the essentialism upon which this interpretation is based. It is not that "lesbians" are fundamentally narcissistic, but that they too are trapped within dominant erotic constructs. Heretofore, gender difference has served as the primary indicator of erotic tension, with "lesbians" neurotically unable to deal with such "difference." However, the belief that homoerotic desire depends on gender similitude obscures both the implication of gender in larger systems of power, and the role of *other* differences in erotic arousal. The poles of gender are only one, and not necessarily the most crucial, of tensions structuring erotic excitement: arousal may be as motivated by the differences *within* each gender as by gender difference itself.[26]

More instructive at this point than psychoanalysis' naming and fixing of the "lesbian" is *Black Widow*'s inability to do so. The destabilization of identity in the film points to the paradox of "lesbian" representation within a heterosexist field of reference. As Judith Roof makes clear, within normative heterosexism "lesbians" cannot be represented except in terms of their unrepresentability.[27] Who *is* "Reni"? Can we even properly call her by that name? A professional dissembler, Reni's multiple impersonations (the sophisticated wife of a New York publisher, the flouncy "airhead" married to a Texas toy mogul, the studious anthropologist on the board of a Seattle museum, the leisured playgirl in Hawaii) defy the certainty presumed by the act of naming. If I've chosen to call her "Reni" because it is the persona she inhabits during her relationship with Alex, the arbitrariness of this choice is demonstrated by the fact that the reviewers consistently call her "Catharine" (interestingly enough, as if her originary persona were more surely "her"), of which "Reni" is a shortened version. And, who is "Alex," who has not only shortened her name from Alexandra, but, once engaged in her search, has been reincarnated in the form of middle-class vacationer Jessica (Jessie) Barnes? Her second transforma-

tion—her "makeover" under Reni's tutelage—underscores the point that it is not only Reni who manufactures, and fractures, identity. Of course, Alex and Reni are not "free" to "choose" their personas: as Reni's hyper-femininity and Alex's new bikini and hairstyle attest, they both must work within existing codes of female behavior. Indeed, the film seems to falter when confronted with possibilities outside of the dominant ideology: who will Alex become after she leaves the court-house in the final frame of the film, walking into the bright sun, but grim-faced and obviously upset by Reni's certain criminal conviction? Will she return (in her blue and white flowered sundress) to her bleak Justice Department "job with green windows"? Will she continue to adopt Reni's identity, becoming her own rendition of the "femme fatale"? Will she "come out" as a "lesbian"? What *are* her options? The film does not, apparently cannot, say.

Such refusals to articulate are constitutive of the film as a whole. *Black Widow* is constructed around two mirroring incoherencies—Reni's desire for Alex and Alex's desire for Reni—and it is only within these gaps that the representation of anything "lesbian" can emerge. Moments of textual excess—moments not required by the logic of plot, but instead functioning to upset the coherency of the narrative—instantiate "lesbian" desire in the film. A series of scenes eroticize the relationship between the women: a CPR practice session involving mouth-to-mouth resuscitation, performed in bathing suits (in which Alex jokes, "You're not taking this personally, are you?"—both an indication and undermining of the sexual tension between the two); a picnic during which Reni seductively lies under watchful Alex's gaze; and an underwater scuba-diving scene, during which, due to the myste-rious failure of Alex's oxygen tank (we suspect foul play), the two experience the enforced intimacy of sharing breath. After all, "lesbian" pleasure is not totally denied in patriarchal culture; rather, it is subtly controlled and disciplined under the male heterosexual gaze.

The most intense moment of textual superfluity—and the greatest incoherency—is the "kiss" exchanged between the two women imme-diately after Reni's marriage to Paul. Insofar as the act of kissing has been widely constructed as a synecdoche of the movements of the erotic body, indeed, the *sine qua non* of erotic desire, its exchange between women most powerfully signifies "lesbian": indeed, the "kiss" is utterly incomprehensible without an acknowledgment of the women's de-

sire(s).[28] However, I want to argue that the "kiss" is also the moment when the film most forcefully *dis*articulates "lesbian" desire: neither sensual nor friendly, the kiss in its brutality comes close to the iconography of rape, a taking of possession, an assertion of both knowledge and power—Reni wants Alex to know that *she* knows *Alex* knows she is a murderer. An explicit warning, it is also the "black widow's" sign of mating—and thus a kiss of death. The "kiss" both does and actively does not signify "lesbian," and as such metonymically figures the film as a whole.

Such incoherencies are evident as well in the publicity for the film. The newspaper ad released by Twentieth-Century Fox provides a visual representation of the film's strategies to simultaneously inscribe and deny "lesbian" significations. Within the upper half of the frame, on either side of a column of bright light, the lit faces of Winger and Russell loom large against a mysterious dark background, dwarfing the anonymous, darkened male figure surrounded by light at the bottom of the frame. Their symmetrically inverted faces are stark and bare, their hair barely visible, their torsos occluded. Suspended in the darkness, the two women embody a mirror image of sexual determination and threat; all visual meaning is gathered in the striking similitude of the shape of and attitude expressed by their eyes, lips, noses, and facial structure. The single male victim, on the other hand, enters, as if from the outside, fully clothed, a trenchcoat providing defense against the threat of the overarching, dual, female gaze.

Visually, this ad poses the primary relationship as female. Yet, intervening between them is not merely the vulnerable man, but a stark, tall column of light, overwritten with these equally stark words: "She mates and she kills. No man can resist her. Only one woman can stop her." Rewriting similarity as antagonism, the written text interjects an essential difference between the dual female images: one is a siren, one a savior, though their lack of physical differentiation makes it impossible to tell which is which. Just as the white column, rising from the figure of the male, interrupts the contiguity of the women, forcing phallic light between the mysterious darkness they represent, the written text imposes a heterosexual interpretation through its triangulation of desire.

Six of the ten reviews I read mentioned the attraction between the

women, and two lamented that the film didn't push further in that direction.[29] None of the reviews questioned, however, what "lesbian" would mean in the context of *Black Widow,* nor did any of them ask *why* the film didn't pursue that direction—what social, psychological, economic, and generic exigencies combined to prohibit a more explicit filmic representation. This reluctance of "liberal" reviewers to interrogate the film's presumptions bespeaks of more than the usual superficiality of such reviews. I suggest that to the extent the film is seen to gesture toward "lesbian" desire, it invokes more anxiety than pleasure in even the "liberal" heterosexual viewer. Rather than embodying an ethic of tolerance and inclusiveness, *Black Widow* demonstrates not only the failure of heterosexuality—encapsulated in the last scene by Paul's stony face as Reni kisses him on the cheek—but the instability of sexual "identity" as such. Neither Alex nor Reni are figured as "lesbian" by birth and, according to the gender and erotic codings the film endorses, both of them obviously could "be" heterosexual if they chose. But, despite the moonlit scenes with Paul, neither woman does so choose, at least not clearly and unequivocally. Defying essentialist categories of erotic identity, the film thus verges on exposing the vulnerability of all erotic subjects. Deep in the heart of desire is an anxiety which not only animates, but constitutes it.

However much *Black Widow* represents "lesbian" desire, its commitment to the conflation of gender and sexuality results in desire's effacement. Whatever positive signification the "kiss" may hold for either woman is subsumed by a generic logic and psychic aggression, a heterosexual teleology, that finally puts the beloved behind bars. In this sense, "lesbian" representation in *Black Widow* is precisely *dis*articulated; through the play of desire and identification, their intersections and conflations, "lesbian" desire is constructed only to be imprisoned. The final look exchanged between the two women is of neither betrayal nor triumph, but longing. It is not a matter, therefore, of arguing that Reni or Alex "is" "a" "lesbian" or *Black Widow* is a "lesbian film," but rather that both black widow(s) and *Black Widow* pose the problem of "lesbian" representation within a dominantly heterosexist and patriarchal system. *Black Widow* articulates "lesbian" desire, rendering it visible, only to reencode it as invisible, inarticulate.

* * *

That *Black Widow* constructs its representation of "lesbian" desire precisely to contain it, that it enforces the impossibility of "lesbian" representation by invoking its possibility, is not the whole story. There is something in excess of the film's strategies of containment: the presence of "real lesbians" in the audience, appropriating and deriving pleasure from the very nuances and fissures the film exposes, wresting the love-story away from the heterosexual teleology demanded by the *film noir*. Insofar as the film cannot be read separately from the transaction taking place as it unrolls before an audience, *Black Widow* becomes an event of cultural production, a moment in which "lesbian" subjectivities themselves are constructed. If "lesbian" viewers enter the cinema with their identities "intact," the boundaries of those identities are refigured by means of the interaction with "lesbian" desire they both witness and engage in. By (im)posing the (im)possibilities of "lesbian" desire, the film literally *invites* "lesbians" in both senses of the word: it allures/attracts them, and offers an opening in which to become the image the film represents. As such, the film enacts its own dominant metaphor: a "black widow," it both seduces and seeks to suppress the desire it solicits.

The status of *Black Widow* as a "lesbian" cult film, however, suggests that its attempt to imprison "lesbian" subjectivity fails. But perhaps imprisonment was not really its goal. For, despite the logic of punishment entailed by Reni's crimes and the *film noir* formula, the primary mode of discipline enacted by *Black Widow* is *correction:* the film succeeds remarkably well in interpellating the "lesbian" subject according to its binary schema of identification and desire. The dominant logic of "the gaze" would suggest that, insofar as Reni and Alex are constructed, respectively, as object and subject of the gaze, the audience should identify with Alex and, through her, desire Reni. And yet, the majority of "lesbians" I know who saw the film defied spectator conventions, constructing Alex as an erotic object to suit *their* desires.[30] At the same time, their construction enacts precisely the conflation of gender and eroticism endorsed by the film and by which the dominant ideology homogenizes "lesbian" desire as "narcissistic": identification *with* Alex leads to desire *for* Alex.

To particularize the set of identities that comprise the "lesbian" at

this historical juncture: "Lesbian" viewers encountered *Black Widow* at a time when "lesbian chic" was in ascendence; no longer an object of suspicion, the "Vogue dyke" became a viable object of desire.[31] Indeed, I would argue that *Black Widow* appealed to "lesbian" viewing communities in part because of its mainstream, cross-over status. Alex, coded as "deviant" in gender role, provides a point of entry—of identification—into the film, and from there, desires for more mainstream pleasures (i.e., the conventionally beautiful woman whom Alex becomes) take over. For an audience hungry for more complex cultural representations of their lives than stereotypes of unattractive "manhaters" afford, *Black Widow* proves an enticing mixture.

And yet, the diverse subject positions of those who call themselves (or are called by others) "lesbian" obviate the possibility of assigning *one* position to the "lesbian" spectator. Differences in class and race fracture the illusory unity of the "lesbian subject," as the filmic object of the gaze is rendered inaccessible (for economic reasons) or undesirable (for cultural or political reasons). Insofar as *Black Widow*'s portrayal of Hawaii is structured from the perspective of Western tourism, its eroticism functions on the basis of the elision of race and class differences. Indeed, as "Hawaii" in *Black Widow* equals four-star hotels, scuba diving, and stunning volcanic eruptions, the film's attitude toward its subject is summed up by Paul: with no irony, he explains to Reni that because he loves the volcano so much, he intends to build a hotel there.

Race and class stratification within the "lesbian" spectator are further complicated by differences in gender identification and erotic practice. The "lesbian" who identifies as "butch" may respond differently to Alex or Reni than would a "femme" or "rough–fluff," and not all "butches," "rough-fluffs," or "femmes" would respond alike.[32] The bisexual who has chosen a monogamous gay relationship may respond to other erotic cues than would the woman who has multiple partners. The feminist who has adopted a "lesbian" identity as a political necessity may feel differently about her desires than would the woman who feels she has been "gay" from birth. Needless to say, those involved in S/M have different erotic tastes from those preferring what has come to be called (reductively, I think) "vanilla" sex. And finally, it must be said that, dominant ideology to the contrary, "les-

bian" desire is extant within many putative heterosexuals. Indeed, despite the linguistic imperative underlying the division between "homo" and "hetero," "lesbian" desire is not oppositional to female heterosexual desire—though what its relation might be (contiguous, tangential, interstitial, disterminate) is yet to be theorized beyond the psychoanalytic narrative that poses "lesbian" desire as that which must be repressed.

The range and diversity of identifications and practices of "lesbians" raise again the question with which I began my analysis of *Black Widow:* What *is* a "lesbian"? What *is* "lesbian" desire? I hope to have shown that such questions can only be answered meaningfully in historically contingent terms. I want to suggest too that, in its singularity and self-identity, "lesbian" is a politically necessary but conceptually inadequate demarcation: to my mind, less a person than an activity, less an activity than a modality of pleasure, a position taken in relation to desire. Its problematic ontological status suggests that it is better used as an adjective (e.g., "lesbian" desire) than a noun signifying a discrete order of being. Neither inhering essentially within subjects nor forceably imposed upon them, "lesbian" is a point of reference around which erotic "difference" can and must rally politically, but upon which it should never stand for long. Rather than affirm "lesbian" desire definitionally (e.g., Alex "is" a "lesbian"), I propose instead the more laborious process of exploring the contradictions inherent in the "lesbian's" construction; for it is the convergences, intensifications, slippages, and displacements between gender and eroticism that make possible a vision of a non-binary mode of erotic pleasure—for *all* erotic subjects.

A final moment of excess: just as Alex leaves the courthouse, two women, one in red, one in blue, walk across the screen. Outside of Hollywood's codes of stardom, these women signify the ordinary, the everyday, as they go about their business. To any "lesbian" viewer, at this historical moment, their stride, affect, dress, and hairstyle suggest "dyke." Why does *Black Widow* end with an image so seemingly superfluous to its diegesis? But *are* they superfluous? As Alex/Jessie walks off into her unknown destiny, as Reni/Catharine/Marielle/Margaret languishes behind bars, these women—an alternative image of

Ambiguities of "Lesbian" Viewing Pleasure

Alex and Reni together—signal visually what the film has suppressed narratively: "lesbian" desire is available, reproducible, and, despite efforts to deny it, everywhere.[33]

Notes

1. Jeffrey Weeks, *Sexuality and its Discontents* (London: Routledge and Kegan Paul, 1985) and Michel Foucault, *The History of Sexuality*, Vol. 1 (New York: Random House, 1976).

2. Sigmund Freud, "Femininity," *New Introductory Lectures on Psychoanalysis*, trans. and ed. James Strachey (New York: W. W. Norton, 1965): 116.

3. Julia Kristeva, "About Chinese Women," *The Kristeva Reader*, ed. Toril Moi (New York: Columbia University Press, 1986), 149.

4. Laura Mulvey, "Afterthoughts on 'Visual Pleasure and Narrative Cinema' inspired by *Duel in the Sun*," *Feminism and Film Theory*, ed. Constance Penley (London: Routledge, Chapman and Hall, 1988): 71.

5. David Halperin, "One Hundred Years of Homosexuality," *Diacritics* 16:2 (Summer 1986): 40.

6. Despite his attempt to separate sexual aim (passive/active) and object (hetero/homo), Freud consistently conflated gender and eroticism through his concept of bisexuality. At times referring to the integration of "masculine" and "feminine" attributes (i.e., activity, passivity), at times referring to the nascent capacity for both hetero- and homoerotic object choice, at times referring to both, "bisexuality" in Freudian usage allows gender and eroticism not only to nudge against, but slip into one another.

7. See Valerie Traub, "Desire and the Differences it Makes," *The Matter of Difference: Materialist Feminist Criticism of Shakespeare*, ed. Valerie Wayne (London: Harvester, 1991). Other feminist theorists are calling for a specification of and differentiation between gender and eroticism, the most sophisticated being Eve Sedgwick, "Across Gender, Across Sexuality: Willa Cather and Others," *The South Atlantic Quarterly* 88:1 (Winter 1989), 53–72; "Epistemology of the Closet (I)," *Raritan* 7:4 (Spring 1988), 39–69; and "Epistemology of the Closet (II)," *Raritan* 8:1 (Summer 1988), 102–130; and Teresa de Lauretis, "Sexual Indifference and Lesbian Representation," *Theatre Journal* 40:2 (May 1988), 155–177. In the final stages of writing this article, I came across an excellent essay by Jackie Stacey, "Desperately Seeking Difference," *The Female Gaze: Women as Viewers of Popular Culture*, ed. Lorraine Gramman and Margaret Marshmont (London: the Women's Press, 1988), 112–129. Stacey analyzes desire or, as she terms it, "fascination" between women in *All About Eve* and *Desperately Seeking Susan* in terms surprisingly close to mine. In fact, she anticipates my critique of psychoanalytic binarism, having isolated the same passage of Kristeva to make her point: "This insistence upon a gendered dualism of sexual desire maps homosexuality on to an assumed antithesis of masculinity and femininity. . . . In arguing for a more complex model of cinematic spectatorship, I am suggesting that we need to separate gender identification from sexuality, too often conflated in the name of sexual difference," p. 121. She even footnotes *Black Widow* as a film in which homoerotic connotations are more explicit than in the films she analyzes.

8. Directed by Bob Rafelson, Screenplay by Ronald Bass, Released by Twentieth-Century Fox. Within the context of this film, I use "lesbian" to describe a desire for other women, whether or not it is ever acted upon. In this, I differ from the dominant trend of using "gay," not only because it generally refers to men, but because its usefulness is increasingly limited to the description of an identity evolving out of a self-conscious minority community. My concept of "lesbian" is also distinguished from the feminist concept of the "woman-identified-woman," which fails to include eroticism as a necessary component. For the most articulate spokesperson for the woman-identified-woman definition, see Adrienne Rich, "Compulsory Heterosexuality and Lesbian Existence," *Signs* 5:4 (1980), 631–60. Like Catharine Stimpson, I see the "lesbian" as a matter of the body, but unlike her, I insist on the importance of fantasy as much as action in the modality of desire; see "Zero-Degree Deviancy: the Lesbian Novel in English," *Critical Inquiry* 8:2 (Winter 1981), 363–79. There exists a long history of debate over definitions of "lesbian," much of it unproblematically asserting the existence of a type of *being* based on certain *credentials* (love for women, political alliance, genital sexual activity). To my mind, what is more crucial than the proving or maintaining of "lesbian" credentials is consistent public affirmation of the rights of "lesbians," a practice with which all persons, regardless of erotic practice, can be involved.

9. See Foucault for an explanation of this phrase.

10. See Janet Bergstrom and Mary Ann Doane, "The Female Spectator: Contexts and Directions," *Camera Obscura* 20/21 (May/Sept. 1989): 5–27. Elizabeth Ellsworth's analysis of "lesbian" reviewers of *Personal Best* has been extremely helpful to my formulation of "lesbian" interventions in dominant media. See "Illicit Pleasures: Feminist Spectators and *Personal Best," Becoming Feminine: The Politics of Popular Culture,* ed. Leslie Roman, Linda Christian Smith, with Elizabeth Ellsworth (London: Falmer Press, 1988): 102–119.

11. E. Ann Kaplan, Response, *Camera Obscura* 20/21 (May/Sept. 1989): 197.

12. Linda Williams, "When the Woman Looks," *Re-Vision: Essays in Feminist Film Criticism,* ed. Mary Ann Doane, Patricia Mellencamp and Linda Williams (Los Angeles: The American Film Institute, 1984): 83–99.

13. Mulvey, "Afterthoughts": 78–9.

14. Luce Irigaray, *This Sex Which Is Not One,* trans. Catharine Porter (Ithaca: Cornell University Press, 1985) and *Speculum of the Other Woman,* trans. Gillian Gill (Ithaca: Cornell University Press, 1985); Laura Mulvey, "Visual Pleasure and Narrative Cinema," *Feminism and Film Theory,* 57–68; and E. Ann Kaplan, "*Woman and Film: Both Sides of the Camera* (Methuen: London, 1983).

15. Carol Clover, "Her Body, Himself: Gender in the Slasher Film," *Representations* 20 (Fall 1987): 212, 213; Mary Ann Doane, "The Woman's Film: Possession and Address," *Re-Vision,* 67–82; *The Desire to Desire: The Woman's Film of the 1940s* (Bloomington: Indiana University Press, 1987); and "Film and the Masquerade: Theorizing the Female Spectator," *Screen* 23:3/4 (Sept./Oct. 1982): 74–88. See also Tania Modleski, *The Women Who Knew Too Much: Hitchcock and Feminist Theory* (New York: Methuen, 1988).

16. Elizabeth Cowie, for instance, encourages us to view film as fantasy, "a *mise en scène* of desire which can be seen to have multiple places for the subject of the fantasy, and for the viewing subject who, through identification, may similarly take up these multiple positions"; Janet Bergstrom speaks of a "textual address which is bisexual (in Freud's sense) and in which identifications are neither stable nor predictable"; and D. N.

Ambiguities of "Lesbian" Viewing Pleasure

Rodowick expresses the relation between "masculine" and "feminine" identifications as "transactional" in *Camera Obscura* 20/21 (May/Sept. 1989): 97, 129, 272. Teresa de Lauretis argues that the female gaze consists of a "double identification" in *Alice Doesn't: Feminism, Semiotics, Cinema* (Bloomington: Indiana University Press, 1984): 144, and *Technologies of Gender: Essays on Theory, Film, and Fiction* (Bloomington: Indiana University Press, 1987).

17. de Lauretis, "Sexual Indifference." Analyses of representations of "lesbians" in film by Mandy Merck, " 'Lianna' and the Lesbians of Art Cinema" and Linda Williams, " 'Personal Best': Women in Love," in *Films for Women*, ed. Charlotte Brundson (London: British Film Institute, 1986): 166–178, 146–154 and B. Ruby Rich, "From Repressive Tolerance to Erotic Liberation: *Maedchen in Uniform," Re-Vision:* 100–130, while interesting descriptions of these films, are not much concerned with the dynamics of the gaze. Of interest in regard to representations of "lesbians" in theater are essays by Jill Dolan, "The Dynamics of Desire: Sexuality and Gender in Pornography and Performance," *Theatre Journal* 39:2 (May 1987), 156–174 and Sue-Ellen Case, "Toward a Butch-Femme Aesthetic," *Making A Spectacle: Feminist Essays on Contemporary Women's Theatre*, ed. Lynda Hart (Ann Arbor: U of Michigan, 1989): 282–299.

18. Marina Heung (*Film Quarterly*), Richard Combs (*Sight and Sound*), and Mike McGrady (*Newsday*) called Alex "frumpy"; Heung added "clumsy and untidy." Charles Sawyer (*Film in Review*) termed her "bookish and sloppy," while for David Denby (*New York*) she was "drab," and for Louise Sweet (*Monthly Film Bulletin*) "dowdily work-obsessed."

19. de Lauretis, *Alice Doesn't:* 82.

20. *Black Widow* is not a feminist film. It makes no attempt to denaturalize the eroticization of the female body, instead visually offering it up for display. In keeping with the *film noir* paradigm, it also thematically destroys the woman who would destroy men. As Belinda Bulge says in "Joan Collins and the Wilder Side of Women": "The *femme fatale* of *film noir* ultimately loses control of the action, as both narrative and camera exert mastery over her. At the end of the film she is symbolically imprisoned by the visual composition of her image, just as, in many of the narratives, she is imprisoned, or killed, for her crime. The destruction of the *film noir* 'spider woman' constitutes a moral lesson: the power of the independent woman is an evil that will destroy her," *The Female Gaze:* 109.

21. The phrase is Mulvey's, "Visual Pleasure": 62.

22. David Edelstein wrote in *The Village Voice* (2/17/87: 70): "Frey sits on the screen like a blob of snail butter. Whenever he's around, the movie can't seem to focus. His Hawaiian Tropics tan is like a cloaking device (it washes him out), and he sounds as if he learned his lines phonetically." In *Vanity Fair*, Arthur Lubow reports that Winger ate a pizza with garlic before their (discarded) love scene; she unconsciously sabotaged it, the writer implies, because she knew the film should be Alex and Catharine, not Alex and her frog prince. "What I can't figure out is why she didn't have paella the next day and clams oreganata the next. She should have stopped taking showers."

23. Such was the view of Magill's *Cinema Annual*, Marina Heung (*Film Quarterly*), David Denby (*New York*), Mike McGrady (*Newsday*), Richard Combs (*Sight & Sound*), David Edelstein (*Village Voice*), and David Lida (*Women's Wear Daily*).

24. Heung, p. 56.

25. Winger's persona transcends film boundaries; in part, her popularity rests on the fact that, irrespective of her particular dramatic role, her voice, features, bodily physique and stance configure her as a powerful woman.

26. Despite his psychoanalytic normalizations, I have found Robert Stoller's work helpful in this regard. See *Observing the Erotic Imagination* (New Haven: Yale University Press, 1985): 53.

27. Judith Roof, "The Match in the Crocus: Representations of Lesbian Sexuality," *Discontented Discourses: Feminism/Textual Intervention/Psychoanalysis,* ed. Marleen S. Barr and Richard Feldstein (Urbana: University of Illinois Press, 1989): 110–116.

28. According to the recent film, *Pretty Woman,* for prostitutes, kissing is *verboten* precisely because it imports emotion into a commercial transaction. According to Cindy Patton, kissing is rarely depicted in pornography because "it brings emotion into the pornography, potentially disrupting the thrill of untrammelled sex" and because "kisses are non-gendered, reciprocal, and non-role defined," "Hegemony and Orgasm—Or the Instability of Heterosexual Pornography," *Screen* 30:1&2 (Winter/Spring 1989): 100, 112. And yet, even "kissing" must be internally differentiated, as the dexterity and autonomy of the female tongue in oral "tonguing" turns the "kiss" into a surrogate for, and deferred promise of, fellatio.

29. Those six were Heung, Sawyer, Denby, Edelstein, and Roger Egbert (*New York Post*). Denby says "the scenes between the two women don't go far enough" and Egbert writes (quite provocatively), "From the moment Winger and Russell meet, there's a strong undercurrent of eroticism between the two women. We feel it, they feel it, and the movie allows it one brief expression—when Russell roughly reaches out and kisses Winger. But Ron Bass, who wrote the screenplay, and Bob Rafelson, who directed, don't follow that magnetism. They create the unconvincing love affair between Winger and the tycoon to set up a happy ending that left me feeling cheated. What would have been more intriguing? Why not follow a more cynical, truly diabolical course—something inspired by the soul of *film noir*? Why not have Winger fall completely under the spell of the black widow, and stand by while the tycoon is murdered so the two women can live happily ever after? And then end on an eerie note as Winger begins to wonder if Russell can trust her with the secret?"

30. For other instances of "lesbian" intervention in visual codes, see Danae Clark, "Commodity Lesbianism in Advertising and Commercial Television," presented at the Society for Cinema Studies Conference, Washington, D.C., May, 1990. See too Jonathan Dollimore's identification of radical strategies of cultural negotiation, "the transformation of dominant ideologies through (mis)appropriation and their subversion through inversion," in "The Dominant and the Deviant: a Violent Dialectic," *Critical Quarterly* 28:1/2 (1987): 179–92.

31. See, for instance, Arlene Stein, "All Dressed Up, But No Place to Go? Style Wars and the New Lesbianism," *Outlook: National Lesbian and Gay Quarterly* 1:4 (1989).

32. "Butch," like "femme," is a historically constructed erotic *style*. Neither isomorphic with maleness nor masculinity, it is not an imitation of men, but a subversion through inversion of dominant masculinist codes. "Butch" implies a critique of the authenticity of masculinity, signifying that maleness and masculinity are also historically constructed categories.

33. I would especially like to thank Brenda Marshall, Darlene Dralus, and the students involved in my course "Representations of Women's Identity" for sharing their responses to this film. Thanks also to Kris Straub, Julia Epstein, Jay Clayton, Ellen Garvey, Susan Zimmerman, Serena Anderlini, and Michael Kreyling for their responses to an early draft. Finally, the Vanderbilt University Research Council graciously extended funds to sustain me during the writing of this essay.

13

"Lessons" from "Nature": Gender Ideology and Sexual Ambiguity in Biology

Bonnie B. Spanier

Just as " 'Nature' played a pivotal role in the rise of political thought . . .",[1] appeals to what is biologically natural are deeply embedded in our cultural beliefs about the meaning of gender and its partner, sexuality.[2] Masculinist beliefs in inherent, biologically-determined differences between two opposing but complementary sexes[3] are found perfused throughout white Western institutions of society, including systems of knowledge. Western culture's dominant knowledge systems (such as the disciplines and the structure and content of education) reflect those beliefs, as feminist critics of the sociology of knowledge continue to demonstrate amply.[4]

A formalized knowledge system functions as an institution—like the law, the family, capitalism, motherhood, etc.—that plays a particular role in sustaining and reproducing dominant beliefs about gender and sexuality, justifying them with the power of the objective and rational Academy. Because the natural sciences have a privileged place at the top of the hierarchy of formal knowledge, critiques of scientific knowledge and education can contribute in fundamental ways to the elimination of sexism, heterosexism, racism, classism, and other forms of oppression. In this essay, therefore, I will investigate the discipline of biology at the cell and molecular levels of organization with regard to its sociopolitical role in the maintenance of constraining beliefs about gender and sexuality. I demonstrate that "natural" models exist which support a notion of gender ambiguity that challenges conven-

tional meanings of male and female. However, I show that the paradigm of heterosexism—superimposing male and female based on a biological determinist ideology of fundamental difference—prevails, not surprisingly, and selectively overrides the use of nature as a model of alternative gender and sexual relationships.

Scientists Impose Dualistic Gender and Male Superiority onto Animals

When scientists look to nature, they usually bring with them their sociopolitical beliefs about what is natural.[5] This self-reinforcing, internally consistent process, then, creates, reflects, and reinscribes often unquestioned assumptions about our world. Within the ubiquitous paradigm of binary gender and male superiority, scientists have, for example, used the male designation to name any species, misidentified the largest bee in the hive as the King Bee, and undervalued female lions as hunters. Thus, in what is considered scientifically objective biology, the male is clearly held up as the normative sex, with the female as a deviation from the norm.[6]

Stereotypic attributes and behaviors (such as aggressive hunting and fighting versus coyness and passivity) are superimposed onto animals[7] often through culturally distorted language (several females with a single male may be called a harem, quite a different connotation from, for example, what is now called the matriarchal organization of elephants). Ruth Hubbard illustrates the illogical and confusing consequences of this form of scientific sexism when she cites a passage on sexual behavior patterns from Wolfgang Wickler's book on ethology. Wickler noted the "curious" fact that:

> between the extremes of rams over eight years old and lambs less than a year old one finds every possible transition in age, but no other differences whatever; the bodily form, the structure of the horns, and the color of the coat are the same for both sexes.[8]

As he also observed, "the typical female behavior is absent from this pattern" and "even the males often cannot recognize a female." Furthermore, "... *both* sexes play two roles, either that of the male or

that of the young male. Outside the rutting season the females behave like young males, during the rutting season like aggressive older males" (Wickler's italics).[9]

Instead of seeing the similarities of male and female Bighorn sheep as an important lesson in the presence of species that exhibit minimal sexual dimorphism (such as humans),[10] Wickler's language reinforces androcentrism and does so in a way that, unless a strong feminist consciousness has intervened, is nearly invisible to most readers. Another researcher's observations about the same sheep also use male-female stereotypes to distinguish among the rams:

> Matched rams, usually strangers, begin to treat each other like females and clash until one acts like a female. This is the loser in the fight. The rams confront each other with displays, kick each other, threat jump, and clash until one turns and accepts the kicks, displays, and occasional mounts of the larger without aggressive displays. The loser is not chased away. The point of the fight is not to kill, maim, or even drive the rival off, but to treat him like a female.[11]

Hubbard's feminist awareness of gender ideology addresses heterosexism as well. She points out that, without the masculinist paradigm of heterosexuality and aggression, the description above could be interpreted very differently: "say as a homosexual encounter, a game, or a ritual dance."

And there are many examples of gender ambiguity in nature, including hermaphroditic animals and plants (many higher plants are "hermaphroditic," having both the male and female organs for producing sex cells), parthenogenic (absence of male) reproduction, and organisms that change from being "female" (egg-producing) to "male" (sperm-producing) in their life cycle. It is noteworthy that a fish that shifts from egg to sperm production was described by a (male) researcher as having as its biological goals becoming male, again setting maleness as a superior achievement.[12]

The example of masculinist bias in animal behavior studies illustrates that the very concept of gender ambiguity is created by our either/or cultural construction of either male or female, homosexual or heterosexual. Perhaps looking at the misrepresentation in a study of another species with minimal sexual dimorphism like humans, we

can see more clearly how the concept of gender ambiguity depends on a prior dualistic system of oppositional genders. If some other system of gender (such as a spectrum of genders) were the standard, our kind of gender ambiguity would not exist. Thus, just as the concept of gender ambiguity threatens the notion of fixed and oppositional categories of male and female, heterosexual and homosexual, the ambiguity is derived from characteristics and behaviors not clearly one or the other; so the current definition of ambiguity depends on the conceptual framework of one-or-the-other and the meanings ascribed to each of the two categories.

From Animals to Man: Sociobiology

Nowhere is the sociopolitical relationship of nature, science, and societal ideologies more apparent now than in the field of sociobiology, the study of the biological bases of social behavior. Published in 1975, E. O. Wilson's *Sociobiology: The New Synthesis* used studies of the social organization of ants and bees as models for understanding the genetic and evolutionary determination of individual and group behavior.[13] The result of this "lesson" from "nature" is a biological determinist (also termed essentialist or biologistic) view of group and individual behavior. For example, Wilson has claimed that natural sex differences in aggression account for the disproportionate presence of men in three arenas: politics, business, and science, and that such fixed differences will not change with equal access to education and careers.[14] Although Sociobiology (the capital S designates Wilson's type of sociobiology as it is applied to humans) has been roundly criticized and critiqued on many grounds (such as invalid or highly questionable assumptions and internally consistent but flawed evidence based on the same masculinist assumptions and distortions in observation),[15] it remains a legitimated field in biology, sanctioned by Wilson's endowed full professorship in Harvard's Biology Department. The influence of Sociobiology is powerfully felt in the social sciences, especially anthropology, just as it is in the broader culture.

A close reading of Wilson's account of homosexuality as a natural adaptation in evolution is instructive as an example of lurking essentialism in the guise of science. In the final chapter of *Sociobiology*,

"Man: From Sociobiology to Sociology," Wilson explores a range of human behaviors and endeavors from the perspective of sociobiological theory. He asks whether there are "genetic predispositions" toward playing certain roles in society or "enter[ing]" certain classes.[16] After stating that "there is little evidence of any hereditary solidification of status," he then states, "Even so, the influence of genetic factors toward the assumption of certain *broad* roles cannot be discounted. Consider male homosexuality" [original emphasis]. Note the leap to social speculation in the guise of the science of genetics and evolution—even in the absence of supporting evidence. He then implies that, since studies show a fixed (ten) per cent of males are mainly homosexual "in many if not most other cultures," this "broad role" may be genetically determined. That assertion is not supported by data other than Kinsey on the U.S.; note the strong universalizing effect of that easy generalization.

Wilson further advances his claims about the biological bases of homosexuality by citing two questionable assertions, yet couching them in misleading scientific normalcy ("now standard"):

> Lallman's twin data indicate the probable existence of genetic predisposition toward the condition. Accordingly, Hutchinson (1959) suggested that **the homosexual genes** may possess superior fitness in heterozygous conditions. His reasoning followed lines now standard in the thinking of population genetics.[17] [emphasis added]

Here we see Wilson's sleight-of-hand: he has transformed a behavior first to a role which is influenced by a genetic predisposition and then to a fixed state determined by "homosexual genes" which are subtly given the status of Mendelian recessive genes in the reference to "heterozygous conditions"—none of which has supporting evidence. Thus, based on accepted concepts in genetics and evolutionary biology, Wilson has created (fictitious) physical entities ("homosexual genes") which "cause" homosexual behavior.[18] It is important to add here that twin studies such as those cited by Wilson are fraught with inaccurate assumptions, methodologies, and conclusions as well as overtly racist and classist agendas; such studies are notoriously undependable as in the now-famous case of Cyril Burt.[19] In spite of the serious questions raised about twin studies, they remain the major evidence put forth in

claims about human genetics influencing behavior, personality, intelligence, mental health, etc.

The broad appeal of Sociobiology to scientists and the public motivated socially-conscious scientists to step over the guarded boundary between science and the rest of society to engage in serious reflection on biases, values, and objectivity in their fields of science. Biologist Ruth Doell and philosopher Helen Longino present a lucid analysis of biases in evolutionary theory and neuroendocrinology, pointing to, among other things, the distance between observation and interpretation or conclusion.[20] Along with simply incorrect generalizations about living beings, it is the lack of questioning about the manipulation of that critical distance (for example, the distance between an observation about rat behaviors in the laboratory and conclusions explaining human behaviors) which distorts much of our current understanding about the nature of gender and sexuality in our efforts to find answers about ourselves from the array of "other" species.

Thus, in spite of the recent scholarship in feminism and in social studies of science,[21] questionable assumptions about the nature of gender and sexuality pervade the field of biology. The biological determinist perspective so well advanced by Sociobiology also pervades biological thinking at the cell and molecular levels of organization. It is in this supposedly gender-free arena of cell and molecular biology that I analyze the impact of sociopolitical beliefs about gender and sexuality. My studies focus on microscopic life: single-celled bacteria, protozoans, and the cells of larger organisms[22]—and the sub-microscopic life within cells: the activity of macromolecules. A feminist analysis of the formal scientific discourse of the field of molecular biology uncovers inaccurate and masculinist superimpositions of Western sex/gender systems onto organisms at the cellular and molecular levels, and explores the mutually reinforcing use of "sex" as scientists move it back and forth between the molecular level of organization and the macro level of animal and, particularly, human behavior.

My analysis below reveals how a masculinist ideology of a dualistic and asymmetric sex/gender system is inappropriately imprinted onto the microscopic levels of life and is then utilized to reinforce notions of natural gender dichotomy and its corollary heterosexism. In the process, I find a studied avoidance or outright denial of homosexuality and sexual ambiguity, even though the construction of gender in one

important case (bacteria) would lead logically to that end—within the standard paradigm.[23]

In addition to demonstrating the distorted cultural/political beliefs about gender and sexuality in certain cases of contemporary biology, I contend that nature can show us nearly everything we wish to see (in part because, it seems, nature is at least as diverse as our human imagination for conceptualizing, and in part because our investigations are dependent on the context of society and thus result, in the best instance, in only partial and, in the worst, grossly distorted information). Hence, the sociopolitical construction of science and our scientific understanding of our world and ourselves goes hand in hand with the sociopolitical construction of gender and sexuality—and requires the same kind of challenging and creative scrutiny.

Bacteria Have Sex

As one of the best textbooks in molecular biology tells us in a major subheading: "Two Distinct Sexes Are Found in *E. coli.*"[24] In the ensuing explication of sexuality in this bacterium, we are informed:

> As in higher organisms, there exist male and female cells, but these do not fuse completely, allowing their two sets of chromosomes to intermix and form two complete diploid genomes. Instead, the transfer is always unidirectional, with male chromosomal material moving into female cells; the converse movement of female genes into male cells never occurs.
> . . .
> Male and female *E. coli* cells are distinguished by the presence of a distinct supernumerary sex chromosome called the F (fertility) factor. When it is present as a discrete body, the cells are male (F+) and capable of transferring genes into female cells. In its absence, *E. coli* cells are female (F−) and act as recipients for gene transfer from male cells.
> . . . all the cells in mixed cultures rapidly become male (F+) donor cells.[25]

Thus, scientists labeled donor and recipient cells male and female respectively, designating them as different strains of *E. coli,* even though they differ only in the presence or absence of the F plasmid. The language used in the textbook, not at all uncommon, leaves no

doubt about the relationship, referring to the "conjugal unions between male and female cells . . ."[26] It is striking that no comment is made about the transsexual change that occurs (within this heterosexist paradigm) with the female changing permanently to a male when the newly copied F plasmid enters the recipient cell.

But what is "male" and "female" about these bacteria? Female is once again (from Aristotle on) defined by absence and passivity, male by the presence of the male signifier (the F plasmid) and activity. This male-female designation is customary in biology textbooks, even though it is based on the inaccurate conflation of two different meanings of sex. The scientific definition of sex—the exchange of genetic material between organisms—is confused with the cultural sense of sex—a sexual act between a male and a female in which the male is the initiator who makes the sex act happen and who donates genetic material while the female is the passive recipient.[27] And, "having sex" carries with it the heterosexist assumption of having two "sexes."

In fact, this conflation of "erotic practices, gender identities, biological sex, sexual object choice . . ." (precisely what the editors of this book cautioned against in the Introduction) does not coincide with the scientific definition of male and female which depends on organisms forming either eggs or sperm or equivalent sex cells (which bacteria do not do, as the textbook explains). Thus, the designation of male and female strains of E. coli is, by scientific definition, incorrect. Moreover, the gendered language is sexist in its use of the stereotypical male as active and female as passive—and heterosexist in its assumption that sexual activity occurs only between a male and a female.

Biologist and historian Scott Gilbert has identified an example of the successful elimination of an incorrect and hetero/sexist designation of male and female—in the study of protozoans. In the 1940s, Tracy Sonneborn convinced his colleagues that replacing the inappropriate terms male and female with nongendered terminology (plus and minus or a and alpha) would generate more accurate and productive research.[28] Obviously, that view did not carry over to the molecular biologists and geneticists of the 1950s.

The propensity for and tenacity of genderizing nongendered beings, reflected here in the natural sciences, suggests both the power and the function of gender ideology in our culture. Thus, it is no accident that a gender ideology of essential male and female difference (even

designated as different *strains*), with the male as the natural controller of action, gets embedded in the study of bacteria. That is, genderized attributions even where totally inappropriate are consistent with the world views of those who have the power to name and to create knowledge, in this case, scientific knowledge. As such, it is easy to understand why such gender attributions might be considered harmless, cute, and even useful for stirring interest in an otherwise dry subject—and why they are difficult to eliminate. Conscious or not, such tacit assumptions support essentialist arguments for sexism, heterosexism, racism, and classism.[29]

Contradictions to the hetero/sexist paradigm are not examined by the scientists, and I suggest that this is a clear avoidance of grappling with the created sexual ambiguity. The instability of such constructed bipolar sex is not examined, for doing so might encourage an investigation into the underlying paradigm and its assumptions. Watson's inclusion of the statement that "all cells will rapidly become male" suggests, in this culture, a misogynistic fantasy of eliminating women altogether. His comment also brings to mind the feminist charge that the masculinist model of heterosexuality is actually based on male homoeroticism.[30] In a different light, one can also imagine how this example from nature might be cited as a justification of "natural" male homosexuality, homosociality, or, more drastically, transsexualism (with females becoming males by gaining what has been absent).

Keeping in mind that the F plasmid is designated the male signifier in this heterosexist paradigm, I found in another textbook (the language of which does *not* play up the attention-getting sexiness of this topic) an error which is highly suggestive of the discourse of recombinant DNA technology.

> *E. coli* F (male) plasmid determines the difference between male and female strains, and encodes the proteins required for cell-to-cell contact during sexual mating. These plasmids are of great use to experimental molecular biologists—they are the essential tools of *recombinant DNA technology*[31] [original emphasis]

The statement implies that the F plasmid itself is at the core of recombinant DNA technology. The significance of this statement is found in the pronouncement by the same authors (leading figures in molecular

biology) of a "new biology," unified and reorganized by the techniques of recombinant DNA technology.[32] Thus, the plasmid/phallus is the powerful "essential tool" of the new biology. However, the designated male signifier, the F plasmid, is *not* one of the plasmids used in recombinant DNA technology. And the second edition of this very successful textbook eliminates that statement entirely. What I am suggesting is a subconscious slip based on an ideology that the male signifier is, indeed, the powerful creator, the ultimate father—in this case, of molecular genetics and its extension to all of biology as the way to view life.

The analogy between the plasmid-as-penis and the powerful pen-as-penis, explored by Sandra Gilbert and Susan Gubar in the first chapter of *The Madwoman in the Attic,* seems obvious. "Is the pen a metaphorical penis?" the authors asked, and found affirmative responses from among the great white male writers "from Aristotle to Hopkins."[33] They therefore concluded:

> Male sexuality, in other words, is not just analogically but actually the essence of literary power. The poet's pen is in some sense (even more than figuratively) a penis.[34]

Mastery, paternity, authority, "Penetrative Imagination," the flow of "scriptural sperm"—women can have none of these because of their inherent lack. The implications of a subconscious association of the bacterial plasmid with the male signifier are two-fold. First, that association suggests a powerful psychosexual factor influencing the high status and dominant role of recombinant DNA research (depending as it does on plasmids as essential tools) in today's science and society. Secondly, with the analogy of gendering the authority of the writer, the association contributes yet another ideological facet to the association of scientific achievement with masculinity.

In a world of very different values where gender did not mean either power differential or mutually exclusive and opposing yet complementary forces, sexuality could still be seen as a form of creativity in art, science, and other forms of expression, but it would not be gender-biased nor concerned with who controls the penis. It would neither set up a contest in which men use their penises in competition with other men (who can pee the farthest? who can keep it up the longest or raise it the greatest number of times?) nor drive men to "control" their

penises in order to keep them out of the hands of women who are seen as trying to castrate them or otherwise appropriate their power. Instead, everyone could be enjoying the pleasures of autoeroticism with the same sense of respect for self as for other selves; everyone could be enjoying the choice and pleasures of sexuality/sensuality free from coercion and domination and hetero/sexism.

The Paradigm for Scientific "Sex Determination" Is Bipolar, Biological Determinist, and Masculinist Once Again

Scientific (referring to the natural sciences) journals evince little, if any, acknowledgment of politics, values, or the social construction of knowledge. The assumptions underlying most scientific articles are that the data represent objective knowledge, limited only by the techniques and accuracy of measurement. Feminist and other radical critiques of science reveal the politics, values, and hidden assumptions that dwell in scientific literature. As such, science inscribes gender polarity more deeply in our society with the powerful claims of scientific objectivity.[35]

The opening statement of a recent *Science* article illustrates the current focus of sex determination studies, aimed at the level of genetics and molecular biology:

> The sex of a human or mouse embryo is normally determined by one or more genes on the Y chromosome.[36]

That statement also typifies the common practice of defining sex determination in terms of the male (chromosomally XY in mammals as compared to the female's XX). In addition to this major point that sex determination nearly always means how *male* sex is determined, further analysis of articles on sex determination in recent years reveals the following distortions generally operating in that literature:[37]

1) The paradigm of sex/gender is that of a dualistic male/female development into male and female beings, with recognition of physically intermediate beings as abnormal or ambiguous. (Thus, ambiguity is contained in the physical overlap of two nonetheless bipolar categories.) An issue of *Science* was devoted to sexual dimorphism in mammals, leaving little room for ambiguity, though it may exist nonetheless.

2) Sex determination (male) focuses on which genes on the Y chromosome control the production of the testes. Thus, "sex" means physical primary and secondary sexual characteristics, mainly the ability to produce sperm, and "determination" refers only to genetics in the narrow sense of the term (the sense which de-emphasizes dynamic interaction at the molecular level).

3) Leaps between animal research such as that of lordosis (mounting) of rats and implications for humans are made frequently, to the advantage of the theories referred to in number 4 below. (Or, with more subtlety, studies of rats, primates, and humans are cited *without* qualifying statements about the lack of parity among them with regard to interpretation.)

4) The dominant theory guiding the relationship of sex dimorphism at the genetic and molecular level to human behavior is that prenatal male sex hormones affect brain development and produce "sex-dimorphic" behaviors such as "energy expenditure," "social aggression," "parenting rehearsal," "peer contact," "gender role labeling," and "grooming behavior."[38] This is done with no reference to the historical and cultural construction of bipolar sex hormones (see below) and minimal reference to the social construction of sex/gender.

5) When included, the issue of sexual orientation is often conflated with gender identity. The following illustrates the assumption that male hormones (androgens) produce a (normal male) sexual orientation to females:

> To test the validity of the prenatal hormone theory, we need to examine human subjects with endocrine disorders that involve prenatal sex-hormone abnormalities. The theory predicts that the effective **presence of androgens** in prenatal life **contributes to the development of a sexual orientation toward females,** and that a deficiency of prenatal androgens or tissue sensitivity to androgens leads to a sexual orientation toward males, **regardless of the genetic sex of the individual.**[39] (emphasis added)

The conflation, then, reflects and reinforces what is normal and what is abnormal in sexual relations. Obviously, in this framework, gay men are deficient in maleness and thus are more female than normal males; conversely, lesbians are male.

6) Little reference is made to the social construction of sex/gender

or the conflation of biological sex (see above) with gender or gender identity. No mention is made of compulsory heterosexuality or historically-specific social constraints against expressing or revealing homosexual interest or behavior or lifestyle. No mention is made of feminist and gay liberationist perspectives on the whole set of issues.[40]

While the language in the *Science* articles is carefully tempered in the tradition of scientific discourse, all the problems delineated by critics (such as inadequate controls, inadequate data collection, alternative explanations, and conflicting work on prenatal hormone exposure) are operant.[41] For example, the following summary statement implies that a hormonal role has been demonstrated but not conclusively, when it has not been demonstrated *at all:*

> A role of the prenatal endocrine milieu in the development of erotic partner preference, as in hetero-, homo-, or bisexual orientation, or of cognitive sex differences has not been **conclusively demonstrated.**[42] (emphasis added)

Such language obscures the conclusion one should come to from the evidence cited in the article: that there is no valid evidence to support a role of endocrine effects, prenatal or otherwise, in sexual orientation—or, for that matter, in sex-dimorphic behavior.

Thus, in the scientific literature, the politics of sexual ambiguity—really, the politics of sex/gender in society—is not represented *overtly* at all. Covertly, the ruling paradigm supports a conservative politics of sex/gender. The sociopolitical construction of gender is not an integral part of the paradigm, given the separation of science from social factors. Sometimes, but not often, societal influences are referred to as additional variables or factors to be considered (elsewhere), but the cultural meaning of gender is not seen as a critical determinant of the range of possibilities of behavior. This is analogous to the situation in sociology, where gender may now appear as a variable but is not incorporated into theories as a powerful category of organization in society.[43] Needless to say, as a consequence, scientific studies of sex differences and similarities are fraught with error and there is little opportunity to transform the scientific study of the meaning of sex, gender, and sexual ambiguity into something that would take into

account their social construction and the inseparable interweaving of biology and society.

In contrast, Diana Long Hall's historical study of endocrinology in the 1920s places the language and paradigm of bipolar sex hormones into a sociopolitical context.[44] The term "sex steroids" reflects and reproduces our dominant masculinist sex/gender system in spite of the knowledge that men and women all have both male (androgens) and female (estrogens) sex hormones, that these male and female hormones are interconverted in the body, that they affect many functions besides sex, that men and women have differing relative amounts of these hormones, and that those relative proportions change over the life cycle (so that women after menopause have lower levels of the major estrogen and progestin than do men of the same age).[45] Hall's study documents the inseparable nature of heterosexism with gender ideology when she cites one researcher's claim that men with higher levels of estrogen were "latent homosexuals."[46]

Sexualizing Macromolecules, Like Sexualizing Bones

Given the persistence of the paradigm of bipolar sex hormones in spite of the evidence to the contrary, it should not surprise us that a professor of obstetrics and gynecology at Yale's School of Medicine should write, in the introductory essay of the *Science* issue on sexual dimorphism:

> [The authors] stress the influence of sex steroids on constitutive proteins (enzymes) throughout the body, **further extending the domain of sex even into processes such as carbohydrate metabolism.**[47] (emphasis added)

This scientific statement, which applies an incorrect concept of "the domain of sex," seems clearly analogous to efforts, begun in Europe in the mid-eighteenth century, to search for (and, hence, create) sex differences based in biology and physiology. Londa Schiebinger has argued:

> It was in the eighteenth century that the doctrine of humors, which had long identified women as having a unique physical and moral character,

was overturned by modern medicine. Beginning in the 1750s, doctors in France and Germany called for a finer delineation of sex differences; discovering, describing, and defining sex differences in every bone, muscle, nerve, and vein of the human body became a research priority in anatomical science.[48]

In her historical study of human physiology and anatomy, Schiebinger shows that drawings of human skeletons that distinguished between a male skeleton and a female skeleton first appeared between 1730 and 1790, sexualizing the human skeleton. Prior to that, in the sixteenth and seventeenth centuries, little was said by leading figures in medicine about sex differences in the human body. Andreas Vesalius, founder of modern anatomy, drew one human skeleton for both male and female nudes; he neither sexualized the bones as happened later nor believed in sex differences in the humors as Aristotle and Galen had.[49]

Schiebinger offers her study of the first representations of the female skeleton as a case study for the grander problem explored by feminists:

> Why does the search for sex differences become a priority of scientific research at particular times, and what political consequences have been drawn from the fact of difference? As we will see, the fact of difference was used in the eighteenth century to prescribe very different roles for men and women in the social hierarchy.[50]

Thus, ambiguity with regard to sex is a direct threat to keeping women in their appropriate roles and lower status in society. Sandra Harding explicates the connection between societal interest in sex differences and the sociopolitical origins of the science of biology:

> Where women cannot seem to escape being perceived as feminine, men seem to fear that they will no longer be men unless they constantly prove their masculinity. Thus it is the masculinity-affirming division of labor by gender, the assignment of individual gender identities to human infants [and even to bacteria!], and the asymmetrical meanings of masculinity and femininity in gender-symbolizing—in gender totemism—that create the androcentric biases in biology.[51] (comment added).

In this framework, giving male and female genders to bacterial cells and to macromolecules serves as an important buttress to the heterosexist

343

system of two complementary genders. Ignoring the obvious implications about the natural creation of a homosexual, homosocial, or transsexual society (remember that, after sexual interaction, all the bacteria become male)—and ignoring the interface of science with society—is not unexpected in this heterosexist and homophobic society.[52]

In conclusion, analysis of discourse related to cellular and subcellular biology reveals reflections of societal biases about sexual ambiguity and provides further evidence for the pervasive effects of masculinist and heterosexist beliefs throughout Western society. To the unaware, such legitimation by a purportedly value-neutral, gender-free science reinforces a biological determinist notion of human sex and sexuality. Thus, the sociopolitical construction of science is inextricably intertwined with the sociopolitical construction of gender and sexual ambiguity. Just as each construction reinforces the other, both must be deconstructed in tandem.

We can look to biology for an appreciation of nature only if we use a meaning of objectivity that includes an awareness of what contributes to and distorts our knowledge. If we look to biology to use it in the same biological determinist manner (meaning fixed, unchanging, predetermined by genes or hormones or brain structure or whatever) utilized so successfully by sexist, racist, classist, and heterosexist projects, we are using the tools of the master to dismantle the master's house,[53] a short-term strategy with serious long-term consequences. That does not mean we can ignore biology—whether we mean our own or the representation of life that we learn as biology. Indeed, I want to encourage the examination, critique, and re-visioning of biology, but with a transformed concept of biology as the inextricable, cumulative, and non-additive experience of our beings within complex, temporally-specific environments.[54]

Notes

It is a great pleasure to acknowledge the support and assistance of the grants and some of the people who have made this work possible. I want to thank Joan Schulz for her ongoing support of my work and her incisive contributions to this essay in particular.

Sexual Ambiguity in Biology

The Feminist Theory Discussion Group of the SUNY Albany Women's Studies Department and my colleagues in the growing arena of feminism and science have made all the difference in the world to my thinking and writing. The Women's Studies Department is a model of feminist support and inspiration to me, as is the Dean of the College of Humanities and Fine Arts, Francine Frank. I want to express my great appreciation to the College, the University, and the SUNY system for the following grants which have allowed me to pursue this work on feminism and molecular biology: NYS United University Professors' Nuala Drescher Award, SUNYA Faculty Research Awards, NYS/UUP Experienced and New Faculty Research Awards. And my loving gratitude goes to Irving and Roselyn Solomon Spanier for their grants and constant support. The Bunting Institute of Radcliffe College, the Lilly Endowment's project on Women in American Society, 1978–80, the Feminist Theory Group at Wheaton College, and the Mellon Seminar on Science at the Wellesley College Center for Research on Women, 1984–85, all provided significant impetus to my work which I gratefully acknowledge.

1. Londa Schiebinger, "Skeletons in the Closet: The First Illustrations of the Female Skeleton in Eighteenth-Century Anatomy," *Representations* 14 (Spring 1986): 43.

2. A similar assertion can be made about the meaning of race and the related category, class. Thus, biological determinist arguments are among the many conditions and beliefs which have historically interstructured racism, classism, sexism, heterosexism, ethnocentrism, etc. See, for example, Stephen Jay Gould, *The Mismeasure of Man* (New York: W. W. Norton, 1981); R. C. Lewontin, Steven Rose, and Leon J. Kamin, *Not In Our Genes: Biology, Ideology, and Human Nature* (New York: Pantheon, 1984); Ruth Hubbard and Marian Lowe, *Genes and Gender II: Pitfalls in Research on Sex and Gender* (New York: Gordian Press, 1979).

3. "Masculine" is understood here in its historically and culturally specific meaning in the tradition that has dominated the "Western world." Thus, I mean that "masculinism" is white supremacist, Eurocentric, and heterosexist as well as male supremacist. Choosing "masculinist" here rather than "Eurocentric" foregrounds the sex/gender system, the focus of this essay and collection, within the grid of interconnecting oppressions based on race, class, gender, etc.

The claim of "natural" complementarity of male and female in personal, sexual, and ideological arenas renders the masculinist concept of "gender" *heterosexist* as well as sexist. The term "hetero/sexist" is a useful reminder of the inseparable (nonetheless often overlooked) relationship of sexism and heterosexism.

4. Just two examples: Ellen Carol DuBois *et al.*, *Feminist Scholarship: Kindling in the Groves of Academe* (Urbana and Chicago: University of Illinois Press, 1987); Christie Farnham, ed., *The Impact of Feminism in the Academy* (Bloomington: Indiana University Press, 1988).

5. For example, Ruth Hubbard, "Have Only Men Evolved?" in *Biological Woman: The Convenient Myth,* Ruth Hubbard *et al.,* eds. (Cambridge, MA: Schenkman Publishing Company, 1982), 17–46. (Also reprinted in S. Harding and M. Hintikka, eds., *Discovering Reality* (Dordrecht, Holland: D. Reidel, 1983), 45–70; and Ruth Hubbard, *The Politics of Women's Biology* [New Brunswick: Rutgers University Press, 1990].) This important analysis includes a look at Darwin's writings on evolution.

6. An example of the persistence of this bias is seen in the use of the male human form as the standard human body form in representations of the biology of humans in junior high school life science books. Sue Rosser and Ellen Potter, "Sexism in Science

Textbooks" in, *Female-Friendly Science,* Sue Rosser, ed. (New York: Pergamon, 1990), 73–91.

7. An example from an issue of *Science* on "Sexual Dimorphism" in mammals, critiqued later in this paper:

> To understand the specifics of male-female differences, let us consider the two sexes as accommodating each other for reproductive efficiency . . . Whereas the male's reproductive pattern could also be periodic, such a system would require that sperm shedding, copulatory behavior, and the **aggression necessary to fend off competitors** be keyed to the cycles of a **receptive female,** a coincidence that would be difficult to accomplish . . . While this system is wasteful of [male] gametes, the other aspects, such as **aggression, can be useful for other life chores.** (emphasis added)

Frederick Naftolin, "Understanding the Bases of Sex Differences," *Science* 211 (March 20, 1981): 1263.

8. Hubbard, "Have Only Men Evolved?": 31.

9. Ibid.: 32.

10. "Sexual dimorphism" is defined in the *Science* issue cited as "any differences in form regardless of whether it is manifest at the morphologic or molecular level" (*Science* 211 (March 20, 1981): 1285).

Humans exhibit relatively little sexual dimorphism, in spite of prevailing beliefs in important physical differences between the sexes. For example, most people believe that men are taller than women. While it is true that the average difference in height is 2–4 inches, the overlap between the two populations is great since the variation within each population (about 24 inches) is much greater than the average difference. Thus, many women are as tall as or taller than many men. However, our *mores* create heterosexual couples in which the male, no matter how tall or short, is nearly always paired with a shorter female.

11. Hubbard, "Have Only Men Evolved?": 32.

12. Interview with Trudy Villars, psychobiologist, July 1, 1987.

13. E. O. Wilson, *Sociobiology: The New Synthesis* (Cambridge, MA: Harvard University Press, 1975).

14. E. O. Wilson, *On Human Nature* (New York: Bantam Books, 1978): 138. Wilson received the Pulitzer Prize for that book, one of several fanciful sequels to *Sociobiology.*

15. See note 2.

16. Consider this language for a moment. The concept of "potential" or "predisposition" is highly persuasive, but how is it measured except by outcome?

17. Wilson, *Sociobiology,* 555.

18. Wilson and others construct a Sociobiological argument that accounts for the presence of "homosexual genes" and homosexual males in populations by saying that such males with the "condition" are "helpers" to their kin, operating "with special efficiency in assisting close relatives to raise children," so their closely-related genes in their kin are preserved. Wilson's assumption that homosexual males do not have children suggests his level of knowledge about homosexuals in society. Further, he does not even mention lesbians or female homosexuality.

19. It was recently determined that Cyril Burt, whose twin studies have been the guiding evidence in this area, fabricated data and even the research assistants who purportedly collected the data in some of his twin studies! See L. S. Hearnshaw, *Cyril Burt: Psychologist* (London: Hodder and Stoughton, 1979) and Lewontin *et al., Not In Our Genes,* 101–106. Current claims about identical twins and behavior are coming

from the University of Minnesota: Thomas J. Bouchard, Jr., D. T. Lykken, M. McGue, N. L. Segal, and A. Tellegen, "Sources of Human Psychological Differences: The Minnesota Study of Twins Reared Apart," *Science* 250 (October 12, 1990): 223–228.

20. Helen Longino and Ruth Doell, "Body, Bias, and Behavior," *Signs* 9 (Winter 1983): 206–227.

21. Examples from the overlap of those two areas: Ruth Bleier, *Science and Gender* (New York: Pergamon, 1984); Anne Fausto-Sterling, *Myths of Gender* (New York: Basic Books, 1985); Sandra Harding, *The Science Question in Feminism* (Ithaca: Cornell University Press, 1986); Evelyn Fox Keller, *Reflections on Gender and Science* (New Haven: Yale University Press, 1985).

22. Protozoans are organisms such as euglena and paramecia, categorized as "eukaryotes" because they have a "true nucleus" bounded by a double membrane, a characteristic they share with all cells of "higher," multicellular organisms. In contrast, bacteria are much smaller single-celled organisms lacking a "true nucleus" and designated "prokaryotes."

23. Inaccurate though it may be.

24. James D. Watson *et al.*, *Molecular Biology of the Gene* (Menlo Park, CA: Benjamin/Cummings Publishing Company, Fourth Edition, 1987), Volume I: 190.

25. Watson *et al.*, *Gene*: 190; 191; 191.

26. Ibid.: 192. Experiments in mapping the genome of the bacteria used agitation with a Waring blender to separate the cells connected during genetic transfer; while the textbook adds that these experiments were called "the blender experiments," they are widely referred to informally as "coitus interruptus."

27. Here, "sex" as the exchange of genetic material is distinct from "reproduction," the creation of new individuals. In some other organisms, such as humans, these two functions are combined biologically in "sexual reproduction"—and then separated with birth control methods and homosexuality. The conflation of "sexual reproduction" and "sexual activity" in humans contributes to the misrepresentation of "sex" in bacteria.

28. The Biology and Gender Study Group, "The Importance of Feminist Critique for Contemporary Cell Biology," *Hypatia* 3 (Spring 1988): 71; T. M. Sonneborn, "Sexuality in Unicellular Organisms," in eds. G. N. Calkins and F. M. Summers, *Protozoa in Biological Research* (Chicago: University of Chicago Press, 1941).

29. See Fausto-Sterling, *Myths,* and Gould, *Mismeasure,* for the historical intertwining of essentialist arguments on sex, race, and class. Also, Sander L. Gilman, *Difference and Pathology: Stereotypes of Sexuality, Race, and Madness* (Ithaca: Cornell University Press, 1985).

30. Sarah Lucia Hoagland, *Lesbian Ethics: Toward New Value* (Palo Alto, CA: Institute of Lesbian Studies, 1988): 29 (note f). See, also, Eve Kosofsky Sedgwick, *Between Men: English Literature and Male Homosocial Desire* (New York: Columbia University Press, 1985).

31. James Darnell, Harvey Lodish, and David Baltimore, *Molecular Cell Biology* (New York: Scientific American Books, 1st Edition, 1986): 137.

32. For a full critique of this issue, see Bonnie Spanier, "Gender and Ideology in Science: A Study of Molecular Biology," *NWSA Journal* 3 (Spring 1991), forthcoming; Bonnie Spanier, *Gender and Ideology in Science: A Study of Molecular Biology* (Bloomington: Indiana University Press, forthcoming).

33. Sandra Gilbert and Susan Gubar, *The Madwoman in the Attic: The Woman Writer and the Nineteenth-Century Literary Imagination* (New Haven: Yale University Press, 1979): 3, 7.

Body Guards

34. Gilbert and Gubar, *Madwoman:* 4.

35. The articles addressed in this section are from *Science* magazine, the publication of the largest organization of scientists in the U.S., the American Association for the Advancement of Science. In contrast to most science journals, *Science* magazine does report on some political issues of science and society, but only in sections set apart for that purpose. The scientific reports and review articles are typical of comparable respected, refereed journals; they reflect an ideology that science is objective fact separate from societal influences. This essay illustrates the error of that belief.

36. G. Mardon, R. Mosher, C. M. Disteche, Y. Nishioka, A. McLaren, D. C. Page, "Duplication, Deletion, and Polymorphism in the Sex-Determining Region of the Mouse Y Chromosome," *Science* 243 (January 6, 1989): 78–80.

37. I cite primarily from an issue of *Science* devoted to "Sexual Dimorphism," edited by Frederick Naftolin and Eleanore Butz, *Science* 211 (March 20, 1981). While that issue was published a number of years ago, current articles reflect no significant change in assumptions and methodology; for example, articles published in *Science* 243 (January 6, 1989), and cited above. *Science* is typical of scientific journals and other publications (conference proceedings, books, etc.) in using the dominant paradigm of sex determination. See a detailed critique in Anne Fausto-Sterling, "Society Writes Biology/Biology Constructs Gender," *Daedalus* (Fall, 1987): 61–76.

38. Anke Ehrhardt and Heino Meyer-Bahlburg, "Effects of Prenatal Sex Hormones on Gender-Related Behavior," *Science* 211 (March 20, 1981): 1313. Comprehensive critiques of the original Money and Ehrhardt research on "masculinized" girls exposed prenatally to androgens and the subsequent claims about that work are found in Anne Fausto-Sterling's *Myths,* Chapter 5: "Hormones and Aggression: An Explanation of Power", esp. 133–141 and Ruth Bleier's *Science and Gender* (New York: Pergamon Press, 1984), esp. 97–103.

39. Ehrhardt and Meyer-Bahlburg, "Effects of Prenatal Sex Hormones": 1316. A more recent article by those authors explicitly uses the same paradigm to explain homosexuality. Anke Ehrhardt, Heino Meyer-Bahlburg, L. R. Rosen, J. F. Feldman, N. P. Veridiano, I. Zimmerman, and B. McEwen, "Sexual Orientation after Prenatal Exposure to Exogenous Estrogen," *Archives of Sexual Behavior* 14 (1985): 57–77. For an in-depth analysis, see Helen Longino, *Science as Social Knowledge: Values and Objectivity in Scientific Inquiry* (Princeton: Princeton University Press, 1990).

40. For example, the concluding paragraph of "Neural Gonadal Steroid Actions," by Bruce McEwen (*Science* 211 (March 20, 1981): 1301–1311:

> In the light of these generalizations, we can consider our own species. The human, like the rhesus monkey, is a species in which masculinization, rather than defeminization, appears to be the predominant mode of sexual differentiation (60). It seems reasonable that the neural substrate for gonadal steroid responsiveness is represented in the human brain in much the same way that we know it to be represented in the brains of rhesus and bonnet monkeys . . . Other articles in this issue (87) elaborate on the extent to which we are able to recognize, **in spite of the environmental influences of learning,** the components of human behavior which are influenced by hormones during development and in adulthood. (emphasis added) (1310)

First, it is instructive to hear the very "reasonable" tone of the leap made between monkeys and humans, brains and behavior. Then, it is important to note how the general scientific methodology employed can *only* see "the environmental influences of learning" as *obscuring* (the verb "obscure" is used in the introductory essay in this issue on sexual

dimorphism: 1264) rather than enlightening the mechanisms of sex development, since "mechanisms" are limited by definition to "biology". And "biology" excludes the dynamic interweaving of our physical beings with our experience within our environment. Further, the articles referenced within the quote above (note 87) are the two articles in the journal that address human sexual behavior, and they are the most guilty of the inaccuracies and questionable assumptions I have delineated. Thus, we see how mutual reinforcement at the "scientific" level renders totally invisible the sociopolitical construction of gender.

41. See Fausto-Sterling, *Myths,* and Bleier, *Science and Gender.*

42. Ehrdardt and Meyer-Bahlburg, "Effects of Prenatal Sex Hormones": 1312.

43. Margaret L. Andersen, *Thinking About Women: Sociological and Feminist Perspectives* (New York: Macmillan, 1983), esp. 16.

44. Diana Long Hall, "Biology, Sex Hormones, and Sexism in the 1920s," in *Women and Philosophy: Toward a Theory of Liberation,* eds., Carol C. Gould and Marx W. Wartofsky (New York: Perigree Books/GP Putnam, 1976), pp. 81–96. For a more recent study, see Nelly Oudshoorn, "Endocrinologists and the Conceptualization of Sex," *J. Hist. Biol.* 23 (1990): 163–187.

45. Andersen, *Thinking About Women:* 31–33.

The naming and characterizing of the "male" and "female" "sex hormones" in the 1920s was a product of cultural beliefs about sex differences. Thus, in spite of the following statement from a 1939 review of a major endocrinology treatise, the paradigm of biologically-determined bipolar male/female "sex" has prevailed:

> The present epoch [with regard to sex hormones] has been characterized as one of confusion because of the demonstration of the close chemical interrelationships of all the sex hormones . . . , the possibility of conversion of one to the other (it will be remembered that the urine of the stallion is one of the most potent sources of estrone, whereas it is not found in the urine of the gelding), the isolation of male hormone from actual ovarian tissue, and the fact that all males secrete estrogens and females androgens. All these matters are now well established as facts. It would appear that maleness or femaleness can not be looked upon as implying the presence of one hormone or the absence of the other, but that differences in the absolute and especially relative amount of these two kinds of substances may be expected to characterize each sex and, though much has been learned it is only fair to state that these differences are still incompletely known.

Herbert Evans, 1939 review of "Endocrine Glands: Gonads, Pituitary, and Adrenals," as quoted in Hall, "Biology, Sex Hormones, and Sexism": 91.

46. Hall, "Biology, Sex Hormones, and Sexism": 89.

47. Frederick Naftolin, "Understanding the Bases of Sex Differences," *Science* 211 (March 20, 1981): 1264.

48. Schiebinger, "Skeletons": 42.

49. That does not mean that the ancients believed in equality. Vesalius accepted Galen's belief that women's reproductive organs were inferior because they were inverted and internal. (Schiebinger, "Skeletons": 48–49)

50. Schiebinger, "Skeletons": 46.

51. Sandra Harding, *The Science Question:* 104.

52. Feminists can be guilty of heterosexist solipsisms as well, as Chodorow's *Reproduction of Mothering* illustrates. In Chodorow's analysis of gender relations and her revisions of Freud within the framework of psychoanalytic object relations theory, she takes us to the door of "natural" lesbianism in the mother-daughter relationship, but

she stops there. The obvious question is: given this particular context, how can we explain why *all* women aren't lesbians? There is no evidence that Chodorow has stepped across the threshold. Nancy Chodorow, *The Reproduction of Mothering* (Berkeley: University of California Press, 1978): 197–200; Adrienne Rich, "Compulsory Heterosexuality and Lesbian Existence," in *Blood, Bread, and Poetry* (New York: Norton, 1986): 32–35.

53. Audre Lorde, "The Master's Tools Will Never Dismantle the Master's House," in *Sister Ousider* (Trumansburg, New York: The Crossing Press, 1984): 110–113.

54. The shadows of biological determinism and essentialism make discussions of biology and feminism problematic, but some feminists, among them Ruth Hubbard and Janet Sayers, articulate an open-minded approach that considers the political dangers of the issue. See, for example, Janet Sayers, *Biological Politics: Feminist and Anti-feminist Perspectives* (New York: Tavistock, 1982), Chapter 10, "Biology and the Theories of Contemporary Feminism"; Ruth Hubbard, *The Politics of Women's Biology* (New Brunswick: Rutgers University Press, 1990). To encourage critical examination of other sciences, I offer a series of guidelines in my forthcoming book and am planning an edited collection of essays on feminist critiques of different areas of the natural sciences.

I4

Misreading Sodomy: A Critique of the Classification of "Homosexuals" in Federal Equal Protection Law[1]

Janet E. Halley

Interrogatory No. 30: [H]ow many members of the Navy, identified as "homosexuals" have been retained in the Navy?

Answer No. 30: The use of the term "identified" makes this question impossible to answer. The term is imprecise. More information is needed.

—Interrogatory of Plaintiff James Miller and Answer of Defendant U.S. Navy, in *Beller v. Middendorf*[2]

If you recently visited Alabama, Arizona, the District of Columbia, Florida, Georgia, Idaho, Louisiana, Maryland, Michigan, Minnesota, Mississippi, North Carolina, Pennsylvania, Rhode Island, South Carolina, South Dakota, Utah, or Virginia—and if while there you willingly participated in any act in which the sex organ of one person touched the mouth or anus of another person, you committed a crime, and in most of these jurisdictions a felony. That is, in almost half of the jurisdictions within the United States, anal intercourse, fellatio and cunnilingus all constitute the felony of sodomy. Your criminal liability is the same whether you identify yourself as heterosexual or homosexual, or whether your partner (or partners) was (or were) of your own gender. If this worries you, you might move to (or restrict your travel to) the twenty-four states where these acts are felonies only if performed without the consent of the sex partner. And if you expect to perform consensual sodomy only with persons of the so-called opposite sex, and you wish to avoid any possibility of criminal prosecution, you should repair to Arkansas, Kansas, Kentucky, Missouri, Montana, Nevada, Oklahoma, Tennessee or Texas. *Every other state* that crimi-

nalizes consensual sodomy does so without regard to the gender of the participants.[3]

The degree to which these legal facts are surprising is the degree to which heterosexual sodomy has disappeared from public awareness. Today, in most states with consensual sodomy statutes, felonious sodomy includes not only cunnilingus and fellatio among gay men and lesbians, but also any oral/genital or anal/genital contacts between heterosexual partners. The statutes as they are written today avoid even suggesting a distinction between homosexual or heterosexual acts or persons—and yet the referentiality of these categories is often said to turn precisely on the criminalization of sodomy.

A remarkable aporia appears here—one that is important not only to an understanding of the operation of the sodomy statutes in our culture but also to the formation of adequate constitutional arguments for gay and lesbian rights. For the common (mis)understanding of the sodomy statutes is on its way to becoming a misreading with the force of law—and if it does so it not only will foreclose the two best constitutional arguments that remain available to gay-rights advocates, but also will legitimate, as a matter of constitutional law, a repressive conception—or rather, dynamic—of gay identity.

In its first section, this essay traces the ways in which federal courts have misread sodomy and the human classifications it generates. In section two, it encourages those who wish to resist this alarming development in equal protection law to reconsider two arguments that have been linchpins of our litigation strategy heretofore: the focus on privacy as the premier *desideratum,* and the claim that sexual orientation should not be punished because it is immutable. Finally, in its third section, this essay argues that sexual orientation identities are produced in a highly unstable public discourse in which a provisional default class of "heterosexuals" predicates homosexual identity upon acts of sodomy in a constantly eroding effort to police its own coherence and referentiality.[4]

I.

Two important federal cases—*Bowers v. Hardwick*[5] and *Padula v. Webster*[6]—frame the current constitutional debate about the character

of sexual orientation identities. In *Hardwick* the U.S. Supreme Court made it resoundingly clear that the constitutional right to privacy does not extend to homosexual sodomy; in *Padula* the U.S. Court of Appeals for the D.C. Circuit ruled that the constitutional guarantee of equal protection under the law does not invalidate the FBI's refusal to hire a woman on the ground that she was a lesbian. Read together, these cases suggest that sodomy is currently misread in a discursive dynamic that not only generates the official version of homosexual identity but also constitutes a "heterosexual" class whose occlusion and instability are crucial to its coercive power.

The cases involve very different legal principles. The right of privacy at stake in *Hardwick,* though nowhere mentioned in the federal constitution, has been held to be implicit in the Fourteenth Amendment's guarantee that no person shall be deprived of life, liberty or property without due process of law. The most notorious privacy right, certainly, is that announced in *Roe v. Wade.*[7] The right to privacy implicates a libertarian conception of government, requiring that federal and state governments *keep out* of certain decisions, and certain places, deemed to be "private"; conversely, it implicates a liberal conception of the individual as an entity with a "private self" concerning which she alone should make decisions. What the Court determined in *Hardwick,* therefore, was that homosexual consensual sodomy was not "private" in this sense; that such sodomy was always legitimately under public scrutiny; and that a state that disliked it could punish it as a felony.

The right at stake in *Padula*—the right to the equal protection of the laws—has very different contours. This right, which is explicitly mentioned though not defined in the Fourteenth Amendment, requires federal and state governments to distribute benefits and impose burdens equally. It is an affirmative obligation, not merely a negative restraint; it applies always and only to intrinsically *public* activity, the activity of *a government;* and it requires governments to develop at least rough-and-ready theories of sameness and difference. In enforcing it the Supreme Court has differentiated between classifications that don't suggest unfairness—for instance, those allowing adults but not children to fly airplanes—and those that do—for instance, those allowing whites but not blacks to ride in the front of the bus. Courts are very deferential to laws using apparently fair classifications: those will be held constitutional as long as they represent *rational* means to reach a *legitimate*

goal of the state. Of course, very few laws subject to this test have been declared irrational and thus unconstitutional. "Suspect classifications"—that is, acts of classification that are suspicious under equal protection doctrine—are to be permitted only when they are the *only* way to reach a *compelling* goal of the state. The *Padula* case involved the classification of "practicing homosexuals." What the D.C. Circuit determined in that case was that the group of "practicing homosexuals" was not a suspect classification, and that the FBI could rationally decide that a member of that group should not be hired as one of its special agents.

Typically, a ruling under the due process clause does not have any bearing on equal-protection doctrine. To take a hypothetical example, it appears that husbands may not invoke the constitutional right to privacy to protect themselves from prosecutions for raping their wives; but no one suggests that, for that reason, the FBI can refuse to hire any married men without violating the equal protection clause. The distinction is a vital one for lesbians and gay men seeking legal protection from the federal courts: having lost so unequivocally the right to privacy, we now turn to the equal protection clause (and a similarly public guarantee, the First Amendment), under which the *Hardwick* case should have no precedential force whatsoever.[8]

According to *Padula*, however, the *Hardwick* case "forecloses [any] effort to gain suspect class status"—that is, any effort to gain meaningful protection under the equal protection clause—"for practicing homosexuals." This unusual application of precedent was justified precisely by the equation of sodomitical conduct with the class of homosexuals which, as we have seen, the sodomy statutes belie. The *Padula* judges ruled that "homosexuals" do not constitute a "suspect class" because Supreme Court, in *Hardwick,* refused to invalidate "state laws that criminalize *the behavior that defines the class*[.]"[9]

According to the *Padula* logic—which has been followed by three other federal appeals courts, and has been rejected by only one federal district court[10]—the class of "homosexuals" is inevitably sodomitical and thus intrinsically felonious; discrimination against it therefore merits no special judicial solicitude. Statutes that expose homosexual sodomy, no matter how clandestine, to public scrutiny and punishment, also define the class of homosexuals and justify its exclusion from public benefits and responsibilities.

The peculiar slippages that attend this definition of the class of "homosexuals" all seem to require some sort of willful blindness to the actual scope of most sodomy prohibitions. The Supreme Court's majority opinion in *Hardwick* provides perhaps *the* most egregious examples of this occlusion. The Georgia criminal provision under which Michael Hardwick was arrested prohibits "any sexual act involving the sex organs of one person and the mouth or anus of another."[11] This is the classic "modern" sodomy statute, describing, with an attempt at clinical precision, certain acts which no person may perform with any other person and avoiding any distinction between heterosexual and homosexual persons.

Michael Hardwick brought a challenge to the statute as it was written: the statute applied to him *as a person,* and invaded the privacy rights he enjoyed *as a person.* But Justice White's opinion for the majority silently refused to recognize the inclusiveness of the statute and of Hardwick's complaint, construing the case as a challenge to the statute "as applied" to Hardwick alone.[12] Narrowing the question in a constitutional case is usually considered sound judicial practice,[13] but here Justice White not only narrowed but also distorted the case before him. He declared that "the issue presented is whether the Federal Constitution confers a fundamental right *upon homosexuals* to engage in sodomy"; having posed the question in that way, he had authorized himself to hold, and did hold, that Georgia's condemnation of "*homosexual sodomy*" validly expressed "majority sentiments about the morality of *homosexuality*."[14]

As written, of course, the Georgia statute expresses no sentiments about "homosexuality" and does not even recognize the distinct existence of a crime of "homosexual sodomy" or of the group of persons denominated "homosexuals." Rather, the *Hardwick* decision itself is constitutive of these entities. Far from deferring, as it claims to do, to the Georgia legislature's classification and condemnation, the Court displaced these with a classification and condemnation of its own. And another displacement is at work here. It was an apparently intolerable truth that any adult within the borders of Georgia is statutorily capable of sodomy, for Justice White occluded this legal fact about all "persons" behind the glaring reification of "homosexuals." After all, *Hardwick* is the case that denied to "homosexuals" the right to privacy, that insisted on the unremittingly public nature of their sexual activities.

Here we have in a single judicial gesture both what Robert Cover would call an act of judicial violence—an enforcement of the state's coercive power upon the body of a litigant[15]—and an act of knowing, or interpreting, that body. For Justice White not only set the constitution's imprimatur on punishment of "homosexual sodomy" but equated that act with "homosexuality" and indeed with "homosexuals"—a group now not only defined but known by its sodomitical essence.

The District of Columbia Circuit's decision in *Padula v. Webster* reproduced this gesture of epistemological legerdemain in its ruling that the *Hardwick* decision forecloses equal protection arguments for gay rights by legitimating a sodomy statute that "criminalizes the conduct that defines the class" seeking protection. *Padula* is both a dangerous precedent and a useful lesson: dangerous because it imported *Hardwick*'s falsifying and punitive scheme of classification intact into equal protection jurisprudence; and useful because this new context may make it easier to see why that scheme of classification is wrong. For the equal protection clause requires courts to scrutinize not classes but acts of classification—not preexisting, given biological groupings of human persons but governmental determinations that certain persons shall belong and others shall not belong to a special favored or disfavored group. At issue in an equal protection case is not merely the government's power to redistribute benefits and burdens, but also its power to create and perpetuate social classifications.

The *Padula* decision draws a spotlight to its own act of classification, therefore, and exposes the dynamics by which that act not only approves of but intensifies the poisonous social discourse that got the sodomy statutes on the books in the first place. On the one hand, the *Padula* definition silently declines to acknowledge the act of self-identification undertaken by uncounted openly gay, lesbian and bisexual men and women who do not commit and have not committed felonious sodomy, displacing that act of classification with its own. Lesbians who forego cunnilingus, the many gay men who have abandoned fellatio and anal intercourse to protect themselves and their lovers from AIDS, self-identified gay men and lesbians who remain celibate, and indeed the thousands of gay men and lesbians who live in states where consensual sodomy is not a crime—no matter how powerfully these individuals shape the meaning of the term "homosexual," the *Padula* court has appropriated from them a power to know better.[16]

And yet even as the *Padula* court thus articulated its power over the public disclosure and meaning of homosexual identity, it declined to give any content to an unacknowledged class which the demarcation of homosexuals, by implication, creates. This silence is most arresting in the *Padula* judges' failure to grapple with the sodomy statute actually in force in the jurisdiction in which they sat when they made their ruling. For this pronunciamento was uttered in Washington, D.C., where, as we have seen, the law prohibits all sodomitical acts without regard to the gender of the actors. According to the statute the judges themselves, no matter what their sexual orientation, are potential sodomites. If indeed felony sodomy were the "behavior that defines the class" of homosexuals, then the class of homosexuals would include every adult in that jurisdiction. But according to the *Padula* logic it is *homosexual* sodomy, not *felony* sodomy, that defines the class of homosexuals: the criminality of sodomitical acts involving persons of different genders is simply assumed out of existence.

In order to make any kind of sense of the D.C. Circuit's ruling, we have to connive with the judges first in ignoring the true scope of the D.C. statute and second in blinking the existence of a second class of persons to which it might apply. The reward for joining in their misprision of the statute is that one can then join them as well in silently constituting the class of those who (mis)read themselves out of the target group of the sodomy statute, those who are exempt, those whose sexual conduct is covered by a mantle of privacy and silence.

This is a pretty significant bribe. Having equated the public identity "homosexual" with felonious sodomy, the *Padula* definition creates a second category—not of heterosexuals but of nonhomosexuals. This capacious "default" class includes not only people who sleep with members of their own gender but aren't publicly identified with this conduct, but also people who routinely commit acts of sodomy with members of a gender other than their own. Thus, in addition to so-called heterosexuals who never commit sodomy, this amorphous and therefore unstable class includes many individuals against whom a facially neutral sodomy statute could be enforced. These individuals are not inherently immune from application of the criminal prohibition: rather they are exempt only as long as they do not expose to public attention their jeopardy. The longer the statute remains unenforced, furthermore, the greater the number of individuals who appear to fall,

by operation of their *and its* silence, beyond its reach but who are actually, perhaps temporarily and perhaps unwittingly, subject to the terms of its bribe.

The nonenforcement of the many facially neutral sodomy statutes thus compounds their misprision, helping to create a legal regime in which homosexual identity is represented not only as criminal but also as transparent; and in which a nonhomosexual majority polices its members' discourse by threatening sporadic punitive assignments of that identity.

II.

The *Hardwick* majority appropriated two essentialist arguments that have been pervasively advanced in gay-rights polemics, and that are now due for reexamination. The first is the basic commitment to *privacy* as a litigation strategy. The second is the argument that gay identity warrants special constitutional protection because it is *immutable*.

Reduced to a rough syllogism, the privacy argument went (and still sometimes goes) like this:

First premise: Constitutional privacy is an irreducible zone of personhood, a retreat which must be left inviolate so that the self might discover and express its nature.

Second premise: "Homosexuals" constitute a distinct class of persons existing in human nature and they must, by their very nature, commit sodomy.

Conclusion: The constitutional right of privacy must extend to homosexual sodomy.

In the *Hardwick* decision Justice White ignored the first premise and scornfully rejected the conclusion, but the second premise permeates his opinion. Like those who advocated the expansion of gay rights on the basis of personhood arguments, Justice White and the concurring majority in *Hardwick* assumed a natural homosexual, a preexisting human class persistently marked and thus adequately defined by the act of sodomy. Unlike the gay-rights advocates, however, who attributed the discovery and knowledge of homosexual personhood to homosexual persons themselves, the Supreme Court majority appro-

priated that power of revealing and knowing to itself and to the state for which it spoke.

The second premise of the privacy syllogism includes an assumption that gay identity emerges ineluctably from an irresistable propensity to commit sodomy. Embedded in the privacy argument, therefore, is a hidden commitment to the idea that sexual-orientation identities are the immutable givens of nature. Such an argument has been made explicit elsewhere in the gay-rights litigation campaign, when advocates have argued that homosexual identity qualifies as a suspect classification under the equal protection clause because it is *immutable*. After *Hardwick* and *Padula* this position, too, requires reexamination.

Before *Hardwick,* the immutability argument seemed not only legally but also rhetorically *à propos.* To many, it seemed a necessary riposte to the majority's fears that some of its members might become gay unless the cost of doing so was high. As it directly allays such anxieties on their own terms, the exonerating power of the mutability argument has struck a popular nerve. A father fought homophobia on behalf of his lesbian daughter, for instance, by revealing that Parents and Friends of Lesbians and Gays have learned that "we did not 'cause,' and our children did not 'choose,' their homosexuality—that sexual orientation, like warts or perfect pitch, is a matter of biological roulette."[17] And Jeffrey W. Levi of the National Gay and Lesbian Task Force, testifying before the Senate Judiciary Committee, engaged in the following exchange with Senator Strom Thurmond:

MR. THURMOND: Does your organization advocate any kind of treatment for gays and lesbians to see if they can change them and make them normal like other people?

MR. LEVI: Well, Senator, we consider ourselves to be quite normal, thank you. We just happen to be different from other people. . . . To . . . answer the question more seriously, the predominant scientific viewpoint is that homosexuality is probably innate, if not innate then formed very early in life[.][18]

Confronted with the supposed requirement for heightened scrutiny that the proposed classification be based on an *immutable* trait, advocates of gay, lesbian and bisexual rights have almost uniformly—though often with visible qualms—embraced the argument that homo-

sexuality is immutable.[19] They have been encouraged by courts supporting gay rights that have justified their rulings by pointing to the supposed immutability of homosexuality,[20] as well as by hostile courts that have based their decisions to *deny* protection to homosexuals on the supposed *mutability* of sexual preference.[21]

As I have demonstrated elsewhere, however, immutability is not in fact a prerequisite for heightened scrutiny under recent Supreme Court precedents.[22] Though the Supreme Court has recognized some classifications to be suspect (or semi-suspect, in a bizarre exception to the canonical doctrinal framework crafted to deal with classifications based on "sex" or "gender") in part because they are deemed to be marked by immutable characteristics,[23] the Court has also held that aliens are a suspect classification in cases involving discriminatory legislation by the states.[24] Alienage, purely a legal status, is mutable. And finally, the Court has refused to deem "suspect" classifications based on other traits that *are* immutable. In *City of Cleburne v. Cleburne Living Center,* for example, the court held that a zoning regulation disadvantaging mentally retarded individuals required only rational basis review (and was unconstitutional under that standard). Indeed, the *Cleburne* decision is a virtual trove of language hostile to an immutability requirement.[25]

These decisions indicate that immutability is at most a *factor* which courts *may* consider in deciding whether to apply heightened scrutiny. The doctrinal focus throughout is on the social dynamics that create and burden classes of persons. And it's a good thing that immutability is not a requirement, because the best way to resist the *Padula* logic as it spreads from one federal appeals court to another, blocking equal protection challenges at the very threshold of the courtroom, is to articulate the constitution of sexual orientation identities in a system of political and highly mutable discursive interactions.

III.

The very judicial decisions in which courts have adjudicated constitutional challenges to anti-homosexual discrimination demonstrate that sexual-orientation identity emerges in a social diacritics which is pervasively public and pervasively unstable. Indeed, these cases demon-

strate that the class of "homosexuals" is a highly contingent classification which arises, with alarming frequency, in arbitrary efforts to rationalize and stabilize the default class of "heterosexuals." As Eve Kosofsky Sedgwick has said of these dynamics, "[i]t is the paranoid insistence with which the definitional barriers between 'the homosexual' (minority) and 'the heterosexual' (majority) are fortified, in this century, by nonhomosexuals, and especially by men against men, that most saps one's ability to believe in 'the homosexual' as an unproblematically discrete category of persons."[26] "Nonhomosexuals" indeed: the legislative and judicial gestures in which these definitional barriers are constructed reveal how the default classification "heterosexual" functions as a lie and a bribe, eliciting the dishonesty of its inhabitants by the threat of precipitous, arbitrary expulsion.

The public status "heterosexual" is an unmarked signifier, the category to which everyone is assumed to belong. Something has to *happen* to mark an individual with the identity "homosexual." Though this marking is accomplished only in complex social interactions, in the following analysis I distinguish two basic narratives: (1) an individual, acting in some sense voluntarily, publicly assumes a gay or lesbian identity; and (2) some other agent—a friend, mother, employer, prosecutor, judge—ascribes or imposes a gay or lesbian identity on an individual, with or without her consent. For the purposes of this analysis I treat these narratives as distinct, though it will repeatedly become apparent that, in the interpretive interactions that make up the world, they are inextricably intertwined. And throughout, I examine these narratives for their contribution, in a process of mutually constitutive interactions, to the generation and socially destructive utility of the classification of "heterosexuals."

Homosexual identity imposed. The legal burdens currently imposed on homosexuality deter people from *appearing* gay, so that, of the total number of self-identified gays and lesbians, only a fraction will voluntarily "come out," and so that, of the remaining "closeted" gays, only a fraction will become subject to the public ascription of gay identity to them. Furthermore, because the assumption of heterosexuality applies in virtually every social interaction—from the encounter of teacher with student, salesperson with shopper, mother with daughter, Supreme Court Justice with clerk—even the most forthright and fearless gay man or lesbian cannot "come out" once and for all in a single

public disclosure: as she moves from one social setting to another she will have to come out afresh or acquiesce in the assignment to her of a nonreferential public identity.

The public identity "homosexual" at any one moment, then, is vastly underinclusive of self-identified gay men and lesbians. It is therefore an even less accurate indicator of individuals who entertain homoerotic desires or have had homosexual experiences without labelling themselves gay or lesbian.

Simultaneous counterforces are at work to ensure that the public identity "homosexual" is overinclusive, encompassing individuals who do not (or do not very often) feel or act on homoerotic desires and who do not denominate themselves gay or lesbian. Consider, for instance, the process and criteria for assigning the public identity homosexual which the Sixth Circuit approved in *Gay Inmates of Shelby County Jail v. Barksdale*. Enforcing a county jail's policy of segregating all homosexual inmates, the intake officer was authorized to "make a purely subjective judgement," and to segregate (among others) inmates who "appear[] weak, small or effeminate[.]"[27]

The problem here is not only that the lack of physical strength or monumental build have no reliable correlation to gay male identity. Nor do we exhaust the error here by pointing out the fallacy that men who desire men must be like women. The scene at the Shelby County Jail emphasizes a more profound element of public homosexual identity that is too often forgotten: in order for the sign to "mean" the signified, there must be an *interpreter,* and the interpreter cannot get out of the web of signifiers which purport to indicate public sexual identity. If he is small himself, or delicate of build; if he is a behemoth; if he is just an average guy; no matter how many pounds of flesh lie on his bones, he will exercise his power of interpretation to channel interpretations of his own body. As Martha Minow has observed, "In assigning the label of difference, the group confirms not only its identity, but also its superiority, and displaces doubts and anxieties onto the person now called 'different'."[28]

Two forms of immutability are being created in such interactions: the segregated inmate is marked—irrevocably for many social purposes[29]—as homosexual, and the officer so marking him confirms his own heterosexuality. Neither form of the immutability of public identity, however, is at all stable.

It is therefore not surprising that courts, legislators and regulators have encountered intractable difficulties in their efforts to write coherent definitions of a homosexual class in order to place legal burdens upon it. When the New Hampshire legislature, in an effort to exclude homosexuals from adoption, foster care and day-care center employment, proposed a definition of homosexuals virtually identical to that advanced in *Padula*,[30] the New Hampshire Supreme Court determined in an advisory opinion[31] that exceptions had to be made to save the bill's constitutionality. It construed the bill to exclude victims of homosexual rape. It then made another exception, for acts not

> committed or submitted to on a current basis reasonably close in time to the filing of the application. . . . This interpretation thus excludes from the definition of homosexual those persons who, for example, had one homosexual experience during adolescence, but who now engage in exclusively heterosexual behavior.[32]

According to the court, homosexual status is occupied exclusively by persons who have engaged in homosexual acts. This decision thus reproduces without noting the underinclusiveness problems so apparent in the *Padula* definition. Interestingly, the court is worried instead about the overinclusiveness of a definition that fails to distinguish as "*heterosexual*" individuals who, though they engaged in the physical acts described in the bill, didn't *intend* them in such a way as to merit the label "homosexual." Those who gave no consent to an act of homosexual sex (rape victims), and those who consented *but only once* stand out in the court's mind as true "heterosexuals."

The patterns of intention in the latter category are deeply problematic. That category includes individuals whose desires may be predominantly homosexual and who have acted on them, but who have determined to mask these facts from themselves by embracing a purely heterosexual subjective identity and from others by passing as straight. The court's example forgives these lies, and builds them into the scheme of state enforcement. And more: the "only once" heterosexual[33] is merely the example forwarded by the court of a much broader category, much more sweepingly permissive of heterosexual self-deception and self-protection. For all those whose homosexual acts are not "commit-

ted on a current basis reasonably close in time to the filing of the application . . ." shall be deemed to be heterosexual.[34]

Even as the New Hampshire court, like the D.C. Circuit in *Padula,* attempts to erect a conceptual structure that will render the status "homosexual" rigid and immutable, it recognizes and privileges certain kinds of changes. The mutability of sexual identity is recognized, and its civil advantages are accorded exclusively to currently self-identified heterosexuals. And yet this privileged class is so heterogeneous that it will contain many individuals who could be ejected at any time.

The discursive characteristics of such an ejection are disturbingly visible in the case of James Miller, a member of the Navy discharged under Navy regulations in effect in 1978. These regulations expressly mandated that any member found to have engaged even in a single homosexual act be processed for discharge.[35] They are structurally identical to the original New Hampshire bill and the *Padula* definition, in that all impose a simple equation of homosexual act with homosexual identity.

The court's analysis of James Miller's case displays an ugly tableau, with the "homosexual" reduced to the object of others' knowledge and as such to language so close to gibberish that it is worse than silence; and with the official knower founding the clarity of its discourse simply upon its power to enforce it. Miller admitted to committing homosexual acts while on leave in Taiwan and at some unspecified earlier time, yet he also "has at various times denied being homosexual and expressed regret or repugnance at his acts."[36] It is tempting to see Miller's confession as a clear indication of his autobiography. But Miller's statements are not fragments of an internal process of self-assessment, however inchoate: he made them to Navy officials under the threat of compulsory punishment.

We oversimplify again if we conclude that Miller cynically declared himself a true heterosexual revolted by his inconsistent actions in order to dupe his inquisitors and obtain an undeserved clemency. For by the inquisitorial interaction recorded here Miller and the Navy create for him a *new public identity.* The possibility of sincerity is simply foregone by such an utterance. Instead, the process of social construction, the interaction in which an individual interprets himself to a world interpreting him, has reached a crisis at which, Robert Cover has suggested, both interpretation and language itself break down.[37] Everyone now

understands—or should understand—that the utterances of the confessor and the categories imposed by the inquisitor have lost all referential power. In the case of plaintiff James Miller, the possibility of discovering any "true" sexual orientation, if it ever existed, has been destroyed.

The Ninth Circuit's decision is replete with indications that some of the naval and judicial decisionmakers were disturbed by this collapse in their discursive program. Both the hearing board convened to consider Miller's discharge and the Senior Medical Officer who examined him balked at applying to Miller the Navy's strict act/status equation. The board found that he had committed homosexual acts while in service, but recommended that he be retained. It is not clear from the published opinion whether this vote expressed a view that Miller was an erring heterosexual, a harmless homosexual, or a human being who could not be fit into rigid ideal categories. The appellate opinion's report on the Senior Medical Officer's evaluation suggests the more critical third alternative. According to Judge Kennedy's opinion, the medical expert found that Miller "did not *appear* to be '*a homosexual*'[.]"[38] Kennedy's typography here recognizes the social artifice of the category "homosexual," a sign I was once willing to take as auspicious.[39] But Judge Kennedy finally rendered these highly equivocal reports legally nugatory, and stabilized the legal assignment of homosexual identity to plaintiff Miller, by interpreting the old rules as creating absolutely no discretion in those charged with carrying them out.[40] In contrast to two other plaintiffs whose appeals were consolidated with Miller's, Kennedy concludes, "The case of Miller is closer but no less *clear*."[41]

The clarity Judge Kennedy invokes here is the dream of raw power that it can escape the centripetal logics of discourse altogether. In this epistemological crisis, the knower of others' sexual identities can be expected to act a little defensive. In particular, he or she will attempt to render invisible the processes by which official knowledge is produced, while refusing to recognize any answering subterfuge in the object of official description. A striking example of these protective strategies is Judge Bork's opinion *Dronenburg v. Zech*—fittingly, a Navy discharge case that arose under Navy regulations revised in 1978 to avoid the consequences, apparently intolerable to decisionmakers policing the class heterosexuals, of the earlier regulation's strict act/status equation.

The new regulations provided for the discretionary retention of "a member who has solicited, attempted, or engaged in a homosexual act on a single occasion *and who does not profess or demonstrate proclivity to repeat such an act. . . .*"[42] Despite the revision, *Dronenburg v. Zech* merely replays the crisis of *Beller v. Middendorf.* Rejecting the argument that the right to privacy encompasses homosexual acts, Judge Bork declares: "*It need hardly be said* that none of these [privacy rights established by Supreme Court precedents] *covers* a right to homosexual conduct."[43] Bork here asserts his own right to say nothing, to remain inscrutable and silent, even as he determines that existing privacy doctrine does not hide from official view—does not "cover"—homosexual conduct. Homosexual conduct must be visible to a knower who is not to be known.

The doctrinal result of such a dynamic has been judicial endorsement of definitions of homosexuality that are not definitions at all. It only seems old fashioned to declare, as a Texas court did in 1909, that a statute prohibiting "the abominable and detestable crime against nature" is perfectly sufficient because "the charge was too horrible to contemplate and too revolting to discuss."[44] Much more recently Maryland's prohibition of oral/genital contact and of "any other unnatural or perverted practice"[45] was held not to be unconstitutionally vague because the language employed conveyed "a clear legislative intention to cover the whole field of unnatural and perverted practices": the state court of appeals "thought it unnecessary to describe in detail practices which are matters of common knowledge."[46] And in his concurrence in *Bowers v. Hardwick,* issued in 1986, Chief Justice Burger placed his *imprimatur* on such definitions, intoning with approval:

> Blackstone described "the infamous crime against nature" as an offense of "deeper malignity" than rape, an heinous act "the very mention of which is a disgrace to human nature" and "a crime not fit to be named."[47]

Well within this tradition of reticence, silence and modest submergence in "common knowledge,"Judge Bork's opinion in *Dronenburg v. Zech* repeatedly calls upon locutions which both assert that his position is patently obvious and mark his reluctance to expose it. His articulations are either unnecessary ("It need hardly be said that . . .";

"To ask the question is to answer it"), redundant (evidence may be drawn from "common sense and common experience") or reluctantly ceded to the exigencies of the moment ("... and, it must be said. ...")[48]

These gestures create the character of the official knower, a man whose "common sense and common experience" render him unexceptionably a member of a stable, common majority that knows without having to find out. The *Dronenburg* opinion nevertheless readmits the epistemological difficulties that its magisterial author pretends to negate. Providing the list of dangers which the Navy policy might rationally be supposed to redress—precisely the list that has been declared needless—Judge Bork supposes the need to prevent encounters that might "make personal dealings uncomfortable where the relationship is sexually ambiguous[.]"[49] Discomfort with such ambiguity could hardly arise if heterosexual identity were as absolute and secure as the unnameability trope suggests. Indeed, Judge Bork deepens his suggestion that anti-homosexual discrimination functions not to punish and separate a clear and preexisting class of homosexuals but to secure the confident subjective and public identities of heterosexuals when he concludes his list of dangers thus:

> Episodes of this sort are certain..., it must be said, given the powers of military superiors over their inferiors, to enhance the possibility of homosexual seduction.[50]

Judge Bork is not worried about homosexual rape, in which the victim is *ex hypothesi* an unwilling partner. Instead, his anxious concern focuses on the heterosexual sailor who *can be seduced* into a homoerotic encounter. A key rationale for anti-homosexual discrimination, then, is anxiety about the ambiguity of heterosexual interactions, about a potential for mutability that undermines heterosexual identity. Lest the change actually take place, "known" homosexuals must be segregated.

Homosexual identity assumed. Some individuals are "exposed" as gay or lesbian; others expose themselves. Official discovery of individuals *in flagrante delicto* and the reports of former sex partners will rarely be available to provide evidence of homosexual conduct and give color to the official conclusion that an individual is "homosexual": much

easier to rely on the professions of homosexuals themselves. Acts of discrimination in this setting seem to avoid the epistemological difficulties that undermine rules founded on homosexual conduct. After all, the open lesbian or gay man has inserted herself into the legally defined class.

Miriam benShalom, for example, while a member of the U.S. Army Reserves, "publicly acknowledged her homosexuality during conversations with fellow reservists, in an interview with a reporter for her division newspaper, and in class, while teaching drill sergeant candidates."[51] In response to this candor the Army moved to discharge her, invoking a regulation providing for the discharge of any soldier who "evidences homosexual tendencies, desire, or interest, but is without homosexual acts."[52] This interaction is apparently unequivocal, benShalom and the Army agreeing as to her status and merely disagreeing as to its substantive value and consequences.

A series of cases involving self-professed homosexuals and bisexuals suggest, however, that legal strictures on sexual orientation carefully manage passage in and out of the closet, giving new and often unwanted meaning to sojourns on either side of the threshold. *Doe v. Casey* offers a complex example of the legal meaning of secrecy in the context of homosexual stigma. The plaintiff, "out of the closet but under cover," was dismissed from his employment as a CIA agent after he voluntarily represented himself as homosexual to a CIA security officer. As the appellate opinion carefully notes, "John Doe is proceeding under a pseudonym only because his status as a CIA employee cannot be publicly acknowledged, not because of any embarrassment about his homosexuality."[53] The context reminds us that legally enforced secrecy can often be a vigorously pursued government goal.

Under the rule of *Board of Regents v. Roth*, a federal employee has a "liberty interest," under the due process clause of the Fourteenth Amendment, in her job. If she is adversely affected in her employment she can seek due process protection, but only upon a showing of an actual change in job status and an accompanying "injury to [her] good name, reputation, honor or integrity, or the imposition of a similar stigma."[54] Applying this rule, the appeals court in *Doe v. Casey* held that, if Doe's dismissal arose from a CIA policy of firing all homosexuals, the key to his due-process claim was whether that action burdened him with a stigma. In a congested and difficult passage, the court denied

368

that Doe, as a self-professed homosexual, could be stigmatized by his dismissal. Because the "real stigma imposed by the [government employer's] action . . . is the charge of homosexuality,"[55] and "[b]ecause Doe himself does not view homosexuality as stigmatizing—and indeed, admits that he is a homosexual[,]" the court ruled that Doe would not be stigmatized by the CIA's disclosure to other government agencies that he was dismissed on the ground of his homosexuality.[56]

The court purports to view the problem of stigma from Doe's point of view: if he disclosed his homosexuality, he clearly sees nothing scandalous in it; and if he sees nothing scandalous in his homosexuality, he has no liberty interest in evading its legal consequences. The apparent respect paid here to Doe's self-conception and self-description is revealed as a sham if we note the implication of the court's reasoning: a self-identified homosexual in government employment, in order to retain a liberty interest in his or her job, must (1) subjectively regard his or her homosexuality as degrading and (2) hide it.

This reasoning creates a new form of the public identity "homosexual" for individuals, like Doe, who reject this invitation to self-denigrating secrecy. The court construes men and women who chose not to remain closeted to have made a simultaneous choice to wear whatever badge the majority determines is appropriate for them. Even as the court attempts to monopolize the power to define and control the subjective experience of stigma, it simultaneously establishes the legal fiction that those harmed by government discrimination have chosen their injury.[57] As an alternative to this violent appropriation of the public identity of a self-professed homosexual, the case opens a pocket of legal protection for individuals who obey a prohibition on homosexuality not by eschewing homosexual acts or rejecting a homosexual subjective identity, but by appearing straight. One cost to them of accepting that protection is that they must also accept the public meaning of their equivocal position—the court's equation of their closetedness with the assumption that they have internalized the substantive determination that homosexuality is degrading to them.

Legal deterrence of homosexuality thus anticipates that many self-identified homosexuals, if allowed to pass as heterosexual, would rather switch than fight. It does all it can to motivate people to change their public self-presentations, fostering a pervasive and unquantifiable regime of mutability. Moreover, because control over the meaning of

public identity is kept firmly in the hands of the anti-homosexual majority, that majority retains the power to dictate still more changes. Department of Defense regulations for granting security clearances recognize how profoundly volatile the closet can be by providing for deeply skeptical review of any applicant who, because she has concealed *anything* about her homosexual conduct or identity, is deemed to be blackmailable. The regulations regard as a disqualifying factor "the fact that any applicant has concealed or attempted to conceal his homosexuality from his employer or from his immediate family members, close associates, supervisors or coworkers."[58]

An equal protection challenge to these regulations, in *High Tech Gays v. Defense Industry Security Clearance Office,* succeeded before the district court but failed on the government's appeal to the Court of Appeals for the Ninth Circuit. In an ominous move, the appeals court ruled precisely on the ground, articulated in *Padula,* that *Bowers v. Hardwick* barred such challenges because it held a sodomy statute constitutional and thus approved the criminalization of "the behavior that defines the class" of homosexuals.[59]

But as the district court had observed *High Tech Gays,* the discrimination at issue involved not sodomy but identity. The lower court noted that the Defense Department's regulations obligate individuals to reveal not only sodomy, not only the very loosely defined group of acts deemed by the regulations to be "homosexual," but even desires: "because the policy relates to sexual preference itself, a person who is merely attracted to people of his own sex, but engages in no activity with them, must reveal his preference to all immediate family members, close associates, coworkers, or supervisors."[60] It is not even clear that, in the Defense Department's eyes, full public disclosure of homosexuality protects one from the transformative power of blackmail: in *High Tech Gays* the Department of Defense offered as evidence of the blackmailability of homosexuals the fact that plaintiff Timothy Dooling, an openly gay man, was approached for purposes of blackmail—even though Dooling had "unequivocally rejected" the offer.[61]

On the threshold between the closet and public homosexual identity, anything can happen. The beliefs of others can suddenly be transformed into one's public identity. Killian Swift, a White House stenographer, lost his job after his employer asked his immediate supervisor whether he was homosexual. She "confirmed that, *to her knowledge,* he is

[*sic*][,]"[62] and he was dismissed. And the threshold is broad indeed, appearing under the feet even of the noncommittal and the inquisitive. Mere advocacy of homosexual rights, mere investigation into the issue of sexual orientation, can trigger suppositions that one is gay, and suppositions can become public reality. When the Army imposed the regulation challenged in *benShalom v. Secretary of the Army,* requiring discharge of any soldier who "evidences homosexual tendencies, desire, or interest[,]" it formalized this interaction. As the district court recognized in that case, under such a regime of sexual identity "[n]o soldier would dare be caught reading anything that might be construed as a homosexually-oriented book or magazine. No soldier would want to be observed in the company of any person suspected of being a homosexual. Most importantly, no soldier would even want to make any statements that might be interpreted as supporting homosexuality."[63]

The rapidity with which an individual can lose control of the secret of her sexual orientation and find it transformed into the opprobrium and civil disabilities of imposed public identity, is exemplified by the story of Marjorie Rowland, a closetted, nontenured guidance counselor at a public high school.[64] Her story starts with an episode in which she treated her own bisexuality as a secret about herself by disclosing it, carefully, to a single coworker. This coworker reported her disclosure to the school's principal. Some time later Rowland counseled the parent of a student confused about his or her sexual identity, advising the parent not to panic at this uncertainty. Fearful after this interview that her job might be threatened, Rowland confided the fact of the interview, and her bisexuality, to the school's vice principal. Soon her sexual identity became a matter of public knowledge, the object of a local effort to get her fired. Throughout the growing turmoil, and with increasing publicity, Rowland continued to make confessions of her sexual identity. Finally she lost her job.

The majority opinion of the Sixth Circuit classified Rowland's first two disclosures as mere private utterances on matters of personal interest, and denied them the protection granted to public speech.[65] It concluded: "[P]laintiff has attempted to make homosexual rights the issue in this case. However, her personal sexual orientation is not a matter of public concern[.]"[66] Having once attempted to keep her bisexuality secret, Rowland could never join a public discourse about

her dismissal. This amputation of part of the body politic results from a view of sexual identity as a *thing,* immutably present prior to discussion of it. But the chain of events that led to Rowland's dismissal demonstrates that the disclosure of homosexual identity, no matter how secretive, *is always* a political act.

Justice Brennan, dissenting from the Supreme Court's denial of *certiorari* in *Rowland v. Mad River Local School District,* carefully delineates the false distinctions on which the Sixth Circuit's holding rests. First, no one can disclose personal homosexual or bisexual identity, even in the most secretive circumstances, without engaging in the current public debate over sexual orientation: "[t]he fact of petitioner's bisexuality, *once spoken,* necessarily and ineluctably involved her in that debate."[67] And second, that act of speech cannot then be distinguished from the sexual identity it reveals: "petitioner's First Amendment and equal protection claims may be seen to converge, because it is realistically impossible to separate her spoken statements from her status."[68]

And what about the interpreter? We vastly underestimate the complexity of the interaction that has taken place here if we understand the town to have discovered a hidden fact—Marjorie Rowland's bisexuality—and to have acted, wisely or foolishly, upon it. Remember that student, whom I will arbitrarily denominate "he." At the time Rowland's narrative began, he was wavering anxiously at the threshold of sexuality, uncertain which little box—gay, straight, or bisexual— he would have to insert himself into. The underlying ambivalence of this student's desires may have survived the storm that swept Rowland from her job. But the storm will have accomplished its purpose if the student learns that, as long as he lives in Mad River, he should not disclose them to anyone again.

Mad River as a political entity emerges from the Rowland controversy *heterosexual.* And, assuming the student heeds his lesson in silence, the class of heterosexuals thus constituted will include him, despite his capacity for confusion about his sexual orientation. No episode I have found in the federal case law makes it so clear that the resulting class of heterosexuals is a default class, profoundly heterogeneous, unstable, and provisional. It can maintain its current boundaries and even its apparent legitimacy only if the student and others like him remain silent. And until they speak, it owes its glory days as a coherent

social category to its members' own *failure to acknowledge* its discursive constitution.

Notes

1. Portions of this essay have been published previously. Sections II and III include revised passages of "The Politics of the Closet: Towards Equal Protection for Gay, Lesbian, and Bisexual Identity," 36 *UCLA L. Rev.* 915 (1989). Some passages in Section III will appear in "The Construction of Heterosexuality," 1 *Stanford J. of Law, Gender & Sexual Orientation* (1991). Thanks are due to both journals for permitting their republication in revised form here.

Legal citations in this essay are current to April 15, 1991, and conform to *A Uniform System of Citation* (13th ed.). Volume numbers precede, and page numbers follow, titles of case reporters and law reviews. Dates refer to dates of publication: for case decisions this will indicate the year the court rendered the opinion under discussion, but for statutes it indicates the year the statute reporter was published, not the year the statute was adopted or last amended.

2. *Beller v. Middendorf*, 632 F.2d 788, 804 n.13 (9th Cir. 1980), *cert. denied sub nom. Beller v. Lehman*, 452 U.S. 905, *cert. denied*, 454 U.S. 855 (1981).

3. Facially neutral statutes are in force in eighteen jurisdictions. Alabama (Alabama Code §§ 13A–6–60(2), 13A–6–65(a)(3) (1982)); Arizona (Ariz. Rev. Stat. Ann. §§ 13–1411, 13–1412 (1989)); District of Columbia (D.C. Code Ann. § 22–3502 (1981)); Florida (Fla. Stat. Ann. § 800.02 (West 1976)); Georgia (Ga. Code Ann. § 16–6–2 (1984)); Idaho (Idaho Code § 18–6605 (1987)); Louisiana (La Rev. Stat. Ann. § 14:89 (West 1987)); Maryland (Md. Code Ann. art. 27, §§ 553–54 (1987)); Michigan (Mich. Comp. Laws Ann. § 750.158 (West 1990)); Minnesota (Minn. Stat. Ann. § 609.293 (1987)); Mississippi (Miss. Code Ann. § 97–29–59 (1972)); North Carolina (N.C. Gen. Stat. § 14–177 (1990)); Pennsylvania (Pa. Stat. Ann. tit. 18, § 3124 (Purdon 1983)); Rhode Island (R.I. Gen. Laws § 11–10–1 (1981)); South Carolina (S.C. Code Ann. § 16–15–20 (Law. Co-op. 1985)); South Dakota (S.D. Codified Laws § 22–22–2 (1988)); Utah (Utah Code Ann. § 76–5–403(1), (3) (1990)); Virginia (Va. Code § 18.2–361 (1988)).

In addition to the Michigan sodomy statute cited above, Michigan has enacted three criminal statutes that do distinguish between gay male, lesbian and heterosexual encounters. The statutes prohibit "gross indecency," a term that may include fellatio, and apply to acts between men, Mich. Comp. Laws Ann. § 750.338 (West 1991); between women, Mich. Comp. Laws Ann. § 750.338a (West 1991); and between a man and a woman, Mich. Comp. Laws Ann. § 750.338b (West 1991). By their terms these statutes apply to private as well as public conduct.

Nine states prohibit sodomy only when the participants are of the same sex. They are: Arkansas (Ark. Stat. Ann. § 5–41–1813 (1975)); Kansas (Kan. Stat. Ann. § 21–3505 (1988)); Kentucky (Ky. Rev. Stat. Ann. § 510–100 (1990)); Missouri (Mo. Rev. Stat. § 566–090(1)(3) (West 1979)); Montana (Mont. Code Ann. §§ 45–2–101(20), 45–2–101(60), 45–2–101(61), 45–5–505 (1989)); Nevada (Nev. Stat. § 201.190 (1986)); Oklahoma (Okla. Stat. tit. 21, § 886 (1983). For a facially neutral statute which has been held to violate the state constitutional right to privacy when applied to heterosexual

sodomy, *see Post v. State,* 715 P.2d. 1105 (Ok. Crim. App.), *cert. denied,* 107 S. Ct. 290 (1986)); Tennessee (Tenn. Code Ann. § 39–13–510 (Sup. 1990)); Texas (Texas Penal Code Ann. § 21.06 (1989)).

Twenty-three states no longer criminalize private, consensual acts of sodomy (though many deem certain classes of individuals, for instance children, to be incapable of consent, and several have criminalized sexual contacts that expose a sex partner to transmission of HIV infection). States that have no sodomy statute *per se* (or that cannot enforce a sodomy statute that remains on the books because it has been judicially repealed or limited) are: Alaska, California, Colorado, Connecticut, Delaware, Hawaii, Illinois, Indiana, Iowa, Maine, Massachusetts, Nebraska, New Hampshire, New Jersey, New Mexico, New York, North Dakota, Ohio, Oregon, Vermont, Washington, West Virginia, Wisconsin, and Wyoming.

4. For the fourth step in this critique—the argument that the federal constitution actually protects individuals from discrimination on the basis of homosexual identity— *see* Halley, "The Politics of the Closet: Towards Equal Protection for Gay, Lesbian and Bisexual Identity," 36 *UCLA L. Rev.* 915, 915–32, 963–76 (1989).

5. *Bowers v. Hardwick,* 478 U.S. 186, 106 S. Ct. 2841 (1986).

6. *Padula v. Webster,* 822 F.2d 97 (D.C. Cir. 1987).

7. *Roe v. Wade,* 410 U.S. 113 (1973).

8. Cass R. Sunstein has constructed a different critique of arguments conflating due process with equal protection analysis in this context. *See* "Sexual Orientation and the Constitution: A Note on the Relationship between Due Process and Equal Protection," 55 *U. Chi. L. Rev.* 1161 (1988).

9. *Padula,* 822 F.2d at 103.

10. *High Tech Gays v. Defense Indus. Security Clearance Office,* 895 F.2d 563 (9th Cir. 1990); *benShalom v. Marsh,* 881 F.2d 454 (7th Cir.), *cert. denied,* 110 S. Ct. 1296 (1989); *Woodward v. United States,* 871 F.2d 1068 (Fed. Cir. 1989); *Jantz v. Muci,* 759 F. Supp. 1543 (D. Kan. 1991).

11. Ga. Code Ann. § 16–6–2 (1984).

12. *Bowers v. Hardwick,* 106 S. Ct. at 2842 n.2.

13. *Ashwander v. Tennessee Valley Authority,* 297 U.S. 288 (1936).

14. *Bowers v. Hardwick,* 106 S. Ct. at 2843, 2846.

15. Robert Cover, "Violence and the Word," 95 *Yale L. J.* 1601 (1986).

16. *See Baker v. Wade,* 553 F. Supp. 1121, 1134 (N.D. Tex. 1982) (Texas sodomy statute prohibiting contacts of the sex organs of one person with the mouth or anus of another does "not prohibit homosexuals from kissing or sexually stimulating their partners with hands and fingers"), *rev'd,* 769 F.2d 289 (5th Cir. 1985), *cert. denied,* 478 U.S. 1022 (1986).

17. Bernstein, "My Daughter is a Lesbian," *N.Y. Times,* Feb. 24, 1988, at A27, col.1.

18. "Thurmond on Homosexuality," *N.Y. Times,* Aug. 2, 1986, at 6, col.1.

19. Most commentators, attempting to fit the class to the doctrine, argue that homosexuality is immutable. Note, "The Legality of Homosexual Marriage," 82 *Yale L. J.* 573, 576 (1973); Miller, "An Argument for the Application of Equal Protection Heightened Scrutiny to Classifications Based on Homosexuality," 57 *So. Cal. L. Rev.* 797, 817–21 (1984), Delgado, "Fact, Norm, and Standard of Review—The Case of Homosexuality," 10 *Univ. of Dayton L. Rev.* 575, 583–85 (1985); Lasson, "Civil Liberties for Homosexuals: The Law in Limbo," 10 *Univ. of Dayton L. Rev.* 645, 656–57 (1985); Boyle, "Marital Status Classifications: Protecting Homosexual and Heterosexual Cohabitors," 14 *Hastings Constitutional L. Q.* 111, 120, 127–28 (1986). The argument is reluctantly

adopted by Arriola, "Sexual Identity and the Constitution: Homosexual Persons as a Discrete and Insular Minority," 10 *Women's Rights Law Reporter* 143, 154–55 (1988). A few publications assert that the immutability argument is empirically or doctrinally problematic in arguments urging the protection of homosexual rights; see Chaitin and Lefcourt, "Is Gay Suspect?," 8 *Lincoln L. Rev.* 24 (1973); Note, "The Constitutional Status of Sexual Orientation: Homosexuality as a Suspect Classification," 98 *Harvard L. Rev.* 1285, 1302 (1985). One article argues that, because homosexuality is not known to be immutable, it cannot form a suspect classification. Comment, *"Bowers v. Hardwick:* Balancing the Interests of the Moral Order and Individual Liberty," 16 *Cum. L. Rev.* 555, 588 (1986).

20. See *Doe v. Commonwealth's Attorney for Richmond,* 403 F. Supp. 1199, 1205 (E.D.Va. 1975) (Merhige, J., dissenting) (rejecting argument that anti-homosexual legislation promotes marriage), *aff'd mem.* 425 U.S. 901 (1976); *Commonwealth v. Bonadio,* 490 Pa. 91, 415 A.2d 47, 50 (1980) (rejecting marriage-promotion justification); *Baker v. Wade,* 553 F. Supp. at 1132 (sexual orientation of many homosexuals immutable and therefore not deterrable); *Gay Rights Coalition of Georgetown University Law Center v. Georgetown University,* 536 A.2d 1, 36 (D.C. App. 1987).

21. See *High Tech Gays v. Defense Indus. Security Clearance Office,* 895 F.2d 563, 573 (9th Cir. 1990) (construing Supreme Court precedent to impose an immutability requirement and rejecting, in part on a finding that homosexuality is not immutable, plaintiffs' argument that heightened scrutiny should be applied to the denial of their applications for federal security clearances); *In re Opinion of the Justices,* 129 N.H. 290, 295, 530 A.2d 21, 24 (1987) (rejecting strict or intermediate scrutiny because "sexual preference is not a matter necessarily tied to gender, but rather to inclination, whatever the source thereof"). The desirability of deterring children from imitating the homosexuality of those around them has loomed large in child custody, child care and education settings. See also *In re Opinion of the Justices; National Gay Task Force v. Board of Education of City of Oklahoma,* 729 F.2d 1270 (10th Cir. 1984), *aff'd by an equally divided court,* 470 U.S. 903, 105 S. Ct. 1858 (1985).

22. See Halley "The Politics of the Closet," 36 *U.C.L.A. Law Rev.* at 923–32.

23. See, *e.g., Frontiero v. Richardson,* 411 U.S. 677, 686 (1973) (sex-based classification held to require "intermediate" scrutiny).

24. *Graham v. Richardson,* 403 U.S. 365 (1971).

25. *City of Cleburne v. Cleburne Living Center,* 473 U.S. 432, 442–43 (1985).

26. Eve Kosofsky Sedgwick, *Epistemology of the Closet,* pp. 83–84 (Berkeley: Univ. of California Press, 1990).

27. *Gay Inmates of Shelby County Jail/Criminal Justice Complex v. Barksdale,* No. 84–5666 (6th Cir., June 1, 1987) (available on WESTLAW, ALLFEDS database).

28. Martha Minow, "The Supreme Court, 1986 Term—Foreword: Justice Engendered," 101 *Harvard Law Review* 10, 51 n.201 (1987).

29. Inmates at the Shelby County Jail may be classified as homosexual if they have been so classified in the past. *Gay Inmates,* at 4. Even without this policy, peers of an inmate classified as a homosexual are not likely to forget it.

30. New Hampshire HB 70 defined "a homosexual" as "any person who performs or submits to any sexual act involving the sex organs of one person and the mouth or anus of another person of the same gender." *In re Opinion of the Justices,* 129 N.H. 290, 293, 530 A.2d 21, 22 (1987).

31. Unlike the federal constitution, some state constitutions allow their courts to issue "advisory opinions" when the executive or legislative branch seeks to ascertain the

legality of proposed regulation or legislation. Absent from these cases are the disputing parties of the typical judicial "case or controversy."

32. *In re Opinion of the Justices,* 129 N.H. at 295, 530 A.2d at 24.

33. Not a typographical error, notwithstanding the many queries this usage has stimulated when I circulated this essay in draft. If we give social interpretations any importance at all, we should acknowledge that people who pass as heterosexual *are* heterosexual in at least one important sense of that term. If this acknowledgement means that the referentiality of the term "heterosexual" begins to appear questionable, *tant mieux.*

34. *In re Opinion of the Justices,* 129 N.H. at 295, 530 A.2d at 24.

35. The Navy's Personnel Manual Bupersman § 340220, *quoted in Beller v. Middendorf,* 632 F. 2d at 803 n.11.

36. *Beller v. Middendorf,* 632 F. 2d at 802 n.9.

37. Cover, "Violence and the Word," 95 *Yale L. J.* 1601, 1602–03 (1986).

38. *Beller v. Middendorf,* 632 F. 2d at 794 (emphasis added).

39. I wish to disavow my earlier, more generous reading of Judge Kennedy's decision, included in my article "The Politics of the Closet," 36 *UCLA L. Rev.* at 952.

40. *Beller v. Middendorf,* 632 F.2d at 801–05.

41. *Beller v. Middendorf,* 632 F.2d at 802 n.9.

42. SEC/NAV Instruction 1900.9C P6b (Jan 20, 1978) (emphasis added) (*quoted in Dronenburg v. Zech,* 741 F.2d 1388, 1389 n.1 (D.C. Cir. 1984)).

43. *Dronenburg v. Zech,* 741 F.2d at 1395–96.

44. *Baker v. Wade,* 553 F. Supp. 1121, 1148 (1982) (quoting Texas Penal Code, art. 342 (1860) (current version at Tex. Penal Code ann. §§ 21.06 1989)), and *Harvey v. State,* 55 Tex. Crim. 199, 115 S.W. 1193 (1909). For astonishing additional examples in this tradition, *see* Lee Edelman, "Homographesis," 3 *Yale J. of Criticism* 189, 190 (1989).

45. Md. Crim. Law Code Ann. § 554 (1987).

46. *Hughes v. State,* 14 Md. App. 497, 500 n.3, 287 A.2d 299, 302 n.3 (1972) (*citing Blake v. State,* 210 Md. 459, 124 A.2d 273 (1956)), *cert. denied,* 409 U.S. 1025 (1972).

47. *Bowers v. Hardwick,* 478 U.S. at 197, 106 S. Ct. at 2847 (Burger, C.J., concurring) (*quoting* Blackstone, 4 *Commentaries on the Laws of England* 215 (London, 1769)).

48. *Dronenburg v. Zech,* 741 F.2d at 1395–96, 1398.

49. *Id.* at 1398.

50. *Id.*

51. *benShalom v. Secretary of the Army,* 489 F. Supp. 964, 969 (E.D. Wis. 1980).

52. Army Regulations Ch. 7–5b(6), 135–178, *quoted in benShalom,* 489 F. Supp. at 969.

53. *Doe v. Casey,* 796 F.2d 1508, 1512 n.2 (D.C. Cir. 1986), *aff'd in part and rev'd in part on other grounds sub nom. Webster v. Doe,* 108 S. Ct. 2047 (1988).

54. *Doe v. Casey,* 796 F.2d at 1522–23 (*citing Board of Regents v. Roth,* 408 U.S. 564 (1972) and *Doe v. United States Department of Justice,* 753 F.2d 1092, 1105 (D.C. Cir. 1985)).

55. *Doe v. Casey,* 796 F.2d at 1523 n.66 (*quoting Beller v. Middendorf,* 632 F.2d at 806).

56. *Id.* at 1523.

57. Cf. *Plessy v. Ferguson,* 163 U.S. 537, 551, 16 S. Ct. 1138, 1143 (1896) (If "the enforced separation of the two races stamps the colored race with a badge of inferior-

ity[,]" "it is not by reason of anything found in the act, but solely because the colored race chooses to put that construction upon it.").

58. Department of Defense Personnel Security Program Regulation, 32 C.F.R. § 154 app. H (1987), *quoted in High Tech Gays v. Defense Indus. Security Clearance Office,* 668 F. Supp. 1361, 1365 (N.D.Cal. 1987).

59. *High Tech Gays v. Defense Indus. Security Clearance Office,* 859 F.2d 563 (9th Cir. 1990), *reversing* 668 F. Supp. 1361 (N.D. Cal. 1987).

60. *Hi Tech Gays,* 668 F. Supp. at 1376.

61. *Id.* at 1375.

62. *Swift v. United States,* 649 F. Supp. 596, 597 (D.D.C. 1986) (emphasis added).

63. *benShalom,* 489 F. Supp. at 974.

64. *Rowland v. Mad River Local School Dist.,* 730 F.2d 444 (6th Cir. 1984), *cert. denied,* 470 U.S. 1009 (1985).

65. *Rowland v. Mad River,* 730 F.2d at 449. The court here applies the rule set forth in *Connick v. Myers,* 461 U.S. 138, 138–39, 103 S. Ct. 1684, 1690 (1983) ("when a public employee speaks not as a citizen upon matters of public concern, but instead as an employee upon matters only of personal interest, absent the most unusual circumstances, a federal court is not the appropriate forum in which to review the wisdom of a personnel decision taken by a public agency allegedly in reaction to the employee's behavior").

66. *Rowland v. Mad River,* 730 F.2d at 451.

67. *Rowland v. Mad River,* 470 U.S. at 1012 (Brennan, J., dissenting from the denial of *certiorari*) (emphasis added).

68. *Id.* at 1016 n.11.

Notes on Contributors

Elizabeth Castelli is Assistant Professor of Religious Studies and Women's Studies at the College of Wooster in Wooster, Ohio. Her work focuses on the usefulness of literary and cultural theory for understanding religious expressions (texts, rituals, pieties). She is currently working on a book entitled BODY POLITICS: INTERPRETATIONS OF POWER AND DISCOURSES OF THE BODY IN EARLY CHRISTIANITY.

Julia Epstein is Associate Professor of English and Chair of the Major in Comparative Literature at Haverford College. She is the author of THE IRON PEN: FRANCES BURNEY AND THE POLITICS OF WOMEN'S WRITING.

Marjorie Garber is Professor of English and Director of the Center for Literary and Cultural Studies at Harvard University. She is the author of three books on Shakespeare. Her essay in this volume is drawn from a longer chapter on "The Chic of Araby" in her most recent book VESTED INTERESTS: CROSS DRESSING AND CULTURAL ANXIETY, (Routledge, 1991), a major study of transvestism in literature and culture.

Janet E. Halley is Associate Professor of Law at Stanford Law School.

Her research focuses on the contributions of law to the formation of gender, sexual orientation, and racial, ethnic, and national identities. She serves as a cooperating attorney for Lambda Legal Defense.

Ann Rosalind Jones is Professor of Comparative Literature at Smith College, where she teaches literary theory, women's writing, and Renaissance studies. She has published THE CURRENCY OF EROS: WOMEN'S LOVE LYRIC IN EUROPE, 1540–1621, studies of Renaissance poetry and prose, and articles on French feminism. She is now finishing POLEMICAL DOUBLES, a study of the early modern gender debate in English pamphlets, drama, and fiction.

Gary Kates is Associate Professor of History at Trinity University in San Antonio, Texas. He is the author of THE CERCLE SOCIAL, THE GIRONDINS, AND THE FRENCH REVOLUTION, and serves on the Board of Editors of FRENCH HISTORICAL STUDIES.

Everett K. Rowson is Associate Professor of Arabic and Islamic Studies at the University of Pennsylvania. He holds a doctorate in Islamic philosophy from Yale University and has published translations of medieval Arabic works of philosophy and history, as well as articles on philosophy and literature in the medieval Middle East. He is currently researching the treatment of homosexuality in Arabic literature and Islamic law.

Judith Shapiro is Provost and Professor of Anthropology at Bryn Mawr College. Her research and publications include work on gender; kinship and social organization; and missionization. She has done field research among indigenous peoples of lowland South America and with a missionary congregation of Catholic women. She has served as President of the American Ethnological Society.

Bonnie B. Spanier is Assistant Professor and Chair of the Women's Studies Department at the State University of New York, Albany. After receiving her doctorate in microbiology and molecular genetics from Harvard University, she taught biology at Wheaton College in Massachusetts. She is co-editor of TOWARD A BALANCED CURRICULUM: A SOURCEBOOK FOR INITIATING GENDER INTEGRATION

PROJECTS. Her research now focuses on feminist critiques of molecular and cell biology, and she is completing a book about gender ideology in the field of molecular biology.

Peter Stallybrass is Professor of English and Chair of Cultural Studies at the University of Pennsylvania. He is the co-author, with Allon White, of THE POLITICS AND POETICS OF TRANSGRESSION and co-editor, with David Kastan, or STAGING THE RENAISSANCE. His EMBODIED POLITICS; ENCLOSURE AND TRANSGRESSION IN EARLY MODERN ENGLAND AND IRELAND is forthcoming from Routledge.

Sandy Stone is a Visiting Professor in the Department of Sociology at the University of California, San Diego, where she teaches film, linguistics, gender studies, and feminist theory. She has done research on the neurological basis of vision and hearing for the National Institutes of Health, was a member of the Bell Telephone Laboratory Special Systems Exploratory Development Group, has been a consultant, computer programmer, technical writer and engineering manager in Silicon Valley, and worked with Jimi Hendrix in music recording. She is Director of the Group for the Study of Virtual Systems at the Center for Cultural Studies of the University of California, Santa Cruz and has published many articles on the phenomenology of communication. Her first science fiction novel, KTAHMET, will be published by Daw Books.

Kristina Straub is Associate Professor of English at Carnegie Mellon University. She is the author of DIVIDED FICTIONS: FANNY BURNEY AND FEMININE STRATEGY and SEXUAL SUSPECTS: EIGHTEENTH-CENTURY PLAYERS and the forthcoming SEXUAL IDEOLOGY.

Valerie Traub is Assistant Professor of Renaissance Drama and Gender Studies at Vanderbilt University. Her book, DESIRE AND ANXIETY: CIRCULATIONS OF SEXUALITY IN SHAKESPEAREAN DRAMA, is forthcoming from Routledge in 1992. Her essay in this volume was awarded the 1990 Crompton-Noll Award by the Gay and Lesbian Caucus of the Modern Language Association.

Body Guards

Randolph Trumbach is Professor of History at Baruch College, City University of New York. He has written THE RISE OF EGALITARIAN FAMILY and has forthcoming THE SEXUAL LIFE OF 18TH CENTURY LONDON. The essay in this collection is one of a number of preliminary studies on the history of homosexual behavior.

Michael Wilson is a lecturer in European history at Princeton University. The essay in this volume is drawn from his Cornell doctoral dissertation, LE COMMERCE DE LA BOHÈME: MARGINALITY AND MASS CULTURE IN FIN-DE-SIÈCLE PARIS.